# PAINTING A PLACE IN AMERICA

# PAINTING A PLACE IN AMERICA

*Jewish Artists in New York 1900–1945*

A Tribute to the Educational Alliance Art School

EDITED BY NORMAN L. KLEEBLATT AND SUSAN CHEVLOWE

The Jewish Museum, New York, published in cooperation
with Indiana University Press, Bloomington and Indianapolis

*Painting a Place in America: Jewish Artists in New York, 1900–1945. A Tribute to the Educational Alliance Art School*, has been published on the occasion of the opening of the exhibition organized by The Jewish Museum, New York, and installed at The Jewish Museum at The New-York Historical Society. The exhibition dates are May 16–September 29, 1991. Exhibition staff: Norman L. Kleeblatt, curator; Susan Chevlowe, assistant curator; Irene Z. Schenck, research associate; Emily C. Whittemore, research assistant; Daniel Kershaw, designer.

Distributed by Indiana University Press, Tenth and Morton Streets, Bloomington, Indiana 47405.

"'Americanizing' the Greenhorns" from *World of Our Fathers*, copyright © 1976 by Irving Howe, reprinted by permission of Harcourt Brace Jovanovich, Inc. U.K. rights by permission of Routledge.

Library of Congress Cataloging-in-Publication Data
Painting a place in America: Jewish artists in New York, 1900–1945/
    edited by Norman L. Kleeblatt and Susan Chevlowe
        p.    cm.
        Includes bibliographical references.
        ISBN 0-253-33121-8 (cloth).—ISBN 0-253-28536-4 (paper)
            1. Artists, Jewish—New York (N.Y.)—Exhibitions. 2. Art, Modern—20th century—New York (N.Y.)—Exhibitions. 3. Art, American—New York (N.Y.)—Exhibitions. I. Kleeblatt, Norman L. II. Chevlowe, Susan. III. Jewish Museum (New York, N.Y.)
    N6538.J4P35  1991
    704'.0392407471'090410747471—dc20                          91-582
1 2 3 4 5 95 94 93 92 91                                        CIP

Cover: Raphael Soyer, *Dancing Lesson*, 1926, oil on canvas, 24 x 20" (60.9 x 50.8 cm). Collection of Renee and Chaim Gross. Photo: Jonathan Morris-Ebbs. (cat. no. 112)

Design: By Design

# CONTENTS

# FOREWORD

The institutions in our city that endure are those that make a difference. The Educational Alliance has remained a vital force the past one hundred years because we have made a difference in the lives—physical, emotional and spiritual—of the people we serve.

A "curious mixture of night school, settlement house, day care center, gymnasium and public forum" is how Irving Howe, in *World of Our Fathers*, described the Alliance during its early years.

At the Alliance's twenty-fifth anniversary celebration in 1915, Justice Benjamin Cardozo commented that the work of the Alliance:

is something which, so far as I know, has never been attempted in just this form by any other institution before. Almost everything that is done here, is done somewhere else, if you split up the work and treat the elements separately; but the great and the original and the unique feature of this work is that here all these elements are brought together just as they are in life.

The Alliance continues today as a vital settlement house, community center and social work agency. With UJA-Federation and private support, and in the best traditions of an agency under Jewish sponsorship, the Alliance continues to develop and provide programs and services to the Jewish population in the various communities we serve. Moreover, with extensive government as well as private philanthropic support, the Alliance serves a cross-section of the entire ethnic and religious population of our city as we confront virtually every conceivable human problem and need—aging, cultural enrichment, drug abuse, early childhood development, homelessness, psychiatric impairment and retardation.

As it did a hundred years ago, the Alliance serves the people of the Lower East Side, but also Greenwich Village, SoHo and TriBeCa, as well as the communities of "Brownstone Brooklyn." Our services are rendered in some nineteen different locations in Manhattan, Brooklyn, Staten Island and upstate New York, the latter at summer camps that include two special camps at Brewster, New York, one for the elderly, the other for the developmentally disabled.

The Alliance has been and is today concerned with everyday needs for physical survival—but also with human dignity and with the human spirit. When we speak of "human dignity" and the "human spirit" at the Educational Alliance, we inevitably think of and speak about our Art School. That school is one of the jewels in our crown—certainly our cultural crown.

The art programs of the Alliance began in 1895, were suspended in 1905 (because of pressures resulting from a new wave of post-pogrom immigration), and resumed twelve years later in 1917. Our Art School has flourished ever since. Many of the great

immigrant artists during the first half of this century who studied and taught at the Alliance's Art School are being honored at this exhibition—Peter Blume, Jo Davidson, Jacob Epstein, Philip Evergood, Adolph Gottlieb, Chaim Gross, Louise Nevelson, Mark Rothko, Ben Shahn, Moses and Isaac Soyer and Abraham Walkowitz. The list of those who studied and taught at the Alliance goes on and on.

The careers of the artists and their works in the exhibition represent a prism through which we can view issues of assimilation and identification during the first half of this century. The Alliance's Art School provides an important chapter in this tale because it offered so many immigrants and children of immigrants their first exposure to and opportunity to study art. The teaching of art was only one of innumerable programs through which the Alliance acted as an agency of American acculturation.

Our Art School today builds on that extraordinary history. Whether we now have any of the potential masters of the future in our ranks, we do not know. What we do know is that we have individuals of all ages— youngsters, teens, mature adults, the elderly—and, as in the past, recently-arrived immigrants—who work and study at our School. They paint, sculpt, craft, photograph and (in our metal sculpture studios) weld. We offer all of these facilities and opportunities for cultural enrichment. Our objective is never to turn away anyone because of an inability to pay.

All you need do is walk through the rooms in our Art School and you will see abundant examples of "human dignity" and of the "human spirit."

We are grateful to the Jewish Museum for honoring through this exhibition the Educational Alliance, its centennial anniversary and our Art School.

Ernest Rubenstein
President
The Educational Alliance
March 12, 1991

*Mr. Rubenstein has served as president of the Educational Alliance since 1983.*

# PREFACE

The Jewish Museum is very pleased to organize this exhibition as a tribute to the one-hundredth anniversary of the Educational Alliance, an organization whose Art School included teachers and students seminal to the study of twentieth century American art. While investigating the social as well as the aesthetic influences on the work of these artists, who were, for the most part, immigrant and first-generation American Jews, the exhibition curators found a new context for the Alliance Art School itself, one which sheds new light on this extraordinary period of American art history.

Throughout the forty-five-year span of the exhibition, several artists' organizations and groups were formed—both formal and informal—which provided places to teach, exhibit and nurture one's cultural, political or professional identity.

Five such organizations are explored in *Painting a Place in America*. The Educational Alliance was the earliest, and its school existed within the walls of a large social service institution. The People's Art Guild, active from 1915 to 1918, advocated a thoroughly democratic approach to the subject matter of art and mounted important modernist exhibitions. The Jewish Art Center, between 1925 and 1927, embraced all of Jewish culture in its lectures, exhibitions and art sales; YKUF, established in 1937 during the Popular Front, was devoted exclusively to Yiddish culture. The Ten were

artists opposed to American Scene painting, and, in the years it met, the group provided a forum for the promotion of abstract art.

Jews became artists in significant numbers for the first time in the early decades of the century, when they migrated to some of the major art centers of the world. Their careers in these cities have inspired a series of exhibitions at the Jewish Museum, of which this is the third. Anglo-Jewish artists were the subject of *The Immigrant Generations* held in 1983. The works of Jewish artists in France between 1900 and 1945 were exhibited in 1985 in *The Circle of Montparnasse*. All these artists are a fairly short distance in time from a world where Jews were set apart, and where Jewishness, if not Judaism, prescribed much of one's identity. In New York, as in Paris and London, immigrant and first-generation Jewish artists encountered extraordinary change. Ultimately, the widely varying relationships between the artists and their Jewish identities, as well as their equally varied artistic styles, preclude any conclusions about a defined "Jewish art."

Additionally, as similar as the three exhibitions might seem on the surface, the relationship of the artists to the art world varies considerably within different national cultures.

The art scene in the Paris of *Circle of Montparnasse* drew many adult Jews who had already been trained in the art academies of Central and Eastern Europe. By contrast,

the Jewish artist in New York, ususally an immigrant or the child of one, became part of the city before being formed as an artist. Although New York artists frequently went to Paris to study the latest contemporary trends, it was their commitment to returning here and disseminating what had been learned that helped make New York an important international art center. *The Immigrant Generations* divided the artists into two groups—the first as part of the massive exodus from Eastern Europe at the turn of the century and the second, among those fleeing Fascism beginning in 1938. The earlier group, whether receiving training in Paris or studying solely in British academies, forged a British modernism. Their role thus parallels that of many Jewish artists of the same generation in New York.

Many thanks to Jewish Museum curator of collections Norman Kleeblatt for his creativity in organizing the exhibition and selecting the work. Added thanks to Susan Chevlowe, who served as assistant curator for the exhibition and co-editor of the publication. Their catalogue essay contains a tremendous amount of information which brings a new interpretation to a familiar group of artists.

Many thanks to Educational Alliance president Ernest Rubenstein for inspiring this exhibition as part of his work in shepherding the centennial celebrations of the Alliance. Our journey back in time to the founding days of the Alliance has renewed our appreciation for its mission and given us new insight into the lives of the people it has served.

Donors to the exhibition have been tremendously generous in their commitment to scholarly projects at the Jewish Museum. Many thanks to the Louis and Anne Abrons Foundation and The Horace W. Goldsmith Foundation, the Oscar & Regina Gruss Charitable & Educational Foundation, Fanya Gottesfeld Heller, the New York State Council on the Arts, the New York City Department of Cultural Affairs and the Alfred J. Grunebaum Memorial Fund. The catalogue was published with the generous assistance of the Lucius N. Littauer Foundation and a contribution from Mr. and Mrs. Walter H. Rubin.

Finally, thanks to the lenders of art, listed on page 13. Their participation in this project is deeply appreciated; their help, and that of the donors, scholars, staff and Jewish Museum Trustees, has enabled the museum to accomplish this ambitious and interesting investigation.

JOAN ROSENBAUM
DIRECTOR
THE JEWISH MUSEUM
FEBRUARY 27, 1991

# ACKNOWLEDGMENTS

*Painting a Place in America: Jewish Artists in New York, 1900-1945/A Tribute to the Educational Alliance Art School* has had a long and complex evolution which has required the cooperation of numerous individuals and institutions.

The contributors to this book have helped broaden our understanding of this period in the history of American art and the social history of Jews in America. We are grateful to Irving Howe and Harcourt, Brace Jovanovich for permitting us to reprint his succinct and insightful analysis of the Educational Alliance. Matthew Baigell accepted a great challenge in undertaking his essay. He labored to ferret out references to the intersection of American art and Jewish culture, and then to extract meaning from them. We thank him for the intensity of his interest and the receptiveness to the subject so evident in his essay. Resident Professor at the CUNY Graduate School Milton Brown, who knew many of the artists included in the exhibition, is the perfect person to provide insight into the meaning of being a Jewish artist in New York. His contribution allows us a fresh, intimate look at the subject.

*Painting a Place in America* would have been inconceivable without the energy, enthusiasm and dedication of Irene Z. Schenck and Emily Whittemore. Irene worked on the initial research for the project, and continued to seek out valuable and necessary information. She wrote artists' biographies as well. Emily also wrote biographies and handled numerous details of the exhibition. Caroline V. W. Goldberg, former curatorial assistant here during 1988 and 1989, also did considerable research from which the exhibition continued to benefit. Anita Friedman, the former senior research associate in this department, although ultimately assigned to other projects, provided invaluable assistance in the earliest stages of this project. Stanley Bergman of YIVO translated a number of Yiddish language documents for us. Wendy Wallis, a student at the CUNY Graduate School, helped with special research. Our gratitude also goes to the volunteers who helped with various aspects of the show: Dora Federbush, Belle Kayne and Anna Ternbach. We also benefited from the research on the participation of Jewish artists in the Social Realist movement as compiled by former assistant curator here, the late Kristie A. Jayne.

A number of artists, their families and friends, and others have provided much information and encouragement for the project. Special thanks go to Leonard Barton, Theresa Bernstein, Ruth Criss Berke, Bernard Braddon, Katherine Criss, Isabelle Dervaux-Travis, Harriette and Martin Diamond, Sandra and Bram Dijkstra, Arthur Granick, Sophie and Gene Gropper, Chaim and Renee Gross, Seymour Hacker, Carolyn and Wesley Halpert, Joseph Lieber, Adele Lozowick, Amy Lowenhar, Suzette Lane

McAvoy, Bea Mandelman, Virginia Hagelstein Marquardt, Benjamin Rifkin, Edith Roach, Michael Rosenfeld, Sidney Schechtman, Joseph Solman, Ellen Sragow, Christina Strassfield, Elissa Van Rosen, Marie Via, John Weichsel and Judith Weichsel Carr, Connie Weinstock and Barbara Zabel.

Of course, no exhibition can be achieved without the cooperation of the numerous lenders, both institutions and private individuals. Special thanks go to Linda Ferber, Linda Konheim Kramer and Barbara Gallati at the Brooklyn Museum; Susan Larsen at the Whitney Museum of American Art; Lynn Marsden-Atlass at Colby College Museum of Art; I. Eric Orav at the Sid Deutsch Gallery; Diana Strazdes, formerly of the Carnegie Museum of Art; Susan Bates at the Museum of Modern Art; Douglas Baxter at Pace Gallery; Jeffrey Bergen at ACA Galleries; Nora Howard at American Capital and Management Research, Inc.; Girard Jackson at Smith-Girard; Martha Fleischman at Kennedy Galleries; Marion Kahan, registrar for the collection of the Rothko family; Sanford Hirsch at the Adolph and Esther Gottlieb Foundation and Ruth and Herbert D. Schimmel.

Our appreciation goes to Nancy Foote of By Design for the editing and design of this book. Dan Kershaw has sensitively realized the exhibition design. We are grateful to them for their dedication, professionalism and, not least, their good humor.

A special thanks to Ward L.E. Mintz, assistant director for programs, and to Peter J. Prescott for their helpful comments on our essay.

The implementation of this exhibition would not have been possible without the help of a number of people with skills in the areas of photography, conservation, framing, etc., all of whom provided expert assistance and advice. Our thanks go to Konstanze Bachmann, Phillip Feld, Charles von Nostitz, John Parnell, Edward Owen and Lisa Sigal.

To all our colleagues at the Jewish Museum who have assisted with this project goes our sincere appreciation.

NORMAN L. KLEEBLATT
CURATOR OF COLLECTIONS

SUSAN CHEVLOWE
ASSISTANT EXHIBITION CURATOR

# DONORS TO THE EXHIBITION

The Jewish Museum gratefully acknowledges the extraordinary cooperation and support of the Educational Alliance in making this exhibition possible.

Major funding for *Painting a Place in America: Jewish Artists in New York, 1900-1945/A Tribute to the Educational Alliance Art School* has been provided by the Louis and Anne Abrons Foundation and The Horace W. Goldsmith Foundation, with additional support from the Oscar & Regina Gruss Charitable & Educational Foundation, Fanya Gottesfeld Heller, the New York State Council on the Arts, the New York City Department of Cultural Affairs and the Alfred J. Grunebaum Memorial Fund.

The catalogue was published with the generous assistance of the Lucius N. Littauer Foundation and a contribution from Mr. and Mrs. Walter H. Rubin.

# LENDERS TO THE EXHIBITION

ACA Galleries, New York
Albright-Knox Art Gallery,
    Buffalo, New York
American Capital Management
    and Research, Inc.
Archives of American Art,
    Smithsonian Institution
The Art Institute of Chicago
The Beinecke Rare Book and Manuscript
    Library, Yale University Library,
    New Haven, Connecticut
Ruth Criss Berke
M. G. Boretz
The Brooklyn Museum
Mr. and Mrs. Armand J. Castellani Collection
Colby College Museum of Art
Sylvan Cole
Columbus Museum of Art
Dallas Museum of Art
Sid Deutsch Gallery, New York
Harriette and Martin Diamond
Dr. Robert Dolgow and Mrs. Toby Cherny
The Educational Alliance, New York
Adolph and Esther Gottlieb Foundation, Inc.
Gene Gropper
Renee and Chaim Gross
Seymour Hacker
Syd and Harry Hausknecht
Hirshhorn Museum and Sculpture Garden,
    Smithsonian Institution
Archer M. Huntington Art Gallery,
    The University of Texas at Austin
Jewish National Fund
Herbert F. Johnson Museum of Art,
    Cornell University
Amy Lowenhar
Adele Lozowick
Lee Lozowick
Judah L. Magnes Museum,
    Berkeley, California

Memorial Art Gallery of
    The University of Rochester
The Metropolitan Museum of Art
Theresa Bernstein Meyerowitz
Joseph and Lillian Miller
The Museum of Modern Art, New York
National Academy of Design, New York
National Gallery of Art, Washington
National Museum of American Art,
    Smithsonian Institution
The National Portrait Gallery,
    Smithsonian Institution
The Newark Museum
The Phillips Collection
Dimitra Richardson
Rose Art Museum, Brandeis University,
    Waltham, Massachusetts
Christopher Rothko
Walter and Lucille Rubin
Salander-O'Reilly Galleries, New York
Mr. and Mrs. Herbert D. Schimmel
Joshua P. Smith
Smith-Girard, Stamford, Connecticut
University Art Museum,
    University of Minnesota, Minneapolis
Walker Art Center
Walsall Museum and Art Gallery,
    Walsall, England
Weatherspoon Art Gallery,
    Greensboro, North Carolina
Joy S. Weber
John Weichsel and Judith Weichsel Carr
Nathan and Baya Weisman
Whitney Museum of American Art, New York
The Mitchell Wolfson, Jr., Collection
YIVO Institute for Jewish Research, New York
Four anonymous lenders

# "AMERICANIZING" THE GREENHORNS

*Irving Howe*

How to educate immigrants in both the English language and American customs became an issue that agitated the East Side for decades. A clean, ruthless sweep of everything they had brought with them? A last-ditch resistance to each and every new influence they now encountered? Not many people openly advocated either course, though there were a good many German Jews, well entrenched in American life, who wanted the first, and at least some Orthodox immigrants who favored the second. Step by empirical step, the immigrant community moved toward biculturalism, though its shrewdest spokesmen, like Abraham Cahan, understood that even if achieved, this equilibrium between past and present could not be maintained for very long.

Nor was it merely toward American culture that the immigrants had to work out some sort of relation. Between them and America stood the German Jews, for whom Judaism was more a faith than an encompassing way of life. With an ease the Russian and Polish Jews could not—indeed, seldom cared to—emulate, the German Jews had thoroughly Americanized themselves, many of them finding a road to the Republican Party and bourgeois affluence. By the turn of the century, the tensions between the established German Jews and the insecure East European Jews had become severe, indeed, rather nasty—a glib condescension against a rasping sarcasm. The Germans found it hard to understand what could better serve their ill-mannered cousins than rapid lessons in civics, English and the uses of soap. But even as they seemed maddeningly smug to the East Europeans, they were bound to them by ties they might have found hard to explain yet rarely wished to deny. A struggle ensued, sometimes fraternal, sometimes fractious, about the best ways to help the hordes of East Europeans find a place in the New World.

One focus of this struggle was the Educational Alliance, curious mixture of night school, settlement house, day-care center, gymnasium and public forum. The Alliance represented a tangible embodiment of the German Jews' desire to help, to uplift, to clean up and quiet down their "coreligionists." Such conscientious leaders of the German-Jewish community as Isidor Straus and Jacob Schiff—men of wealth, men at ease in the New World, men who could pick up the telephone and get through to the mayor—brought about a merger in 1889 of three agencies, the Hebrew Free School Association, the Young Men's Hebrew Association and the Aguilar Free Library Society, into one large center located in a five-story building on East Broadway and Jefferson Street. Named the Educational Alliance in 1893, it became for several decades a major source of help to the new immigrants, as well as a major cause of contention between uptown and downtown immigrant Jews.

In forming the Educational Alliance the German Jews were influenced by the settlement-house movement of the 1880s,

FIG. 1
Grand Street on the
Lower East Side.

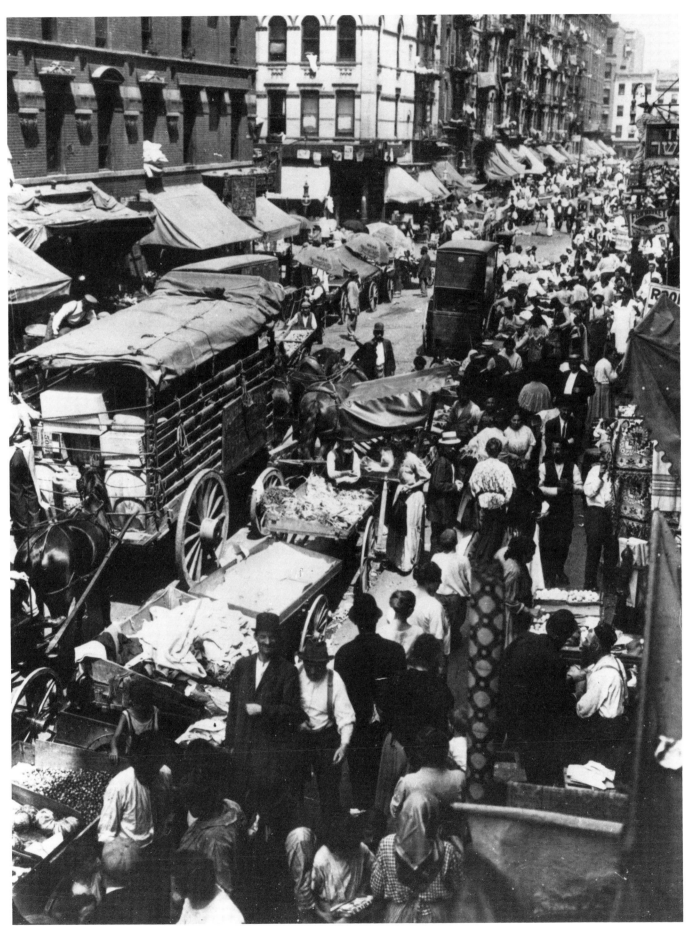

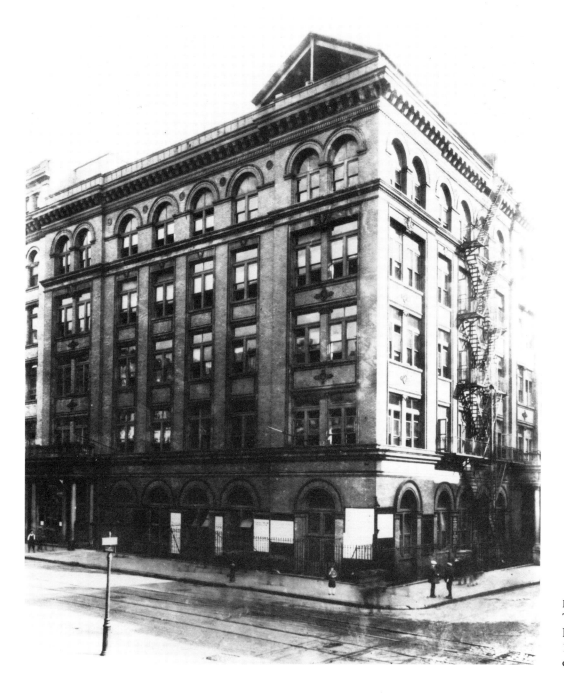

FIG. 2
The Educational Alliance
Building at
197 East Broadway
on the Lower East Side.

through which such high-minded men and women as Charles Stover, Felix Adler, Jane Addams and Lillian Wald hoped to provide the poor with cultural and moral aids that would train them to help themselves. That the motives of the German Jews were often pure seems beyond doubt. They poured money, time and energy into the Alliance, and often were rewarded by the downtown Jews with fury and scorn. Yet neither can it be doubted that the attitudes of the German Jews were calculated to enrage. An uptown weekly, the *Jewish Messenger*, announced that the new immigrants "must be Americanized in spite of themselves, in the mode prescribed by their friends and benefactors." The *Messenger* found these plebeian Jews "slovenly in dress, loud in manners and vulgar in discourse," and would have liked to "pull down the ghetto . . . and scatter its members to the

16

corners of the nation."[1] Down on Rivington and Delancey streets there were people quite prepared with compliments in turn.

Throughout its life the Alliance was racked by the question: to what extent should it try to "Americanize" the greenhorns? A historian friendly to the Alliance wrote that some of the "older Jewish settlers [a euphemism for German Jews] wished to effect a rapid change in the lives of these immigrants. Impatient with people with whom they were neither socially nor intellectually *en rapport* but whom they could not help acknowledging as their own, they advocated the immediate abandonment by the immigrants of their Old World cultural patterns and the overnight transformation into full-fledged Americans."[2] Especially in the early years of the Alliance, this often meant that it aped such public—day and night—school routines as flag saluting and patriotic singing, which annoyed the stiff-necked immigrants, both Orthodox religious and orthodox radical, who felt they had a fair portion of culture on their own.[3]

The sponsors of the Alliance soon realized that the immigrant's "spirit was not mute; that a great heritage lodged in him. . . . They therefore followed the wiser policy of . . . gradual adjustment."[4] Slowly, very slowly, they came to understand that assimilation had to be seen as a process to be eased rather than a program to be legislated. Yet even this formula was hard to enforce. For there were always passionately held differences as to whether the Alliance should stress the old or the new, traditional Hebraic and Yiddish or American culture and customs.

In its best years, between the turn of the century and the First World War, the Alliance threw itself into communal aid and popular education with a kind of frenzy. In 1898 its directorship was taken over by David Blaustein, himself an East European immigrant who had made his way through Harvard, served briefly as a rabbi and was now one of the first to reflect seriously upon the problems of Jewish social service. An intelligent man, Blaustein gradually softened the "Americanizing" pressures of the Alliance and came to feel that people like himself might even learn from their "clients." He was one of the first public figures of the East Side to move past the fixed rhetoric of Jewish ideology and, both in his practical work and in a series of sensitive essays, confront the particulars of immigrant experience.

Under Blaustein's leadership the Alliance bristled with activity. There were morning classes for children needing preparation to enter public school; night classes for adults struggling with English; daytime classes for waiters, watchmen and bakers who worked at night; classes in Yiddish and Hebrew; classes in cooking and sewing; classes in Greek and Roman history taught by Edward King, a Scotch Comtean with leftist politics and a passion for enlightening the poor; classes for Hebrew teachers who might want to learn English—alas, admits the *Eleventh Annual Report*, "sparsely attended,"[5] even though held "on the lines laid down in Spencer's *Essays on Education*"; enormously popular classes held in Yiddish by the spellbinding preacher Hirsh Masliansky, who combined Jewish uplift with a shrewd gloss on Americanism; classes in music and art (among the art students were Jacob Epstein, Ben Shahn, Chaim Gross, Moses and Isaac Soyer, William Zorach); classes at an offshoot called Breadwinners College, started by Thomas Davidson, a wonderfully zealous gentile teacher who created a sort of Ruskin College staffed by volunteers, to which, as the *Eleventh Annual Report* jubilantly noted, "belt-makers, button-hole makers, collectors, collar-makers, carpenters, cutters, cloakmakers, cigar-makers, embroiderers" came regularly, and where Morris Raphael Cohen taught the Book of Job on Monday and "Social Evolution" on Sunday.

The conductor of the children's orchestra at the Alliance, Sam Franko, would recall:

My class was composed of about thirty-five members, ranging from ten to fifteen years of age, and distinguished more by ambition than by talent. Their parents, most of them immigrant

Russian Jews, thought their offspring to be geniuses . . . . I have often reproached myself for the strictness and severity with which I treated these children, ill-clad and undernourished as many of them were . . . . When the rehearsals were over, everything was forgotten; the young students never missed an opportunity of accompanying me to the station . . . . It was a sight to see so many children marching in a body through the streets of New York each armed with a violin case.[6]

In turn, one of Franko's students remembered:

The large room in which Sam Franko's orchestra rehearsed in the evenings was in the daytime a studio where art students drew, painted, and modeled with clay. The walls were hung with unframed paintings . . . . Before and after our rehearsals . . . I used to examine the paintings and the sculpture with interest . . . . The portraits were mostly of East Side types . . . . There were figures of children, fat shrewd-looking women, and young and old men of the Hasidic type, with curled earlocks and beards, their faces a bright unhealthy hue, their eyes shining with a kind of rapture.[7]

The Alliance tried almost everything. A People's Synagogue with sedate services in Hebrew and German was set up in 1900, never very successful. On the High Holy Days services were held for ten cents a ticket, "to combat . . . . the opening of synagogues in dance halls and meeting rooms . . . presided over by officials imbued with mercenary motives only."[8] At one or another time the Alliance had an orchestra, a Halevy Singing Society, an Anton Rubinstein Musical Society, a Children's Choral Union. The passion of musical instruction, shared by even the least-educated immigrants, was satisfied by low-cost lessons in violin, piano and mandolin. In the 1890s Tuesday-evening concerts "of a very high order"—as if the German Jews would ever sponsor anything that wasn't!—were held for a five-cent admission charge. Art exhibitions; birthday celebrations of great figures ranging from Aristotle to Longfellow; a mass of literary clubs (the Carlyle, the Gladstone, the Tennyson), some of which, notes one *Annual Report* dolefully,

collapsed into "mere social gatherings;" a roof garden opened in 1896 for the summertime use of children and mothers, where Nathan Straus established a depot for the sale of sterilized milk (average daily attendance in 1896 was 4,600); a boys' camp and a girls' camp in the summers; a school for physical culture; a Legal Aid Bureau to help deserted wives; endless theatrical performances—all this and more made the Educational Alliance into something like the "immigrant's university and club" that one of its *Annual Reports* boasted it was.

Yet for all its good works, the Alliance could never settle into harmony, either within its own institutional life or in relation to the immigrant masses. With the latter there was always distance and misunderstanding, an obtuseness of good faith. A report prepared in 1902 by Bernard Ernst, superintendent of the Alliance's camp for boys, catalogued the woes that East Side ragamuffins could inflict on social workers and camp directors:

It is a discouraging fact that the East Side boy despises manual labor . . . . Apart from intellectual exertion, all labor appears menial to him. The few duties at the camp—none of them irksome or onerous—were shirked and evaded with perplexing regularity. Boys had to be literally driven to make their beds . . . . Larger boys bribe the juniors to do their work . . . . When asked to help to remove rocks from the baseball field, the reply was, "What has the camp got the farmer for?" When one senior was asked about the "philosophy" of dishwashing, his reply was, "What are women for?"

The East Side boy is accustomed to excessive over-feeding. He wants six thick slices of bread—over half a loaf at every meal. He loathes vegetables largely because he does not know them as food. Lettuce is called "grass" and not eaten; cauliflower is meant for cattle. . . . Table manners are woefully absent. Everybody puts his knife in his mouth.[9]

It was probably no one's fault, this long tradition of misunderstanding. How could Mr. Ernst get through to boys needing six slices of bread with each meal? How could he understand the underflow of anxiety in Jew-

FIG. 3
A class in language instruction combined with an "americanization" lecture at the Educational Alliance around the turn of the century.

ish life that the fixation on food released, caricatured and assuaged? And how could he have supposed that in the eyes of his charges he was anything but a rather stuffy comic figure?

From the moment of its birth the Educational Alliance came under attack. Orthodox Jews were aghast at its innovations in prayer, socialist Jews at its devotion to petty reform. In 1900 a group of Yiddish intellectuals, with the playwright Jacob Gordin at their head, set up a rival institution, the Educational League, declaring it was time "the people downtown cut away from the apron strings of the German Jews."[10] A mass meeting brought together two thousand people in March 1903 at the Grand Central Palace, where Gordin presented a skit ridiculing uptowners and "social workers." Called "The Benefactors of the East Side," it has a pretentious German-Jewish philanthropist declare that he and his friends, "like Abraham Lincoln," are working to liberate the slaves. "To be sure, the East Side people aren't black, but they *are* Romanians. They aren't Ethiopians, but they *are* Russians." Gordin's sketch was as effective as it was nasty, and his audience loved it.[11]

Gradually the Alliance bent under such attacks, learning to show a bit more warmth and respect for the people it proposed to uplift. But where the rival Educational

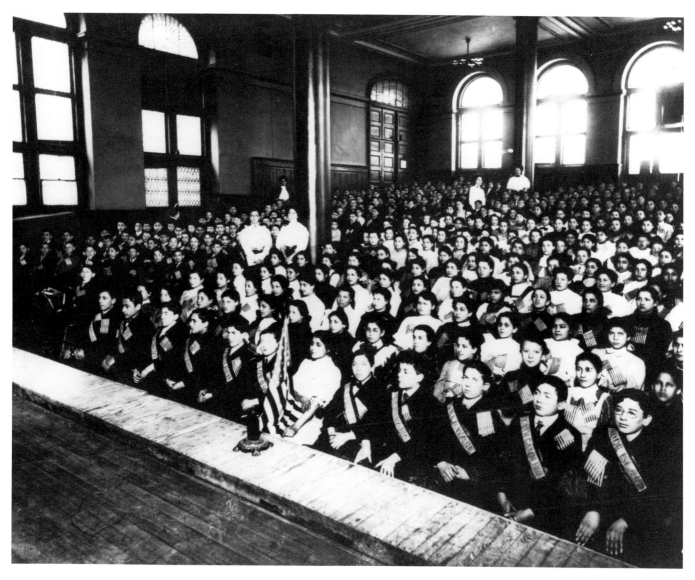

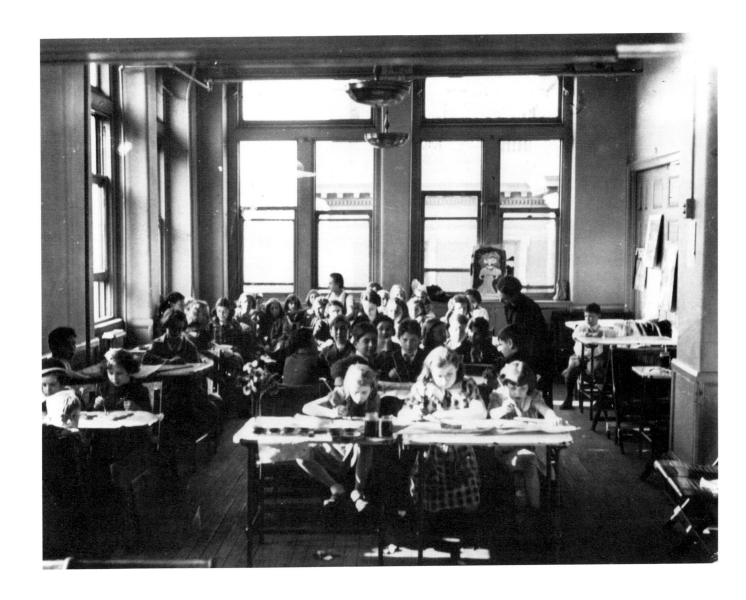

League soon collapsed, the Alliance kept doing its work: Gordin could write rings around the Schiffs and the Strauses, but when it came to the day-to-day work any institution requires for survival, he was not much in evidence.

Nor was the Alliance without intellectual defense. In a once-influential book called *Jewish Philanthropy* (1917), Boris Bogen charged that the "leaders of the East Side were, practically speaking, indifferent to the matters pertaining to their immediate neighbors. They were busy with higher ideals; they were engaged in the strife of world-wide movements."[12] This was a shrewd thrust, striking directly at a major weakness of the whole immigrant culture. Men dreaming of salvation, in this world or an-

other, were seldom prepared for small, unglorious tasks such as the Alliance undertook.

The memories of those who read in its libraries and attended its lectures vary to an astonishing extent. Zero Mostel, who began to paint in its art classes, summoned his experience through an image of space: after the overcrowded apartment in which he grew up, "the Alliance gave me a new life — I had never seen such *big* rooms before!"[13] Equally telling is the memory of a Yiddish poet, Joseph Rolnick, who in 1910 was living on Madison Street and each morning would walk to a garment shop on Chambers Street.

While it was still dark I used to stop at a column of the El, scribble a few rough lines that came to

20

me. . . . Sunday mornings I would go to the Alliance and there finish the poem. In the large reading room I often dozed off, together with others who grew sleepy from the warmth. The librarian used to walk up and down waking the sleepers . . . but I learned to hear her steps before she came near my chair. Not once did she catch me dozing.[14]

The memories of Eugene Lyons were bitter:

We were "Americanized" [at the Educational Alliance] about as gently as horses are broken in. In the whole crude process, we sensed a disrespect for the alien traditions in our homes and came unconsciously to resent and despise those traditions, good and bad alike, because they seemed insuperable barriers between ourselves and our adopted land.[15]

The memories of Morris Raphael Cohen were warm:

It was [at the Alliance] that my father and mother went regularly to hear the Rev. Masliansky preach . . . in Yiddish. It was there that I drew books from the Aguilar Free Library and began to read English. . . . It was there that I first met Thomas Davidson who became the light of my life and of my intellectual development. . . . A window of my life opening on the soul-strengthening vista of humanity will always be dedicated to the Educational Alliance.[16]

Who was right, Lyons or Cohen? Each in turn, both together, and neither alone. The German Jews, intent upon seeing that the noses of those East Side brats were wiped clean, surely proved themselves to be insufferable, and anyone raised in the clatter of Clinton Street or the denial of Cherry Street had good reason to rage against the uptown Jews. Yet, in a way, the latter were right: physical exercise and hygiene *were* essential to the well-being of their "coreligionists" and somehow, through prodding and patronizing, they had to be convinced of this. The East European Jews felt free to release their bile because they knew that finally the German Jews would not abandon them, and the German Jews kept on with their good works even while reflecting on the boorish-

ness of the "coreligionists." Out of such friction came a modest portion of progress.

End Notes

1. *Jewish Messenger*, 25 September 1891, 4.

2. S. P. Rudens, "A Half-Century of Community Service: The Story of the New York Educational Alliance," *American Jewish Year Book*, 1944, 73-86.

3. The Alliance's *First Annual Report* breathes an astonishing condescension: "The importance of physical training for our downtown brethren cannot be overestimated. Our coreligionists are often charged with lack of physical courage and repugnance to physical work. Nothing will more effectively remove this than athletic training." *First Annual Report*, Educational Alliance, 1893. The 1899 report of the Alliance's Committee on Moral Culture solemnly warned that "within the contracted limits of the New York ghetto . . . medieval Orthodoxy and anarchistic license are struggling for mastery. A people whose political surroundings have entirely changed, who are apt to become intoxicated with liberty of action which has suddenly been vouchsafed to them . . . is apt to depart from its mooring and to become a moral menace." Committee on Moral Culture: Louis Marshall, 8 November 1899, in American Jewish Archives, Cincinnati. In later years the more sensitive leaders among the German Jews came to understand their errors in the Alliance and elsewhere. Louis Marshall wrote in a letter to a friend that the German Jews "held themselves aloof from the people . . . . They acted as Lords and Ladies Bountiful bringing gifts to people who did not seek gifts . . . . The work was done in such a manner as not only to give offense, but to arouse suspicion of the motives." Marshall to Samuel Greenbaum letter, 3 February 1919, quoted in Lucy Davidowicz, "The Jewish World: A Study in Contrasts," *Jewish Social Studies*, April 1963, 110.

4. Rudens, 74.

5. *Eleventh Annual Report*, Educational Alliance, 1903.

5. Sam Franko, *Chords and Discords*, 1938, 127.

6. Samuel Chotzinoff, *Day's at the Morn*, 1964, 87.

7. *Nineteenth Annual Report*, Educational Alliance, 1911.

8. Bernard Ernst, "East Side Boys and Manual Labor," report to Educational Alliance, 1902.

9. *American Hebrew*, 15 June 1900, 155.

10. Jacob Gordin, "*Di volteter fun der ist sayd,*" in *Yacov Gordins eyn-akters*, 1917, 28-44.

11. Boris Bogen, *Jewish Philanthropy*, 1917, 233.

12. Interview, 12 April 1973.

13. Joseph Rolnick, *Zikhroynes*, 1954, 200.

14. Eugene Lyons, *Assignment in Utopia*, 1937, 4-5.

15. Morris Raphael Cohen, *A Dreamer's Journey*, Boston, 1949, 280.

16. Morris Raphael Cohen, *A Dreamer's Journey*, Boston, 1949, p.280.

FIG. 4
Louise Nevelson instructing a children's art class at the Educational Alliance, ca. 1937.

# AN EXPLOSION OF CREATIVITY:
# JEWS AND AMERICAN ART IN THE TWENTIETH CENTURY

*Milton W. Brown*

The Napoleonic Wars, spreading the seeds of the French Revolution, transformed European society, not least of all by emancipating Jews from the ghettos of Western Europe. The consequent explosion of creativity that accompanied that liberation is one of the most fascinating chapters in modern history. Jews, though relatively small in number, significantly influenced this transformation, providing a potent new leavening element in nineteenth-century Europe, an unanticipated infusion of talent from a genetic reservoir that had been almost hermetically sealed by social proscription and self-imposed religious and cultural inhibitions. Jews can be rightfully proud of that well-documented contribution to European society which, even if somewhat grudgingly, granted them the birthright of a freedom they had not enjoyed for centuries.

The United States was only peripherally influenced by this first wave of Jewish emancipation. The earliest Jewish immigrants in colonial times were Sephardic refugees, still searching for asylum after the Spanish expulsion, who established themselves in discreet little settlements along the Eastern seaboard. A small but steady stream of Jews continued adventurously to make their way to the New World. Here they enjoyed a fragile tolerance, yet remained unassimilated within the body politic and, though numerically insignificant, played a notable role in American history. It was not until 1848, after the failure of the revolution in Germany, that a more substantial emigration of German Jews took place as part of the great influx of liberal and radical refugees from the German reaction. They became the core of

the Jewish community in the United States.

Then, in the last decades of the nineteenth century, the massive modern immigration to the United States began. As Jews, we have had a tendency to see it as a specifically Jewish phenomenon. But this mass emigration from Eastern and Southern Europe at the turn of the century was the direct response to America's growing need for labor. Within this broad context, however, the situation of the Eastern European Jew was unique. Especially within the Russian Empire, the Jews lived in a ghettoized pale under oppressive restrictions and conditions that went far beyond simple poverty. The Russians had defeated Napoleon, and Jewish emancipation never occurred in Russia. With the coronation of Czar Alexander III and the pogroms of 1881, the Jewish situation became even more onerous. The exodus that began in that decade mushroomed to record numbers when the Russian defeat in the war with Japan in 1905 led to a new outbreak of anti-Semitic pogroms. The period from 1880 to World War II saw what was probably the greatest mass migration of Jews in history, from Russia, Poland, Romania and the Austro-Hungarian Empire to the United States and, to a lesser degree, Latin America. The saga of this experience has been told extensively and well, recently—most brilliantly and comprehensively—by Irving Howe in *World of Our Fathers*. In reading this book, much of my own past returned to mind vividly and nostalgically, and I realized for the first time that in my own small way I belonged to the tail end of this epic. The memories of those years are still my memories, even if some are secondhand, and I can

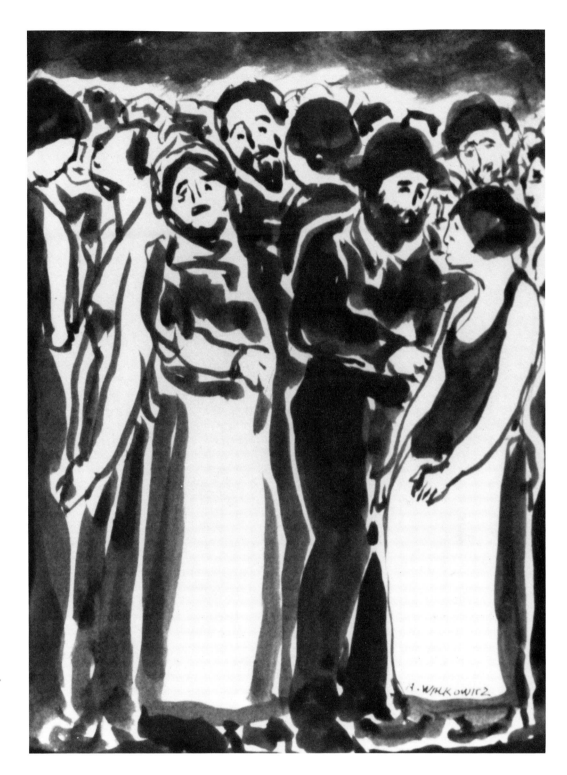

FIG. 5
Abraham Walkowitz,
*Untitled* (*East Side Figures*),
ca. 1904-1905, ink on
paper, 7 1/2 x 5 1/2"
(19 x 14 cm). The Jewish
Museum, New York.
(cat. no. 124)

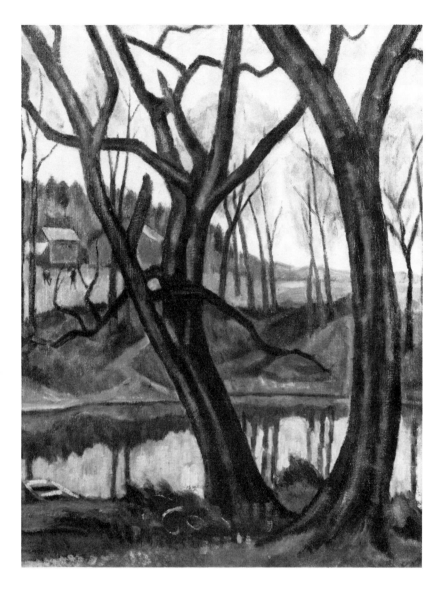

FIG. 6
Samuel Halpert, *Trees*,
1917, oil on canvas,
27 x 23" (68.6 x 58.4 cm).
The Jewish Museum,
New York. Gift of Dr. and
Mrs. Wesley Halpert with
donor maintaining life
estate. (cat. no. 52)

mother's family lived in a *dorf*, the one Jewish family in a peasant village) and of the voyage here and settlement in the *goldene medineh* (The Golden Land), which had not always lived up to expectations. The story of my mother's journey alone to this country as a young woman seemed to me an epic tale comparable to the voyages of Columbus or of the Pilgrims on the Mayflower. I had difficulty reconciling the hairbreadth adventures with the slight, gentle middle-aged Jewish woman from Bensonhurst. Many years later, in 1934, I had the unforgettable experience of visiting my grandmother and other members of the family and going by buckboard to my mother's old *dorf* and meeting the peasant friends of her youth. My memories, aside from those of my American life, which I lived in the streets and in school, were and still are of a kind of mythic past, but one still so vivid that I can fit pieces of it into the jigsaw of recorded history.

Despite the vivid memories, I did come at the tail end of the epic. By the time I was born, my parents, and most of our family and friends, had moved in a new wave out of the old ghettos of the East Side, Williamsburg and Brownsville to the suburbs of Brooklyn and the Bronx, out of the proletariat and poverty to middle-class stability, if not yet affluence. Our roots remained in that ideal egalitarian Jewish culture, *Yiddishkeit*, the secular sense of being Jewish outside the religious community, which they had brought with them from the Old Country. This was not the ghetto melting pot of the turn of the century, and my generation, growing to maturity between the wars, had quite a different perspective from those that preceded. My desire to be an artist, for instance, seemed natural, and I had role models. Louis Lozowick and Frank Kirk were family friends; as a teenager I studied with Lozowick. It was natural to continue in college and at the National Academy of Design, where I studied with Leon Kroll. I had no real opposition from my parents, save for the constant reminder that artists, musicians or writers did not make a living (except, perhaps, as teach-

in a sense reach out beyond my own time back to the turn of the century.

Born in Newark, New Jersey, in 1911, the first child of immigrant parents from the Ukraine, I learned Yiddish as my first language, and the customers in my parents' little grocery store jokingly called me *"der greener"* (the newcomer). I grew up in the cultural milieu of my parents, family and friends. In those years I absorbed, through listening and being told and read to, a wealth of lore which I can still recall: the facts and myths of Jewish history and legend, the heritage of family, stories and descriptions of the Old Country (my father came from a *shtetl*, but my

ers). But they did earn *kuved,* or respect, even reverence. They were honored as much by secular Jews as were Talmudic scholars by religious Jews, for their dedication to a vocation more spiritual, if not godly, than purely material.

How did the earlier generations of immigrant Jews from the towns and hinterlands of Eastern Europe come to art? This again is a subject that has been argued in some detail without producing entirely satisfactory or precise answers. It is certainly true that religious restrictions against the "graven image" were not as rigid as has been supposed and there was a good deal of decoration even within a religious context. But in fact in Western Europe after the emancipation, the Jewish contribution to the visual arts throughout the nineteenth century was less apparent than to the other arts, or to the sciences and professions. And in the United States during the same period the Jewish presence in art was negligible. It was only toward the turn of the century that Jewish artists began to surface, and they were all East European in origin: Maurice Sterne, Max Weber, Abraham Walkowitz, Samuel Halpert, William Zorach and Leon Kroll. It seems nearly impossible, when one's origins are in the urbanized ghetto or the *shtetl* of Eastern Europe, to make the quantum leap to a cosmopolitan art, no less an avant-garde art, in one generation, as these men did. This phenomenon is more understandable when we acknowledge that many of these immigrants, especially the younger ones, and certainly the intellectuals, were not dominated by the *shtetl* or conservative mentality, but had already been emancipated; touched by European enlightenment, they had become secularized and radicalized. The migration might have been daunting, but a new world and a new age beckoned, and they seemed somehow to have been prepared for the challenge.

They did not walk into a vacuum or a totally hostile environment when they arrived. The established and affluent German-Jewish community played a major role as a

FIG. 7
Raphael Soyer, *Louis Lozowick,* ca. 1929-1930, oil on canvas, 26 x 19" (66 x 48.3 cm). Collection of Adele Lozowick. (cat. no. 115)

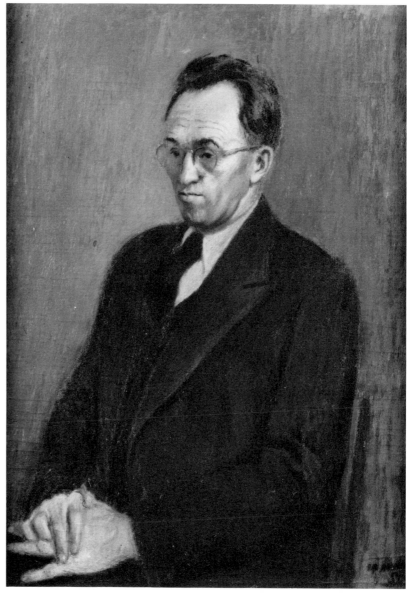

support group in guiding, nurturing and educating the new immigrants. And it is of some importance that although the German Jews were not involved in this first Jewish creative efflorescence of art here, they did serve a crucial function in its ideological and financial support. Alfred Stieglitz was among the first to champion modern art and photography in his gallery 291; Gertrude and Leo Stein in their Paris salon introduced many young American artists to modern art, and Walter Arensberg and his wife made their New York apartment the gathering place for a circle of avant-garde artists and intellectuals. These contributions to American art and culture should not be underestimated.

The dam was breached at the turn of the century, and in the next decades the wave of Jewish artists became a flood, especially in New York. I knew some of the artists from that first generation—Max Weber, Walkowitz and Kroll—as a student of art and then art history in the thirties. From 1946 on, as a member of the art department faculty at Brooklyn College, I got to know many more from the next generation, and then from my own. It would be pretentious to list them all here.

In 1939, when my wife and I, newly married, moved to Knickerbocker Village, a housing project set in the Lower East Side, it was like a journey back in time to the turn of the century, when the immigrants had settled there. The East Side had not changed much physically, though the ethnic mixture was now a bit different. The Irish had moved out, but the later influx of African-Americans and Hispanic-Americans had not yet begun. Around the old Five Corners (Chatham Square) were Chinatown, an enclave of Italians and a small cluster of Spaniards, and north along East Broadway to Delancey Street the heart of the old Jewish ghetto remained, with so many of its old landmarks left that one could think oneself back in the past. The Educational Alliance was still there and functioning, though attracting a different public, as were the offices of the Yiddish

newspapers, the *Forwerts* (Forward) and *Der Tog* (The Day). Essex Market was flourishing, and Orchard Street was crowded with pushcarts and loud with the sounds of another time and place. Moskowitz and Lupowitz, Gluckstern's and Katz's Delicatessen were still serving the faithful, and you could get a knish at Shmulka Bernstein's and an egg cream almost anyplace. Middle-aged Jewish women came back from all over to shop for clothes on Division Street. The Jewish theater was very much alive, at least on weekends, with the magisterial Maurice Schwartz (doing Shakespeare in Yiddish, of course), the hilarious Menashe Skulnick and the illustrious matinee idol Ivan Lebedev still holding forth, and the Café Royale still catered to the Jewish intellectual elite. In some curious way, the physical past had outlived the present.

The nexus between the early years of the century and the later decades was still fairly obvious, though beginning to fade. The period in which I grew to maturity and about which I can write with more authority—or at least from firsthand experience—is the thirties. By then the Jewish artists were more acculturated, and yet not so different from the pioneering generation. There remained an underlying continuum in ideology, culture and environment. Jewish artists, once or twice removed from the *shtetl,* still remained Jewish, thought of themselves as such, and had certainly not denied their heritage. But most of them no longer spoke Yiddish, very few to my knowledge were formally or even consciously religious, and very few thought of themselves as Jewish artists or were concerned with Jewish art. Only Ben-Zion was committed to the biblical past, Max Weber to Jewish themes on occasion, and Mark Rothko to religion, but in some universal sense, certainly not Jewish. All of them preferred to be ranked with their peers on an absolute scale of values. Jewishness was not the issue in the thirties, though it did begin to surface to some extent during the Hitler years, and later, following the revelations of the Holocaust. Many, if not most, artists,

FIG. 8
William Gropper, *Newspaper Clipping,* 1936, oil on canvas, 27 1/2 x 34 1/2" (69.9 x 87.6 cm). Collection of Gene Gropper. (cat. no 46)

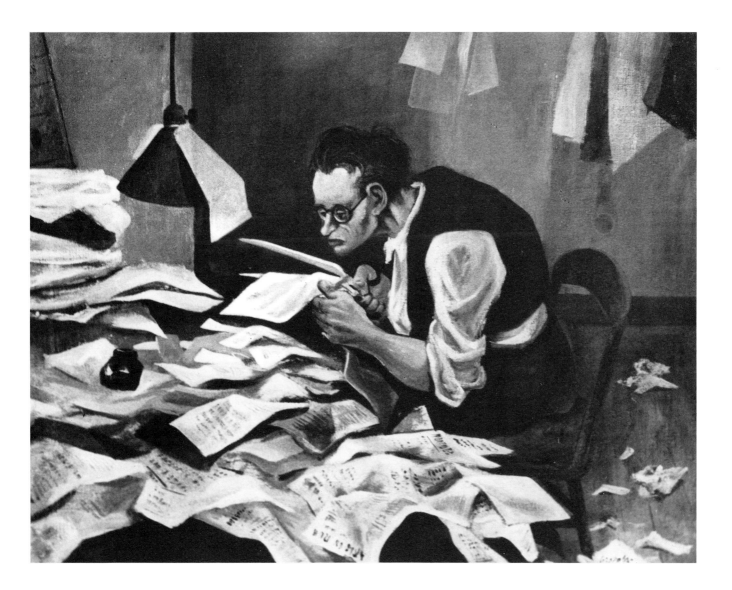

gentiles as well as Jews, were more concerned with larger social problems and with art as an instrument of social change rather than a vehicle of ethnic cultural expression. And for many Jewish artists during the Depression years, a radical social or political stance seemed consistent with the time-honored Jewish tradition of social justice.

The problem of a Jewish art or Jewishness in art remains vexing and possibly insoluble. Though many Jewish artists from here and abroad during those years rallied in ethnic solidarity to such organizations as YKUF (Yiddisher Kultur Farband), few subscribed to the ideological call for a Jewish art.

By now the Jewish artist in America, though he may still feel Jewish, has been thoroughly absorbed into American culture, and in recent years has had a significant role in the transformation and definition of that culture. The differences between a Rothko and a Clyfford Still, or a Barnett Newman and an Ad Reinhardt, are purely personal. And the connection between a Jack Levine and a Chaim Soutine is not their Jewishness but the internationalism of modern art, which makes it possible, by the same token, for Soutine, the Polish Jew, and Georges Rouault both to be great French artists. For a time, at least, and in a unique way, the cumulative contribution of several generations of immigrant Jewish artists added a new vitality and a large reservoir of talent to American art and to American culture in general.

# FROM HESTER STREET TO FIFTY-SEVENTH STREET: JEWISH-AMERICAN ARTISTS IN NEW YORK

*Matthew Baigell*

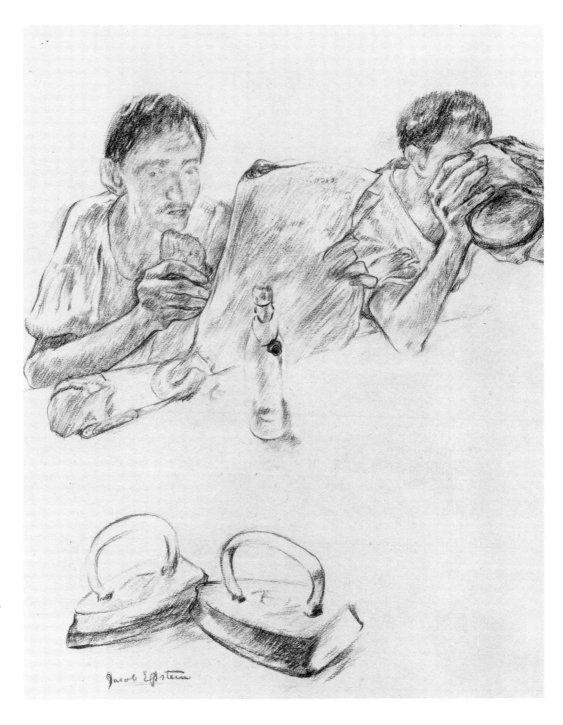

FIG. 9
Jacob Epstein, *'Lunch in the Shop' or 'The Sweatshop'*, ca. 1900-1902, black chalk, 21 x 17" (53 x 43 cm). Walsall Museum and Art Gallery (Garman-Ryan Collection). (cat. no. 28)

Several interrelated stories need to be told concerning the lives and careers of Jewish-American artists in New York City between 1900 and 1950. These stories are filled with human incident, passion and paradox, with ambiguities brought about by the ideal of assimilation and the resultant destruction of Jewish-European culture in America, and with instances of success by artists who entered into and affected the course of American art. At the same time we need to deal with the chronology of who did what and when, with the ways in which individual artists were affected by their Jewish heritage, with the manner in which mainstream critics viewed these artists, with the interminable search for definitions of what is "Jewish art" and who is a "Jewish artist," and with the insoluble dilemma of distinguishing between Jewish religious and Jewish cultural heritages. This essay only begins to inquire into what is a very rich field for further exploration.[1]

## THE TURN OF THE CENTURY: BREAKING GROUND

First, we need a symbolic date, one that announces the Jewish presence in American art. That date is 1902, the year in which Hutchins Hapgood's book *The Spirit of the Ghetto* was published (fig. 10). A collection of sympathetic observations about the people who inhabited the Lower East Side, the book was illustrated by Jacob Epstein, with some additional illustrations by Bernar Gussow. Hapgood clearly delighted in Epstein's sketches of Jewish religious and cultural figures as well as of the life on the streets. He praised Epstein's desire to paint "the life of his people in the Ghetto." But the well-intentioned Hapgood also succumbed to several current stereotypes. Jews were melancholic above all else and they lived, despite poverty and high incidences of disease, a picturesque life. "Epstein is filled," Hapgood wrote, "with a melancholy love of his race, and his constant desire is to paint his people just as they are: to show them in their

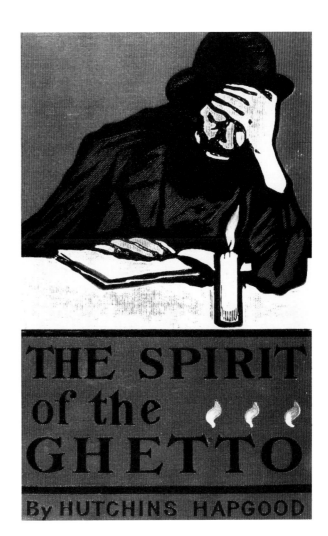

FIG. 10
Jacob Epstein, *The Spirit of the Ghetto* by Hutchins Hapgood, New York: Funk and Wagnalls, 1909, 312 pages, 52 black and white reproductions of drawings, and 1 color cover design, unnumbered edition, 7 1/2 x 5" (19 x 12.5 cm). Judah L. Magnes Museum. (cat. no. 31)

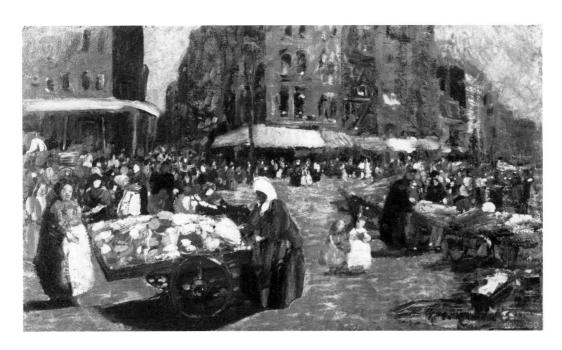

suffering picturesqueness."[2] (Several years later, in magazine interviews in 1911, some realist artists, including George Luks, Jerome Myers and William Glackens, described slum life with equal insensitivity as charming, picturesque and basically happy.[3][fig. 11])

Hapgood, who had first noticed Epstein's work at an exhibit at the Hebrew Institute, found it important because it suggested an interesting departure from American art. Epstein dealt with life and its actualities. "The typical life of the community is expressed," Hapgood wrote. "Of what American painter from among the Gentiles can this be said? Where is the typical, the nationally characteristic, in our art?" Hapgood did find in American art some interest in experimentation, but "no simple presentation of well-recognized and deeply felt national or even sectional life; merely essays in art . . . showing no warm interest in any one kind of life." Hapgood hoped that Epstein

and other ghetto artists might help change this situation by adding color and warmth to American art, rooted as they were in their community. But they would have to work fast, since a ghetto school of art would arise at a time when, as Hapgood realized, the ghetto itself was passing out of existence.[4]

Years later, reminiscing about his youth, Epstein recalled his pleasure in observing people on Hester Street. But he also recalled that as much as he enjoyed the feeling of community he found there, he was not a religious person who wanted to remain within the confines of that community. Like Hapgood, he, too, felt distress over the waning of the vibrant East European-Jewish culture on the streets and in the coffee shops and synagogues. But after reading Walt Whitman and the Russian novelists, and after looking at art in uptown galleries, he knew that he was not the artist to establish a regionalist school based on life in the

ghetto. "I saw a great deal of Jewish ortho-dox life, traditional and narrow," he wrote in 1940. "As my thoughts were elsewhere, this did not greatly influence me, but I imagine that the feeling I have for expressing a human point of view, giving human rather than abstract implications to my work, comes from those early formative years."[5] Rather than remain an East Sider, let alone a New Yorker, Epstein left for Paris in 1902 and settled in England permanently in 1905, where he became a major sculptor with few esthetic or spiritual ties to any Jewish com-munity, despite Jewish patronage. Nor, in his writings, did he indicate much interest in his Jewish heritage.

Epstein's story underlines the tremen-dous problems faced by young Jews who wanted to become artists around the turn of the century. Problems with parents aside, what were their obligations to remain within the community? If they wanted to leave, how much cultural baggage should they take with them, if any? That is, should they assimilate totally, partially or not at all? And if they remained within the community, what kind of support could they expect from a society that did not so much disdain fine art as lack awareness of it? Between the second com-mandment, the poverty and the cultural insularity of many East European Jews, and their limited opportunities to study art in Eastern Europe, support for the fine arts was not an uppermost concern. Even if craft and folk-art traditions were maintained in the design of objects for the synagogue and the home, including the representation of the human figure, appreciation of the fine arts lagged considerably, a complaint often voiced in interviews and articles through these years.

We might also ask, in what ways did an artist know the community? Certainly it was not monolithic, and just as certainly not all artists knew it in the same way. Epstein's parents were financially comfortable. Other artists who came from very poor families, such as Abraham Walkowitz and William Gropper, worked at odd jobs when very young probably leaving little or no time for religious training beyond the age of ten, when most boys left *heder* (a school in which young boys learned Hebrew, often by rote). Their ties were perhaps more environ-mental than religious. Others, such as the Soyer brothers, Raphael, Moses and Isaac, grew up in relatively secular and enlightened homes, and acknowledged their Judaism culturally and intellectually. Still others, such as Max Weber and Maurice Sterne, came from Orthodox backgrounds, but since Weber explored Jewish subject matter and Sterne did not, family background was a variant rather than a determinant. There is simply no model to explain why young Jews became artists and how they chose to relate to the community. These issues are, of course, not compelling ones today. But earlier in the century, when so many artists shared some aspect of the immigrant experience, and when both Jewish and mainstream critics often tried to deal with that experience–with the artists' "race" and "heritage," as well as with their newly discovered American environ-ment–these issues were of significant con-cern.

Epstein's departure for Europe in 1902 was paradigmatic of the desire on the part of several artists to leave the ghetto not only for a life of assimilation into the mainstream culture, but also for escape from the intellec-tual and cultural constraints of middle-class existence to the more adventurous life of the avant-garde. Beginning in 1901, Jewish art-ists started going to Europe, particularly to Paris, where they learned about the new movements in art. Bernard Karfiol went abroad in 1901 and remained there until 1906. Samuel Halpert made several trips between 1902 and 1916. Maurice Sterne traveled to Europe and the South Pacific from 1904 to 1915. Max Weber, in Paris from 1905 to 1909, helped establish Matisse's first art classes. Abraham Walkowitz stayed in Europe from 1906 to 1907, and William Zorach traveled abroad from 1910 to 1911.

But even before these artists gained ac-cess to artistically radical circles abroad, sev-eral others had already begun or even com-

pleted their studies at such conservative institutions as the National Academy of Design in New York City. Sterne had enrolled as early as 1894, Halpert in 1899 and Karfiol the next year. And around 1904 Ben Benn, Leon Kroll and Zorach had also enrolled.

Perhaps a few or all of these artists were confronted by some form of anti-Jewish sentiment in the United States, but it appears in the literature only as an occasional passing remark. Hostile comments there were, but these were generated by the modernist art styles some Jewish artists preferred rather than by their religious backgrounds. Even Alfred Stieglitz, a lightning rod for hostile commentary because of his position as the first great impresario of modern art in the United States, was attacked for his taste, not his religion.

Within the small community of modern art, Jews were quite prominent. We may consider Walkowitz to have been the first modernist in America upon his return from Europe in 1907. His solo exhibition the next year at the Julius Haas framing shop was probably the first such event by a modernist. Weber's show at Haas's shop in 1909 was probably the second. And in the *Forum Exhibition of Modern American Painters*, held in 1916 as a partial response to the overwhelming European presence at the famous Armory Show of 1913, two of the six members of the organizing committee–Stieglitz and Dr. John Weichsel–were Jewish, and four of the seventeen artists exhibited–Ben Benn, Man Ray, Walkowitz and Zorach—were Jewish as well. The quick and easy acceptance of these figures depended in part upon the fact that the overwhelmingly conservative American art world considered all modernists to be outsiders, Jew and non-Jew alike. But more important, one cannot find in the United States (except in a few instances to be noted below), as one does in Europe, the pejorative comments linking Jews and modernism. The facts of the American situation do not lend themselves to one historian's observation that "in nearly every society in which Modern was perceived

(rightfully) as threatening authority, as a subverter of stability, Modernism and Jews were linked."[6]

## THE TEENS: DISSEMINATION AND REDEFINITION

What about the creation and the presentation of art within the Jewish-American community? Even though Walkowitz had painted East Side scenes by 1903, he and the rest of the modernists, as well as traditionalists like Leon Kroll, had essentially left the community. Within the community, however, a support for the production, if not the acquisition, of art became apparent through the formation of art schools, art programs and art exhibitions. The Educational Alliance, founded in 1889, sponsored art classes in its early years and then once again, beginning in 1917, under the leadership of Abbo Ostrowsky. The purpose of these classes has been variously interpreted. Ostrowsky felt that they should lead to some form of assimilation. Rather than affirm that students reflect community values and customs, he wanted to foster independent thought. And at the time of the golden jubilee celebration in 1943, he asserted that the Alliance "devoted itself to the vital problem of adjusting the foreign-born Jew socially, culturally, and economically to his new environment." In contrast, Louis Lozowick, after acknowledging that the Alliance art classes were among "the first organized efforts in America to turn the creative energies of the Jew to the plastic and pictorial arts," insisted that the school's aim was to provide the student with "a definite social orientation. He is made to feel his identity with the community of which he is a product by drawing inspiration from its life, reflecting the peculiarities of its environment, and embodying in permanent form its cultural heritage."[7] These two statements– one suggesting assimilation, the other nonassimilation–might seem today to be conflicting, but within the context of their time they had a different and less conflicting meaning. That meaning depended upon the assumption that the community would be

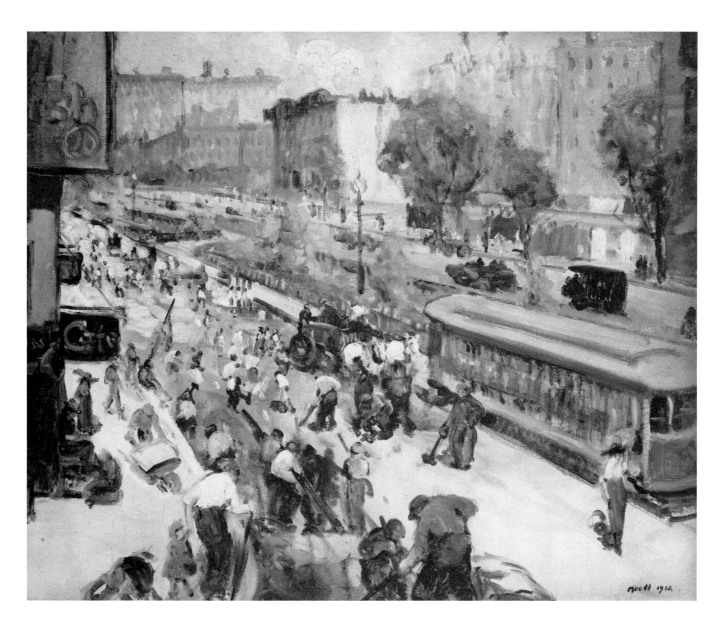

FIG. 12
Leon Kroll, *Untitled*, 1912,
oil on canvas, 24 x 29"
(61 x 73.7 cm). Private
collection. (cat. no. 61)

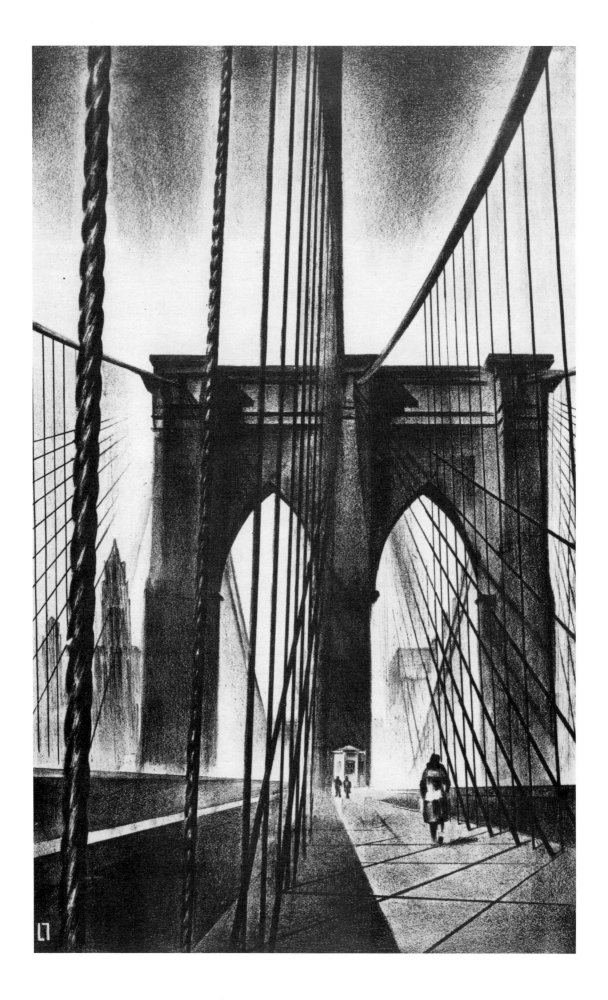

transformed by the American experience, but that it would also retain its identity as a community. It became necessary for artists to think independently in response to the new environment, but independence was to be influenced by the matrix of history, experience and heritage residing in the community. It would seem that Ostrowsky and Lozowick wanted to have it both ways: to be independent and to belong. For the first generation, and perhaps for the second, this unstated assumption was certainly possible because of shared experiences and memories. But not for the third. Parenthetically, Lozowick manifested several of the conflicts and equivocations faced by Jewish-American artists. A determined leftist at least during the 1920s and 1930s, he nevertheless maintained close cultural, but not religious, ties to Judaism. For example, he wrote about Jewish artists for *The Menorah Journal* during the 1920s, but considered them only as artists, not as Jewish artists.

A variety of people supported and encouraged exhibitions in addition to the art programs sponsored by organizations such as the Alliance. In 1911, for example, Saul Raskin, art and theater critic of *Das Neie Land*, proposed a series of exhibitions of works by Jewish artists. Perhaps the exhibition the following year, in 1912, at the Madison House Settlement, founded by the Ethical Culture Society, was held in direct response to Raskin's suggestion. Most of the artists were termed Russian-Jewish immigrants, but non-Jewish artists such as realists George Luks and Jerome Myers also participated. All were considered to be "in sympathy with, or [to] have found inspiration in, this section of the city." The reviewer, Henry Moscowitz, a member of the Society, found the artists to be "individualists" and "insurgents filled with an instinct for original self-expression." This accounted for the presence of works by modernists Halpert, Walkowitz and Weber. But Moscowitz grew more serious after using the artspeak of the day. Facing the assimilation problem directly, he said that the show challenged the immigrant artist to conserve his

own culture but at the same time to blend it with American culture. He found moral peril in the second generation's desire to discard all traditions. "We must deepen [the immigrants'] conception of an American by relating these conserving forces in their race inheritance with the idealism of American democracy."[8] In other words, there should be a middle way. Or, rather, the choice should not necessarily be to leave or to stay, but to forge another kind of identity, artistic and otherwise, combining the religious-cultural inheritance with American traditions.

The most energetic organization to sponsor exhibitions and art classes was the short-lived People's Art Guild. Founded in 1915 by Dr. John Weichsel, the Guild was, like the Alliance, largely but not exclusively a Jewish-American organization. Weichsel's socialist leanings prompted him to want to make art available to the working classes and to encourage art appreciation through labor union participation. Art classes were soon established in various neighborhood associations for the purpose of reclaiming "the people's life for self-expression in art and to make it hospitable ground for our artists' work." By the time the Guild closed in 1918, it had sponsored over sixty exhibitions; the largest, containing three hundred works by eighty-nine artists, was held in the Jewish Daily Forward Building in May 1917.[9]

These various organizations and independent exhibitions provided a framework for the dissemination of art consciousness through the immigrant community. They were also part of the largely forgotten development of organizations and groups–such as the writers' group *Di Yunge*–that furnished secular intellectual outlets within the community and provided training grounds for artists and writers who would, to a greater or lesser extent, leave the community. This happened with increasing frequency during the 1920s. Among the early modernists, such as Weber and Walkowitz, one senses a schizoid or revolving-door pattern. Committed as they were to secular and American themes, they also exhibited in

FIG. 13
Louis Lozowick, *Brooklyn Bridge*, 1930, lithograph, 13 x 7 7/8" (33 x 20 cm). Collection, The Museum of Modern Art, New York. Gift of Abby Aldrich Rockefeller. (cat. no. 67)

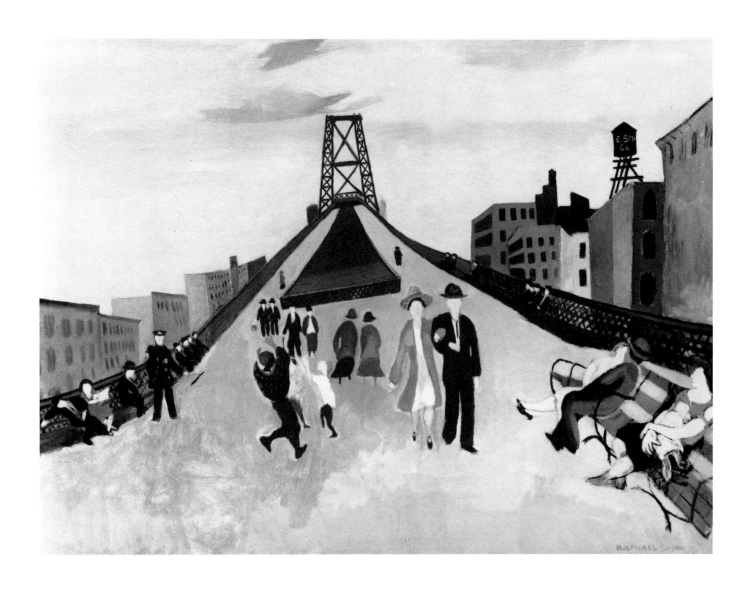

Lower East Side shows and even found subject matter there.

Quite often art critics for the art magazines and major metropolitan dailies would mention an artist's Jewish background as biographical information, but would discuss the work solely in American terms. For example, one critic thought Halpert to be "among the forefront of the Americans who are perfecting an adequate mode of expression for modern art." Another critic, quite delirious with joy over Sterne's drawing of a man sitting on the ground, wrote "as soon as my eye falls on this drawing by Mr. Maurice Sterne, I feel that up to this moment I have never known what drawing is." About the same time, Hamilton Easter Field, who orga-

nized an exhibition of Bernard Karfiol's work, asserted that the artist demonstrated "an intensity of feeling so rare in American art that there seems to be no one with whom he can be compared. . . . Karfiol's work has, therefore, but little in common with modern painting in America. It is the expression of an individual, not an expression of an epoch nor of a community."[10]

### THE TWENTIES AND EARLY THIRTIES: IN THE MAINSTREAM

Many Jewish-American artists, like Karfiol, had become so assimilated that nobody commented–in print, at least–about the makeup of the panel that debated the question "Nationalism in Art—Is It an Advantage?" at the

FIG. 15
Ben Shahn, *East Side
Soap Box*, 1936, gouache,
18 1/2 x 12 1/4"
(47 x 31.1 cm).
Private Collection.
(cat. no. 101)

*Opposite*:
FIG. 14
Raphael Soyer, *The Bridge*,
1926-1927, oil on
canvas, 22 1/4 x 30 1/8"
(56.5 x 76.5 cm).
Hirshhorn Museum
and Sculpture Garden,
Smithsonian Institution.
Gift of Joseph H.
Hirshhorn, 1966.
(cat. no. 113)

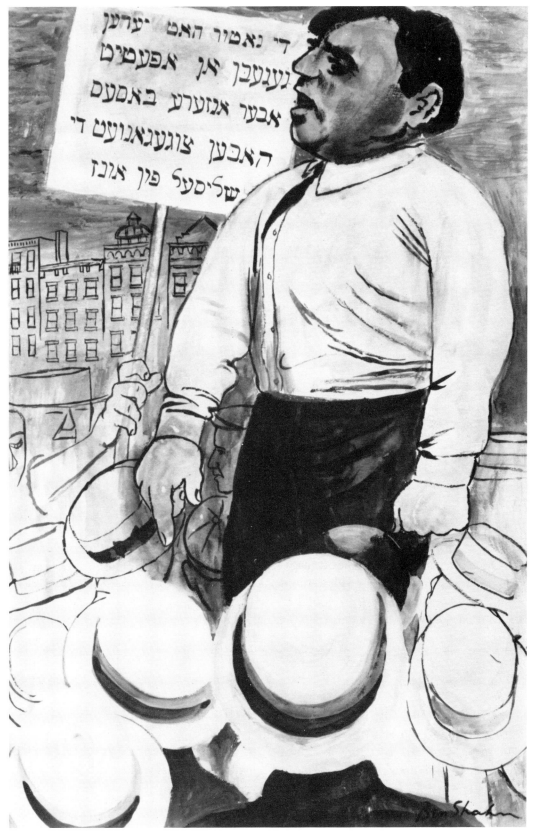

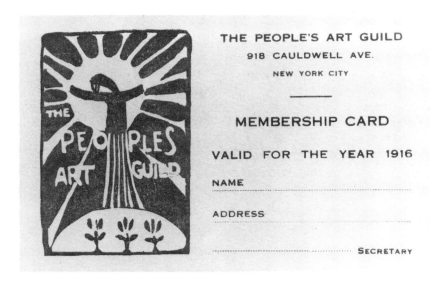

Whitney Museum of American Art early in 1932. Two of the four panelists were Jews; Zorach argued for the affirmative, Sterne for the negative. This debate reflected the growth of nationalistic feeling that emerged after World War I and became all but irresistible in the art world by 1930. Gathered under the rubric of the American Scene movement, its strength caused internationalist artists like Sterne to soften their public pronouncements about provincialism in general and the American Scene movement in particular. He stated, avoiding a clear-cut position, that "we should encourage the growth of national art, but we must also avoid provincialism." Zorach addressed the ethnic issue directly in his defense of nationalism. "Painting Jewish types," he said, "does not create Jewish art, nor concentration on the American scene make an American artist." Rather, the flavor of a country would permeate an artist's work if the artist "drew inspiration from his life and surroundings and belongs as an artist first to that national life."[11] For Zorach, America as a country clearly superseded the Lower East Side as a community. Whatever the merits of the arguments, their validity is less important today than the fact that Zorach and Sterne were invited to argue the issue—and from opposing sides. Paradoxically, Sterne,

in later years knowing that six million of his coreligionists were murdered by the Nazis, became, in effect, a Jewish nationalist, or, rather, a Jewish internationalist, believing that "a Jewish consciousness was created which transcended national boundaries because Jews had no occasion to be grateful to nations in which they happened to be living," if those nations despised them. He condemned German Jews for having admired and emulated the gentile world, and he also condemned Christians in general for failing to "practice the tenets of Christ, that other Jew." But he did not channel his rage into a coherent position on nationalism in general or in art specifically.[12]

Unlike those African-American artists whose works were reviewed by mainstream critics in the 1920s and 1930s, Jewish-American artists were usually not identified by race or religion. The comments of several critics in the 1920s and of the participants in the Whitney Museum debate in 1932 clearly indicated that many Jewish-American artists were accepted as American artists clear and simple. But during these years, as a result of the nationalism that appeared after World War I, the position of Jewish-American artists and intellectuals became something to consider with care, both in the mainstream and in the Jewish-American world. Nationalistic feelings reached beyond the larger issues of American nationalism to that of ethnic and racial identity. Groups of hyphenated Americans who wanted to remain hyphenated sustained a period of self-appraisal, self-questioning and redefinition. Among Jewish-American artists, some, like Max Weber, explored Jewish themes; others, like Louis Lozowick, studiously avoided any mention of Jewish matters, even when discussing Jewish artists in critical essays. Some, like Leon Kroll, either maintained or adopted assimilationist positions, while others eagerly joined Jewish-American art organizations. There is no easily discernible pattern in these activities. But the decade of the 1920s does seem to have been an especially trying one for Jewish-American

artist, creativity emerging from continuous interaction with one's surroundings and, by extension, heritage.[23] What linked all of these artists, critics and observers together was the desire to understand the nature of being a Jewish-American, an African-American or an American lacking hyphenated status of any sort, as well as what influence environment played in artistic creativity.

Unlike Tofel, or Thomas Hart Benton, however, many Jewish-American artists rejected any artistic connection with their community. This would include Louis Lozowick, who in the 1920s and 1930s preferred to interpret modern America rather than a foreign and traditional Jewish culture. In the 1920s he developed a geometrical style and content based on American industrial and urban forms, and in the 1930s he turned to Social Realist theme (figs. 19, 22 and 100). He wrote reviews of the works of Jewish artists who lived both in Europe and America, but rarely, if ever,

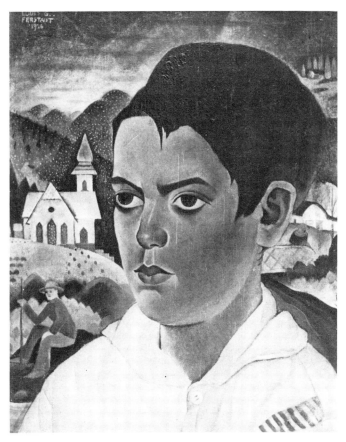

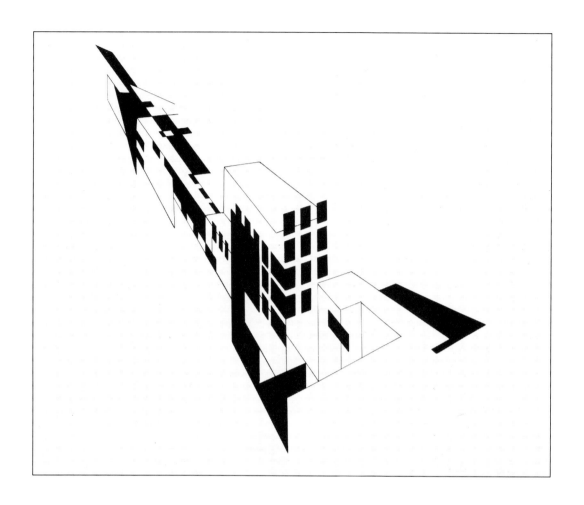

FIG. 22
Louis Lozowick, *Shifting Planes*, 1929, pen, brush and ink, 9 1/2 x 14" (24.1 x 35.6 cm). Collection of Lee Lozowick. (cat. no. 65)

referred to the fact of their Jewishness. In articles written for *The Menorah Journal* in the 1920s, Lozowick and art critic Jerome Klein surveyed the Parisian and New York art scenes, noting that many Jewish artists had exhibited works in a variety of modern styles, even figuring prominently in them, but they found few who had turned to Jewish themes of any sort. In fact, they seem to have made a point of deliberately avoiding mention of the artists' personal and religious backgrounds. Their sympathy for abstract styles, Lozowick explained on one occasion, prompted them to ignore personal, religious or social themes, particularly when the Jewish-American community so completely ignored its artists anyway.[24]

One can also search unsuccessfully through writings by and about many artists for any mention of their Jewish backgrounds, or find only the most minimal acknowledgment. (Of course, artists were under no obligation to admit to anything.) Leon Kroll, for instance, an artist whom Chaim Gross considered important for opening doors into the mainstream art world, made no mention of his Jewish background in his autobiography. Nor did the sculptor Jo Davidson in his. Others, like William Zorach, Maurice Sterne and Chaim Gross, either scarcely indicated that they were Jewish or discussed their backgrounds very briefly. Gross, for example, comes from a Hasidic family, but he does not elaborate on his assertion–which does not seem present in his work anyway–that when "I visit the synagogue and when I see my people, I am inspired. And this is reflected in my work."[25] (Gross did turn to Jewish themes by the 1960s.)

## MAX WEBER AND HIS CRITICS

The range, then, among Jewish-American artists is quite broad. Among the early modernists, Max Weber was the one most attracted to Jewish themes, which he began to explore in 1918. He had been an acknowledged major modernist since 1909, the year he returned from Europe. A veteran exhibitor, he had had a solo exhibition at Haas's frame shop that year; his work appeared in the exhibition entitled *Younger American Painters* at Stieglitz's Little Galleries of the Photo-Secession in 1910, and he was the first modern artist to be given a solo exhibition in a museum (the Newark Museum, 1913). We can only speculate about his reasons for exploring Jewish subject matter. Perhaps his intense involvement with the modern movement since 1905 both in Europe and in the United States had exhausted him emotionally. Perhaps his father's death and the war, which reaffirmed the hyphenated American feelings of many immigrant groups, induced him to examine his Orthodox roots.[26] Perhaps the growing anti-Semitism in America and the recent pogroms in Eastern Europe reaffirmed his desire to find spiritual and thematic anchors in Judaism.

Whatever the reasons, the critical responses are almost as interesting as his work. Some critics ignored entirely Weber's new themes, concentrating only on questions of quality. One laudatory article of 1921 referred to him only as an American of Russian descent. Seven years later, Jerome Klein, writing in *The Menorah Journal*, studiously avoided any mention of Weber's religion or subject matter, and praised instead his great sense of style, claiming that Weber had a better grasp of formal structure in landscape painting than such luminaries as John Singer Sargent, George Inness and Winslow Homer. And in the next year, 1929, the important artist Arthur B. Davies called Weber "the greatest landscape painter in America and the greatest painter of trees in the world."[27]

But the Jewish critic Paul Rosenfeld, in a long article on American artists written early in the decade, considered Weber in a different light and perhaps indirectly helped contribute to some stereotypical observations of Jewish artists and their subjects. Rosenfeld found Weber's work to be too derivative and too intellectual. And he also wanted to see Weber express more strongly "the mystical metaphysical Jew," rather than "the assimilative power of the Jew."[28] The two ideas—the derivative nature of Jewish artists and the mystical, metaphysical and also melancholic nature of Jewish people—appeared often in subsequent reviews by non-Jewish critics as they tried to grapple with what was for them an exotic group of artists and an unknown and unknowable subject matter.

In one of the first critical responses to Weber's new subject matter, Henry McBride found the "new quality . . . not based upon

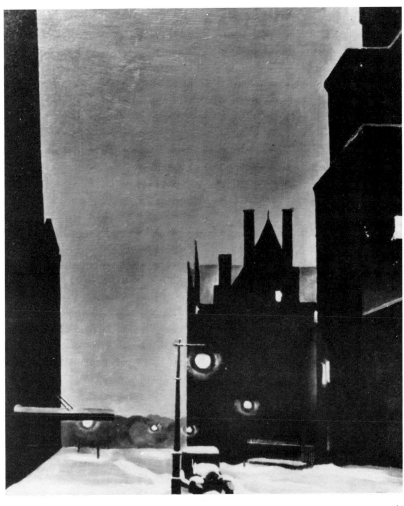

Fig. 23
Stefan Hirsch, *Winter Night*, 1928, oil on panel, 22 1/2 x 19 3/4" (57.2 x 50.2 cm). Collection of The Newark Museum. Anonymous gift, 1929. (cat. no. 55)

45

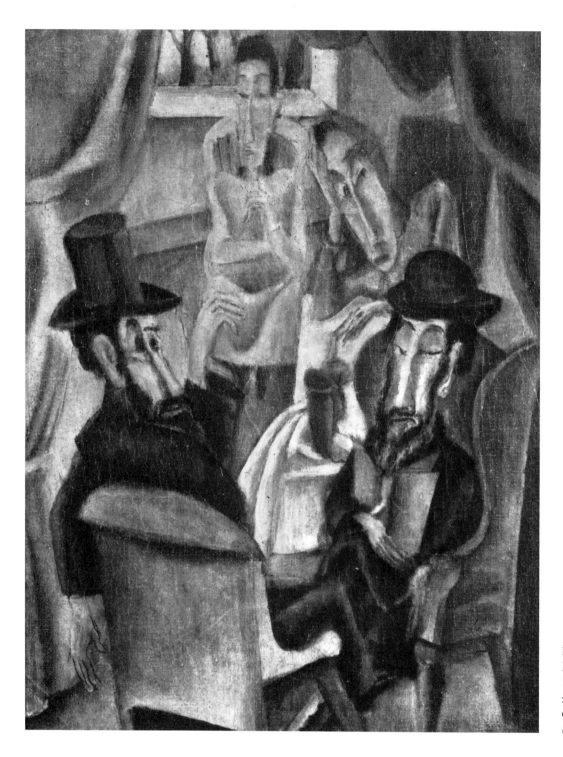

FIG. 24
Max Weber, *Sabbath*,
1919, oil on canvas, 12 1/2
x 10" (31.7 x 25.4 cm).
Collection of Joy S. Weber.
(cat. no. 137)

the lugubriousness of Weber's themes, nor the long beards of the Jews who wail upon the housetops after the manner of the prophets, but it comes to me in an abstract way from the color chiefly. . . . It seems to have come straight from the Old Testament to Weber." McBride also found Weber's new paintings "to reek with melancholy."[29] Weber's rabbis and women in interior set-

tings do appear somewhat melancholic—the "typical" Jewish countenance—but words like "studious" and "thoughtful" might be just as appropriate. Prophets did not (at least to my knowledge) wail upon house-tops. McBride seemed to have Chagall's fiddlers in mind here. And the direct pipeline from the Old Testament to Weber seems a Jewish variation on the belief that like mem-

46

bers of other minority groups he had special access to a particular source of inspiration. (Native Americans were supposed to have easy access to their unconscious.) Finally, I doubt that Weber's sense of color came from the Old Testament, but more likely from his studies with Matisse in 1907 and perhaps from childhood memories of his grandfather who worked as a textile dyer.[30]

Another critic, Forbes Watson, found that

when Mr. Weber paints woeful racial pictures that belong to his own race and are evolved from the sadness of that race . . . his art comes closest to the sense of life as contrasted with a mental art born out of art. . . . Mr. Weber does, in his best Jewish pictures, rise completely above mental self-consciousness or suggestibility to the heights of a poetical and biblical tragedy.

Another observer, the great collector Duncan Phillips, mined this tragic vein when he observed that Weber's *Draped Head*, a figure painted before 1923 of a woman wearing a shawl, was "a little masterpiece of tragedy [fig. 25]. The tormented soul of a race speaks through this portrait which carries on the Byzantine and El Greco traditions [which were of course unknown to *shtetl* Jews from Eastern Europe]." On another occasion, Phillips thought that Weber combined his sources (Byzantine and El Greco again, with Cèzanne) to provide "a unique expression of his race and of his religion. Here we find him interpreting the meaning of the Talmud for the pious Orthodox Jew [who would of course never go to a modern, secular artist for an opinion]." Yet another observer, museum curator Lloyd Goodrich, found in Weber "a strong sense of the Hebrew past, of that long history so rich in spiritual genius, so full of tragedy and triumph." Weber's imagery was also considered to be "expressive of the mind of his race."[31]

It is too easy and not really fair to make sarcastic comments about these basically well-intentioned observations by critics trying to understand and describe strange subject matter. Since the paintings were not religious in the sense of illustrating doctrine or the lives of biblical personages, but were, rather, genre studies of contemporary activities, the critics tried to explain what they thought was the nature of the Jewish mind and soul. Their comments were not unlike their stereotypical expositions in the 1920s and 1930s on the nature of African-American art. Invariably, African-American artists were thought to convey in their work a sense of rhythm characteristic of their race.[32]

Weber himself was much less the cosmic expositor of his race than his critics imagined him to be. Of his painting *The Talmudists* (plate 6), completed in 1934, he wrote:

I was prompted to paint this picture after a pilgrimage to one of the oldest synagogues of New York's East Side. I find a living spiritual beauty emanates from, and hovers over and about a group of Jewish patriarchal types when they congregate in search of wisdom in the teaching of the great Talmudists of the past. . . . To witness a group of such elders bent on and intent upon

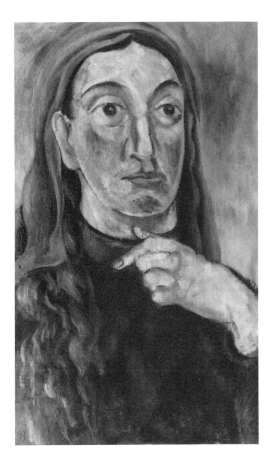

FIG. 25
Max Weber, *Draped Head*, before 1923, oil on canvas, 21 x 13" (53.3 x 33 cm). © The Phillips Collection, Washington, D.C.

nothing but the eternal quest and interpretation of the ethical, significant and religious content of the great Jewish legacy—the Torah—is for me an experience never to be forgotten.[33]

Weber's statement, which must have seemed filled with insight and meaning to the general public at the time, is a lot less religious and a lot more nostalgic than it initially seemed to be. For the Orthodox, such study is literally an accepted part of daily life at home, at the synagogue or in the yeshiva. For Weber, his trip was a pilgrimage to his past, not a daily jaunt in the present. This experience "never to be forgotten" was already a memory rather than part of his daily routines. This is not meant to criticize Weber, but to put into perspective what is a very touching painting by a man no longer inside the kind of faith revealed by his subjects. In broader American terms, *The Talmudists* is the Jewish equivalent of those religious paintings American Scenists were then producing, such as John Steuart Curry's *The Gospel Train* (1929) and Thomas Hart Benton's *Lord Heal the Child* (1934), all of which represent, simultaneously, memories of the past, the lost certainties of religious upbringing and belief, the picturesque hab-

its of people bypassed by modern secular society, and the affirmation that religion can still define one's personal culture.

Like Weber, Maurice Sterne and others also challenged the comprehension of critics. One, in discussing Sterne's exhibition at the Museum of Modern Art in 1931, the first solo exhibition by a living artist at that museum, was distressed by Sterne's constant travels (Europe in 1904, Egypt in 1911, Burma and Java in 1912, the western United States in 1917, Italy in 1918). He thought that "all this represents the struggle of an artist to find himself. It is a rather sad story. . . . We must all be kind to Maurice Sterne. Worse than not having a country is not knowing what country one would like to have." The choice of country, for the critics, was either Russia or the United States. (Sterne was born in Libau, Latvia, a Germanic port on the Baltic Sea.) One critic claimed that Sterne's instincts had been formed before the age of twelve, when he emigrated from Russia, but hedged by saying "what contribution this early environment made is not evident in his painting except in possible indefinite shades of personality." Another critic acknowledged his foreign birth "like many other of our countrymen he is really a Russian" but insisted that he was American through "long association, residence, marriage, and [has] no affinity whatsoever with the national art of Russia." Yet another critic, coupling him with other artists, said, "the Oriental Semitic from Russia has made an exceptionally good record in art since his transplantation to our shores."[34]

Conflicting and confusing readings can also be collated about other artists. The point is that the notion of the melting pot still appealed to many mainstream critics: There was something interesting, even exotic, in coming from someplace else. *This* was certainly in the American tradition. Probing an artist's background, therefore, might lead to a better understanding of the artist's contribution to American art as well as to a more accurate assessment of the quality of the work.

FIG. 26
Max Weber, Jewish New Year Greeting to Abraham Walkowitz, 1934. Weber's woodcut design was executed ca. 1918–1920. Abraham Walkowitz Papers, Archives of American Art, Smithsonian Institution.

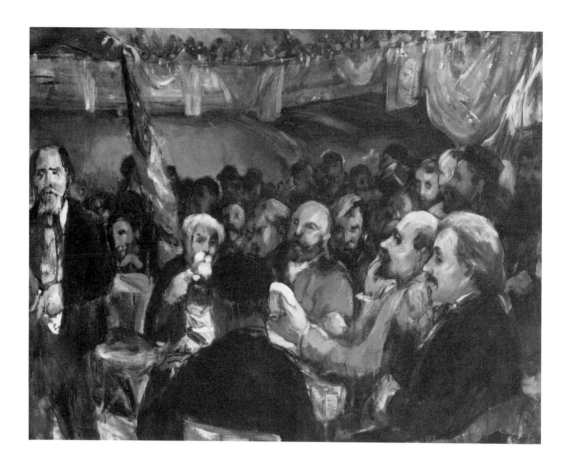

FIG. 27
Theresa Bernstein, *Zionist Meeting, New York*, 1923, oil on canvas, 34 1/4 x 44 1/2" (87 x 113 cm). Jewish National Fund. Seated lower right, Albert Einstein, and next to him, Chaim Weitzmann. (cat. no. 15)

## ON THE NATURE OF "JEWISH ART"

During the 1920s primarily, but on through the 1960s, critics debated the nature of Jewish art itself. Did it exist? If so, what were its characteristics? Another recurrent question was why so many Jewish artists emerged just before and after World War I. One observer tried to deal with all these issues simultaneously. His argument went something like this: Jews really have no feeling for the pictorial in nature. How else to explain the lack of empirical descriptions in the Old Testament? Jews, he insisted, do not see things as much as they think about things. This suggests "a congenital deficiency in plastic sense." But even if Jews lack plastic vision, they are nevertheless sensitive to ornamental, if not representational, forms. "And it is precisely because the ability to 'see plastically' is not necessary in modern art that the eminence of the Jew is possible," since modern art—

Cubism, Futurism—is an art of reason and synthesis, two intellectual pursuits in which Jews do very well. Even when modern art will have run its course, Jewish art will remain decorative and abstract because it is the "road that Jewish psychology has destined."[35]

In contrast, another critic, in discussing Max Weber's work, insisted that his racial heritage saved him from painting in a dry, arid way, that his humanism "prevented his withdrawing into that separation from God and Man which for a time obsessed French Cubists."[36] Here the racial/religious argument led to an entirely contradictory conclusion.

Still others suggested that a nonspecific something in the Jewish worldview added spiritual overtones to an artist's work, that the fate of man is a Jewish theme because "the Jewish spirit is focused mostly on the moral quest and deals in the main with the relation between man and man," and that a concern

for social justice, the disadvantaged and the exploited is shared by many Jewish artists. Benjamin Kopman found fellow artist Abraham Walkowitz to have a "nervous temperament. This nervousness is [more in his life than in his work] a Jewish characteristic, and it makes him . . . a Jewish artist even more than the family sentiment which he displays." (It is interesting to note here that the nervousness which Kopman found in Walkowitz was the very quality that critics found to be one of the most American in John Marin's work.) Jennings Tofel thought the Jewish quality in an artist's work was ineffable beyond simple description. When a Jewish artist freed himself from external influences, Tofel held, the artist would reveal his soul. "This is sensed when one becomes familiar with the work of the Jewish artist. One feels an identification which is recognizable through the impulsive line, neurotic motion of the figures, and an ethical conception of the world."[37]

William Zorach, like others, waffled considerably in defining a Jewish art. At a symposium in 1948, he said in successive sentences that Jewish art did not exist because of the varied environments in which Jews have lived, and that Chagall and Weber "create something Jewish in their art, but that is just because they lived, philosophized, and conducted themselves consciously as Jews. Therefore something Jewish vibrates in them which is strong enough not to have been entirely drowned by the strong European influences."[38]

Harold Rosenberg, the critic of Abstract Expressionism and other contemporary movements, put the argument in existential terms. Denying the existence of a Jewish style and a unique Jewish experience, he held that identity was the most serious problem in Jewish life as well as in modern life. Therefore, when Jewish artists "assert their individual relation to art in an independent and personal way," they are involved in "a profound Jewish expression."[39] This is another way of saying that all assimilated people are trying to figure out who they are

50

as unique individuals. It does not help those who want to identify "Jewish" and want to know what that Jewish identity is. But since, as the opinions above suggest, nobody can agree on a definition of Jewish art, then all we can say is that some people want to believe there is something called Jewish art and that in some way it reflects both Jewish life and the Jewish religious heritage, however these might be defined.

## THE THIRTIES: SOCIAL REALISM AND CLASS CONSCIOUSNESS

These considerations of ethnicity in art were much more commonly deliberated during the 1920s than they were in subsequent years. Today it is sometimes painful to read them because the logic is so faulty and the wishful thinking so obvious. In the 1930s, however, with the rise of Social Realist art, class consciousness largely replaced, but did not eliminate, ethnic consciousness. In fact class consciousness among Jewish-American artists provided one of the principal routes into the mainstream, since concern for the American situation during the Great Depression meant that one was functioning as an American painter. This might help explain why so many Jewish-American artists joined such left-wing organizations as the John Reed Clubs, founded in 1929, the Artists Union in 1933, and the American Artists' Congress in 1936. The first and last of these were Communist-sponsored organizations and it is no secret that Jewish-Americans were among the most militant members. The majority of the founders of the New York chapter were Jewish-American: Hugo Gellert, William Gropper, Fred Ellis, Louis Lozowick and Joseph Pass. And Jewish-American artists, if not in such overwhelming proportions, also participated in the founding and running of the American Artists' Congress. These included Max Weber, whose own personal journey encompassed not only radical modern styles and traditional Jewish subject matter but socially committed art and politics as well.[40]

There is, of course, more to this complex

FIG. 28
Raphael Soyer, *The John Reed Club: The Committee*, 1932, lithograph on paper, 10 5/8 x 14 5/8" (27 x 37.1 cm). Hirshhorn Museum and Sculpture Garden, Smithsonian Institution. Gift of Raphael and Rebecca Soyer, 1981, in honor of Abram Lerner. Left to right: Nimo Piccoli, Adolf Wolff, Walter Quirt, Iver Rose, Anton Refregier. (cat. no. 116)

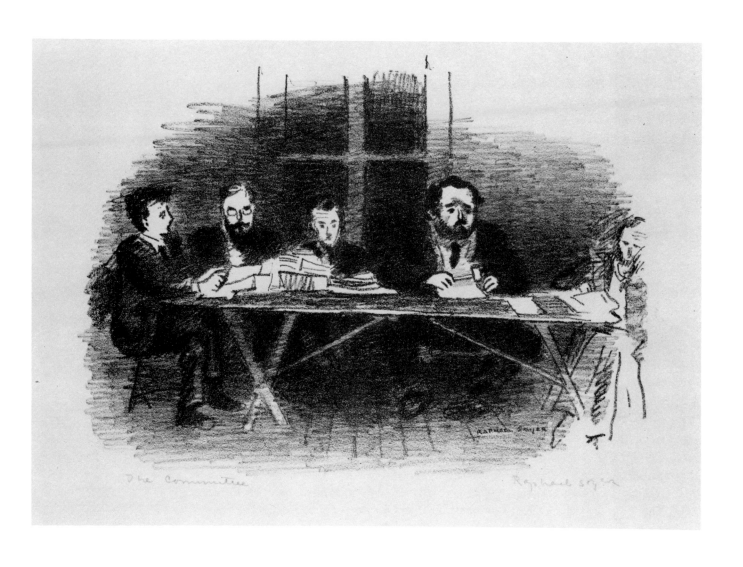

The Committee                                          Raphael Soyer

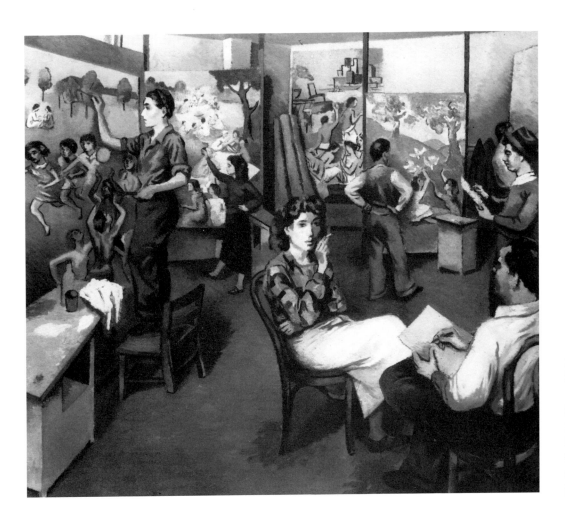

FIG. 29
Moses Soyer, *Artists on WPA*, 1935, oil on canvas, 36 1/8 x 42 1/8" (91.8 x 107 cm). National Museum of American Art, Smithsonian Institution. Gift of Mr. and Mrs. Moses Soyer. (cat. no. 110)

issue than merely saying that class consciousness replaced ethnic consciousness. What other factors might have prompted Jewish-American artists to veer toward the left? We might speculate in the following ways.

Until the founding of the state of Israel, Jews were the perennial marginalized group, always the outsiders. This was certainly the case during and immediately following the great migration to the United States early in this century. Able to think of becoming part of the mainstream in American society in ways heretofore impossible in Europe, many Jews consciously tried to abandon their heritage and to suppress their background. But studies of minority groups suggest that attempts at assimilation often carry a heavy psychological price. Lower-status minority groups, in their frustrated attempts to join the higher-status majority culture, became self-hating instead of directing their anger

against the idealized majority culture.[41] In the 1920s and 1930s, Jewish-American artists did both: they internalized their Jewishness as a stigma and lashed out at the majority culture.

As for directing their anger at themselves, Jewish-American artists abandoned the religious aspects of Judaism quickly. Those sympathetic to Communism or to leftist politics in general accepted the point of view articulated during the so-called "Third Period of Communism" (1928 to 1935), according to which organized religion, ethnic separatism and nationalism, here meaning Jewish nationalism and Zionism, were evils to be avoided: assimilation was the proper course to follow. But the artists could not forget their culture entirely. It was what they knew. The Bible, in addition to mainstream society, also reminded them of their shortcomings as Jews and of their constant

*Opposite:*
FIG. 30
Minna R. Harkavy, *American Miner's Family*, 1931, bronze, 27 x 31 3/4 x 24" (68.6 x 80.7 x 61 cm). Collection, The Museum of Modern Art, New York. Abby Aldrich Rockefeller Fund, 1938. (cat. no. 53)

backsliding into evil ways. Even the nonreligious must have remembered the self-criticisms woven into the liturgy of Yom Kippur, the Day of Atonement. Freud, in his *Civilization and Its Discontents*, commented upon the biblical misfortunes visited upon Jews, noting that, rather than question God, they "produced the prophets, who held their sinfulness before them; and out of their sense of guilt they created the overstrict commandments of their priestly religion." As a way of dealing with so many injunctions to be virtuous in the face of so much wickedness, Jews developed a messianic vision—a time in which forces of good would overcome forces of evil—as in the writings of Isaiah.[42] Pious Jews turned to the

Messiah. Emancipated Jews turned to political solutions as their messianic vehicle to a better, freer and physically safer life. In the 1920s and 1930s, Communism provided secular Jews with just such a vehicle to allow them to deny their own Jewish heritage and to punish the majoritarian American capitalistic society by its overthrow or modification.

Jewish-American radicals in the United States, attracted to Russian models as early as the 1880s, discovered in the 1920s and 1930s "the lure of the Russian utopia."[43] The appeal of the Soviet Union must have been difficult to resist. It offered governmental planning, full employment, the myth of the idealistic, communal new man, and a society

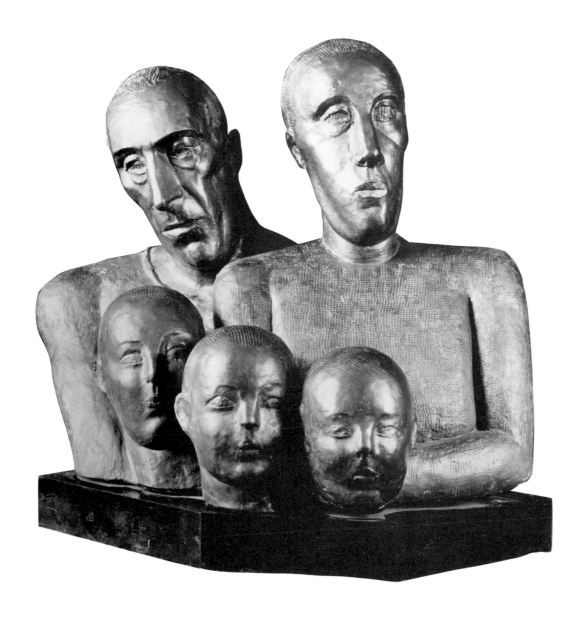

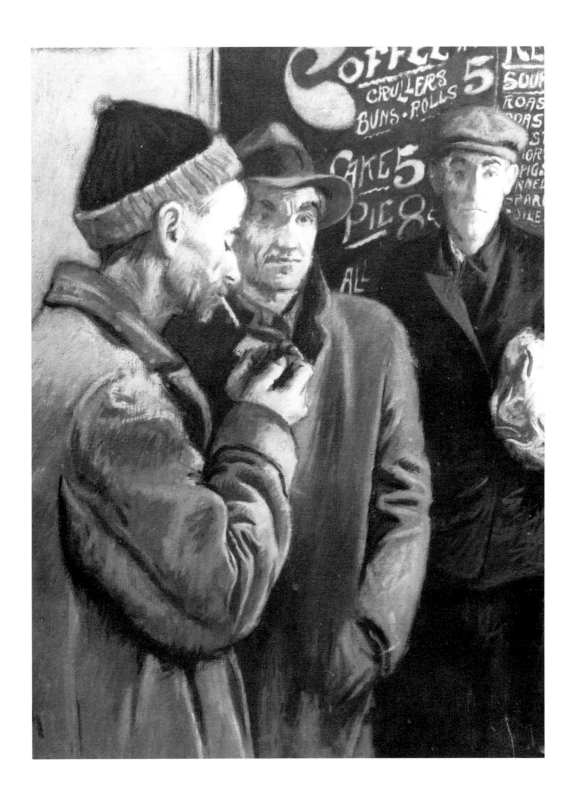

it as it is—mean, dirty, avaricious. Self-glorification is artistic suicide. Witness Nazi Germany."[48] The big question was: could it happen here? Given the tensions of the time and the fear of being spiritually as well as physically annihilated in a Fascist world, Soyer's comments must have struck raw nerves throughout the art world.

It is not too farfetched to say that the left-leaning Jewish-American artists "coalesced" into ("formed" is too strong a word) an identifiable group which loosely shared similar political, aesthetic and stylistic interests. William Gropper, at the extreme left, caricatured rabbis and rich Jewish socialists in the pages of the *Frayhayt*, a Communist newspaper.[49] Other artists accommodated their politics to their degree of commitment to the Jewish-American community, particularly with the rise of the Popular Front in 1936. For instance, sculptor Aaron J. Goodelman chaired the art department of the leftist, and therefore internationalist, Jefferson School of Social Science in New York City, but he was also a member of the Jewish Art Center, the art section of YKUF (World Alliance for Yiddish Culture), a Popular Front organization, which held an exhibition in New York City in 1938 to assert the presence of Jewish culture in the face of the rising tide of anti-Semitism, and he was also active in the Sholem Aleichem Folk Shule, a secular Yiddishist organization.[50] Other, less political artists challenged in 1935 the narrow aesthetic outlook of *Art Front*, the newspaper of the Artists Union. These artists, whose works might be characterized as being nonpolitical expressionist, banded together and exhibited jointly for about six years. Calling themselves the Ten, they included Ben-Zion, Ilya Bolotowsky, Adolph Gottlieb, Louis Harris, Yankel Kufeld, Marcus Rothkowitz (Mark Rothko), Louis Schanker, Joseph Solman and Nahum Tschacbasov.[51]

Many Jewish-American artists navigated between these divergent shores. For example, Raphael Soyer, looking back from the early

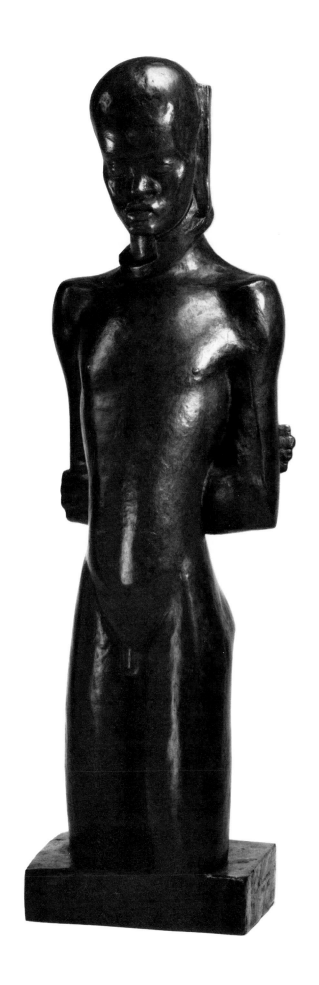

1980s, said that "the John Reed Club of writers and artists helped me to acquire a progressive worldview, but I did not let it change my art, which never became politically slanted. I painted what I knew and what I saw about me." And what he painted were the unemployed and the homeless. Left-wing critics did not respond positively to Soyer's work. In a review of his solo exhibition in 1935, a critic for the *New Masses* found that his "rotting men" and flophouse scenes did not "constitute a healthy tendency in revolutionary painting." The critic wanted a more vigorous and positive statement.[52]

The attitude an artist exhibited must have been almost as important as the making of paintings with an upbeat message. Moses

Soyer, Raphael's twin brother, wrote a touching review, really a confession, of his own exhibition in 1935, in which he explained that he painted the people he knew and with whom he lived—friends, family. He then said that he should paint the working class, but that he did not yet feel able to do so. "Indeed," he said, "one would be utterly blind in these days of race hatred, depression and the Blue Eagle [referring to the New Deal] not to align himself with the class to which he feels he belongs."[53]

Several Jewish-American artists did come from the working class, but the Soyers grew up in a poor but educated, multilingual middle-class family. Why the identity with the working class? Here we may apply an idea

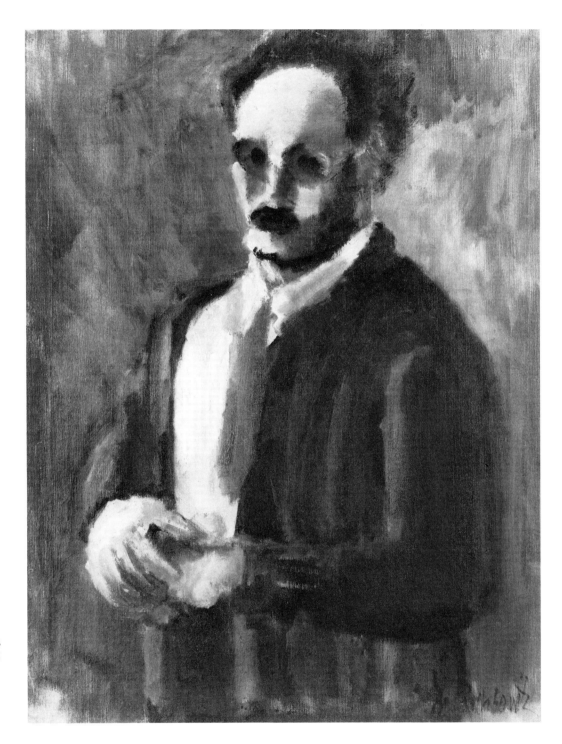

FIG. 37
Mark Rothko, *Self-Portrait*,
1936, oil on canvas, 32 1/4
x 26" (82 x 66 cm).
Collection of Christopher
Rothko. © 1991 Christo-
pher Rothko. (cat. no. 90)

Raymond Williams, the leftist literary critic, posited in his book, *Culture and Society*.[54] In brief, working-class culture views society itself as the vehicle for both collective and individual development. The entire society develops together through individual exertion. By contrast, middle-class culture views society as a neutral base from which each individual can develop in his or her own way. Given the facts that Jews were not going to change society either as individuals or collectively as Jews and that the Communist Party, which identified with the working class, provided a forum for change, it is then reasonable to assume that even if artists were not card-carrying Communists, they would still find Communism attractive as the vehicle for change that capitalism could never be. And so Moses Soyer wanted to identify with a class of which he was really not a member.

To many outsiders, Jewish-American artists must have seemed a monolithic block. Thomas Hart Benton, the central figure of the Regionalist movement, probably felt this way. In his writings, and probably in his conversations, he appears to have conflated Jewish artists and Communists, not always in a favorable light.[55] He even included a hostile caricature of a Jewish intellectual in one of the mural panels of *The Arts of Life in America* completed for the Whitney Museum of American Art in 1932, now in the New Britain Museum of American Art (fig. 39). As a champion of American Scene painting, primarily based on rural subject matter, Benton also denied the validity of the work of several Jewish-American artists, whatever their degree of left-wing politics. Briefly, Benton believed that a living art grew from engagement with the history, habits and environments of particular locales. Left-wing artists in New York City, who had little or no knowledge of the American past or present, could not, therefore, make meaningful paintings of the American scene. On one occasion he even accused members of the John Reed Club of submit-

ting their art to doctrine rather than to actual experiences in America. Preferring an art based on regional, geographic or historical factors, he did not acknowledge the Jewish-American experiences of class and religious antagonisims, poverty, racism and hypocrisy, which in the eyes of the New York painters were just as American as Benton's preferred rural subjects.

But, like Benton, Jewish-American artists also traveled around the country in search of subjects to paint. The experiences they sought out and recorded were different, however. Mervin Jules, for example, visited mining towns during the 1930s "to experience the situation at first hand, do sketches and use them as part of documentation of the kinds of pictures we were interested in doing." He spent days with workers, and visited union headquarters, bars and jails. He went to cities to observe the lives of industrial workers to study "the terrible existence and the misery, the hunger, the unhealthy living conditions and the lack of hope produced in the life of the people that [echoing Moses Soyer] we felt an identity with." Harry Gottlieb, another left-wing artist, also visited coal-mining areas to observe living conditions.[56] In this way Jules and Gottlieb were able to experience life in the United States and to enter into its present history without the burden of what they probably considered to be moribund traditions.

Among artists who did not choose to travel around the country, or who traveled very little, urban life was quite sufficient. Raphael Soyer, for example, often said that New York City was his America. Impressed by the great variety of ethnic, religious and economic groups living in reasonable harmony, he found New York to be a microcosm of the entire nation.[57]

## WORLD WAR II AND THE POSTWAR YEARS

By the late 1930s the Moscow Trials, the Hitler-Stalin Pact, and the Soviet invasion of Finland dampened "the lure of the Russian utopia." Many artists remained socially com-

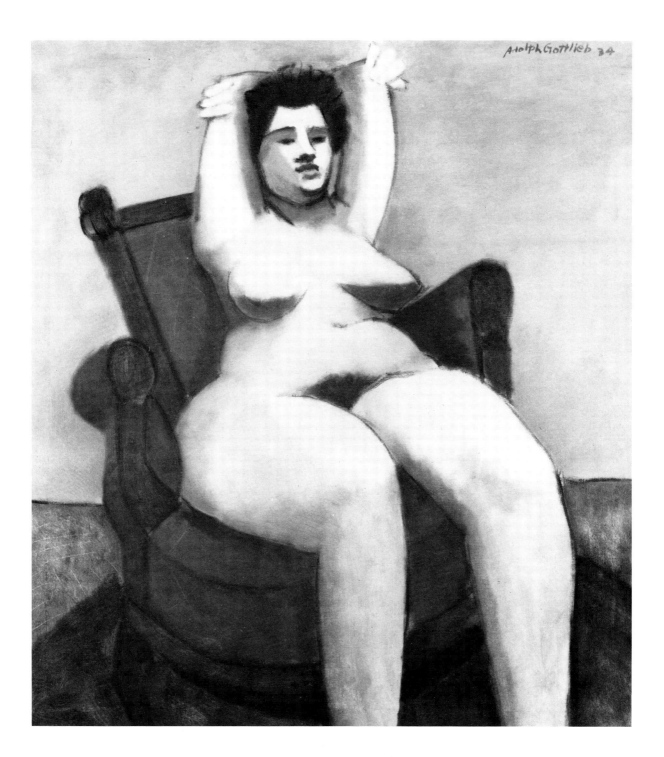

FIG. 38
Adolph Gottlieb, *Seated
Nude*, 1934, oil on canvas,
39 9/16 x 35 1/2" (100.5 x
90.2 cm). Collection of the
Adolph and Esther
Gottlieb Foundation, Inc.
© 1979 Adolph and Esther
Gottlieb Foundation, Inc.
(cat. no. 43)

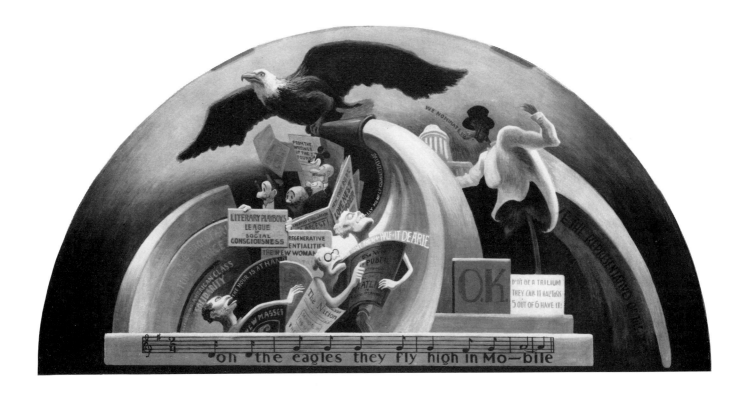

FIG.39
Thomas Hart Benton,
*Political Business and
Intellectual Ballyhoo*,
tempera with oil glaze, 4'8
1/2" x 9'5"  (1.43 x 2.87
m). From the collection of
the New Britain Museum
of American Art, Connecti-
cut. Harriet Russell Stanley
Fund.

*Opposite:*
FIG. 40.
Ben-Zion, *De Profundis: In
Memory of the Massacred
Jews of Nazi Europe*, 1943,
gouache, ink, wash, pen
and ink, sheet: 24 x 19"
(61 x 48.3). Collection,
The Museum of Modern
Art, New York. Given
anonymously.

mitted, but their viewpoints changed. The
advent of World War II and the torture and
murder of millions of Jews in the 1940s
deeply affected their art. In light of the enor-
mity of the situation, artists responded in
personal terms, since no single political or
stylistic point of view could encompass their
feelings. Older modernists, such as Max
Weber, continued to paint Jewish genre
scenes. William Gropper turned to Jewish
themes after the war, as one observer said, "to
learn more about his people—to sing of their
history and achievements." In fact he did not
so much reveal his new learning as his per-
sonal anguish in a booklet on the Holocaust
*Your Brother's Blood Cries Out* and in a series
of works, one completed each year, to com-
memorate the Warsaw Ghetto. A common
theme in these works was rabbis at prayer. Ben
Shahn began to use Hebrew letters after
1948, something he had not done since the
middle 1930s. Some of his paintings and
prints included images of destruction and
death, but he did not make works specifically
of Holocaust scenes, preferring instead "to
be universal in feeling and . . . avoid an

exclusively racial significance or 'ethnic self-
pity.'" Ben-Zion, who probably painted more
biblical scenes than any other artist, created
a series entitled *De Profundis* (fig. 40). "As
one who identifies himself with the massa-
cred ones, and as an artist," he said, "I could
not restrain a personal expression of grief." In
the *De Profundis* series, the patriarchal Jew is
a dominant image because to Ben-Zion he
was the backbone of the Jewish people and
their culture.[58]

Several younger artists, however, per-
haps lacking that crucial attachment to the
immigrant and ghetto experiences, did not
feel the need to respond to the Holocaust in
direct artistic terms or to anything particu-
larly Jewish, either. At some moment in the
1940s, therefore, a great divide opened be-
tween those younger artists who wanted and
those who did not want to maintain connec-
tions to Jewish culture and tradition. The
former found and continue to find outlets in
organizational and synagogue commissions
for paintings, sculptures, mosaics and stained
glass. Some of the latter became founders of
Abstract Expressionism, which, most critics

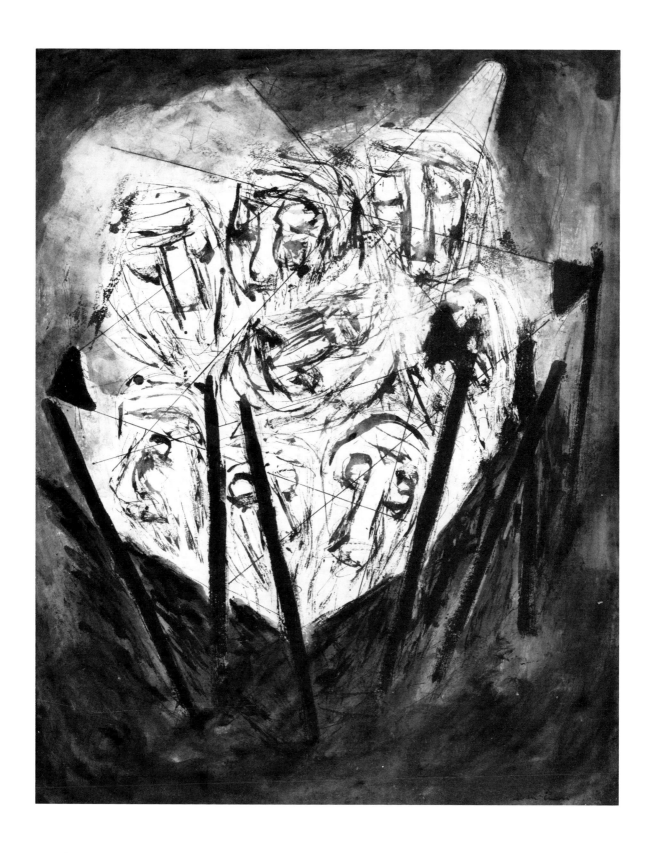

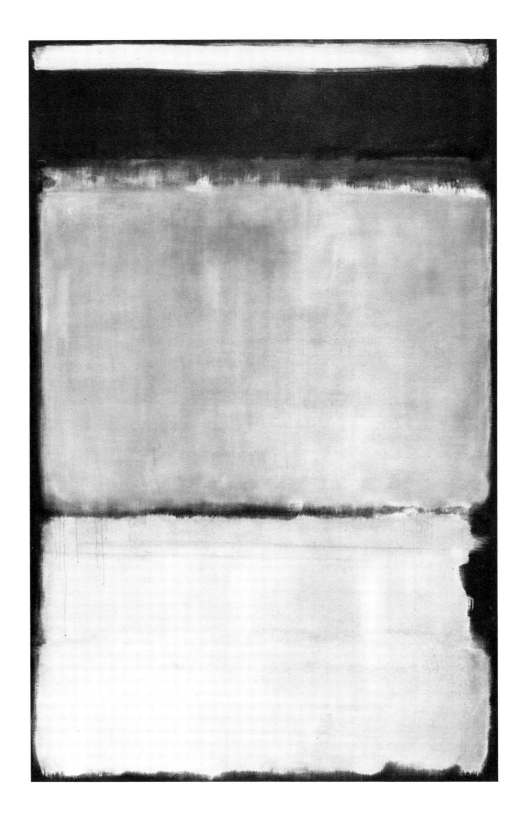

30. Daryl R. Rubenstein, *Max Weber: A Catalogue Raisonne of His Graphic Work* (Chicago: University of Chicago Press, 1980), 2.

31. Forbes Watson, "In the Galleries," *The Arts* 16 (April 1930): 568; Duncan Phillips, *A Collection in the Making* (New York: Weyhe, 1926), 62; Phillips, "Personality in Art: III," *The American Magazine of Art* 28 (April 1935): 221; Lloyd Goodrich *Max Weber* (New York: Whitney Museum of American Art, 1949), 40. See also Lewis Mumford, "The Art Galleries," *The New Yorker* 11 (December 14, 1935): 42.

32. See, for example, Howard DeVree, "Richmond Barthe," *Magazine of Art* 32 (April 1939): 232.

33. Goodrich, *Max Weber*, 47. See also "Max Weber: A Note on 'Talmudists,'" *The Menorah Journal* 23 (April–June 1935): 100; Grace Pagano, ed., *Contemporary American Painting: The Encyclopedia Britannica Collection* (New York: Duell, Sloan, Pearce, 1945), illus. 115; Kampf, *Jewish Experience*, 180–181.

34. McBride, "Maurice Sterne in Retrospect (1933)," *Flow of Art*, 297; Inslee A. Hopper, "Instinct, Environment, Tradition—Maurice Sterne," *The American Magazine of Art* 29 (December 1936): 807; Harry Buel, "Notes of the Month," *International Studio* 95 (January 1930): 58; Duncan Phillips, "Personality in Art: III," *The American Magazine of Art* 28 (April 1935): 217–218.

35. Aaron Spivak, "The Jew Enters the Plastic Arts," *The Menorah Journal* 16 (May 1929): 404, 406, 408.

36. Florence Gilliam, "Max Weber: Humanist," *The Menorah Journal* 11 (December 1925): 580.

37. Kampf, *Jewish Experience*, 51, 70. Benjamin Kopman, *Abraham Walkowitz* (Paris, 1927), cited in Kampf, 57. David Ignatoff, "Abraham Walkowitz," *Zukunft* (December 1949), cited in Kampf, 57. Isaac Lichtenstein, *Abraham Walkowitz* (New York: Machmadein Art Editions, 1946), n.p. Nochum B. Minkoff, "Artists and Scholars View Yiddish Art" (1948): 15, in the Jewish Museum archives. For Marin, see Paul Rosenfeld, *Port of New York* (New York: Harcourt, Brace, 1924), 162.

38. Minkoff, "Artists and Scholars," 11.

39. Harold Rosenberg, "Is There a Jewish Art" *Commentary* 42 (July 1966): 59. See also "Jews in Art (1975)," *Art and Other Serious Matters* (Chicago: University of Chicago Press, 1985), 58–69.

40. Francine Tyler, "Art Front (1934–1937), the Magazine of the Artists' Union," (Ph.D. dissertation, New York University, 1991), ll; and Matthew Baigell and Julia Williams, eds., *Artists Against War and Fascism: Papers of the First American Artists' Congress* (New Brunswick: Rutgers University Press, 1986), intro.

41. Estelle Frankel, "The Promises and Pitfalls of Jewish Relationships," *Tikkun* 5 (September–October 1990): 19.

42. Sigmund Freud, *Civilization and Its Discontents*, James Strachey, trans. (New York: Norton, 1961), 82; and Frankel, "The Promises and Pitfalls," 96.

43. Daniel Bell, *Marxian Socialism in the United States* (Princeton: Princeton University Press, 1952), 152n. See also Irving Howe, *World of Our Fathers* (New York: Harcourt, Brace, Jovanovich, 1976), 102.

44. Daniel Aaron, *Writers on the Left* (New York: Avon, 1965), 150.

45. Matthew Baigell, *The American Scene: American Painting of the 1930s* (New York: Praeger, 1974), 210n.

46. "A Jewish Writers' Symposium on Radicalism," *The Literary Digest* 118 (November 24, 1934): 19. See also Baigell and Williams, eds., *Artists Against War and Fascism*, intro.

47. Meyer Schapiro, "Race, Nationality and Art," *Art Front* 2 (March 1936): 10, 12.

48. Moses Soyer, "The Second Whitney Biennial," *Art Front* 1 (February 1935): 7–8.

49. J. Anthony Gahn, "William Gropper—Radical Cartoonist: His Early Career, 1897–1928," *The New-York Historical Society Quarterly* 54 (April 1970): 132–34.

50. From the Aaron J. Goodleman and YKUF files at the Jewish Museum.

51. Gerald M. Monroe, "Art Front," *Archives of American Art Journal* 13 (No. 3, 1973): 15–16; The Ten, Archives of American Art, Roll 2714, Frame 975.

52. Raphael Soyer, "An Artist's Experiences in the 1930s," in Patricia Hills, *Social Concern and Urban Realism: American Painting of the 1930s* (Boston: Boston University Art Gallery, 1983), 27; and Stephen Alexander, "Art Review," *New Masses* 14 (March 12, 1935): 28.

53. Moses Soyer, "About Moses Soyer," *Art Front* 1 (February 1935), 6.

54. Raymond Williams, *Culture and Society, 1780–1850* (1958), 325, 327. Cited in Tyler, "Art Front," 30.

55. Matthew Baigell, "Thomas Hart Benton and the Left," in R. Douglas Hurt and Mary K. Dains, eds., *Thomas Hart Benton: Artist, Writer, Intellectual* (Columbia: State Historical Society of Missouri, 1989), 19 - 23.

56. Tyler, "Art Front," 273 - 274; and Sheryl Conkleton and Gregory Gilbert, *Harry Gottlieb* (New Brunswick: Zimmerli Art Museum, 1983), 24 - 25.

57. Raphael Soyer mentioned this to me on several occasions.

58. August L. Freundlich, *William Gropper: Retrospective* (Miami: Joe and Emily Lowe Art Gallery of the University of Miami, 1968), 23, 29; Ziva Amishai-Maisels, "Ben Shahn and the Problem of Jewish Identity," *Jewish Art* 12 - 13 (1987): 306n, 310; Stephen S. Kayser, *Ben-Zion: Biblical Paintings, 1948 - 1952*, (New York: The Jewish Museum, 1952), *passim*. See also Alfred Werner, "Ben-Zion, Jewish Painter," *Midstream* 19 (November 1973): 33 - 34.

59. Harold Rosenberg, "Tenth Street: A Geography of Modern Art," *Art News Annual* 28 (1959): 137.

60. Grossman, *Art and Tradition*, 47, 96.

61. Werner Haftmann, *Mark Rothko* (Düsseldorf: Städtische Kunsthalle, 1971), cited in Kampf, *Jewish Experience*, 201; Andrew Carnduff Ritchie, intro., *Salute to Mark Rothko* (New Haven: Yale University Art Gallery, 1971), 163.

62. Interview with Stanley Kunitz by John Beardsley with Cynthia J. McCabe in Cynthia J. McCabe, *The Golden Door* (Washington, D.C.: The Smithsonian Institution Press, 1976), 163. Dore Ashton, *About Rothko* (New York: Oxford University Press, 1983), 6, 7, 9. See also James E. B. Breslin, "The Trials of Mark Rothko," *Representations* 16 (Fall 1986): 1–41.

63. Thomas Hess, *Barnett Newman* (New York: The Museum of Modern Art, 1971), 53, 55, 71.

64. Kampf, *Jewish Experience*, 197.

65. Barnett Newman, "The Sublime Is Now," *Tiger's Eye* 1 (December 15, 1948): 23.

66. Hess, *Newman*, 61.

67. Hess, *Newman*, 53.

68. For an interesting article appropriate to this discussion on why Neo-Hasidism, rather than Hasidism, appeals to assimilated Jewish-Americans, see Peter Eli Gordon, "Imagining Hasidism," *Tikkun* 5 (May 1990): 49 - 51.

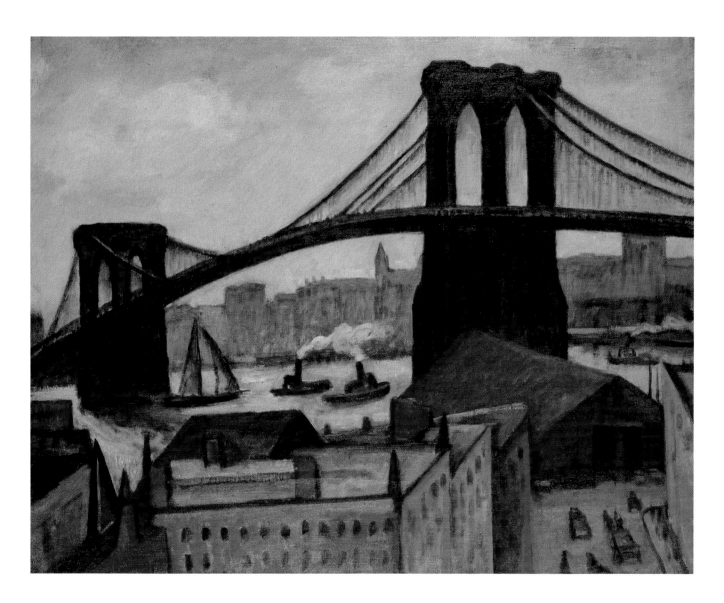

PLATE 1
Samuel Halpert, *View of Brooklyn Bridge*, ca. 1915-1919, oil on canvas, 28 1/2 x 36 1/16" (72.4 x 91.8 cm). The Brooklyn Museum. Gift of Benjamin Halpert. (cat. no. 51)

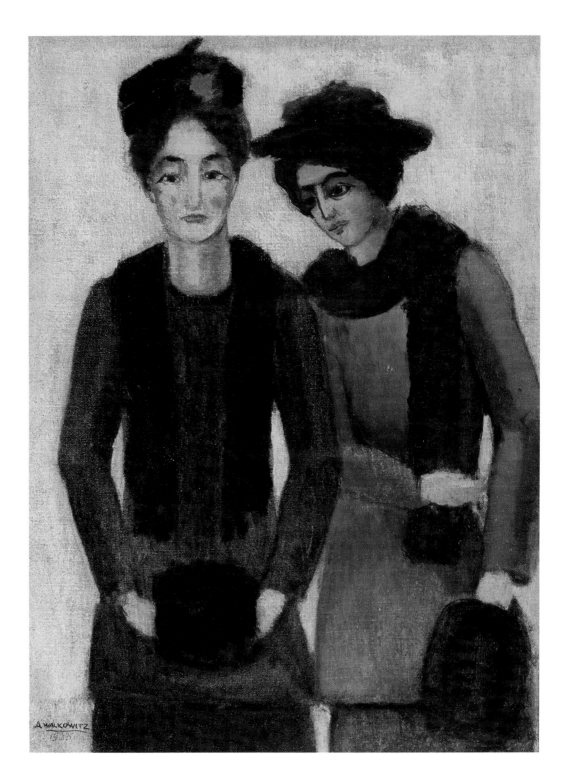

PLATE 2
Abraham Walkowitz,
*On the Avenue*, 1905, oil
on canvas, 16 x 12 1/2"
(40.6 x 31.8 cm).
Collection of Nathan
and Baya Weisman.
(cat. no. 127)

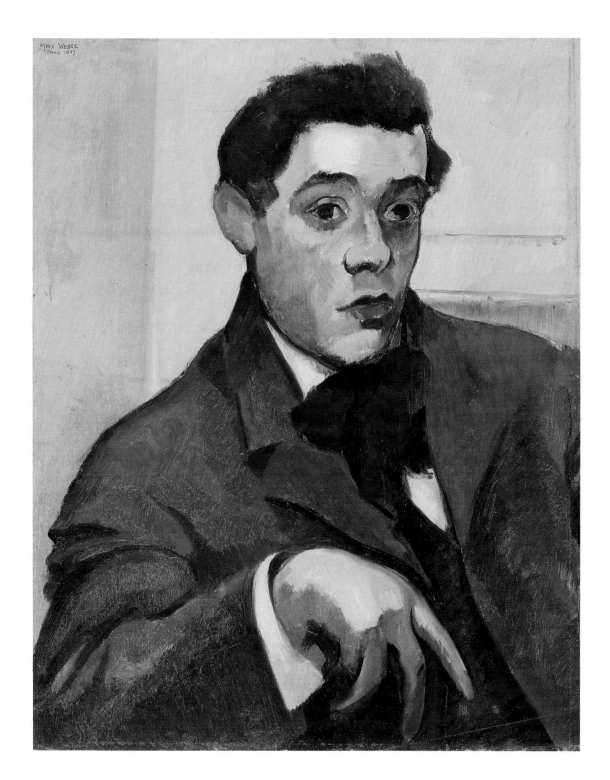

PLATE 3
Max Weber, *Abraham
Walkowitz*, 1907, oil on
canvas, 25 1/4 x 20 3/16"
(64 x 51.2 cm). The
Brooklyn Museum. Gift of
Abraham Walkowitz.
 (cat. no. 131)

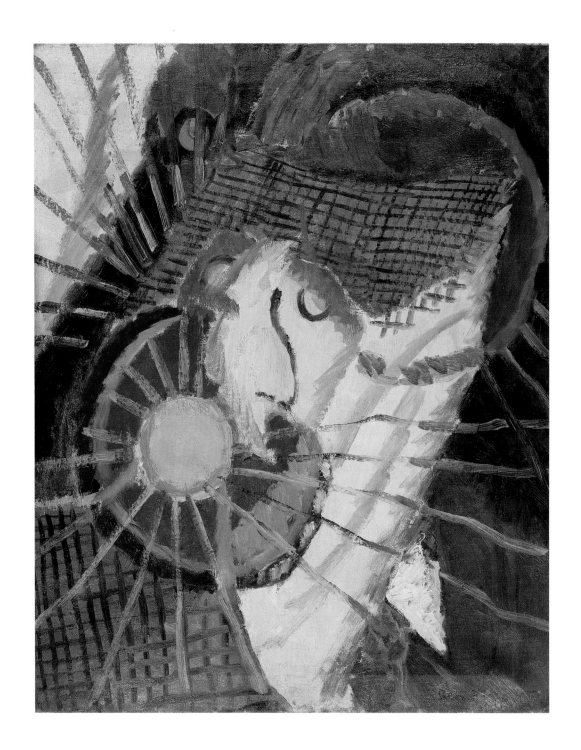

PLATE 4
Ben Benn, *Portrait of M.H.*
(Marsden Hartley), 1915,
oil on canvas, 27 x 22 1/4"
(68.6 x 56.5 cm). Univer-
sity Art Museum, Univer-
sity of Minnesota,
Minneapolis. Gift of Ione
and Hudson Walker.
(cat. no. 10)

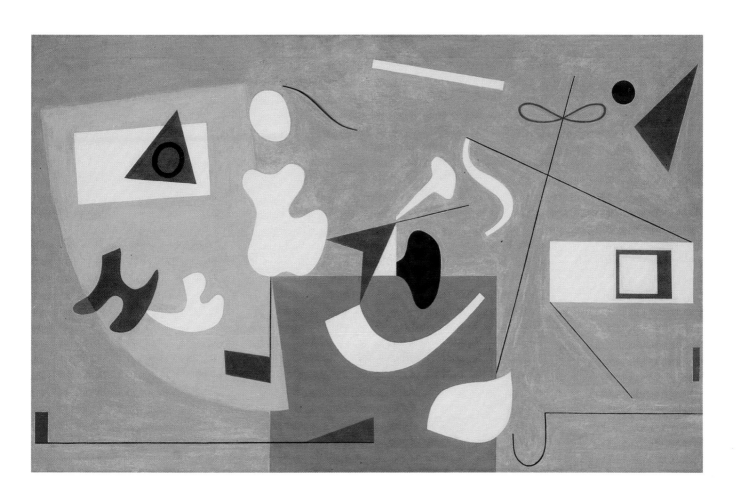

PLATE 5
Ilya Bolotowsky, *Study for
New York's World's Fair
Mural, Hall of Medical
Science*, 1938-1939, oil on
canvas, 30 x 48" (76.2 x
121.9 cm). The Art
Institute of Chicago,
Wilson L. Meade Fund.
© 1990 The Art Institute
of Chicago. All Rights
Reserved. (cat. no. 20)

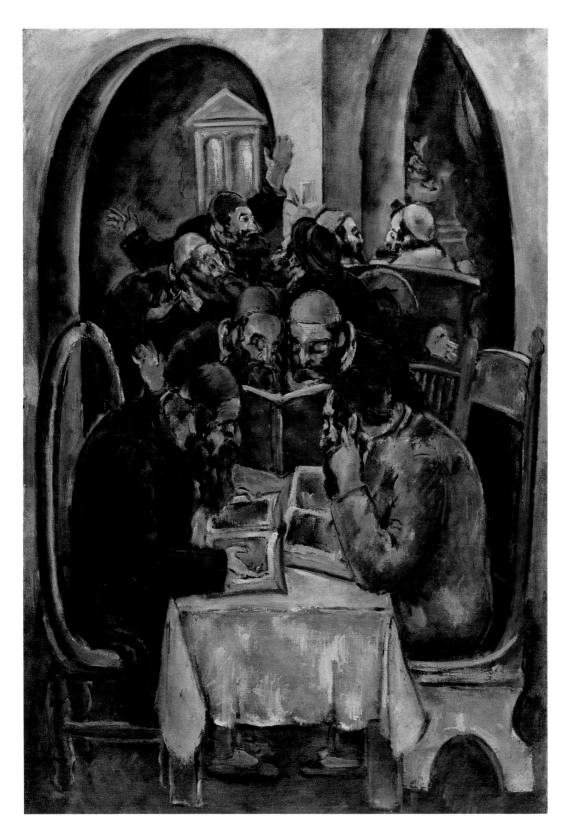

PLATE 6
Max Weber,
*The Talmudists*, 1934,
oil on canvas,
50 x 33 3/4"
(127 x 85.7 cm).
The Jewish Museum,
New York. Gift of
Mrs. Nathan Miller.
(cat. no. 138)

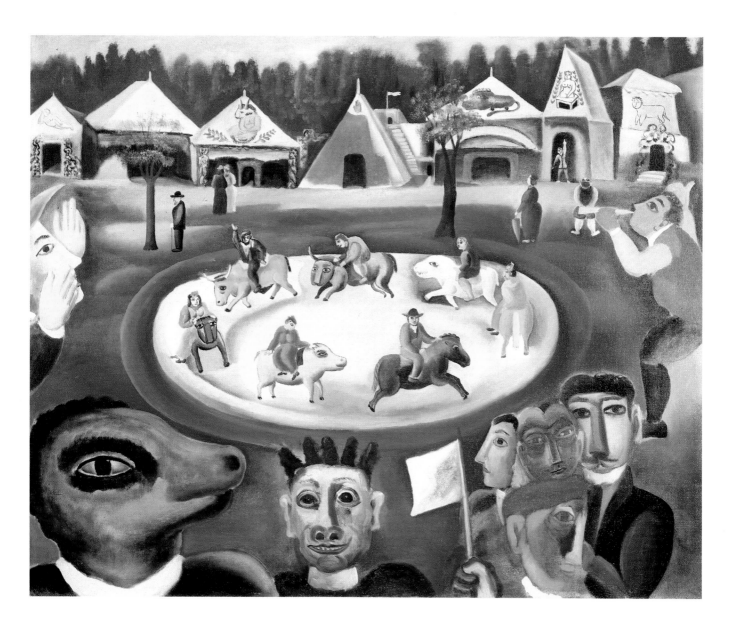

PLATE 7
Benjamin Kopman, *Circus*,
before 1930, oil on canvas,
42 x 50" (106.7 x 127 cm).
Collection of Walter and
Lucille Rubin.
(cat. no. 59)

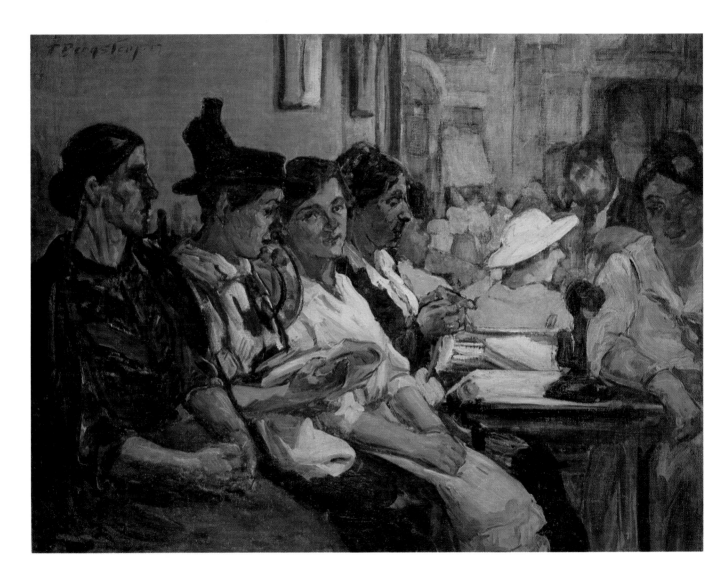

PLATE 8
Theresa Bernstein, *Waiting
Room Employment Office*,
1917, oil on canvas, 30 x
40" (76.2 x 101.6 cm).
Private collection,
Connecticut. (cat. no. 14)

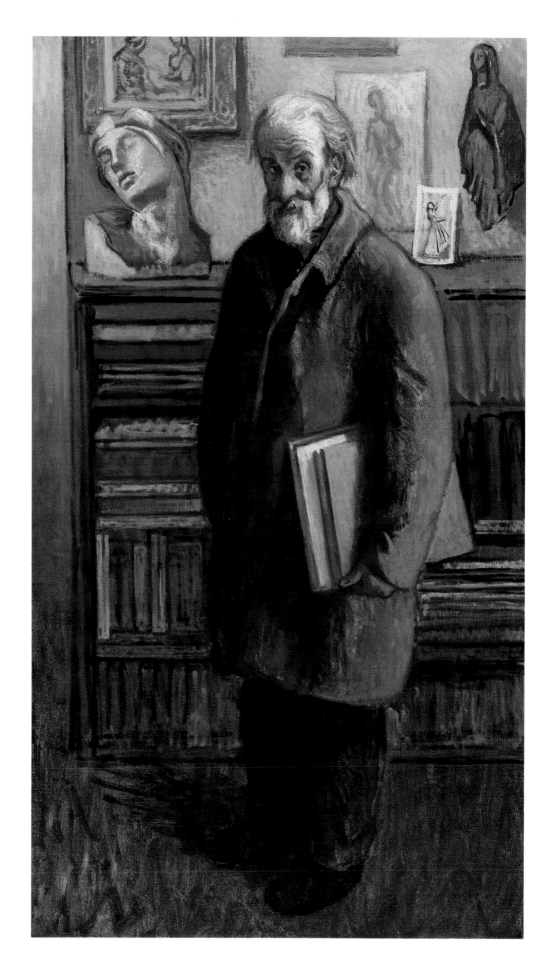

PLATE 9
Moses Soyer, *The Lover of Books*, 1934, oil on canvas, 42 x 23 1/2" (106.7 x 59.7 cm). The Jewish Museum, New York. Gift of Ida Soyer. (cat. no. 109)

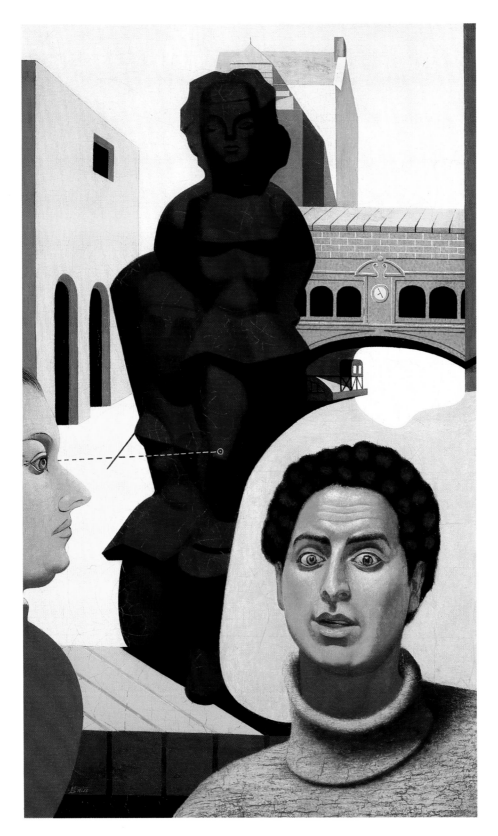

PLATE 10
Francis Criss, *Why the Line?*, 1935, oil on canvas, 40 x 23" (101.6 x 58.4 cm). Courtesy ACA Galleries, New York. (cat. no. 24)

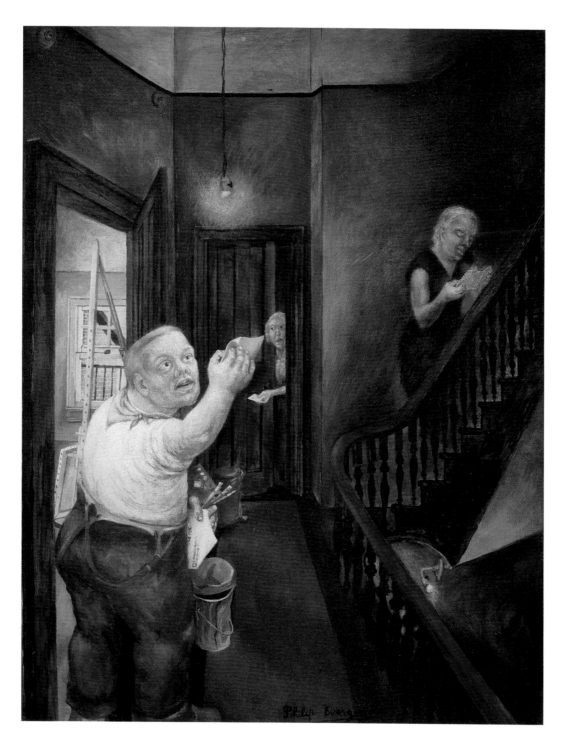

PLATE 11
Philip Evergood, *The Pink
Dismissal Slip*, 1937, oil on
masonite, 28 x 22"
(71.1 x 55.9 cm). Herbert
F. Johnson Museum of Art,
Cornell University. Gift of
Harry N. Abrams.
(cat. no. 35)

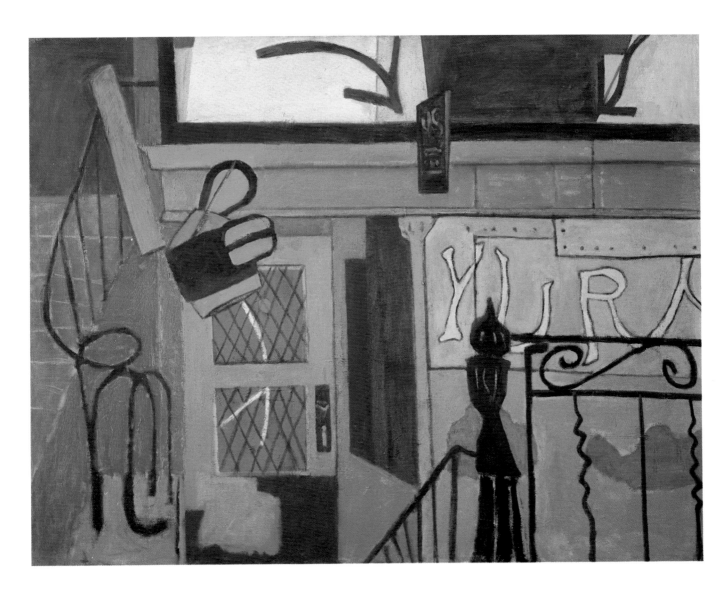

PLATE 12
Joseph Solman, *The
Tinsmith's Shop*, n.d., oil
on canvas, 36 x 47" (91.4 x
119.4 cm). Courtesy
Salander-O'Reilly Galleries,
New York. (cat. no. 104)

# PAINTING A PLACE IN AMERICA:
# JEWISH ARTISTS IN NEW YORK, 1900-1945

*Norman L. Kleeblatt and Susan Chevlowe*

*. . . [The immigrants to America] are no longer masses of aliens, waiting to be melted down into the indistinguishable dough of Anglo-Saxonism. They are rather threads of living and potent cultures, blindly striving to weave themselves into a novel international nation, the first the world has seen.*

—Randolph Bourne,
"Trans-national America," 1916[1]

New York City, in the first years of this century, was developing into a vital metropolis. Uptown, the new fortunes of the robber barons threatened the old-line status-quo; in Greenwich Village bohemian culture defied bourgeois institutions, and downtown the influx of immigrants challenged the social fabric. At one end of the ideological spectrum stood the social reformers and philanthropists who worked to improve living standards for the immigrants and to acclimate them to American society. On the other end stood the anarchists and socialists as alternative voices for the laboring classes. These heady years came to a virtual end with the Great War. The ensuing period of isolationism culminated in a near halt to immigration. Those involved in the arts during this period of introspection sounded the call for an expression of a distinctly American character.

By the early 1920s, immigrant and first-generation Jewish-Americans had become a genuine force in city cultural life. The Great Depression and the government relief programs for artists magnified an incipient cultural chauvinism and consequently raised the question of who defines the American character and how it is interpreted. By the time World War II ended, America found itself as one of the world's two great powers, and New York City had become an international cultural capital.

Jews had become so integral a part of the New York art world that few even gave thought to the distinctions between them and persons of other cultural backgrounds. Abstract Expressionism, the apex of America's aesthetic invention, would have been unthinkable without the involvement of Jewish artists, critics, dealers and collectors.[2]

But this situation was not always the case. Only a handful of Jews are recorded as artists in the nineteenth century, and none achieved a reputation significant enough to leave an imprint on mainstream American art. The few Jewish men who did become artists, like Moses Jacob Ezekiel (1844–1920), Solomon Nunes Carvalho (1815–1897) and Gustav Henry Mosler (1841–1917) to name but the most prominent, were members of comfortable, bourgeois families.[3] They enjoyed the luxury of starting financially uncertain careers in a field which, at least in Europe, had been closed to Jews until the early 1800s. Also, owing to the centuries-long exclusionary practices of the Christian-dominated art academies, the profession had become sociologically alien to Jews. Like numerous other American art-

*Left:*
FIG. 43
Louis Lozowick and his
father in Russia, ca. 1904.
Louis Lozowick Papers,
Archives of American Art,
Smithsonian Institution.

*Right:*
FIG. 44
Samuel Halpert with his
brothers, sister and parents.
Downtown Gallery Papers,
Archives of American Art,
Smithsonian Institution.

ists of the last century, Jews frequently found greater financial rewards in Europe.

The first decade of the twentieth century was a turning point for Jewish artists. Not only would Jews (in both America and Europe) enter the field in greater numbers, but disproportionate percentages—now mostly immigrants and first-generation citizens—established significant reputations as American artists. This phenomenon must be attributed in part to the increase in the Jewish population in New York. More important was the fact that their geographical distance from traditional and restrictive cultures allowed for infinitely greater professional latitude. In a city known for its iconoclasm, old rules could be set aside and new ones could be broken. While the Jew might have to overcome alienation, poverty and hostility to the plastic arts from both family and community, it was nevertheless possible for immigrants and the children of immigrants to attempt a career in the visual arts. Financial reward was often many years into the future, but a significant group was able to make a living in commercial art and teaching.

While the tiny number of nineteenth-century Jewish artists built barriers between their enlightened form of private religious practice and their totally secularized professional lives, the younger generation often fused their cultural backgrounds with their artistic pursuits. Conforming with Randolph Bourne's critical model opposed to American homogenization and advocating the preservation of ethnic cultural traditions, these twentieth-century Jewish-Americans found that their identities as American artists were inextricably linked with a community that often neither understood nor appreciated their art.[4] Many were identified with Jewish culture simply by being connected with other artists of like background, and frequently through their membership in specific artists' organizations, whether or not these alliances had been established with specific Jewish platforms.

These groups, the focus of this study, include the Art School of the Educational Alliance, one of the most important of the many settlement houses on the Lower East Side; the People's Art Guild, which brought art exhibitions to the immigrant community

between 1915 and 1918; the Jewish Art Center, which promoted Yiddish culture and sponsored exhibitions from 1925 to 1927; YKUF, the Jewish Popular Front group organized in 1937; and the Ten, a chance coming together of the original members of an avant-garde group that exhibited together between 1935 and 1939.[5]

Talented Jewish-American artists of this century, whose first language was frequently Yiddish and who were born in such places as Kovno in Lithuania and Bialystok, Stary Constantine or Kaminetz Podolsk in the Ukraine, found at least as much success as did other Americans. All had limited opportunities for sale and exhibition of their work. While some settled in other American cities, most came directly to New York—the center of Jewish immigration and the artistic center of the United States. Representing these immigrant groups were Louis Lozowick, Louise Nevelson, Mark Rothko, Ben Shahn, Raphael Soyer, Abraham Walkowitz, Max Weber and William Zorach. Adolph Gottlieb, Barnett Newman and William Gropper were children of immigrants.

Like other American artists, Jews absorbed the influence of European modernism and helped forge and promote the American styles of Precisionism, Social Realism and Abstract Expressionism. The city itself, physically and socially, helped inspire artists of all backgrounds (such as the Ashcan School realists) to turn against the genteel subject matter of the academic tradition.

During the first and second decades of the twentieth century, the first U.S. exhibitions of modern European art created a stimulating atmosphere for the gradual expansion of radical visual invention by American artists. Aside from the National Academy of Design, founded in 1825, a number of other art schools had been functioning in New York since the late nineteenth century. All admitted Jewish students;

*Left:*
FIG. 45
Peter Blume, at right, and his family in Smorgon, Russia, 1909.
Courtesy the artist.

*Right:*
FIG. 46
Edith Fivoosiovitch, at left, and her sister, Sonia, Odessa, Russia, ca. 1902. Edith Halpert née Fivoosiovitch married the artist Samuel Halpert and in 1926 opened the Downtown Gallery, dedicated to exhibiting the work of contemporary American artists. Downtown Gallery Papers, Archives of American Art, Smithsonian Institution, Washington, D.C.

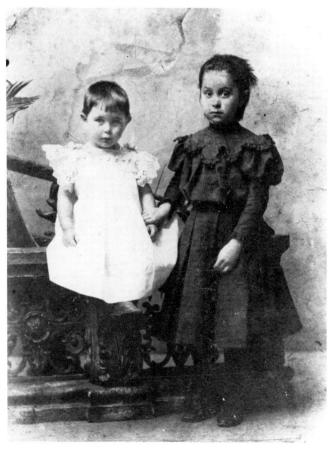

others would open throughout the coming decades. In 1898, thirty-six schools operated in New York, including those in private studios like Henry Mosler's at Carnegie Hall, Cooper Union, the Art Students League, and the New York School of Art.[6] On the Lower East Side a number of now well-known artists studied for a minimal fee at the Educational Alliance. In the immigrant community art instruction was also given at various periods at the University Settlement and the Greenwich Neighborhood House.

The rise and success of Jewish-American artists in the first decades of the century coincided with the expansion of art activity in the United States. While the Academy had always sought to foster a taste and market for American art, new and existing galleries began exclusively to show contemporary works by living American artists or include them in exhibitions. Between 1907 and 1918 the noted photographer and art impresario Alfred Stieglitz's Little Galleries of the Photo-Secession, better known as 291, the Daniel Gallery, the Montross Gallery, the Macbeth Galleries, the Bourgeois Galleries, the Anderson Galleries and Knoedler and Co. were among the most important commercial spaces offering advanced European art or works by young American artists.[7] American artists traveling abroad also transmitted European styles to New York—among the Jews Weber, Walkowitz, Samuel Halpert and Zorach were some of the earliest.

Alongside this activity in twentieth-century American art were organizations or institutions in which Jewish artists participated with the goal of creating an interest in art within their own community. Often their non-Jewish colleagues joined in the art events of the Jewish community, and were indeed important advocates for young Jewish artists. Especially among radicalized artists, problems of the immigrant community coincided with social concerns and ideas about the role art and the artist should play in transforming society. This attitude is exemplified by Robert Henri, a non-Jew and anarchist and leader of the Ashcan School, who taught many of the twentieth-century immigrant Jewish artists.

Randolph Bourne, the American cultural critic for journals ranging from the left-wing periodical *The Masses* to the journal of the Jewish student society at Harvard *The Menorah Journal*, opposed the melting pot theory and U.S. efforts to Americanize its new arrivals. Writing while World War I raged in Europe, Bourne, a non-Jew, expressed his belief that homogeneity and assimilation would lead to the same nationalist fire that had engulfed much of the world and would cause the U.S. to enter the conflict. Bourne was part of the circle of critics around the *Seven Arts*, whose editors were James Oppenheim, Paul Rosenfeld, Waldo

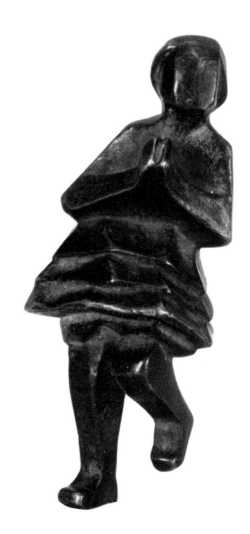

FIG. 47
Saul Baizerman, *Dancing Girl ("The City and the People")*, 1921 (probably cast 1950), bronze, 3 3/4 x 1 1/2 x 1 1/2" (9.5 x 3.8 x 3.8 cm). Hirshhorn Museum and Sculpture Garden, Smithsonian Institution. Gift of Joan Hay Baizerman, New York, 1979. (cat. no. 3)

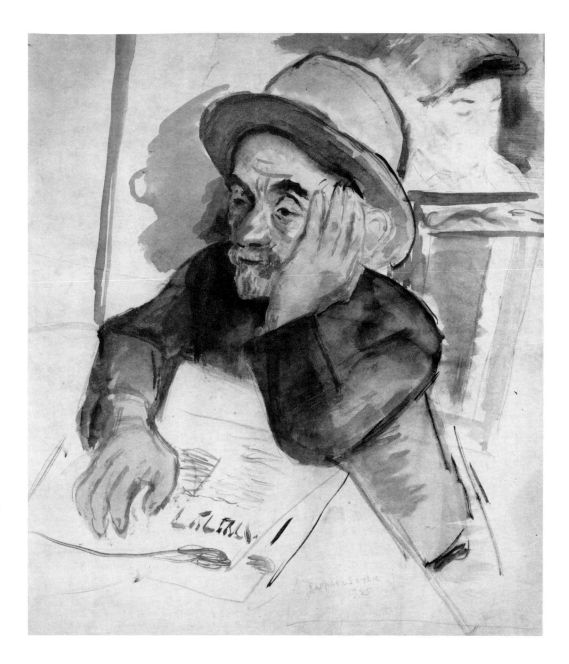

FIG. 48
Raphael Soyer, *In a Jewish Cafe*, 1925, watercolor and pencil on paper, 21 3/4 x 19 3/8" (55.2 x 49.2 cm). Hirshhorn Museum and Sculpture Garden, Smithsonian Institution. Gift of Joseph H. Hirshhorn, 1966. (cat. no. 111)

Frank—three Americans born to German-Jewish families—and Van Wyck Brooks. *Seven Arts* optimistically reflected pre-war internationalism and harmony among the diverse ethnic groups in America. From an outsider perspective, the editors viewed the Jewish Lower East Side as a model "community where race, nationality and culture were integrally related." No doubt Oppenheim's experience as a social worker on the Lower East Side exposed him to radical thinking emanating from the ghetto. To achieve what Bourne called "co-operative Americanism," immigrant Swedes, Germans,

Italians and Jews each must maintain the integrity of their cultural heritages, and in so doing would strengthen America and enrich its cultural tradition.[8]

### THE EDUCATIONAL ALLIANCE ART SCHOOL

Founded in 1889, the Educational Alliance was a settlement house whose mission was to Americanize the masses of Jewish immigrants on the Lower East Side. Gradually, however, it would espouse the idea of cultural pluralism as expressed by Bourne and others. Settlement houses were a specific target for Bourne, who railed against Progressives of

his era, such as social worker Jane Addams, founder of Hull House in Chicago, whom he considered condescending and smug.[9] Pressure from within the community among those who shared the ideas later developed into a coherent philosophy by Bourne was already having an effect on the Americanization policies of the Educational Alliance by the first decade of the twentieth century. Yiddish and other European languages, previously prohibited on the premises, were now permitted. The language itself, with its own inflections and semantics, carried within it the very life of the culture; but it had been,

in the view of the progressive Americanized Jews, considered an alien, *shtetl* culture, and thus, at least in the early days of the Alliance, was anathema to its objectives.[10]

In 1895, only six years after its founding, the Educational Alliance began an informal program of art classes. This served a twofold purpose: to prepare students for the art academies "uptown" and to improve these same students' "standards of taste."[11] Mirroring efforts of New York's progressive community, the Alliance's ambition was indeed to morally uplift its charges, and one way of doing so was to raise their aesthetic standards. For example, settlement house workers led a petition to the Metropolitan Museum of Art to keep its galleries open on Sundays, the only day on which laborers could attend. In 1891, the museum finally did so, consequently recording its highest attendance for the week.[12]

The Educational Alliance took this initiative one step further by bringing art directly to the ghetto. From 1892 to 1897 it held annual art exhibitions, the first three in cooperation with the University Settlement, another Lower East Side settlement house. These were loan exhibitions from private collections. The 1895 exhibition, for example, was organized by such distinguished members of the National Academy of Design as Hugh Bolton Jones, Henry Siddons Mowbray, James Craig Nicoll and Walter Shirlaw, all artists of the American genteel tradition. Although no catalogue of the show survives, judging from the membership of the art committee, the works would have included traditional subject matter in the styles of the then fashionable French Academy and the popular Barbizon or Munich schools. The success of the exhibition can be measured in its attendance figures, almost 106,000 visitors in just under five weeks.[13] The power of art to morally uplift the masses was clearly the main reason the Alliance continued such efforts despite the cost. In 1896 a second free art exhibition was held, this time for seventeen days and with a total attendance of 90,000. As the president of

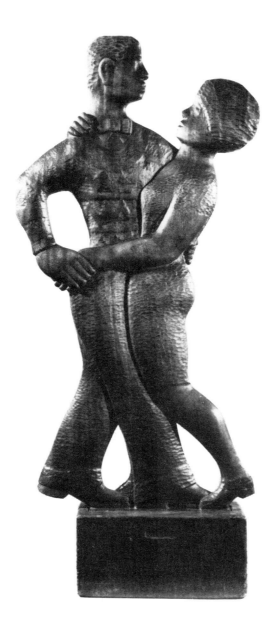

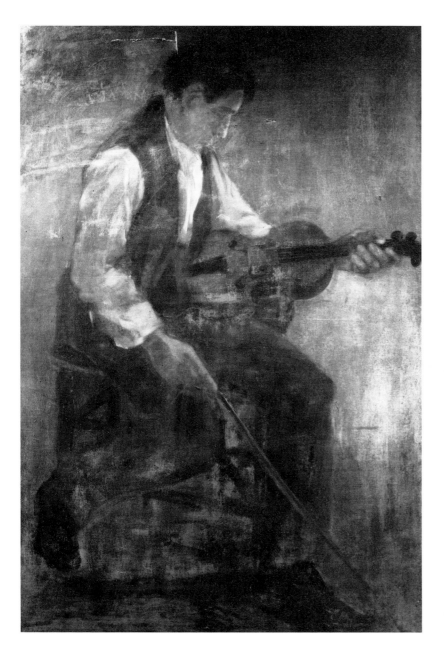

FIG. 50
Abraham Walkowitz,
*The Violinist*, 1895, oil on
canvas, 48 x 34" (122 x
86.4 cm). The Jewish
Museum, New York.
(cat. no. 122)

the Alliance summarized in the Annual Report for that year:

We believe that these exhibitions are great incentives to the education and development of taste, that they lead to reading, to study and to the appreciation of the beautiful, thus throwing a ray of much needed sunshine on darkened lives.[14]

The immigrant community itself could understand that there was a moral goal in mounting an exhibition of fine art. As one "aged Jew" commented after seeing the 1896 show and having it explained to him: "Oh! That is grand! It will keep many away from vice," a grandiloquent translation from what the Alliance's report referred to as "jargon," the pejorative term for Yiddish.[15]

Although apparently not involved in the Alliance's initial free art exhibitions, Henry McBride, who would become an influential art critic and a champion of modernism, became the mainstay of its art program. McBride joined the Art School in 1898. Under his direction the School continued to offer students instruction in the traditional academic method of drawing from plaster casts; however, he added life drawing, which became the dominant practice at the Alliance in the following years. Among McBride's early pupils were Jo Davidson, Halpert and Walkowitz. Walkowitz also taught at the Alliance around 1900 (fig. 50). Jacob Epstein may have taught drawing as well as studied at the Alliance around 1895, and he organized an early student art show there.[16]

The Art School quickly grew under McBride's direction, by 1902 adding courses in industrial design and painting. A second drawing teacher joined in 1900; three more, including Bernar Gussow, in 1901. There were six teachers in all by the next year. Jerome Myers, another non-Jewish faculty member, conducted the painting class in 1904.

In 1901 McBride organized one of the earliest exhibitions of works by the Art School's own students. Their subjects were their East Side neighborhood and its residents. The success of these novice artists in

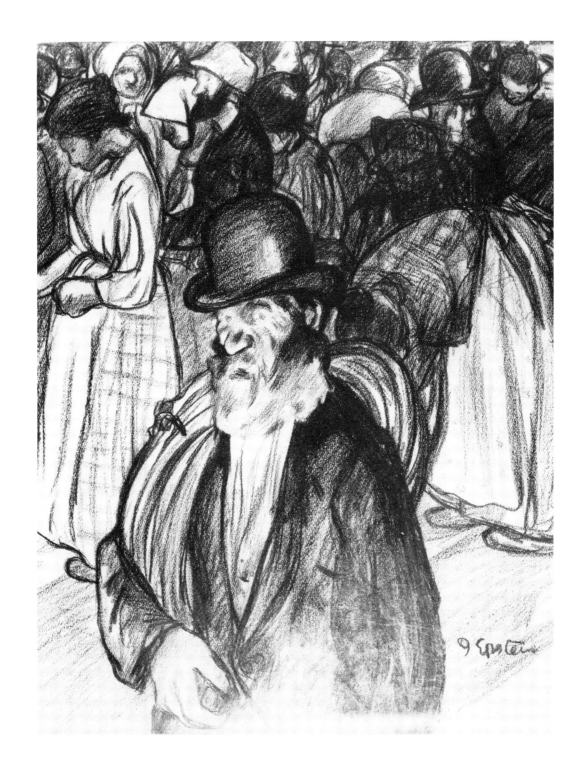

FIG. 51
Jacob Epstein, *A Hester
Street Crowd*, ca. 1900–
1902, black crayon, 23 3/4
x 10 1/8" (60.3 x 25.8 cm).
The Jewish Museum, New
York. Gift of Karl Nathan.
(cat. no. 29)

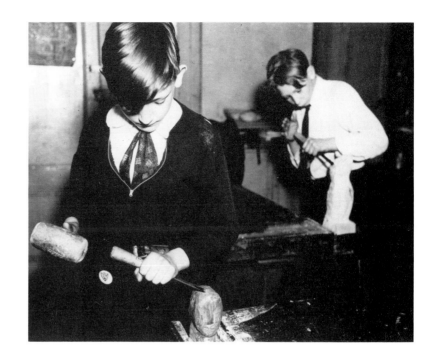

*Right:*
FIG. 60
Chaim Gross's sculpture class, 1937. Courtesy of the Educational Alliance.

*Below:*
FIG. 61
Abbo Ostrowsky instructing students in a life class at the Educational Alliance, ca. 1920. Courtesy of the Educational Alliance.

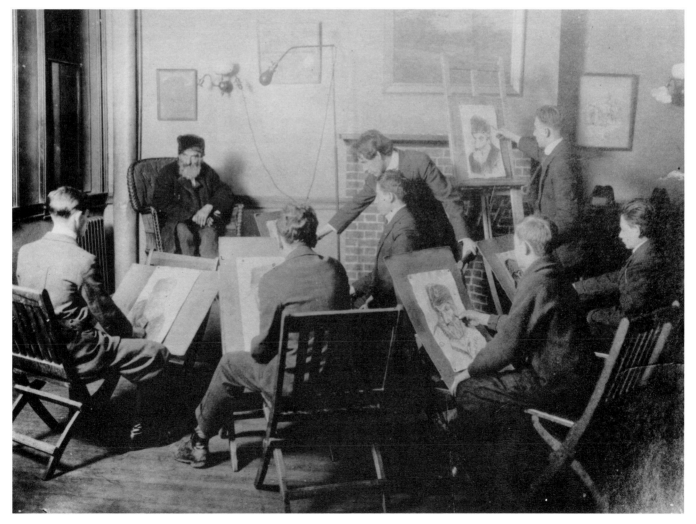

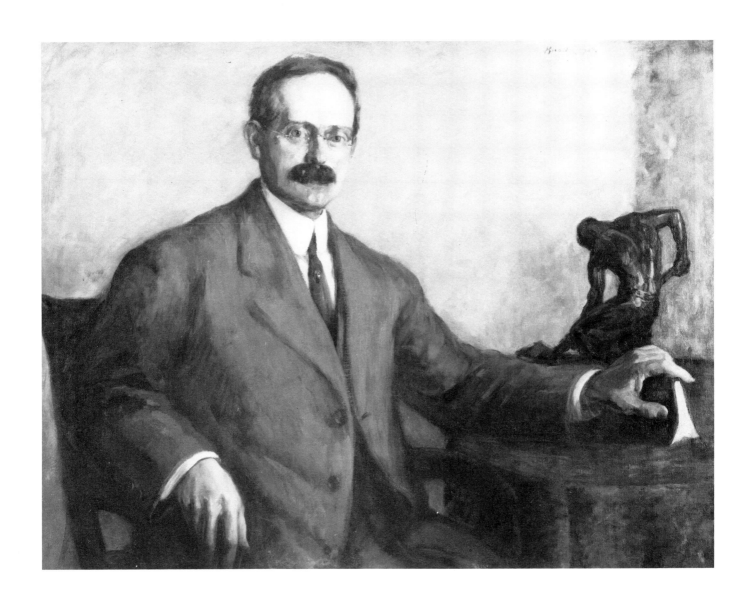

## THE PEOPLE'S ART GUILD

The very existence of John Weichsel's People's Art Guild may not have been possible without the settlement house movement. The art exhibitions, art classes and lectures the Guild sponsored were held at these community centers as well as at other institutions in poor and working class New York neighborhoods. The first exhibition was held in 1915 at the University Settlement. Over sixty others were staged during the three years of the Guild's activity between 1915 and 1918. In 1918 it had 322 active members. It exhibited primarily the work of living American artists, but occasionally Old Master prints and modern French art were shown as well. Its purpose

was to create a viable market for the work of its artists among the working classes and to make art part of their lives. Eventually, however, Weichsel would conclude that the settlement houses were not a successful forum for disseminating art to the masses or supporting the community's artists.[32]

Ironically, it does not appear that the Educational Alliance was ever host to one of the Guild's exhibitions. In fact, the Alliance declined to lend its facilities for the Guild's major exhibition of May 1917, which had to be held instead at the offices of the Yiddish daily newspaper, the *Forverts* (Forward), its neighbor on East Broadway, and a center of radical activity.[33] Apparently, the Alliance's resources to take on such an endeavor had already been overtaxed by the 17,000 immi-

Opposite:
FIG. 62
Leon Kroll, *Portrait of John Weichsel*, 1912, oil on canvas, 30 x 40" (76.2 x 101.6 cm). Collection of John Weichsel and Judith Weichsel Carr. (cat. no. 60)

Below:
FIG. 63
Announcement of a meeting at the home of John Weichsel which led to the formation of the People's Art Guild, 1915. John Weichsel Papers, Archives of American Art, Smithsonian Institution, Washington, D.C.

grants a day who came through its doors, even though the fall of that same year it did reinstate its art program .[34]

As educator and founder of the Guild, Weichsel was, like Lozowick and Ostrowsky, an Eastern European immigrant deeply involved in the cultural life of the Lower East Side. He was born in 1870 in Wloclavak, Poland, into a comfortable middle-class home. His younger brother sponsored his voyage here sometime in the 1890s, after he had completed a degree in engineering at the University of Zurich. Later he earned a doctorate in psychology from New York University and around 1900 became head of the Department of Mechanics and Drafting at the Hebrew Technical Institute in New York.[35]

As noted, Weichsel helped organize the *Forum* exhibition, and, through his writings, especially in Stieglitz's *Camera Work*, was an active figure in the mainstream New York art world during the second decade of the century. Like Lozowick, Weichsel held strong convictions about the social and political role of art in the Jewish community. His observation, made in an article in a Yiddish journal about his friend Walkowitz, also held true for himself, that "he combined his *Yiddishkeit* with the general culture." In fact, one might say the same for the organization Weichsel created, the People's Art Guild.[36]

The first meeting of a group of artists at John Weichsel's home that would lead to the formation of the Guild was announced in a printed invitation in January 1915 (fig. 63). The meeting was called by "a number of Jewish painters and sculptors" concerned with "the now prevailing art conditions in our ghetto."[37] Subsequently the prospectus and constitution of the Guild were printed, both in Yiddish and English. Precisely who those painters and sculptors referred to in the invitation were, and who actually attended, is not known. Perhaps among the founding members were Halpert and William Meyerowitz—both actively involved in its activities. Although Weichsel did not elaborate on the "prevailing conditions in our ghetto," it is evident from his later writings that he was referring to the lack of opportunity and support for artists from the Lower East Side, and the Jewish community generally. Weichsel was also particularly

IN VIEW OF THE NOW PREVAILING ART CONDITIONS IN OUR GHETTO A NUMBER OF JEWISH PAINTERS AND SCULPTORS HAVE DECIDED TO MEET AT THE HOME OF JOHN WEICHSEL 918 CAULDWELL AVENUE BRONX ON SATURDAY JANUARY 9 1915 AT 8.30 P.M. FOR THE PURPOSE OF ORGANIZING THEMSELVES INTO AN ASSOCIATION YOUR PRESENCE WILL BE WELCOME IF YOU ARE IN SYMPATHY WITH THE CAUSE

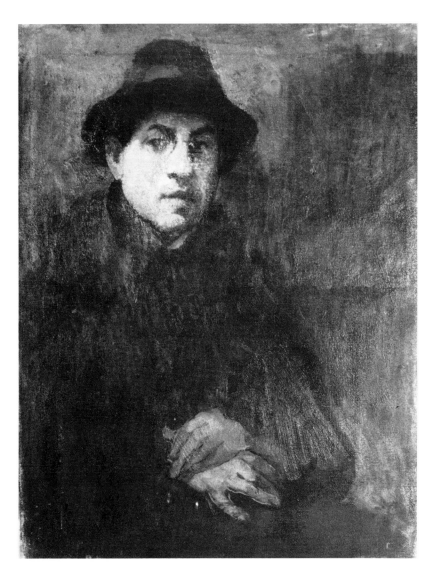

*Above:*
FIG. 64
William Meyerowitz,
*Self-Portrait*, 1917, oil on
canvas, 23 3/8 x 18 1/4"
(59.6 x 46.4 cm). Courtesy
of Smith-Girard, Stamford,
Connecticut. (cat. no. 72)

*Opposite:*
FIG. 65
Max Weber, *New York at
Night*, 1915, oil on canvas,
33 7/8 x 20 1/16" (86 x
50.1 cm). Archer M.
Huntington Art Gallery,
The University of Texas at
Austin. Lent by Mari and
James Michener. (cat. no.
132)

concerned that the economic conditions
there, as well as the pressures toward as-
similation, would abrogate the spirit of the
community.

Weichsel, who held to both anarchist
and socialist positions, resisted integration
of artists into New York's uptown art life.
He also opposed the strategy of the
progressives and others to use art to "en-
lighten" or "uplift" the masses. His efforts
on behalf of artist workers challenged the
commercialism of the gallery system, an ex-
ample of the materialism of capitalist soci-
ety.[38]

Weichsel's connection from 1912 or
earlier with the anarchist Ferrer Center (also
known as the Modern School) would prove
the formative ideological stage towards the
establishment of his own People's Art Guild.
There Weichsel lectured on art, education
and culture. Not a sectarian organization by
any means, the membership of the Ferrer
Association was predominantly Eastern Eu-
ropean working-class, immigrant Jews, but
most of its teachers, like its director Will
Durant, were not. Margaret Sanger, Upton
Sinclair and Lincoln Steffens lectured there
as well. It was frequented by a number of
Jewish artists, writers and intellectuals, in-
cluding the anarchists Alexander Berkman
and Emma Goldman, who was influential in
securing financial backing for the establish-
ment of the school.[39]

The Center was established in 1911 as a
school for adults and children based on edu-
cational principles stressing freedom and
individuality. At its art school, Henri and
George Bellows employed teaching meth-
ods, including rapid sketching and short
poses, that opposed the training offered by
traditional art schools and the Academy.
Henri had been drawn to anarchism by
Goldman and began teaching at the Center
in 1911.[40] Classes were informal and often
accompanied by the piano music of Leo
Ornstein, an avant-garde composer whom
Zorach depicted in a portrait of 1918. The
artists who attended the informal evening
life classes and general discussions led by

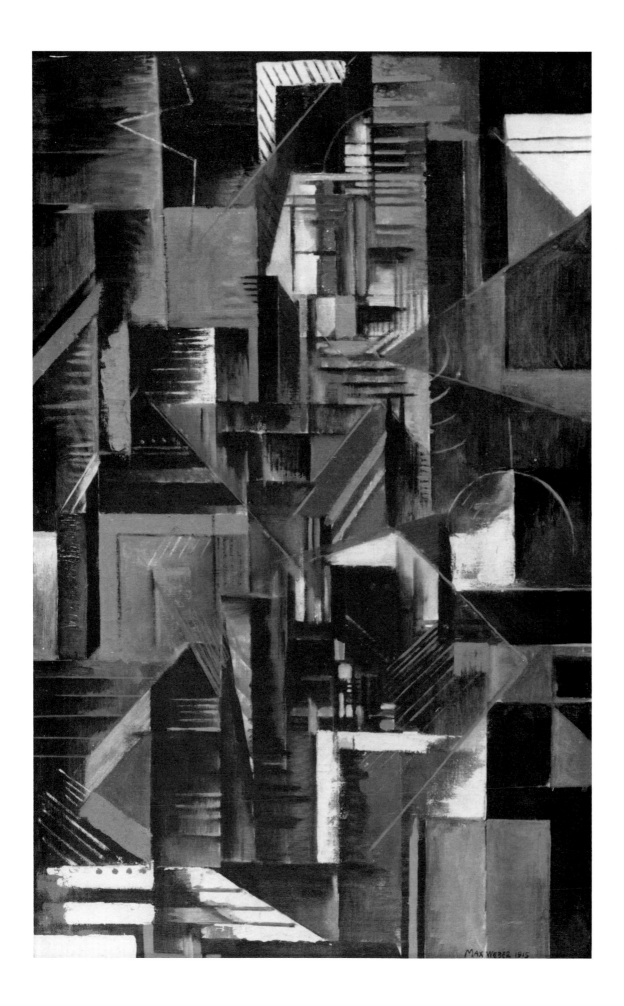

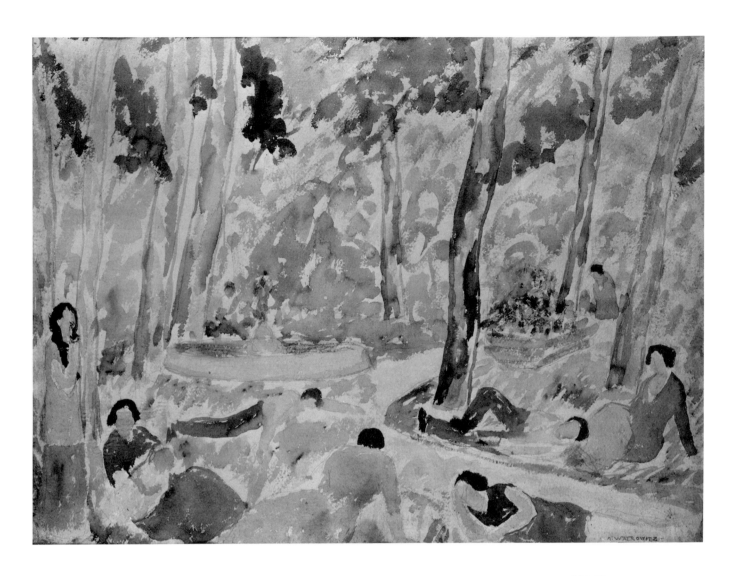

FIG. 66
Abraham Walkowitz,
*Summer*, 1912, watercolor
on paper, 21 1/2 x 29 1/2"
(54.6 x 74.9 cm). The
Metropolitan Museum of
Art, Alfred Stieglitz
Collection, 1949. All rights
reserved, The Metropolitan
Museum of Art. This work
was included in the
People's Art Guild Exhib-
ition at the Forward
Building in 1917.
(cat. no. 129)

Bellows and Henri (both associated with the People's Art Guild) included the Jewish artists Ben Benn, Gropper, Halpert, Man Ray, Moses Soyer, Walkowitz, Sol Wilson, Weber, Adolf Wolff and Zorach as well as their non-Jewish colleagues Stuart Davis, Rockwell Kent, Robert Minor, John Sloan and Niles Spencer. These artists formed a close knit group and lasting friendships. For younger Jewish artists, like Gropper and Man Ray (Emmanuel Radnitsky), the classes at the Modern School were the first serious art instruction they received. Other students simultaneously studied at the Art Students League or the National Academy of Design.[41]

Wolff, a Belgian Jew, would have first become aware of the social relevance of art through the sculptor Constantin Meunier, his teacher at the academy in Brussels. It may have been Wolff who communicated the ideas of radical Belgian artists to Weichsel. In 1913, Weichsel wrote that the Socialist Party in that country was the first to understand "the importance of a free art in the struggle of workers for a better future."[42]

The Ferrer Center also provided a nexus between radical politics and the artistic avant garde. Halpert, Walkowitz, Weber and Zorach, who all supported leftist causes, were among the artists working in a modern idiom, influenced by Cézanne, Cubism and Fauvism. Even realist artists such as Henri were directly associated with the Stieglitz circle. He frequented Stieglitz's 291 and there met Weber, inviting him to the Ferrer Center.

The artists at the Ferrer Center became active in the Guild once it was established in 1915. Halpert, who first visited the Center after his return from Europe in 1912, was one of them, and even met his future wife, Edith Gregor Fein, at one of Weichsel's Friday night salons where she recalled being introduced to Zorach, Walkowitz, Nadelman, Weber and Wolff. Halpert also met Man Ray at the Ferrer Center and later roomed with him at an artists' colony in Ridgefield, New Jersey, in 1913 (fig. 67). Man Ray, on the other hand, who later

FIG. 67
Samuel Halpert, *Interior with Man Ray*, 1914–1915, oil on canvas, 36 x 28 3/8" (91.4 x 72.1 cm). Rose Art Museum, Brandeis University, Waltham, Massachusetts. Gift of Mrs. Edith Gregor Halpert. (cat. no. 50)

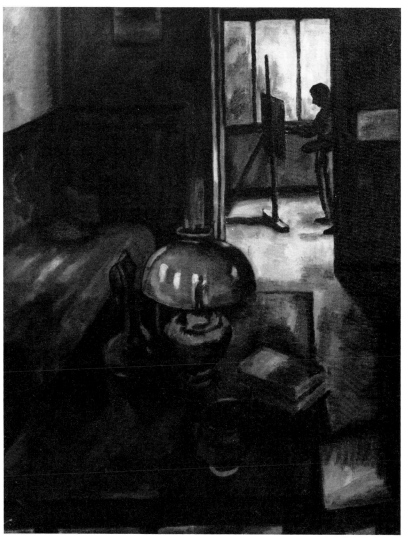

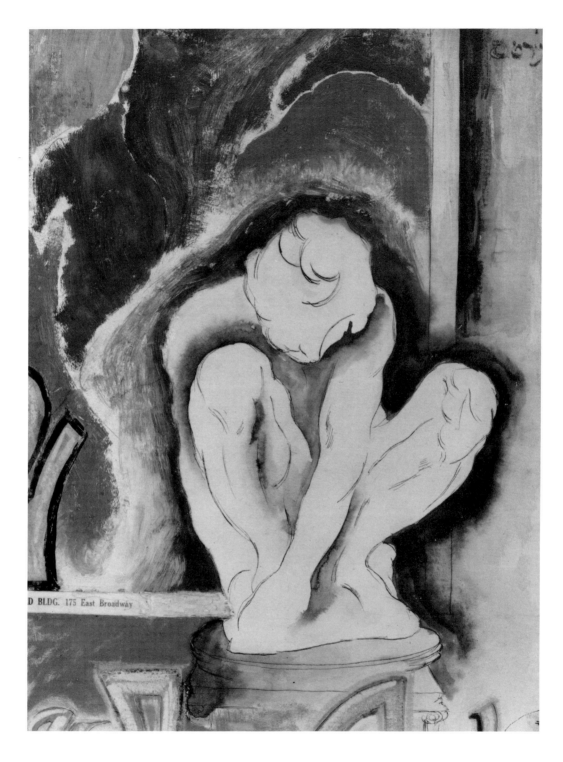

In the image: D BLDG. 175 East Broadway

FIG. 68
Attributed to William
Zorach, *Study for Poster for
the People's Art Guild
Exhibition at the Jewish Daily
Forward Building*, ca. 1917,
mixed media on board, 15 x
11 1/2" (38.4 x 29.2 cm).
Collection of John Weichsel
and Judith Weichsel Carr.
(cat. no. 145)

remembered Weichsel's regular Wednesday night talks given at the Ferrer Center, never became active in the Guild; he declined Weichsel's invitation to exhibit at the University Settlement in 1915.[43]

Zorach did not meet Weichsel at the Ferrer Center, but probably later, in 1915, at one of the meetings of the People's Art Guild. The Guild's meetings—more accurately dinners held at the Weichsel home on Friday evenings—in a sense substituted art and politics for the religious traditions of the Sabbath eve. From then on he exhibited with the Guild, designing its membership card and possibly a poster for the *Forward* exhibition (figs. 16 and 68). Weichsel also promoted Zorach's work outside the Guild by including him in the *Forum* exhibition.[44]

Weichsel's commitment to radical ideology was also evident in his association with John Sloan, whom he met in 1912.[45] The Guild gave Sloan his second one-man exhibition at the Hudson Guild in 1916, which Walkowitz and Thomas Hart Benton assisted in hanging (fig. 69). Sloan, along with Walkowitz, participated in more Guild exhibitions than any other member artists.[46] At the *Forward* exhibition, nine of Sloan's works were included, among them the 1913 drawing entitled *Before Her Makers and Her Judge* (fig. 71), a commentary on the court's unfair treatment of prostitutes that had previously been reproduced in the radical magazine *Masses*.[47] Many of Sloan's fellow staffers on the *Masses*, among them the young Stuart Davis, were also members of the People's Art Guild. Other contributors, including Henri, Bellows, Robert Minor and Walkowitz, were associated both with the Ferrer Center and the People's Art Guild.[48]

The main work of the People's Art Guild was arranging art exhibitions, but it also sponsored lectures. Sculptor Mahonri Sharp Young, son of the Mormon leader Brigham Young, and the three Jews Weber, Kroll and Weichsel, spoke at Guild-sponsored events at the Independent School of Art and the Modern Art School on Washington Square.[49] Interestingly, Weichsel owned a sculpture of

a laborer by Young (a work influenced in both style and social conviction by Meunier) which is on the desk behind him in Kroll's 1912 portrait (fig. 62).

One show sponsored by the Guild was exclusively of "advanced painting and drawing," and was held in late 1917 at the Church of the Ascension Parish House on West Eleventh Street in Greenwich Village. Among its supporters were McBride, now a full-time art critic for the *Sun*, and Walter Pach, one of the organizers of the Armory Show. Among the thirty-three artists who showed sixty-eight works were Marius de Zayas, Picabia, Derain, Picasso, Metzinger, O'Keeffe, Schamberg, Halpert, Benn, Walkowitz, Russell and Wright (fig. 70).[50]

Weichsel's anti-establishment position naturally led him to recognize the settlement house itself as an ideological enemy. The

FIG. 69
Exhibition poster for John Sloan exhibition sponsored by the People's Art Guild, 1916. John Weichsel Papers, Archives of American Art, Smithsonian Institution.

111

present art system, Weichsel believed, was supported by members of the very same patron class who were on the boards of settlement houses. Art, for Weichsel, was a meaningful way to redress crime and other social ills of the ghetto, because art expressed the uniqueness of the human soul. Opposed to Julia Richman's desire to instill bourgeois values in the poor by raising their moral standards, Weichsel sought to extract the exceptional essence imbedded within each immigrant:

The neighborhood house could counteract the debasing influences of present industrialism by nothing better than by endowing the masses with a deeply seated habit of participation in the diverse phases of surrounding life in a beautiful manner. For this the gap should be removed that is now separating art and life. To make art more social and life more artistic—that is the leading idea of the People's Art Guild.[51]

Like Lozowick, Weichsel believed that the aim of a settlement house art school or art center was to bring people into closer touch with their own circumstances. From his *Yiddishkeit* perspective this also meant sustaining the Jewish masses' attachment to their cultural heritage. Weichsel elaborated on this in his prospectus for a National Jewish Museum. This venture, outlined in December 1917, was undertaken with the cooperation of Mrs. Sholem Asch, who along with her husband, the Yiddish writer, was a sponsor of the Guild's May exhibition at the Forward Building.[52]

In the prospectus, Weichsel confidently stated his anti-assimilationist view that Jewish cultural traditions had to be preserved for the benefit of "the lofty ideals" of America itself.[53] This nationalist sentiment was more clearly defined later, when Weichsel wrote that a popular art—emerging from ghetto neighborhoods—could not help but become a "truly national art."[54] In this document he wrote that a Jewish community "bereft of its soul" would be unable to make a real "cultural contribution" to this country.

The museum he planned would collect and display traditional ritual objects from an

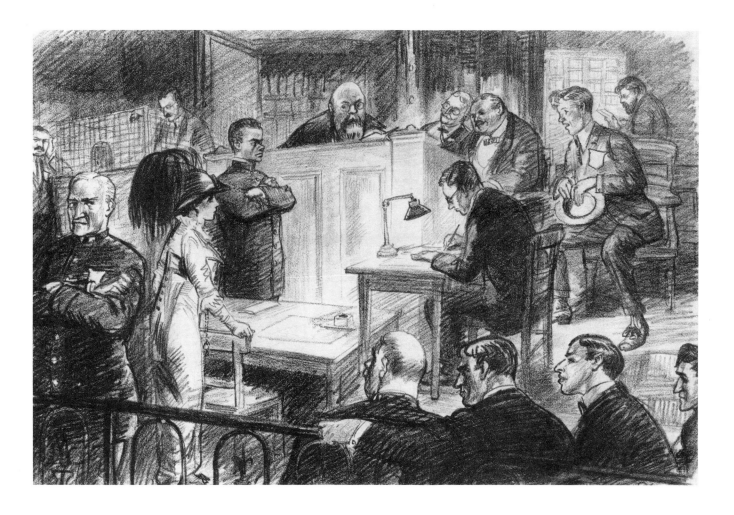

earlier, religious phase of Judaism no longer valid in the secular Yiddishist world of contemporary Jews.[55] The art, on the other hand, would include work by contemporary "Jewish workers" and "by others, when of Jewish interest." A place was also reserved for artifacts of "signal events in modern Jewish life." Weichsel referred to Jewish art without describing the kind of subject matter this implied. The museum would work cooperatively with congregations, clubs and labor unions to make art available to the public both in exhibitions and through sales outlets. It would also undertake the publication of scholarly research in the field of Jewish art; sponsor theatrical performances and readings of Jewish poetry, and establish a library of Jewish culture. However, evidence of the execution of these plans has not come to light.[56]

The scope of Weichsel's efforts and his sheer energy are clearly evident in the largest and most ambitious exhibition sponsored by the Guild, in May 1917 at the Jewish Daily Forward Building on East Broadway. In the preface to the catalogue for that show, Weichsel stated that "the People's Art Guild is planting the seed of art among the foreign-born, mostly, Jewish [Lower East Side] population."[57] Well over half of the eighty-nine artists who exhibited three hundred works were Jews, many from the Lower East Side, but non-Jewish artists, freqently major figures in the art world, were also included. An exhibition that combined some of the most advanced art of the period with the work of unknown artists from the Jewish community, it demonstrated Weichsel's ability to combine "*Yiddishkeit* with the general culture."

The show included works by Jewish artists Weber, Jennings Tofel, Davidson, Ben-

FIG. 71
John Sloan, *Before Her Makers and Her Judge, Illustration for "The Masses," August 1913,* crayon on paper, 16 1/2 x 25" (41.9 x 63.5 cm). Collection of Whitney Museum of American Art. Purchase.

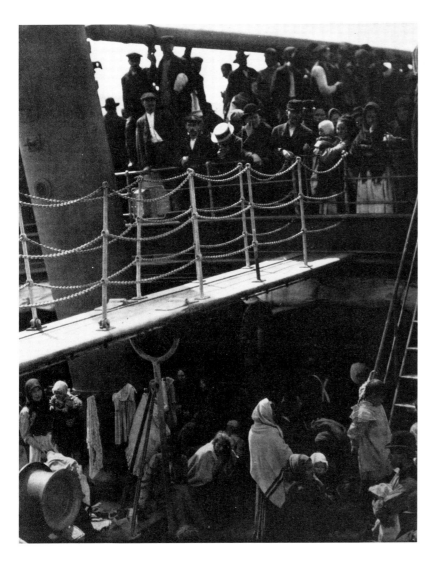

FIG. 72
Alfred Stieglitz, *The Steerage*, 1907, from *Camera Work*, #36, plate 9, photogravure, 7 3/4 x 6 1/4" (19.7 x 15.9 cm). Collection, The Museum of Modern Art, New York.

upper deck of a ship, symbolized for the assimilated German Jew his self-proclaimed escape from the "nouveaux riches . . . mob" and his connection with his fellow, poorer East European co-religionists (fig. 72).[59]

A number of former Educational Alliance students, as well as two of its instructors William Auerbach-Levy and Ostrowsky, also took part in the *Forward* exhibition. Ostrowsky recalled the success of the show in his later years, noting that "[t]o many, it was the first time to come to see an exhibition of paintings. [The] People's Art Guild exhibition in the Forward had long lines of workers patiently waiting, after long hours in the sweatshops, to see the paintings by American and immigrant artists."[60]

The Yiddish writer David Ignatoff remembered: "The crowds who came to the opening were so great that it became necessary to call the police to hold back the people who sought to push their way into the hall."[61]

Weichsel saw an "art proletariat" developing on the Lower East Side.[62] The presentation of the latest in avant-garde tendencies alongside conventional realist art produced by and about the local East Side community was part of his plan. Weichsel understood that modern art was far from elitist in intent; it was anti-bourgeois, anti-establishment. The inclusion of Stieglitz and the artists he represented at 291 was the link for Weichsel between modern art and radical politics.[63] Stieglitz too sympathized with the anarchists' view. His close friends like the writer Sadakichi Hartmann and other contributors to *Camera Work*, as well as the artists of his circle, were associated both with the Guild and the Ferrer Center.

The *Forward* was a sale exhibition. Prices for the art ranged from $15 for individual works by obscure artists from the ghetto, Abraham Datz and Alfred Feinberg, to $2,500 for the most expensive work in the show, George Bellows's *River Front* (possibly *Riverfront, No. 1*, 1915, Columbus Museum of Art, Columbus, Ohio). These prices, even on the low end, were high for the average worker, given the Guild's aim to make art

jamin Kopman and Halpert among others. The non-Jews included Sloan, Bellows and Henri, all three of whom were sponsors of the exhibition. Most of the avant-garde artists who participated in the *Forum* show, Wright, Maurer, Hartley, Benton, Marin, Benn, Walkowitz and Of, also showed.[58] Sponsors of the exhibition included major Jewish philanthropists: Stephen Wise, Judah Magnes, Jacob Schiff, Samuel Lewisohn and Philip Lewisohn.

Stieglitz, who lent works by the artists in his circle, was himself represented by two photographs, including his famous *The Steerage* of 1907. This image, taken from the

available to working people in their homes. In this regard, Weichsel recognized, prints were an important key to the popularization of art.[64] Theoretically, the sale of prints would create the transformation he dreamed of, making the market less reliant upon commercial galleries and uptown art patrons. It would bring affordable art to the people.[65]

One such example was issued in 1917. The etching, by an obscure artist, Abraham Phillips, depicts a potato wagon on a crowded Lower East Side street (fig. 73). This work, reflecting the life of the people and connected with the community, was an example of Weichsel's idea of a proletarian art.

FIG. 73
Abraham Phillips, *Potato Wagon*, etching, 1917, 6 3/4 x 8 3/4" (17.1 x 22.2 cm). The Jewish Museum, New York. Gift of John Weichsel and Judith Weichsel Carr. (cat. no. 88)

Issued By The Peoples Art Guild

## JEWISH ART CENTER

The Jewish Art Center was founded in Greenwich Village in 1925. Its leading voices were the painters Kopman and Tofel. The latter wrote extensively on art for both Yiddish literary and cultural periodicals as well as for the avant-garde publications of the Société Anonyme. Tofel was born in 1891 in Tomashev, Poland, the son of a tailor. In 1905 he came to America and early on met David Ignatoff, through whom he was introduced to the circles of *Di Yunge* (The Young Generation), a group of Yiddish writers, and their successors the Introspectives (the *In Zikhist* group). Tofel became particularly close with Mani Leib, one of this group.[66]

The Jewish Art Center was "dedicated to the Jew—the worker." Tofel was concerned with wide-ranging social issues and was committed to the Jewish community. His aesthetic views were complex. Like the *Di Yunge* writers, who rebelled against the "sweatshop" poetry of the older generation, Tofel was adamantly opposed to painting "only the rough, the cynic[al], the ugly." He felt that such pictures would only embitter

the working classes. Tofel allied himself with modern artists, affirming the importance of a subjective vision, which he called "expressionism."[67]

Although Tofel is generally considered to have been part of the *Di Yunge* group, he shared ideas with the Introspective poets with whom he was also acquainted—Jacob Glatstein, A. Leyeles and N. Minkoff, who issued their manifesto in 1919. In contrast to the impressionist poetry of *Di Yunge*, the Introspectives advocated free verse and anti-sentimentality.[68] Perhaps only coincidentally, predating the poets' manifesto, in 1917 Kopman, Tofel and Claude Buck (Kopman's brother-in-law) had formed the nucleus of a group of artists also called the Introspectives.

These painters first exhibited together at the Whitney Studio in 1917 and, shortly thereafter, with a larger group at the Knoedler Gallery. Their shared program was voiced in Tofel's manifesto, which affirmed "the principle of beauty, order and the faculties of imagination and fancy." Their art was Symbolist in orientation and looked to Giorgione, El Greco, Rembrandt, Millet, Monticelli and the Americans Fuller, Albert Pinkham Ryder and Ralph Albert Blakelock.[69]

The Jewish artists had greater success than their Yiddish poet colleagues because their pictorial language was accessible to a significantly wider audience. Nevertheless, the poets shared the artists' intention to look inside themselves and to use their cultural heritage as the framework for making a contribution to American letters. Theirs was "American poetry written in Yiddish."[70] Yiddishist introspection became more urgent in the 1920s, no doubt a reflection of and a reaction to the increased isolationism of the period.

Tofel credited Ignatoff and his journal *Shriftn* with laying the groundwork for the Jewish Art Center by publishing artists' work and writings. Ignatoff, Tofel noted, "was possibly the only Jewish writer who encouraged the modern free expression in the arts."[71] For instance *Shriftn* reproduced

FIG. 74
Left to right: Jennings (Yehuda) Tofel, David Ignatoff and Joseph Rolnick, ca. 1922. Courtesy of Arthur Granick.

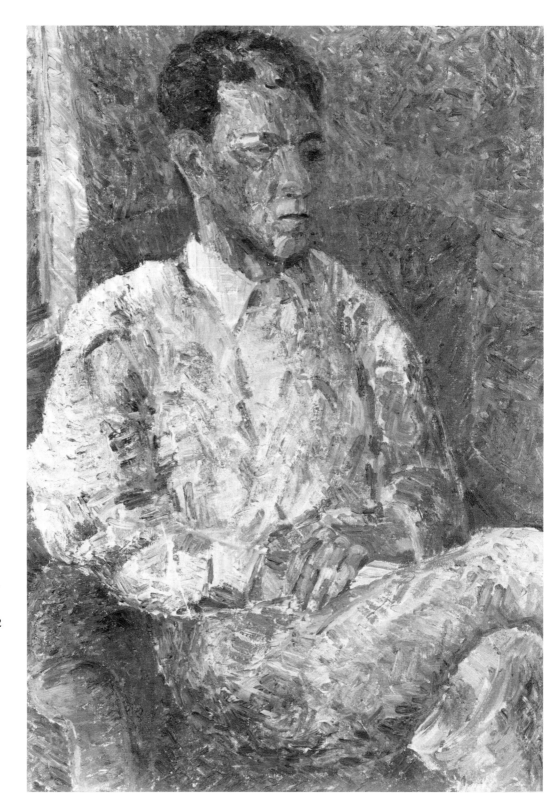

FIG. 75
Jennings Tofel, *Portrait of
Mani Leib*, 1942, oil on
canvas, 24 x 17" (61 x 43.2
cm). YIVO Institute
for Jewish Research.
(cat. no. 120)

FIG. 76
Max Weber, *Untitled*, ca.
1918, woodcut, 4 x 2 1/2"
(10.2 x 6.4 cm). The
Jewish Museum, New
York. Gift of
Mr. and Mrs. William B.
Jaffe. (cat. no. 133)

in the revolutionary movement in Europe between 1903 and 1906. Proletarian themes and the labor movement again became particularly relevant to his work during the Depression. Leivick, Halpern, Mani Leib and Ignatoff had all come from poor or working-class backgrounds and they had also been involved in revolutionary movements.

The artists shared the social and political commitments of the poets. Both groups had suffered persecution in Europe and poverty in America. Glatstein had published in the anarchist *Di Fraye Arbeter Shtime* (The Free Voice of Labor). Both Leyeles, whose first poems were included in *Di Fraye Arbeter Shtime*, and the sculptor Aaron J. Goodelman, who showed with the Jewish Art Center, were active in the Workmen's Circle, a socialist-oriented fraternal organization which was influenced by Bund ideas. Goodelman lived in the Workmen's Circle's Sholem Aleichem apartment house complex in the Bronx, where he had a studio adjacent to that of Abraham Manievich, who also showed with the Center.[72]

Halpern's poems of the 1920s address themes of social injustice, the Sacco and Vanzetti case and lynchings, as did the works of Shahn, Minna R. Harkavy, Tofel, Goodelman, Ribak and numerous other Jewish artists involved with Social Realism. Artists with strong social commitments, such as Raphael Soyer and Lozowick, expressed them through illustrations for the *New Masses* beginning in 1927 and in activities of the John Reed Club and its art school beginning in 1929 (figs. 32 and 77).

At least thirty-five artists participated in the Jewish Art Center's exhibitions held between 1925 and 1927. A number of artists involved with the Center had also exhibited with the People's Art Guild, including Benn, Abraham Harriton, Kopman, Joseph Suib, Tofel, William and Marguerite Zorach, Saul Berman, Joseph Biel, Lena Gurr, Halpert, Ostrowsky, the Italian-American Concetta Scaravaglione and Walkowitz. The latter seven were also involved with the Educational Alliance. Tofel and a group of the

Weber's "Cubist" poems and his series of woodcuts inspired by both Post-Impressionism and cubo-futurism, as well as his own encounters with primitive art. These were also printed in the *Modern School* magazine of the Ferrer Center and were later used in Jewish New Year's greetings sent to his friends (fig. 26). Ignatoff also published H. Leivick's *Der Goylem* (The Golem) in 1921, accompanied by Tofel's and Weber's illustrations (fig. 76).

*Di Yunge*, initially an "art for art's sake" movement, opposed the anarchist and socialist proletarian verse of the early so-called "Sweatshop" poets in New York. Ignatoff came from radical stock: he had been active

FIG. 77
Louis Lozowick, cover of
Prospectus for *New Masses*,
December, 1925. The
design is the same as the
artist's painting of ca.
1925–1926 in the
collection of the Walker
Art Center, Minneapolis.
Photograph courtesy of
Virginia Hagelstein
Marguardt.

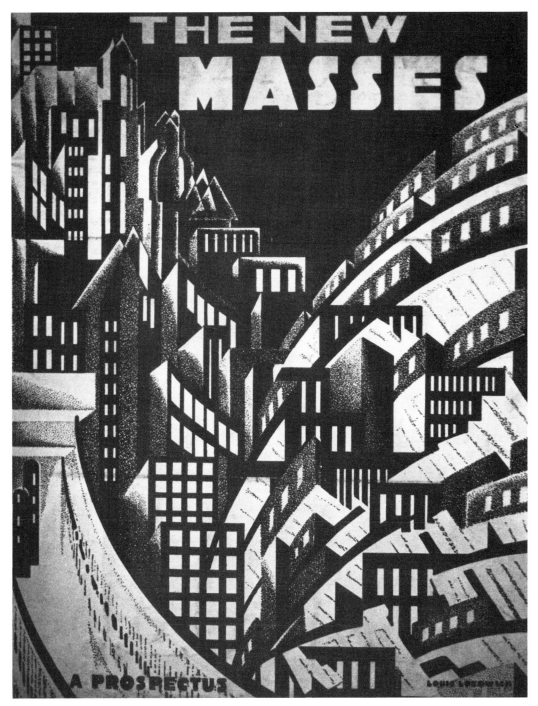

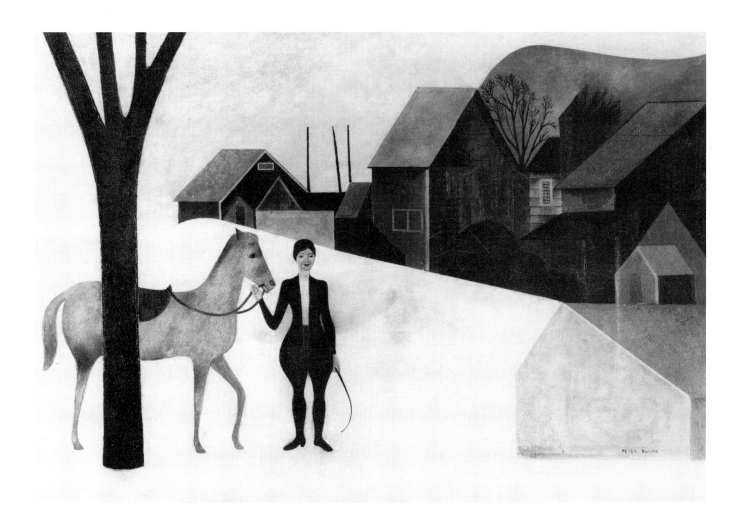

FIG. 78
Peter Blume, *Home for Christmas*, 1926, oil on canvas, 23 1/2 x 35 1/2"
(59.7 x 90.2 cm). Columbus Museum of Art. Gift of Ferdinand Howald.
(cat. no. 16)

Yiddish poets were also in residence at the Alliance's summer art school in Bayside, Queens, in 1923.[73]

Many of the other artists exhibiting with the Jewish Art Center would have been too young to participate in the People's Art Guild's activities. Others had not yet emigrated to America during the time the Guild was in operation. For some of the younger artists, such as Gross, Ribak, Maurice Sievan and Raphael Soyer, the Center was one of their first exhibition venues in New York. For other recent European arrivals like the Ukrainian-born Manievich, a seasoned professional, who had shown with Jewish groups in Russia, the Center offered the opportunity to show his work once again with fellow Jewish artists. Lozowick too had been associated with Jewish artists, particularly the Constructivist El Lissitzky, during his four

years in Paris and Berlin. He was also connected with the Yiddish literary review *Albatross*, an Expressionist journal published in Berlin (fig. 79). Returning to New York in 1924, he continued his Jewish associations by exhibiting at the Art Center.

The Center's activity in the 1920s underscores the prevailing issues of the decade: nationalism and assimilation. Writing in this period Tofel admitted that clinging to his cultural identity was his choice; assimilation was such an easy course for Jews. Tofel, who had anglicized his name (he was born Yehuda Toflevicz) could write:

And who discovered the Jew in me? Who finds it essential that I should remain and be named a Jew? no one except I. The older generation of Jewish artists in America got rid of its Jewishness as if it were an imposing hindrance. They removed even its mannerism, though not the out-

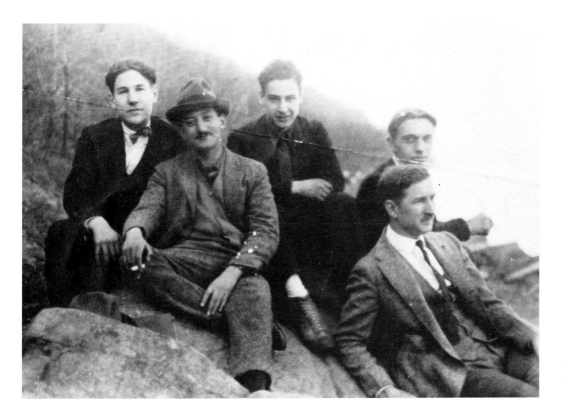

FIG. 83
Barnett Newman, Adolph
Gottlieb, Alex Borodulin,
Otto Soglow, and an
unidentified friend in
Central Park, New York,
ca. 1925. © 1979 Adolph
and Esther Gottlieb
Foundation, Inc.

FIG. 84
Adolph Gottlieb and his
family in New York. ©
1979 Adolph and Esther
Gottlieb Foundation, Inc.

cious apartment on Riverside Drive (figs. 83 and 84). Rothko, born in Dvinsk and raised in Portland, Oregon, shared a tenement flat on the Lower East Side with Harris, after attending Yale University on scholarship from 1921 to 1923.[83] His Jewish background would be expressed in an almost covert way in his paintings of the mid-1930s.

Although most of the artists might have thought of themselves as Solman did (he had learned to read and write Yiddish as a child) as identifying culturally as Jews, Ben-Zion was the only one who maintained traditional religious ties, which he expressed in his artworks. As the son of a cantor, he had a background in Hebrew as well as Yiddish. He had come to New York from the Ukraine

and published a play in Hebrew in 1921. Before he started painting in 1933 he was closely associated with Hebrew writers.

Curiously, Rothko and Gottlieb depicted Christ's crucifixion in paintings exhibited with the Ten. This subject has often been employed, in an ironic iconographic twist, to represent Jewish suffering in the modern era. Jewish artists exploited this subject as a means of identifying with the traditional Christian iconography of Western art. Clearly Rothko and Gottlieb, who were very concerned with the threat of Fascism, used the symbolic Jewish reference to the crucifixion consciously. In Rothko's 1936 version, surviving only in a photograph, the two dark stripes appearing on Christ's loin

FIG. 85
Ben-Zion, *Jacob's Dream*, 1937, oil on canvas, 36 x 43" (91.4 x 109.2 cm). Collection of Joseph and Lillian Miller. (cat. no. 8)

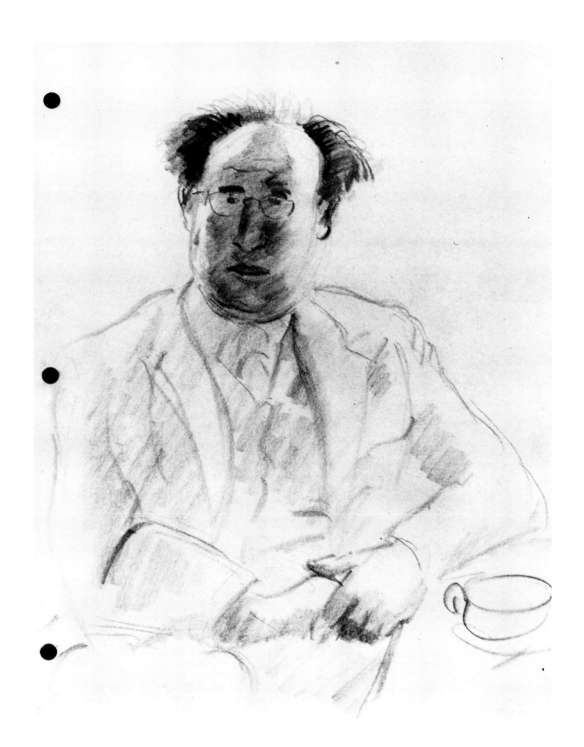

FIG. 86
Adolph Gottlieb, *Portrait of
Marcus Rothkowitz*, ca.
1932, pencil on paper, 11 x
8 1/2" (27.9 x 21.6 cm).
Collection of the Adolph
and Esther Gottlieb
Foundation, Inc. © 1979
Adolph and Esther
Gottlieb Foundation, Inc.
(cat. no. 42)

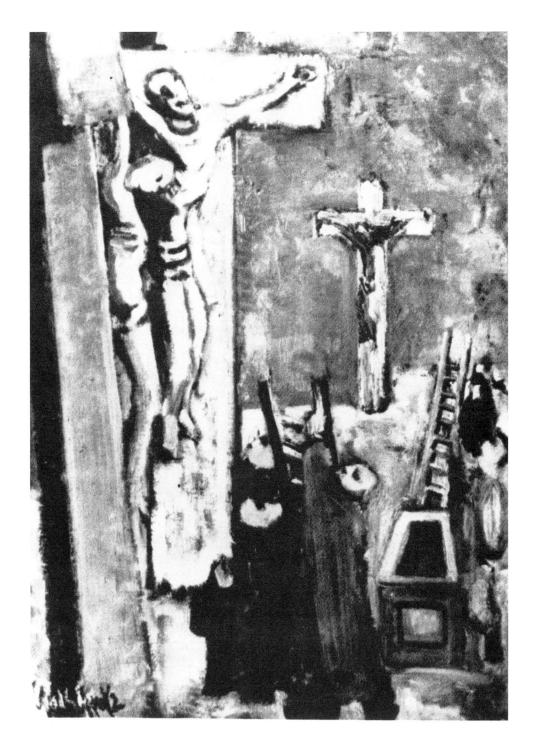

FIG. 87
Mark Rothko, *Crucifixion*,
before 1936, oil on canvas.
Whereabouts unknown.
© 1991 Christopher
Rothko and Kate Rothko
Prizel.

American Art Section (fig. 96). He was also a supporter of a Jewish national homeland in Birobidzhan in the Soviet Union, which initially drew support among many left-wing Jews throughout the Diaspora.[97]

H. Leivick, the Yiddish poet who had earlier been associated with both *Frayhayt* (Freedom) and *Der Hamer* (The Hammer) was also among the founders of YKUF, becoming a vice chairman of its American section. M. Olgin and Mielach Epstein, editors of *Der Hamer*, were also vice chairmen.[98]

Two years before YKUF's first exhibition Jewish-American artists under the auspices of the Organization for Jewish Colonization in Russia (ICOR) mounted an exhibition of their work to be sent to the Soviet Union and presented to create a museum in

FIG. 97
Frank C. Kirk, *All He Left*, ca. 1940–1945, oil on canvas, 30 x 39 3/4" (76.2 x 101 cm). National Academy of Design, New York. (cat. no. 56)

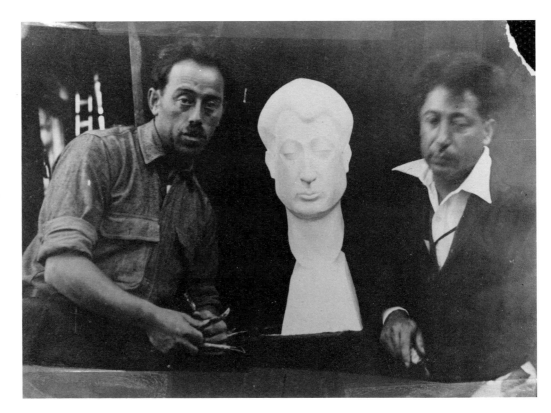

*Right:*
FIG. 98
Aaron Goodelman, left,
with Yiddish writer Moshe
Nadir, and Goodelman's
portrait bust of him, 1930s.
Courtesy of
Dr. C. Weinstock

*Below:*
FIG. 99
William Gropper, *Hostages*,
1942, oil on canvas, 21 x
32 1/8" (53.4 x 81.9 cm).
Collection of The Newark
Museum. Purchase, 1944.
Sophronia Anderson
Bequest Fund. (cat. no. 47)

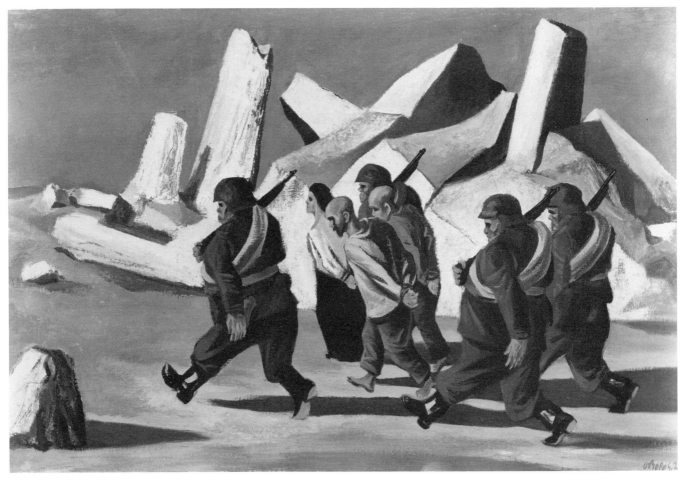

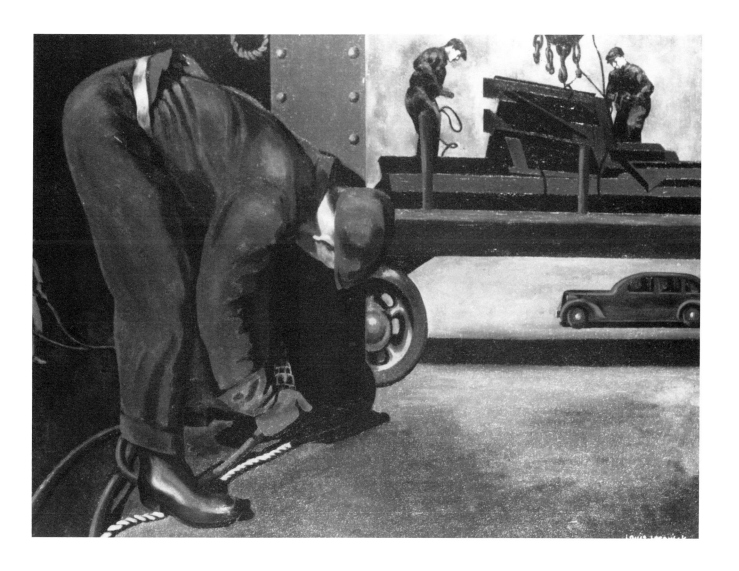

FIG. 100
Louis Lozowick, *Riveter (City Builders)*, 1932, oil on canvas, 18 x 24" (45.7 x 60.1 cm). Courtesy Sid Deutsch Gallery, New York. (cat. no. 68)

Birobidzhan. The cause had a broad appeal and many artists exhibited, including Benn, Kirk, Gropper, Goodelman, Wolff, Harkavy, Francis Criss, Manievich and Moses Soyer. Information on this exhibition is scant; however, Goodelman exhibited a head of Moshe Nadir, the Yiddish writer and humorist, in a stark planar style reminiscent of earlier Cubist portrait sculpture (fig. 98). Nadir had been associated with *Di Yunge* and in his earliest lyrics described the tribulations of New York's immigrants. An immigrant from Galicia, Nadir had returned for a visit to the Soviet Union in 1926 and was a contributor to *Frayhayt* from 1922 until 1939, when he became disillusioned with Communism following the Stalin-

Hitler non-aggression pact.[99]

Kirk was secretary of the committee that organized the Birobidzhan exhibition. He had been involved in the revolutionary movements in Russia and immigrated to the United States in 1910. Although essentially an academic painter, Kirk was a Communist and remained committed to portraying scenes of working-class life. Distinguished and refined, according to his biographers, Kirk also supported himself working at factory jobs, as did many other artists of this time.

An important precedent in Soviet-U.S. artists' relations was the John Reed Club's exhibition *Revolutionary Art in the Capitalist Countries* held at the Museum of New

FIG. 101
Ilya Bolotowsky, *White Abstraction*, ca. 1935, oil on canvas, 18 1/2 x 22 1/4" (47 x 57 cm). Collection of The Newark Museum. Gift of Jerry Lieber, 1981. (cat. no. 19)

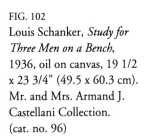

FIG. 102
Louis Schanker, *Study for Three Men on a Bench*, 1936, oil on canvas, 19 1/2 x 23 3/4" (49.5 x 60.3 cm). Mr. and Mrs. Armand J. Castellani Collection. (cat. no. 96)

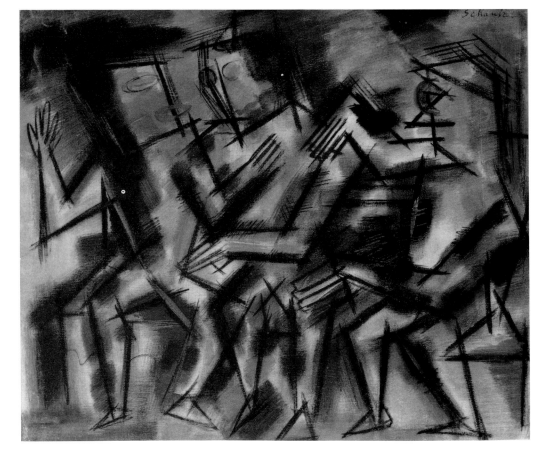

FIG. 107
Barnett Newman,
*The Beginning*, 1946,
oil on canvas;
40 x 29 3/4" (101.6 x 75.6
cm). The Art Institute of
Chicago, through prior gift
of Mr. and Mrs. Carter H.
Harrison. Photograph
courtesy of The Art
Institute of Chicago.

End Notes

1. Randolph S. Bourne, "Trans-National America," *Atlantic Monthly* 118, 1 (July 1916): 95. See also Randoph S. Bourne, "The Jew and Trans-National America," *Menorah Journal* 2, 5 (December 1916): 277–284.

2. See Irving Sandler, *The Triumph of American Painting: A History of Abstract Expressionism* (New York: Harper and Row, 1970) and Serge Guilbaut, trans. Arthur Goldhammer, *How New York Stole the Idea of Modern Art: Abstract Expressionism, Freedom and the Cold War* (Chicago and London: The University of Chicago Press, 1983).

3. Joseph Gutmann, "Jewish Participation in the Visual Arts of Eighteenth and Nineteenth-Century America," *American Jewish Archives* 15 (April 1963): 21–57.

4. On Randolph Bourne see Edward Abrahams, *The Lyrical Left: Randolph Bourne, Alfred Stieglitz and the Origins of Cultural Radicalism in America* (Charlottesville: University Press of Virginia, 1986). On the lack of an artistic tradition within the Jewish community see Alfred Werner, "Ghetto Graduates," *The American Art Journal* 5, 2 (November 1973): 71–82.

5. These groups have also been discussed in the following: Avram Kampf, *Jewish Experience in the Art of the 20th Century* (South Hadley, Massachusetts: Bergin and Garvey, Publishers, Inc., 1984), 50–57 [reprinted as *Chagall to Kitaj: Jewish Experience in 20th Century Art* (London: Lund Humphries in association with the Barbican Art Gallery, 1990), 40–51, 54–61. Exh. cat.]; Irving Howe, with the assistance of Kenneth Libo, *World of Our Fathers* (New York: Touchstone Book published by Simon and Schuster, 1976), 573–585; and Benjamin and Barbara Harshav, translated with the participation of Kathryn Hellerstein, Brian McHale, and Anita Norich, *American Yiddish Poetry: A Bilingual Anthology* (Berkeley, Los Angeles, London: University of California Press, 1986), 54–62. John Weichsel, namesake and grandson of the founder of the People's Art Guild, has written a master's thesis on that group. See "The People's Art Guild," M.A. thesis, Hunter College, New York, 1965. A copy is in the John Weichsel Papers, Archives of American Art, Smithsonian Institution.

6. *American Art Annual*, 1, 1898.

7. Judith Katy Zilzcer, "The Aesthetic Struggle in America, 1913–1918: Abstract Art and Theory in the Stieglitz Circle." Ph.D. dissertation, University of Delaware, 1975. Unpublished. Appendix I, 236–261.

8. Arthur Frank Wertheim, *The New York Little Renaissance: Iconoclasm, Modernism and Nationalism in American Culture, 1908–1917* (New York: New York University Press, 1976), 179–180. Bourne, "The Jew and Trans-National America," 279.

9. Abrahams, *The Lyrical Left*, 65.

10. Berrol, "In their Image: German Jews and the Americanization of the *Ost-Juden* in New York City," *New York History* 63, 4 (October 1982): 429.

11. Educational Alliance, *Annual Report*, 1899, 15.

12. Howe, *World of Our Fathers*, 214. Winifred Howe, *A History of the Metropolitan Museum* 1 (New York: Metropolitan Museum of Art, 1913), 236, 238–247.

13. Educational Alliance, *Third Annual Report*, 1895, 15.

14. Educational Alliance, *Fourth Annual Report*, 1896, 16.

15. Ibid., 18.

16. Educational Alliance *Annual Reports* and Board minutes from the Alliance archives. See also *The Educational Alliance Art School Retrospective Art Exhibit*, preface by John I. H. Baur (New York: The Educational Alliance, 1963). Exh. cat., and *The Educational Alliance Art School Exhibition of Paintings and Sculpture*, preface by Abbo Ostrowsky (New York: The Educational Alliance, Associated American Artists Galleries, 1940). Exh. cat. Hutchins Hapgood, *The Spirit of the Ghetto* (New York: Schocken Books, 1966), 249. (Originally published, New York: Funk and Wagnalls Co., 1902). A letter from Samuel Halpert to John Weichsel dated November 14, 1915, indicates that he studied drawing with Epstein at the Neighborhood Guild (later renamed the University Settlement) prior to taking classes with McBride at the Educational Alliance. Samuel Halpert file at the Jewish Museum; letter given to the Museum by John Weichsel.

17. Educational Alliance, *Ninth Annual Report*, 1901, 23.

18. Henry McBride, *The Flow of Art* (New York: Atheneum Publishers, 1975), 164. Irma B. Jaffe, *Joseph Stella* (Cambridge: Harvard University Press, 1970), 5–11. Revised edition, New York: Fordham University Press, 1988. Quoted in Werner, "Ghetto Graduates," 82.

19. Educational Alliance, Minutes of the Board of Directors, April 10, 1905, unpublished typescript from the archives of the Educational Alliance.

20. Milton W. Brown, *The Story of the Armory Show* (New York: Abbeville Press and The Joseph H. Hirshhorn Foundation, 1988), 153–186.

21. Later Ostrowsky excluded the work of the most advanced artists (specifically Gottlieb, Newman, Rothko and Schanker) from alumni exhibitions of the Educational Alliance "because of their negation of the esthetic principles adhered [to] by the School." Possibly Ostrowsky interpreted their abstraction as a turning away from social concerns. Letter from Abbo Ostrowsky to Lena Gurr, September 7, 1966. Lena Gurr Papers, Archives of American Art, Smithsonian Institution.

22. The young Ostrowsky had been the assistant director of the People's Art Traveling Exhibitions which brought art to remote regions of Kherson, Poltava and Kiev in the Ukraine. He brought this social commitment with him when he immigrated to the United States in 1908. See Abbo Ostrowsky "Memoir" in the Ostrowsky Papers, YIVO Institute for Jewish Research. Also on microfilm at the Archives of American Art, Smithsonian Institution.

23. The issues involved in the call for an American art are quite complex and interrelated with the development of the study of American art history as an independent field. See Elizabeth Johns, "Scholarship in American Art: Its History and Recent Developments," *American Studies International* 22, 2 (October 1984): 3–40, and Wanda M. Corn, "Coming of Age: Historical Scholarship in American Art," *The Art Bulletin* 70, 2 (June 1988): 188–207.

24. Royal Cortissoz, "Ellis Island Art," *American Artists* (New York and London: Charles Scribner's Sons, 1923), 17–22.

25. Maxwell Anderson, "Do Immigrants Beat Us At the Artistic Game?" *New York Globe* (June 29, 1919): 12. Other such articles included David Rofenstein, "A Community Art School," *School and Society* 15, 384 (Saturday, May 6, 1922): 494–498, and Walter A. Dyer, "An East Side Art Movement," *International Studio* 63 (December 1917): 50–51. An article on an exhibition of student work Ostrowsky arranged at the University Settlement was reported in *The Guild Journal* 5, 6 (May–June 1915): 10–11. Already a tradition at the University Settlement, this practice was continued at the Educational Alliance.

26. Rofenstein, "A Community Art School," 495.

27. Zabel, Barbara Beth. "The Precisionist-Constructivist Nexus: Louis Lozowick in Berlin," *Arts* 56, 2 (October 1981): 121–127.

28. The Educational Alliance, "Art School Series of Lectures," 1920, pamphlet. Minutes of the Educational Alliance Board, from the files of the Educational Alliance.

29. Julia Richman in National Council of Jewish Women, *Proceedings of the First Convention*, 1896, 207. Quoted in Selma C. Berrol, "When Uptown Met Downtown: Julia Richman's Work in the Jewish Community of New York, 1880–1912," *American Jewish History* 70, 1 (September 1980): 45.

102. Ben Shahn
*Resources of America (Two panels,*
*mural study, Bronx, New York,*
*Central Post Office)*, 1939-1943
Tempera on fiberboard
Each panel, 5 x 39 1/2" (12.7 x
100.3 cm)
National Museum of American
Art, Smithsonian Institution,
Transfer from General Services
Administration

103. Ben Shahn
*Liberation*, 1945
Tempera on cardboard mounted
on composition board
29 3/4 x 40" (75.6 x 101.4 cm)
The Museum of Modern Art, New
York, James Thrall Soby Bequest

104. Joseph Solman
*The Tinsmith's Shop*, n.d.
Oil on canvas
36 x 47" (91.4 x 119.4 cm)
Courtesy Salander-O'Reilly
Galleries, New York

105. Joseph Solman
*The Coal Bin*, 1937
Oil on canvas
25 1/8 x 34" (63.8 x 86.4 cm)
Courtesy Salander-O'Reilly
Galleries, New York

106. Isaac Soyer
*Art Beauty Shoppe*, 1934
Oil on canvas
42 x 29 1/2" (107.9 x 75 cm)
Dallas Museum of Art, Gift of the
Public Works of Art Project

107. Moses Soyer
*Old Man in Skull Cap*, 1922
Oil on canvas
29 3/4 x 21 1/2" (75.6 x 54.6 cm)
The Jewish Museum, New York,
Gift of Henry Margoshes

108. Moses Soyer
*Chaim and Renee Gross in the*
*Studio of Chaim Gross*, 1932
Oil on canvas
27 x 29" (68.6 x 73.7 cm)
Collection of Renee and
Chaim Gross

109. Moses Soyer
*The Lover of Books*, 1934
Oil on canvas
42 x 23 1/2" (106.7 x 59.7 cm)
The Jewish Museum, New York,
Gift of Ida Soyer

110. Moses Soyer
*Artists on WPA*, 1935
Oil on canvas
36 1/8 x 42 1/8" (91.8 x 107 cm)
National Museum of American
Art, Smithsonian Institution, Gift
of Mr. and Mrs. Moses Soyer

111. Raphael Soyer
*In A Jewish Cafe*, 1925
Watercolor and pencil on paper
21 3/4 x 19 3/8" (55.2 x 49.2 cm)
Hirshhorn Museum and Sculpture
Garden, Smithsonian Institution,
Gift of Joseph H. Hirshhorn, 1966

112. Raphael Soyer
*Dancing Lesson*, 1926
Oil on canvas
24 x 20" (60.9 x 50.8 cm)
Collection of Renee and
Chaim Gross

113. Raphael Soyer
*The Bridge*, 1926-1927
Oil on canvas
22 1/4 x 30 1/8" (56.5 x 76.5 cm)
Hirshhorn Museum and Sculpture
Garden, Smithsonian Institution,
Gift of Joseph H. Hirshhorn, 1966

114. Raphael Soyer
*Self-Portrait*, 1927
Oil on wood panel
11 1/8 x 8 1/4" (30.2 x 20.1 cm)
The Phillips Collection,
Washington, D.C.

115. Raphael Soyer
*Louis Lozowick*, ca. 1929-1930
Oil on canvas
26 x 19" (66 x 48.3 cm)
Collection of Adele Lozowick

116. Raphael Soyer
*The John Reed Club:*
*The Committee*, 1932
Lithograph on paper
10 5/8 x 14 5/8" (27 x 37.1 cm)
Hirshhorn Museum and Sculpture
Garden, Smithsonian Institution,
Gift of Raphael and Rebecca Soyer,
1981, in honor of Abram Lerner

117. Raphael Soyer
*Reading from Left to Right*, 1938
Oil on canvas
26 1/4 x 20 1/4" (66.7 x 51.4 cm)
Lent by the Whitney Museum of
American Art, New York, Gift of
Mrs. Emil J. Arnold in memory of
Emil J. Arnold and in honor of
Lloyd Goodrich

118. Jennings Tofel
*Mother and Child*, 1926
Oil on canvas
24 x 22 1/8" (61 x 56.2 cm)
Hirshhorn Museum and Sculpture
Garden, Smithsonian Institution,
Gift of Joseph H. Hirshhorn, 1966

119. Jennings Tofel
*Family Reunion*, 1929
Oil on canvas
18 1/4 x 21 3/4" (46 x 55.2 cm)
Hirshhorn Museum and Sculpture
Garden, Smithsonian Institution,
Gift of Joseph H. Hirshhorn, 1966

120. Jennings Tofel
*Portrait of Mani Leib*, 1942
Oil on canvas
24 x 17" (61 x 43.2 cm)
YIVO Institute for Jewish Research

121. Nahum Tschacbasov
*Deportation*, 1936
Oil on canvas
32 x 48" (81.3 x 121.9 cm)
Lent by the Metropolitan Museum
of Art, Gift of Samuel S. Goldberg,
1945

122. Abraham Walkowitz
*The Violinist*, 1895
Oil on canvas
48 x 34" (122 x 86.4 cm)
The Jewish Museum, New York

123. Abraham Walkowitz
*Dancing Figure*, 1903
Pen and watercolor on paper
8 3/4 x 5 7/8" (22.2 x 14.7 cm)
The Jewish Museum, New York,
Gift of the artist

124. Abraham Walkowitz
*Untitled (East Side Figures)*,
ca. 1904-1905
Ink on paper
7 1/2 x 5 1/2" (19 x 14 cm)
The Jewish Museum, New York

125. Abraham Walkowitz
*Untitled (East Side Figures)*, ca.
1904-1905
Ink on paper
6 7/8 x 9 7/8" (17.5 x 25.1 cm)
The Jewish Museum, New York

126. Abraham Walkowitz
*Untitled (East Side Figures)*, ca.
1904-1905
Ink on paper
6 3/4 x 5 1/4" (17.1 x 13.3 cm)
The Jewish Museum, New York

127. Abraham Walkowitz
*On the Avenue*, 1905
Oil on canvas
16 x 12 1/2" (40.6 x 31.8 cm)
Collection of Nathan and Baya
Weisman

128. Abraham Walkowitz
*Self-Portrait*, ca. 1910
Etching
8 3/4 x 5 15/16" (22.2 x 15 cm)
The Jewish Museum, New York,
Gift of the artist

129. Abraham Walkowitz
*Summer*, 1912
Watercolor on paper
21 1/2 x 29 1/2" (54.6 x 74.9 cm)
Lent by the Metropolitan Museum
of Art, Alfred Stieglitz Collection,
1949

130. Abraham Walkowitz
*Improvisation of New York City*,
ca. 1916
Oil on canvas
44 x 33" (111.8 x 83.8 cm)
Albright-Knox Art Gallery,
Buffalo, New York, George B. and
Jenny R. Mathews, Elisabeth H.
Gates and Edmund Hayes Funds,
1979

131. Max Weber
*Abraham Walkowitz*, 1907
Oil on canvas
25 1/4 x 20 3/16" (64 x 51.2 cm)
The Brooklyn Museum, Gift of
Abraham Walkowitz

132. Max Weber
*New York at Night*, 1915
Oil on canvas
33 7/8 x 20 1/16" (86 x 50.1 cm)
Archer M. Huntington Art Gallery,
The University of Texas at Austin,
Lent by Mari and James Michener

133. Max Weber
*Untitled*, ca. 1918
Woodcut
4 x 2 1/2" (10.2 x 6.4 cm)
The Jewish Museum, New York,
Gift of Mr. and Mrs. William B.
Jaffe

134. Max Weber
*Untitled*, ca. 1918
Woodcut
4 x 2 1/2" (10.2 x 6.4 cm)
The Jewish Museum, New York,
Gift of Mr. and Mrs. William B.
Jaffe

135. Max Weber
*Untitled*, ca. 1918
Woodcut
4 x 2 1/2" (10.2 x 6.4 cm)
The Jewish Museum, New York,
Gift of Mr. and Mrs. William B.
Jaffe

136. Max Weber
*Untitled*, ca. 1918
Woodcut
4 x 2 1/2" (10.2 x 6.4 cm)
The Jewish Museum, New York,
Gift of Mr. and Mrs. William B.
Jaffe

137. Max Weber
*Sabbath*, 1919
Oil on canvas
12 1/2 x 10" (31.7 x 25.4 cm)
Collection of Joy S. Weber

138. Max Weber
*The Talmudists*, 1934
Oil on canvas
50 x 33 3/4" (127 x 85.7 cm)
The Jewish Museum, New York,
Gift of Mrs. Nathan Miller

139. Max Weber
*At the Mill*, 1939
Oil on canvas
40 1/8 x 48 1/4"
(101.9 x 122.6 cm)
Collection of The Newark
Museum, Purchase, 1946, Wallace
M. Scudder Bequest Fund

140. Marguerite Zorach
*Mountains*, n.d.
Oil on wood panel
12 7/8 x 16" (32.7 x 40.6 cm)
Collection of John Weichsel and
Judith Weichsel Carr

141. William Zorach
*The Roof Playground*, 1917
Oil on canvas
29 x 23 3/4" (73.7 x 60.3 cm)
Lent by the Whitney Museum of
American Art, New York, Gift of
Mr. and Mrs. Arthur G. Altschul

142. William Zorach
*Figure of Marguerite*, 1921
Bronze
21" (53.3 cm) high
Sid Deutsch Gallery, New York

143. William Zorach
*Head of Edith Gregor Halpert*, 1930
Jaune Nile marble
12 3/4 x 8 1/2 x 8" (32.4 x 21.6 x
20.3 cm)
Weatherspoon Art Gallery, Gift of
Mr. and Mrs. Herbert S. Falk and
Mr. and Mrs. Carl O. Jeffress

144. William Zorach
*Head of Christ*, 1940
Stone (peridotite) with marble base
20 5/8 x 10 1/4 x 11 5/8" (52.4 x
26 x 29.6 cm)
The Museum of Modern Art, New
York, Abby Aldrich Rockefeller
Fund, 1942

145. Attributed to William Zorach
*Study for Poster for the People's Art
Guild Exhibition at the Jewish Daily
Forward Building*, ca. 1917
Mixed media on board
15 x 11 1/2" (38.4 x 29.2 cm)
Collection of John Weichsel and
Judith Weichsel Carr

Documentation, photographs and letters
for the exhibition lent by the Archives of
American Art, Smithsonian Institution,
Washington, D.C.; the Beinecke Rare
Book and Manuscript Library, Yale
University Library, Alfred Stieglitz
Collection; the Educational Alliance; the
YIVO Institute for Jewish Research; the
Library of the YIVO Institute for Jewish
Research, and Amy Lowenhar.

# ARTISTS' BIOGRAPHIES

**WILLIAM AUERBACH-LEVY** (1889-1964)
William Auerbach-Levy was born on February 14, 1889, in Brest-Litovsk, Russia, to Jacob Auerbach and Fania Seitles. The family immigrated to the United States when he was about five years old and settled on New York's Lower East Side; they adopted the surname Levy upon arrival in their new country. At the age of eleven Auerbach-Levy was admitted to the National Academy of Design, where he took lessons in etching with Charles Mielatz. In 1911, after graduating from college, he won the Academy's Mooney Traveling Scholarship and sailed for Europe for a two-year stay. He enrolled in classes at the Académie Julian in Paris and studied with Jean-Paul Laurens. His etchings were so highly regarded that, though a student, he was invited to exhibit at the Salon de Paris. At the same time he displayed his talent for caricature by amusing other artists, like William Zorach, with his drawings of them.

Upon his return to New York, Auerbach-Levy accepted a teaching position at the National Academy of Design, and in 1920 he succeeded Mielatz as instructor of etching, retaining that post until 1935. He also began, in 1920, a twenty-eight-year association with the Educational Alliance as an instructor in their Art School. A master etcher, Auerbach-Levy also worked in oil, chalk, pastel, pencil and charcoal. Specializing in portraiture and figure studies, he became known for his sensitive delineation of character.

In 1914 he won first prize at an exhibition of the Chicago Society of Etchers. Four of his works were shown in 1917 in the People's Art Guild exhibition at the Forward Building, including his etching *The New Talmud*. In 1924 he had a one-man show at the Milch Galleries in New York, which included a *Self-Portrait* in oil and several etchings with Jewish subjects, among them *Torah* and *Patriarch's Prayer*. One year later he won the Isaac N. Maynard Portrait Prize at the National Academy of Design and in 1926 he was elected an associate of the Academy.

Auerbach-Levy reached a turning point in his career after winning an award in the Pennsylvania Academy of the Fine Arts' first exhibition of caricatures in 1924. Encouraged by this success, he gained a position on the New York *World* as caricaturist for its theater section, which he held until the newspaper's demise in 1931. He also contributed drawings to the New York *Post* and to magazines including *The New Yorker* and *Vogue*. Concurrent with his new profession, he continued to paint and etch. In 1928 he won a Guggenheim Fellowship and returned to France. In 1938 he participated in the first exhibition of the World Alliance for Yiddish Culture (YKUF).

In 1947 Auerbach-Levy wrote *Is That Me? A Book about Caricature*, in which over one hundred of his caricatures of political, theatrical and artistic personalities were reproduced, including Jo Davidson and Abraham Walkowitz. It also contained the drawing *A Testimonial Dinner*, commemorating the event held in his honor on the occasion of his twenty-fifth anniversary as a teacher at the Educational Alliance Art School. Committed to the Alliance, he participated in all their major exhibitions, including their own twenty-fifth-anniversary celebration in 1940, in which he showed the painting *Father and Daughter*. He exhibited with the Alliance for the last time during his life at their 1963 retrospective.

SELECTED SOLO EXHIBITIONS

1924    *Paintings, Etchings and Drawings by William Auerbach-Levy*, Milch Galleries, New York

1930    *Exhibition of Original Drawings and Caricatures Chiefly of People Connected with the Stage by William Auerbach-Levy*, Harlow, McDonald and Co., New York

1970    *William Auerbach-Levy*, ACA Galleries, New York

SELECTED GROUP EXHIBITIONS

1914    Society of Etchers, Chicago

1915    *Panama-Pacific Exposition*, San Francisco

1917    *People's Art Guild Exhibition at the Forward Building*, New York

1917    *Annual Exhibition*, Pennsylvania Academy of the Fine Arts, Philadelphia (also exhibited 1922-1928, 1937)

1921    *Annual Exhibition*, National Academy of Design, New York (also exhibited 1925)

1923    *International Print Makers Exhibition*, Los Angeles

1925    *Black and White Exhibition*, Salmagundi Club, New York

1926    *Jewish Center Exhibition*, Detroit

1938    *First Exhibition of Painting, Sculpture, Graphic Arts and Yiddish Books and Press*, World Alliance for Yiddish Culture (Yiddisher Kultur Farband), New York

SELECTED BIBLIOGRAPHY

*William Auerbach-Levy*. New York: ACA Galleries, 1970. Exh. cat.

Auerbach-Levy, William. *Is That Me? A Book about Caricature*. New York: Watson-Guptill Publications, Inc., 1947.

*Current Biography*. New York: H. W. Wilson Company, 1948.

*The Educational Alliance Art School Retrospective Art Exhibit*. Preface by John I. H. Baur. New York: The Educational Alliance, 1963. Exh. cat.

O'Gorman, James F., ed. *Aspects of American Printmaking, 1800-1950*. Syracuse: Syracuse University Press, 1988.

Reese, Albert. *American Prize Prints of the 20th Century*. New York: American Artists Group, Inc., 1949.

## SAUL BAIZERMAN (1889-1957)

Saul Baizerman was born in Vitebsk, Russia, on December 25, 1889, the son of a poor itinerant harnessmaker. When he was thirteen years old he modeled a portrait of his father, Lebof Baizerman, in clay; later, as a mature artist, he modeled both parents in hammered copper: *My Father* (1933-1938) and *My Mother* (1940-1949). He received his earliest training in art in 1904-1905 at the Imperial High School in Odessa. A political fugitive, he left Russia in 1909 for England, traveling through Belgium, where he was impressed by the sculptures of Constantin Meunier.

Baizerman arrived in the United States in 1910 and settled in New York City. Working at odd jobs during the day as a housepainter or artist's model, he supported himself and attended art school at night. In 1911 he enrolled in classes at the National Academy of Design. For the next nine years, he studied at the Beaux-Arts Institute of Design with Solon Borglum. Around 1919 he also attended classes at the Educational Alliance Art School, where he met Moses Soyer. In 1920 Baizerman won a competition for a monument to be placed in front of Grant's Tomb, but he subsequently rejected the commission. Four years later the Dorien Leigh Gallery in London gave Baizerman his first

solo show; he went to England for the exhibition and then traveled to the Soviet Union. From 1925 to 1926 he and his wife, the painter Eugenie Silverman, journeyed through Italy and France, where he had a work exhibited at the Salon des Indépendants in Paris.

Around 1921, adopting a modernist approach, Baizerman turned away from traditional bronze casting and experimented with direct sculpting in the material, modifying his bronzes with hammer blows. For thirty-three years, from 1920 to 1953, he worked on a series of small hammered bronze sculptures, *The City and the People*, whose subjects documented the everyday life of ordinary working-class men and women. They included *Pants Presser, Man and Machine, Pushcart Woman* and *Rabbi*. He then explored the possibilities of working with large flat sheets of copper. Hammering thousands of minute blows on both sides of the copper sheets, he made each side equally rich in plasticity and texture. In this manner he fashioned idealized nude figures in high relief, exemplified in his *March of the Innocents* of 1932-1939. Many of his later sculptures focused on the female torso. This method of hammering directly on the metal, without recourse to molds or preliminary drawings, became his preferred technique.

In January 1931, a fire in his studio destroyed most of his sculpture, including all his hammered copper pieces. Two years later he had his first solo exhibition in the United States at the Eighth Street Gallery, where he showed his early small bronzes. In 1934 Baizerman returned to the Educational Alliance as a teacher and remained there for six years. During this time the first exhibition of his new hammered copper works took place at the Artists' Gallery. In 1949 the Whitney Museum purchased *Slumber* (1940-1948), making it the first of his hammered copper works to enter a museum collection. Baizerman won a grant in 1951 from the American Academy of Arts and Letters and the following year he received a Guggenheim Fellowship. In 1953 the Walker Art Center in Minneapolis honored him with a major retrospective. He died in 1957.

SELECTED SOLO EXHIBITIONS

SELECTED GROUP EXHIBITIONS

SELECTED BIBLIOGRAPHY

Armstrong, Tom. *200 Years of American Sculpture*. New York: Whitney Museum of American Art, 1976. Exh. cat.

Dabakis, Melissa, and David Finn. *Vision of Harmony: The Sculpture of Saul Baizerman*. Redding Ridge, Connecticut: Black Swan Books, Ltd., 1989.

Goldstein, Carl. "The Sculpture of Saul Baizerman." *Arts* 51, 1 (September 1976): 121-125.

Held, Julius S. *Saul Baizerman*. Minneapolis: Walker Art Center, 1953. Exh. cat.

Held, Julius S. *Saul Baizerman Sculpture*. Huntington, New York: Heckscher Museum, 1961. Exh. cat.

King, Lyndel, intro. *American Paintings and Sculpture in the University Art Museum Collection*. Minneapolis: University of Minnesota, 1986.

McCabe, Cynthia Jaffee. *The Golden Door: Artist-Immigrants of America, 1876-1976*. Washington, D.C.: Smithsonian Institution Press, 1976. Exh. cat.

Messer, Thomas M., foreword. *Saul Baizerman*. Boston: Institute of Contemporary Art, 1958. Exh. cat.

## BEN BENN (1884-1983)

Benjamin Rosenberg, known as Ben Benn, was born on December 27, 1884, in the Ukrainian village of Kaminetz Podolsk. He immigrated with his family to New York in 1894. Between 1904 and 1908, Benn attended the National Academy of Design, where he met fellow students Leon Kroll and William Zorach. The Academy curriculum stressed portraiture built up with broad, painterly brushstrokes, a technique that remained the foundation of Benn's style.

Though Benn never studied in Europe, by 1912 he started to use flattened forms and space in his compositions, indicating an awareness of European modernism. Benn preferred traditional subject matter—portraits, figures, landscapes and still lifes. His early palette tended toward earth tones, but by the mid-teens his canvases were bolder in color and more decorative in style, reflecting the influence of Post-Impressionism, Wassily Kandinsky and his close friend Marsden Hartley.

In 1915, Benn settled in a large studio in Manhattan, which was a meeting place well into the 1930s for artists such as Hartley, Charles Demuth, Elie Nadelman, Joseph Stella and Abraham Walkowitz, the poet e.e. cummings and the playwright Eugene O'Neill. Benn's portrait of Hartley (1915), one among many he made of the artist, is perhaps the most radically abstract work of his career. Benn participated in the Forum Exhibition (1916), the People's Art Guild Forward Exhibition (1917) and a number of other shows sponsored by the Guild between 1915 and 1918, as well as the first annual exhibition of the Society of Independent Artists (1917). During the later teens, the artist's work became stylistically more eclectic, including experiments with flattened and highly simplified shapes.

In the 1920s Benn further broadened his style, his canvases reflecting at different times a painterly realism, a brooding expressionism and an appreciation of Matisse. Benn's first solo exhibition was held in 1925 at J. B. Neumann's New Art Circle Gallery, and in 1926-1927 the artist was included in group shows at the Jewish Art Center.

During the thirties, Benn began to lay descriptive calligraphic lines over large flat patches of color or masses of painterly strokes. At this time the artist also depicted urban scenes, yet, unlike the Social Realists, his work was more an affirmation than a critical commentary on the human condition.

After World War II, Benn experimented with geometric grids, Cubist faceting and swirling networks of line. In 1963 his work was exhibited in *The Decade of the Armory Show* at the Whitney Museum of American Art, New York, and two years later in a retrospective at the Jewish Museum, New York. Benn lived the majority of his life in New York, but died in Connecticut in 1983.

### SELECTED SOLO EXHIBITIONS

1925    *Ben Benn*, J. B. Neumann's New Art Circle Gallery, New York

1938    *Ben Benn*, The Artists' Gallery, New York (also exhibited 1941, 1949)

1950    *Ben Benn*, Hacker Gallery, New York (also exhibited 1952, 1953)

1953    *Paintings by Ben Benn*, Walker Art Center, Minneapolis

1954    *Ben Benn*, Butler Institute of American Art, Youngstown, Ohio

1956    *Ben Benn*, Harry Salpeter Gallery, New York (also exhibited 1957, 1959)

1963    *Ben Benn, Paintings*, Babcock Galleries, New York (also exhibited 1965-1967, 1970)

1965    *Ben Benn: Painter*, The Jewish Museum, New York

1982    *Ben Benn*, Branchville Soho Gallery, Ridgefield, Connecticut (also exhibited 1983)

1983    *Ben Benn: An American Painter, 1884-1983*, Hammer Galleries, New York

### SELECTED GROUP EXHIBITIONS

1907    *Oils by Eight American Artists*, The Artist Gallery, New York

1916    *The Forum Exhibition of Modern American Painters*, Anderson Galleries, New York

1917    *People's Art Guild Exhibition at the Forward Building*, New York

1917    *People's Art Guild Exhibition*, Church of the Ascension Parish House, New York

1917    *First Annual Exhibition of the Society of Independent Artists*, Grand Central Palace, New York (also exhibited 1918, 1921-1924)

1923    *Exhibition of American Art*, Chambre Syndicale de la Curiosité et des Beaux-Arts, Paris

1926    *Exhibition of Paintings, Drawings and Sculptures*, Jewish Art Center, New York (also exhibited 1927)

1927    *Annual Exhibition*, Whitney Studio Club, New York (also exhibited 1928)

1932    *Biennial Exhibition*, Whitney Museum of American Art, New York (also exhibited 1934, 1950)

1933    *American Sources of Modern Art*, The Museum of Modern Art, New York

1935    *Abstract Painting in America*, Whitney Museum of American Art, New York

1936    *Exhibition of Works of Art Presented by American Artists to the State Museum of Birobidzhan*, Birobidzhan, Soviet Union (traveled)

1938    *First Exhibition of Painting, Sculpture, Graphic Arts and Yiddish Books and Press*, World Alliance for Yiddish Culture (Yiddisher Kultur Farband), New York

1950    *American Painting Today*, The Metropolitan Museum of Art, New York

1963    *The Decade of the Armory Show: New Directions in American Art 1910-1920*, Whitney Museum of American Art, New York (traveled)

1974    *Ben Benn/José de Creeft*, Hirshhorn Museum and Sculpture Garden, Smithsonian Institution, Washington, D.C.

### SELECTED BIBLIOGRAPHY

*Ben Benn: The Octogenarian Decade*. Ridgefield, Connecticut: Branchville Soho Gallery, 1983. Exh. cat.

Geist, Sidney. "Profile: Ben Benn." *The Arts Digest* 28, 1 (October 1, 1953): 15, 25-28.

The Jewish Museum. *Ben Benn: Painter.* New York: The Jewish Museum, 1965.

Kramer, Hilton. "The Achievements of Ben Benn." *Arts* 30, 7 (April 1956): 24-27, 29.

Lozowick, Louis. *One Hundred Contemporary American Jewish Painters and Sculptors.* New York: YKUF Art Section, 1947.

## BEN-ZION (1897-1987)

Benzion Weinman was born in Stary Constantin in the western Ukraine on July 18, 1897. He moved with his family first to Tarnopol and then, by 1909, to Tarnov, in Galicia, where his father served as a cantor in the largest synagogue in the region. He was educated at yeshiva and privately, and while still young began to write poems in Hebrew and to draw. During World War I the family lived in Vienna, and Ben-Zion studied art at the Volkshaus there. The family returned to Tarnov in 1918. Two years later Ben-Zion's father died, and shortly thereafter he immigrated with his mother to the United States.

In 1921 Ben-Zion's Hebrew drama *The Struggles of a Violin* was published in Berlin. He also wrote fairy tales and stories, and in New York associated with the Hebrew poets Bavli, Halkin and Silkiner. During this period Ben-Zion supported himself as a Hebrew teacher. In 1933 he began to paint, in an effort to find a means of expression that could voice his horror at growing Nazism and anti-Semitism in Europe. During his early career he was supported by work on the WPA. In 1935 he joined a group of artists, including Rothko, Gottlieb and Solman, who would exhibit together as the Ten, and in the same year he painted the first of his many biblical pictures, *Prophet in the Desert*, in his characteristic flat, expressionist style, with forms heavily contoured in black.

In 1936 the artist had his first one-man show at the Artists' Gallery. He exhibited in the first show of the Yiddisher Kultur Farband (YKUF) in New York in 1938. As his reputation grew throughout the 1940s, he exhibited regularly at the Bonestell and Bertha Schaefer galleries in New York. From 1943 through 1956 Ben-Zion taught at Cooper Union in New York. In 1947 he had one-man exhibitions at the University Museum of Art, Ann Arbor, Michigan, the University of Iowa and the Baltimore Museum of Art, and in 1948 at the Art Institute of Chicago. In that same year his biblical paintings were shown at the Jewish Museum, New York. Three portfolios of his etchings on biblical themes were published by Curt Valentin, New York, in the early 1950s.

In 1959, the year of a retrospective of his work held at the Jewish Museum, Ben-Zion began to make welded sculptures of iron, continuing to employ religious motifs, but also taking inspiration from natural elements, including birds, animals and insects. In these he used found metal scraps picked up on his trips to New Mexico, Utah and elsewhere in the West. In 1978 paintings and sculptures by Ben-Zion were exhibited at the Haifa Museum in Israel. The artist continued working through the 1980s and his sculptures were shown in New York at the Terry Dintenfass Gallery in 1985. He died in New York in 1987.

### SELECTED SOLO EXHIBITIONS

1936    *Ben-Zion*, The Artists' Gallery, New York

1937    *Ben-Zion: Paintings and Drawings*, East River Gallery, New York

1941    *Ben-Zion*, Bonestell Gallery, New York (also exhibited 1942, 1943)

1945    *Ben Zion: Paintings*, Bertha Schaefer Gallery, New York (also exhibited 1946-1948, 1951)

1947    *Ben-Zion: Paintings*, Baltimore Museum of Art

1948    *Ben-Zion: Paintings*, The Art Institute of Chicago

1948    *Ben-Zion: Biblical Paintings*, The Jewish Museum, New York

1952    *Ben-Zion: Biblical Paintings (1948-1952)*, The Jewish Museum, New York

1953    *Ben-Zion: Biblical Etchings*, United States National Museum, Smithsonian Institution, Washington, D.C.

1955    *Ben-Zion: An Exhibition in Honor of the Jewish Tercentenary in the United States*, City Art Museum, St. Louis

1955    *Ben-Zion*, Duveen-Graham, New York (also exhibited 1956)

1957    *Ben-Zion: Etchings on Biblical Themes*, Bezalel National Museum, Jerusalem

1959    *Ben-Zion, 1933-1959: A Retrospect*, The Jewish Museum, New York

1961    *Ben-Zion*, ACA Galleries, New York

1964    *Ben Zion: Judges and Kings, Eighteen Etchings*, Far Gallery, New York (also exhibited 1965)

1968    *Ben-Zion*, Klutznick Exhibition Hall, B'nai Brith, Washington, D.C.

1969    *Ben-Zion*, Rapaporte Treasure Hall and the American Historical Society Galleries, Brandeis University, Waltham, Massachusetts

1978    *Ben-Zion*, Haifa Museum, Israel

1985    *Ben-Zion: Iron Sculpture*, Terry Dintenfass Gallery, New York

### SELECTED GROUP EXHIBITIONS

1935    *The Ten: An Independent Group*, Montross Gallery, New York (also exhibited 1936)

1936    *Opening Exhibition*, Municipal Art Gallery, New York

1936    *The Ten*, Galerie Bonaparte, Paris

1937    *The Ten*, Georgette Passedoit Gallery, New York (also exhibited 1938)

1938    *First Exhibition of Painting, Sculpture and Graphic Arts and Yiddish Books and Press*, World Alliance for Yiddish Culture (Yiddisher Kultur Farband), New York

1938    *"The Ten" Whitney Dissenters*, Mercury Galleries, New York

1939    *The Ten*, Bonestell Gallery, New York

1939    *Art in a Skyscraper*, American Artists' Congress, New York (also exhibited 1940)

1944    *An Exhibition of Religious Art Today*, The Institute of Modern Art, Boston

1945    *Annual Exhibition*, Whitney Museum of American Art, New York (also exhibited 1948-1950)

1963    *Contemporary and Ancient Art*, Minneapolis Institute of Arts

1975    *Jewish Experience in the Art of the Twentieth Century*, The Jewish Museum, New York

1990    *Chagall to Kitaj: Jewish Experience in 20th Century Art*, Barbican Art Gallery, London

### SELECTED BIBLIOGRAPHY

Dubin, Lillian, and Tabita Shalem, eds. *Ben-Zion: Iron Sculpture.* New York: Alpine Fine Arts Collection, Ltd., 1985.

Kayser, Stephen S. *Ben-Zion: Biblical Paintings (1948-1952).* New York: The Jewish Museum, 1952. Exh. cat.

Kayser, Stephen S. *Ben-Zion, 1933-1959: A Retrospect.* New York: The Jewish Museum, 1959. Exh. cat.

## THERESA BERNSTEIN (born 1890)

Theresa F. Bernstein was born in 1890 to immigrant parents, Isadore and Anna Ferber Bernstein. Her father was a textile manufacturer. In 1905 she visited several cities in Europe while traveling with her mother. Two years later she entered the School of Design for Women in Philadelphia, from which she was graduated in 1911. There she studied with Elliott Daingerfield and Daniel Garber. Garber, like Robert Henri, had been a pupil of Thomas Anschutz. She also studied briefly with William Merritt Chase at the Art Students League in New York that year. In 1912 she traveled to Berlin and Munich and for the first time saw the modern work of the German Expressionists. Returning to New York, where her family had relocated, Bernstein worked in a studio on Fifty-fifth Street. Her early paintings, in richly painted earth tones, capture the life of New York City's streets in a quick, impressionist manner. Her subjects and style ally her with the Ashcan School, led by Henri, but she was not a formal member of this group.

Despite her exposure to German modernism and her visit to the Armory Show in New York in 1913, abstraction did not appeal to Bernstein. The new tendencies in art had little visible effect on her paintings, except perhaps in her bolder use of color.

In the mid-teens Bernstein began to paint the activity of beachgoers at Atlantic Beach and Coney Island, which brought a new lightness and brighter palette to her pictures. She visited Cape Ann in Gloucester for the first time in 1916, and for decades afterward painted the landscape and people of the Massachusetts shore community. The next year she was included in the People's Art Guild Forward Exhibition. Bernstein married the painter William Meyerowitz, who was very involved in the work of the People's Art Guild, in 1919, and the couple frequently exhibited together.

During the twenties, in addition to urban views, she painted such well-known Jazz figures as Lil Hardin and Louis Armstrong, using an energetic line to convey the rhythm and movement of their music. Classical concerts were also among her subject matter, and she painted these for many years. During the twenties and thirties, Bernstein and Meyerowitz counted among their artist friends Stuart Davis, Edward Hopper, Milton Avery and Raphael Soyer, all of whom visited the couple often at their summer house in Gloucester. The couple conducted art classes there, as well as in the city, and were early teachers of Louise Nevelson.

After her marriage Bernstein developed a sense of her own Jewish heritage from her husband, who had been a cantor. Jewish subjects—weddings, synagogues, a still life of a seder table—appear occasionally in Bernstein's own work. In 1932 the couple settled into a studio on West Seventy-fourth Street. In the mid-1930s Bernstein was secretary of the Artists' Congress and lobbied in Washington for the continuation of the WPA's art programs, although her contemporary depictions of urban life lack a socially critical view.

Bernstein has continued to paint themes from everyday life. Her one-hundredth birthday was the occasion for an exhibition of her work in 1989 at the Stamford Museum and Nature Center in Connecticut, which later traveled to Simmons College and the Crane Collection in Boston. A major exhibition of her paintings of the city during the teens and twenties was held in 1990 at the Museum of the City of New York.

### SELECTED SOLO EXHIBITIONS

1919    *Paintings by Theresa F. Bernstein*, Milch Galleries, New York

1926    *Theresa F. Bernstein*, Civic Club, New York

1930    *Theresa Bernstein*, Grand Central Art Galleries, New York

1940    *Paintings by Theresa Bernstein*, Baltimore Museum of Art

1948    *Exhibition of Etchings and Monotypes in Color by Theresa F. Bernstein*, United States National Museum, Smithsonian Institution, Washington, D.C.

1973    *Theresa Bernstein*, Butler Institute of American Art, Youngstown, Ohio

1985    *Theresa Bernstein*, Smith-Girard, Stamford, Connecticut

1989    *Theresa Bernstein: Expressions of Cape Ann and New York, 1914-1972, A Centennial Exhibition*, The Stamford Museum and Nature Center, Stamford, Connecticut (traveled)

1990    *Echoes of New York: The Paintings of Theresa Bernstein*, Museum of the City of New York

### SELECTED GROUP EXHIBITIONS

1915    *Panama-Pacific Exhibition*, World's Fair, San Francisco

1916    *Annual Exhibition*, Pennsylvania Academy of the Fine Arts, Philadelphia (also exhibited 1917-1930, 1932-1934, 1938)

1917    *People's Art Guild Exhibition at the Forward Building*, New York

1917    *Imaginative Paintings by Thirty Young Artists of New York City*, Knoedler Galleries, New York

1918    *Annual Exhibition*, Society of Independent Artists, New York (also exhibited 1919-1931, 1933-1944)

1920    *Oil Paintings by Theresa F. Bernstein and Etchings by William Meyerowitz*, Syracuse Museum of Fine Arts

1920    *Annual Exhibition*, Whitney Studio Club, New York (also exhibited 1925-1928)

1920    *An Exhibition of Paintings by Robert Henri, Charles Bittinger, Theresa Bernstein and Etchings by William Meyerowitz*, The Memorial Art Gallery, Rochester, New York

1926    *First Annual Exhibition*, New York Society of Women Artists, Anderson Galleries, New York

1926    *Sesqui-Centennial International Exhibition*, Philadelphia

1933    *A Century of Progress Exhibition of Paintings and Sculpture*, The Art Institute of Chicago

1936    *Exhibition of Works of Art Presented by American Artists to the State Museum of Birobidzhan*, Birobidzhan, Soviet Union (traveled)

1938    *First Exhibition of Painting, Sculpture, Graphic Arts and Yiddish Books and Press*, World Alliance for Yiddish Culture (Yiddisher Kultur Farband), New York

1950    *Jewish Artists—1950: Annual Exhibition*, Congress for Jewish Culture Art Center, The Jewish Museum, New York

1983    *New York Themes: Paintings and Prints by William Meyerowitz and Theresa Bernstein*, New-York Historical Society, New York

1988    *New York: Empire City in the Age of Urbanism, 1875-1945*, Grand Central Art Galleries, New York

1989    *American Women Artists: The Twentieth Century*, Knoxville Museum of Art, in conjunction with Bennett Galleries, Knoxville, Tennessee (traveled)

### SELECTED BIBLIOGRAPHY

Burnham, Patricia M. "Theresa Bernstein." *Woman's Art Journal* 9, 2 (Fall/Winter 1989): 22-27.

Cohen, Michele. *Echoes of New York: The Paintings of Theresa Bernstein*. New York: Museum of the City of New York, 1990. Exh. brochure.

Jackson, Girard. *Theresa Bernstein: Expressions of Cape Ann and New York, 1914-1972*. Stamford, Connecticut: Stamford Museum and Nature Center and Smith-Girard, 1989. Exh. cat.

Lozowick, Louis. *One Hundred Contemporary American Jewish Painters and Sculptors*. New York: YKUF Art Section, 1947.

Meyerowitz, Theresa Bernstein. *William Meyerowitz: The Artist Speaks*. Philadelphia: The Art Alliance Press, 1986.

## PETER BLUME (born 1906)

Peter Blume was born on October 27, 1906, in Smorgon, Russia. His father, a tanner, had participated in the revolution of 1905, and in 1909 he immigrated to the United States, where he was involved in the union activities of the crafts trade. Two years later his family joined him, settling in Brooklyn. Blume began his art studies with evening classes in the Brooklyn public schools and at the Educational Alliance Art School from 1921 to 1924. There he met Isaac and Moses Soyer and Chaim Gross, who became close friends. During 1922 Blume also attended the Art Students League, and around 1925, although his main interest was painting, he joined Gross in sculpture classes at the Beaux-Arts Institute of Design in New York.

In the early 1920s Blume had a studio on Thirteenth Street in Greenwich Village and worked as a lithographer's apprentice. His Precisionist style of the mid-twenties evolved from his deep appreciation of the meticulous technical brilliance of the early Flemish and Italian masters and the simplified volumes, rationalism and clear precision of contemporary French Purism. Humorous, often even ominous, juxtapositions also began to appear in his work at this time. In the fall of 1925, he joined the Daniel Gallery, which represented a number of Precisionist painters, including Charles Sheeler and Niles Spencer.

During the last half of the decade, Blume divided his time between New York and rural New England. In the former he painted factories and bridges, while in the latter he was inspired by farms and the landscape, which he painted in a flat, naive style. Around 1926, Blume was introduced to Surrealism by Alanson Hartpence, an avant-garde poet and manager of the Daniel Gallery. The artist's work soon reflected this influence, as is apparent in *Parade* (1930), a composite of Pre-

cisionist views of New York docks juxtaposed with distorted renderings of medieval armor. The otherwise drab color scheme is punctuated by patches of vibrant color. His first solo show was held in New York at the Daniel Gallery in 1930.

Blume received Guggenheim Fellowships in 1932 and 1936, which enabled him to travel to Italy. In 1934 he emerged on the international scene as the youngest painter to win first prize at the Carnegie International Exhibition with his painting *South of Scranton* (1931). Juxtaposing men leaping on the deck of a docked boat with images of strip mining, it was one of the first examples of a style sometimes called Social Surrealism, showing the irony of human survival amid destruction and chaos.

Around this time, Blume made Sherman, Connecticut, his home and began to work for the Public Works of Art Project and the WPA/FAP, creating drawings, watercolors and three murals for government buildings. He began to employ greater surrealistic and symbolic effects in such paintings as *The Eternal City* (1934-1937), a response to his experience of Italy under Mussolini. Blume joined and exhibited with the American Artists' Congress and the Yiddish Popular Front group YKUF in the late thirties. He traveled widely, and was the artist-in-residence at the American Academy in Rome from 1956 to 1957, from 1961 to 1962, and again in 1973. The artist's later work generally depicts groups of people or animals within an environment symbolizing the bizarre struggle of life. In 1976 a retrospective exhibition of Blume's work was held at the Museum of Contemporary Art in Chicago. The artist lives in Connecticut.

### SELECTED SOLO EXHIBITIONS

1930 *Paintings by Peter Blume*, Daniel Gallery, New York

1937 *"The Eternal City" by Peter Blume*, Julian Levy Gallery, New York

1947 *Peter Blume*, Durlacher Brothers Gallery, New York (also exhibited 1948, 1949, 1959, 1964)

1964 *Peter Blume, Paintings and Drawings in Retrospect, 1925-1964*, Currier Gallery of Art, Manchester, New Hampshire (traveled)

1968 *Peter Blume*, Kennedy Galleries, New York

1970 *Peter Blume: Recollection of the Flood and Related Works*, Bernard Danenberg Galleries, New York

1976 *Peter Blume: A Retrospective Exhibition*, Museum of Contemporary Art, Chicago

1980 *Peter Blume: "From the Metamorphoses": Recent Paintings and Drawings*, Terry Dintenfass Gallery, New York

1982 *Peter Blume: Selected Paintings, Drawings and Sculpture Since 1964*, The New Britain Museum of Art, Connecticut

1987 *Peter Blume: Paintings and Drawings*, Terry Dintenfass Gallery, New York

### SELECTED GROUP EXHIBITONS

1926 Daniel Gallery, New York

1932 *Biennial Exhibition*, Whitney Museum of American Art, New York (also exhibited 1933, 1934, 1936, 1938, 1939, 1941, 1947, 1948)

1933 *A Century of Progress Exhibition of Paintings and Sculpture*, The Art Institute of Chicago

1934 *Carnegie International Exhibition of Painting and Sculpture*, Pittsburgh (also exhibited 1950)

1934 *Modern Works of Art: Fifth Anniversary Exhibition*, The Museum of Modern Art, New York

1938 *First Exhibition of Painting, Sculpture, Graphic Arts and Yiddish Books and Press*, World Alliance for Yiddish Culture (Yiddisher Kultur Farband), New York

1939 *Art in Our Time*, The Museum of Modern Art, New York

1940 *The Educational Alliance Art School 25th Anniversary Exhibition*, Associated American Artists Galleries, New York

1942 *Artists for Victory*, The Metropolitan Museum of Art, New York

1954 *The Abbo Ostrowsky Collection of the Educational Alliance Art School*, The Jewish Museum, New York

1963 *The Educational Alliance Art School Retrospective Art Exhibit*, American Federation of Arts Gallery, New York

1982 *Realism and Realities: The Other Side of American Painting, 1940-1960*, Rutgers University Art Gallery, New Brunswick, New Jersey (traveled)

### SELECTED BIBLIOGRAPHY

Adrian, Dennis, and Peter Blume. *Peter Blume: A Retrospective Exhibition*. Chicago: Museum of Contemporary Art, 1976. Exh. cat.

163

Ferguson, Charles B. *Peter Blume: Selected Paintings, Drawings and Sculpture Since 1964.* New Britain, Connecticut: The New Britain Museum of American Art, 1982. Exh. cat.

Getlein, Frank. *Peter Blume.* New York: Kennedy Galleries, 1968. Exh. cat.

Lozowick, Louis. *One Hundred Contemporary American Jewish Painters and Sculptors.* New York: YKUF Art Section, 1947.

Miller, Dorothy C. *Peter Blume: "From the Metamorphoses."* New York: Terry Dintenfass Gallery, 1980. Exh. cat.

Trapp, Frank Anderson. *Peter Blume.* New York: Rizzoli, 1987.

## ILYA BOLOTOWSKY (1907-1981)

Ilya Bolotowsky was born on July 1, 1907, in St. Petersburg, Russia, to Jules Bolotowsky, an attorney, and Anastasia Shapiro, an artist. He received his first lessons in drawing from his mother. Caught in the Russian Revolution, the family, who were anti-Bolsheviks, fled in 1920 to Constantinople (Istanbul).

In 1923 the family immigrated to America and settled in New York. Bolotowsky enrolled in classes at the National Academy of Design in 1924 and studied there for six years with Ivan Olinsky. At the end of 1931 he went to Europe, traveling through Italy, Germany, Denmark, England and France. When he returned he experimented with abstract painting, at first influenced by the Cubists he had seen abroad. Then, in 1933, he was profoundly impressed with exhibitions of Mondrian and Miró in New York. He executed his first abstract painting *White Abstraction* in 1934-1935, which paid homage to Malevich with its black lines against white space.

In 1934 Bolotowsky was employed by the Public Works of Art Project, painting realistic scenes of the city, such as *In the Barber Shop.* He later joined the mural division of the WPA/FAP and in 1936, influenced by the biomorphic forms of Miró, he designed one of the first abstract murals in America for the Williamsburg Housing Project in Brooklyn. Next he designed an abstract mural for the Health Building, Hall of Medical Science, at the New York World's Fair of 1939. By the time he executed his mural for the Hospital for Chronic Diseases on Welfare Island in 1941, the geometric vocabulary of Suprematism prevailed.

During this period Bolotowsky was involved in the founding of several avant-garde art organizations. In 1935 he joined Mark Rothko and Adolph Gottlieb in forming the Ten. At their show at the Mercury Gallery in 1938, they decried the Whitney Museum's predilection for American Regionalist and Social Realist paintings. In 1936, Bolotowsky became a cofounder, with Gertrude Greene, Ibram Lassaw and Louis Schanker, of the American Abstract Artists. He was also a charter member, in 1940, of the Federation of Modern Painters and Sculptors. In 1938, he entered his painting *Abstraction No. 1* in the first exhibition of the World Alliance for Yiddish Culture (YKUF).

During World War II Bolotowsky served with the United States Army Air Corps in Nome, Alaska, as a technical translator and compiler of a Russian-English military dictionary. After his return, he began a twenty-eight-year career as a professor of art, starting at Black Mountain College.

In the 1940s Bolotowsky rediscovered Mondrian and his principles of Neoplasticism; eliminating the diagonal, as well as all biomorphic elements, he adopted Mondrian's vertical and horizontal lines and right angle. Though a strict follower of Neoplasticism, he was unorthodox in his use of colors, choosing violet, orange and, occasionally, green, in addition to the primaries. Around 1947 he began to paint his diamond-shaped canvases, and in the 1950s experimented with tondos and ovals, which became lifelong challenges. In 1961, Bolotowsky created his first sculptures of freestanding painted columns composed of wood, Lucite or aluminum.

A multifaceted artist, Bolotowsky also wrote stories and plays and made documentary films of artists. In 1971, he received a prize from the National Institute of Arts and Letters. In 1974, the Guggenheim Museum held a retrospective exhibition of his works. He died in 1981 in New York City.

## SELECTED SOLO EXHIBITIONS

1946　*Ilya Bolotowsky,* J. B. Neumann's New Art Circle, New York (also exhibited 1952)

1954　*Ilya Bolotowsky,* Grace Borgenicht Gallery, New York (also exhibited 1956, 1958, 1961, 1963, 1966, 1968, 1970, 1972, 1974, 1976, 1978, 1980)

1960　*Ilya Bolotowsky,* State University College of Education, New Paltz, New York

1974　*Ilya Bolotowsky,* Solomon R. Guggenheim Museum, New York

1974　*Ilya Bolotowsky,* National Collection of Fine Arts, Smithsonian Institution, Washington, D.C.

1985　*Homage to Bolotowsky 1935-1981,* Fine Arts Center Art Gallery, State University of New York, Stony Brook, New York

## SELECTED GROUP EXHIBITIONS

1936　*New Horizons in American Art,* The Museum of Modern Art, New York

1942　*American Non-Objectives,* Museum of Non-Objective Painting, New York

1947　*Abstract and Surrealist American Art,* The Art Institute of Chicago

1950　*Annual Exhibition,* Whitney Museum of American Art, New York

1968　*The 1930s: Painting and Sculpture in America,* Whitney Museum of American Art, New York

1976　*The Golden Door: Artist-Immigrants of America, 1876-1976,* Hirshhorn Museum and Sculpture Garden, Smithsonian Institution, Washington, D.C.

1983　*Abstract Painting and Sculpture in America, 1927-1944,* Museum of Art, Carnegie Institute, Pittsburgh

1986　*The Machine Age in America 1918-1941,* The Brooklyn Museum, New York

1989　*The Patricia and Phillip Frost Collection: American Abstraction 1930-1945,* National Museum of American Art, Smithsonian Institution, Washington, D.C.

## SELECTED BIBLIOGRAPHY

Bolotowsky, Ilya. "Adventures with Bolotowsky." *Archives of American Art Journal* 22, 1 (1982): 8-29.

Bolotowsky, Ilya. "On Neoplasticism and My Own Work: A Memoir." *Leonardo* (July-August 1969): 221-230.

Breeskin, Adelyn D. *Ilya Bolotowsky.* New York: Solomon R. Guggenheim Museum, 1974. Exh. cat.

King, Lyndel, intro. *American Paintings and Sculpture in the University Art Museum Collection.* Minneapolis: University of Minnesota, 1986.

Lane, John R., and Susan C. Larsen, eds. *Abstract Painting and Sculpture in America, 1927-1944.* New York: Museum of Art, Carnegie Institute, in association with Abrams, 1983. Exh. cat.

**MINNA CITRON** (born 1896)

Minna Citron was born in Newark, New Jersey, to Simon and Lena (Tobias) Wright. Her father, who was of Alsatian descent, died when she was eight, leaving behind a family of five children. She began to study painting in 1924 at the Brooklyn Institute of Arts and Sciences with Benjamin Kopman. After one year she studied at the New York School of Applied Design for Women, graduating in 1927. For the next seven years she attended the Art Students League, studying with Kenneth Hayes Miller, Kimon Nicolaides and Harry Sternberg. During this time she had her first one-woman show, in 1930, at the New School for Social Research.

In the mid-thirties Citron moved from Brooklyn to Manhattan, taking a studio in the same building where Miller worked on East Fourteenth Street. Along with Isabel Bishop and Reginald Marsh, she become identified with Miller and the Fourteenth Street School, a group of artists who lived and worked near Union Square, documenting the ceaseless human traffic of vagrants, shoppers, political orators and neighborhood characters. Later she moved her studio to 857 Broadway, where Bishop's studio was.

In 1935 Citron had her first major one-woman show, titled *Feminanities*, at the Midtown Galleries, which satirized women in various activities of modern life. During this time she was employed by the WPA/FAP as a teacher of painting. In 1938 she participated in the first exhibition of YKUF, the World Alliance for Yiddish Culture, which showed her oil *Staten Island Ferry*. In this same year, she received a government commission to paint two murals on the subject of the Tennessee Valley Authority for the U.S. Post Office in Newport, Tennessee. During the two years spent researching this theme, she created a series of paintings, drawings and lithographs on workers involved in this historic project, which were later exhibited at the Art Students League.

In the mid-forties Citron joined printmaker Stanley William Hayter's Atelier 17, where she remained for fifteen years. There her contact with European refugees, including Chagall and Lipchitz, influenced her evolution toward becoming an abstractionist. She made her first completely abstract print in 1946.

From the 1940s through the 1960s Citron showed in numerous exhibitions abroad and traveled extensively in South America and Europe. She had solo exhibitions in São Paulo, in Havana, at the U.S. Embassy in London, and in Lima and Santiago. In 1947 she represented the United States government at the Congrès International d'Education Artistique in Paris. As director of the Pan American Women's Association, she traveled through South America on a lecture tour. In addition, she was the Paris correspondent for *Iconograph* magazine in 1946 and wrote articles for the *College Art Journal* and other magazines.

Citron received many awards in recognition of her professional achievement, including Yaddo and MacDowell Fellowships and a Ford Foundation grant. She served as a delegate to the 1972 National Conference on Women, held at the Corcoran Gallery in Washington, D.C. Today Minna Citron still lives near Union Square.

SELECTED SOLO EXHIBITIONS

1930   New School for Social Research, New York (also exhibited 1950)

1932   Brownell-Lambertson Gallery, New York

1935   *Feminanities*, Midtown Galleries, New York (also exhibited 1937, 1941)

1940   *Two Murals of T.V.A.*, Art Students League, New York

1941   Corcoran Gallery of Art, Washington, D.C.

1952   Museu de Arte Moderna, São Paulo, Brazil

1954   *A Decade of Citron Paintings*, Louisville Art Center, Kentucky

1956   Instituto Nacional de Cuba, Havana

1967   U.S. Embassy, London

1968   Instituto Cultural Peruano-Norte Americano, Lima

1976   *Minna Citron: Selected Paintings 1950-1960*, Pace University, New York

1982   *Minna Citron: Selected Works 1930-1980*, Galeria Joan Prats, New York

1986   *Minna Citron at 90*, Douglass College Library, Rutgers University, New Brunswick, New Jersey

1986   *A Salute to Minna Citron on Her 90th Birthday*, Sragow Gallery, New York

1990   *Minna Citron: A Survey of Paintings and Works on Paper 1931-1989*, Susan Teller Gallery, New York

SELECTED GROUP EXHIBITIONS

1938   *First Exhibition of Painting, Sculpture, Graphic Arts and Yiddish Books and Press*, World Alliance for Yiddish Culture (Yiddisher Kultur Farband), New York

1939   *Art in a Skyscraper*, American Artists' Congress, New York

1941   Carnegie Institute, Pittsburgh (also exhibited 1942, 1943)

1945   *Portrait of America*, The Metropolitan Museum of Art, New York

1955   *14 Painter-Printmakers*, The Brooklyn Museum, New York

1976   *7 American Women: The Depression Decade*, Vassar College Art Gallery, Poughkeepsie, New York

1983   *Artists for Victory*, Library of Congress, Washington, D.C.

1988   *Women Artists of the New Deal Era: A Selection of Prints and Drawings*, The National Museum of Women in the Arts, Washington, D.C.

SELECTED BIBLIOGRAPHY

Chapman, Max. *From the 80 Years of Minna Citron*. New York: Wittenborn Books, 1976.

Greengard, Stephen N., ed. "Ten Crucial Years: The Development of U.S. Government Sponsored Artists Programs, 1933-1943: A Panel Discussion by Six WPA Artists." *Journal of Decorative and Propaganda Arts* 1 (Spring 1986): 40-61.

Landau, Ellen G. *Artists for Victory*. Washington, D.C.: Library of Congress, 1983. Exh. cat.

Marling, Karal Ann, and Helen A. Harrison. *7 American Women: The Depression Decade*. Poughkeepsie, New York: Vassar College Art Gallery, 1976. Exh. cat.

Rubinstein, Charlotte Streifer. *American Women Artists*. Boston: G. K. Hall and Co., 1982.

**FRANCIS CRISS** (1901-1973)

Born in London of Russian descent on April 27, 1901, Francis Criss (Hyman Fischel Criss) was the eldest of the seven children of Samuel and Katherine Criss. The family immigrated to the United States in 1904, settling in Philadelphia. While recuperating from a childhood bout with polio, Criss began to sketch, revealing his artistic talent. He attended the Graphic Sketch Club from the time he was ten until he was sixteen. From 1917 to 1921 he studied at the Pennsylvania Academy of the Fine Arts, and in 1920 he went abroad after having won the Cresson Scholarship for study in Europe. Criss came to New York City in 1926 and attended evening classes at the Art Students League. Among his instructors at the League were Boardman Robinson and Kimon Nicolaides;

from 1929 to 1931 he studied with Jan Matulka.

In November 1932, Criss was included in the Whitney Museum's first biennial exhibition, contributing *Astor Place*, which the museum subsequently purchased. Two months later he was given his first one-man show at the Contemporary Arts Gallery in New York; among the paintings exhibited was *My Wife and Mina*. In the spring of 1933 Criss received his second solo exhibition at the Mellon Galleries in Philadelphia, which included portraits and New York City scenes such as *The "El"*. In 1934 Criss traveled to Europe on a Guggenheim Fellowship. While in Italy he produced his strongest political work entitled *Fascism*. Painted in a Surrealist style reminiscent of de Chirico, it commented on military power. After his return to New York Criss joined the WPA, and in 1935 he was one of twelve artists chosen to design murals for the Williamsburg Housing Project in Brooklyn; among the other artists were Bolotowsky, Matulka and Stuart Davis, the latter a neighbor in Greenwich Village. Criss's mural, *Sixth Avenue El*, with its sharply delineated flat forms, demonstrated his kinship with the Precisionists Niles Spencer and Charles Sheeler. Concentrating on industrial themes and architectural elements of the city, Criss painted subway stations, skyscrapers and factories in a strong geometric style. He used bright, unmodulated colors to decorate the linear, flat, unembellished buildings exemplified in *Rhapsody in Steel* (1939). Favorite themes as nuns, the elevated train and Astor Place reappear in several versions of his work. A portraitist as well, Criss depicted family members and fellow artists, including Chaim Gross in *Why the Line?* (1935). In 1938 Criss participated in the first exhibition of the World Alliance for Yiddish Culture (YKUF), joining his friends Stuart Davis and Chaim Gross.

From the late 1930s to 1940s Criss supported himself as a commercial artist, illustrating magazine articles and designing book jackets and posters. During these years he also taught extensively at such institutions as the Albright Museum Art School, the Art Students League, and the New School for Social Research. Though he painted infrequently during this period, he accepted several commissions for portraits of rabbis and also portrayed his father in his religious garb. In 1943 he joined Philip Evergood and Aaron Goodelman in the exhibition *Our Country's Worth Fighting For*, sponsored by An American Group. During the 1960s he experimented with pointillism and also began a series of painted collages juxtaposing faces cut from photographs with bits of newspaper. He died in New York in 1973.

SELECTED SOLO EXHIBITIONS

1933    *Francis Criss*, Contemporary Arts Gallery, New York

1933    *Francis Criss*, Mellon Galleries, Philadelphia

1950    *Francis Criss*, The Cartoonists and Illustrators School, New York

1953    *Paintings by Francis Criss: Moods and Tempo of New York*, Philadelphia Art Alliance

1966    *Francis Criss: Retrospective*, School of Visual Arts, New York

SELECTED GROUP EXHIBITIONS

1932    *Biennial Exhibition*, Whitney Museum of American Art, New York (also exhibited 1936, 1938, 1940, 1943)

1934    *Annual Exhibition*, Pennsylvania Academy of the Fine Arts, Philadelphia (also exhibited 1942-1946, 1966)

1936    *New Horizons in American Art*, The Museum of Modern Art, New York

1937    *Biennial Exhibition*, The Corcoran Gallery of Art, Washington, D.C. (also exhibited 1939, 1943, 1947)

1942    *Artists for Victory*, The Metropolitan Museum of Art, New York

1982    *Images of America: Precisionist Painting and Modern Photography*, San Francisco Museum of Modern Art (traveled)

1985    *The Surreal City: 1930s-1950s*, Whitney Museum of American Art at Philip Morris, New York (traveled)

1986    *Commemorative Exhibition of the 50th Anniversary of the American Artists' Congress*, ACA Galleries, New York

1986    *The Machine Age in America 1918-1941*, The Brooklyn Museum, New York

SELECTED BIBLIOGRAPHY

Archives of American Art, Smithsonian Institution, Washington, D.C., Francis Criss Papers.

Berman, Greta. "Abstractions for Public Spaces, 1935-1943." *Arts* 56, 10 (June 1982): 81-86.

*Francis Criss*. Philadelphia: Mellon Galleries, 1933. Exh. cat.

*The Ebsworth Collection: American Modernism 1911-1947*. St. Louis, Missouri: The Saint Louis Art Museum, 1987. Exh. cat.

Fort, Ilene Susan. "American Social Surrealism." *Archives of American Art Journal* 27, 3 (1982): 8-20.

Tsujimoto, Karen. *Images of America: Precisionist Painting and Modern Photography*. Seattle: University of Washington, 1982. Exh. cat.

Wilson, Richard Guy, Dianne H. Pilgrim and Dickran Tashjian. *The Machine Age in America 1918-1941*. New York: Abrams, 1986. Exh. cat.

## JO DAVIDSON (1883-1952)

Joseph Davidson was born in New York on March 30, 1883, the son of Russian immigrants living on the Lower East Side. His Orthodox father was devoted to religious study and prayer, while his mother supported the family by sewing ties. Davidson studied at the Educational Alliance during the late-1890s under Henry McBride and was a close friend of Samuel Halpert. From 1899 to 1902 he studied at the Art Students League under George de Forrest Brush. After a few months attending classes at the Yale School of Art, Davidson returned to New York in 1902 to focus on sculpture, working as an assistant to Herman A. MacNeil.

Davidson moved to Paris in 1907, attending the École des Beaux-Arts briefly. From then on he lived mostly in New York and France. Also in 1907 Gertrude Vanderbilt Whitney purchased one of his works and the following year he exhibited in the *Salon d'Automne*. In 1913 Davidson participated in the Armory Show and had his first solo show at the Reinhardt Gallery in New York. During the teens the artist's portrait sculpture gained increasing popularity among the elite and became the lucrative focus of his work. His naturalistic style was at this time considered avant-garde for its lively, if at times coarse, impressionistic surface. Leaving traces of the clay-modeling process intact, he revealed his adherence to the modernist ideal of remaining true to the materials. Davidson participated in the People's Art Guild exhibition at the Forward Building in 1917 and the following year began to exhibit with the Whitney Studio Club. During World War I the artist worked as a news correspondent and afterward was commissioned to create bronze portraits of the Allied leaders, including President Wilson and General Pershing.

Davidson traveled to the U.S.S.R. in the early twenties to create portrait sculptures of Soviet political and intellectual figures. In 1925 he was awarded the title of Chevalier of the Legion of Honor by the French government. During the thirties the artist began to experiment with polychrome baked into terra-cotta, as in his portrait of John D. Rockefeller, Sr. Joining other artists opposed to Fascism, Davidson supported the Loyalist cause of the Spanish Civil War, visiting the country in 1938, where he executed portraits of the Loyalist leaders. These were shown during the same year in a New York exhibition to benefit Spanish children, sponsored by a committee that included the artists Rockwell Kent, Walter Pach and William and Marguerite Zorach, as well as the writer Dorothy Parker, among others.

During 1941 Davidson traveled to South America, modeling portrait heads of the leaders of ten South American republics. In 1944 the artist participated in the National Council of American-Soviet Friendship. After World War II Davidson entered two competitions for Holocaust memorials, one in Warsaw, Poland, commemorating the ghetto, and the other for a Riverside Drive monument in New York, which was never executed.

In 1952, Davidson visited Israel to create a portrait series of Israeli leaders, including Prime Minister David Ben-Gurion. The artist died in Tours, France. The National Portrait Gallery in Washington, D.C., held a retrospective of Davidson's work in 1978.

## SELECTED SOLO EXHIBITIONS

1913   *Sculpture by Jo Davidson*, Reinhardt Gallery, New York (also exhibited 1916, 1920)

1914   *Exhibition of Sculpture by Jo Davidson*, Leicester Galleries, London

1920   *Sculpture by Jo Davidson*, The Art Institute of Chicago

1921   *Exhibition of Bronze Busts of War Heroes by Jo Davidson*, Corcoran Gallery of Art, Washington, D.C.

1922   *Sculpture-Drawings by Jo Davidson*, Wildenstein Gallery, New York (also exhibited 1926)

1931   *Exhibition of Portrait Busts of Some Contemporary Men of Letters by Jo Davidson*, M. Knoedler and Co., London

1933   *Exhibition of a Group of Abstractions*, Marie Sterner Galleries, New York

1933   *Exhibition of Recent Portraits in Bronze and Polychromed Terra-Cotta by Jo Davidson*, M. Knoedler and Co.,

New York (also exhibited 1940, 1967)

1938   *An Exhibition of Jo Davidson Sculpture Including Portraits of Leading Spanish Personalities for the Benefit of the Spanish Children's Milk Fund*, Arden Gallery, New York

1942   *Bronzes by Jo Davidson, Presidents of the South American Republics*, National Gallery of Art, Washington, D.C.

1947   *Jo Davidson*, American Academy of Arts and Letters and National Institute of Arts and Letters, New York

1948   *Retrospective Exhibition of Sculptured Portraits and Other Works by Jo Davidson*, New York Museum of Science and Industry, New York.

1978   *Jo Davidson, Portrait Sculpture*, National Portrait Gallery, Smithsonian Institution, Washington, D.C.

1980   *Jo Davidson in Relation to His Time*, ACA Galleries, New York

1983   *Jo Davidson, American Sculptor, 1883-1952*, Hammer Galleries, New York

## SELECTED GROUP EXHIBITIONS

1908   *Salon d'Automne*, Paris

1913   *International Exhibition of Modern Art*, organized by the Association of American Painters and Sculptors, 69th Regiment Armory, New York (traveled)

1917   *People's Art Guild Exhibition at the Forward Building*, New York

1917   *First Annual Exhibition of the Society of Independent Artists*, Grand Central Palace, New York (also exhibited 1918)

1918   *Annual Exhibition*, Whitney Studio Club, New York (also exhibited 1920-1924, 1926-1928)

1932   *American Painting and Sculpture (1862-1932)*, The Museum of Modern Art, New York

1933   *Biennial Exhibition*, Whitney Museum of American Art, New York (also exhibited 1936, 1939, 1941-1945)

1933   *A Century of Progress Exhibition of Paintings and Sculpture*, The Art Institute of Chicago

1940   *Exhibition of Paintings and Sculpture by the Art School Alumni of the Educational Alliance*, Associated American Artists Galleries, New York

1953   *Twenty-fifth Anniversary*, Sculpture Center, New York

1954   *Abbo Ostrowsky Collection of the Educational Alliance Art School*, The Jewish Museum, New York

1963   *Retrospective Art Exhibit of the Educational Alliance Art School*, American Federation of Arts Gallery, New York

## SELECTED BIBLIOGRAPHY

Davidson, Jo. *Between Sittings: An Informal Autobiography*. New York: Dial Press, 1952.

*Jo Davidson, Portrait Sculpture*. Washington, D.C.: National Portrait Gallery, Smithsonian Institution, 1978. Exh. cat.

Kuhn, Lois Harris. *The World of Jo Davidson*. New York: Farrar, Straus and Cudahy, Jewish Publication Society, 1958.

*Retrospective Exhibition of Sculptured Portraits and Other Works by Jo Davidson*. New York: New York Museum of Science and Industry, 1948. Exh. cat.

## JACOB EPSTEIN (1880-1959)

Born November 10, 1880, in New York City to Orthodox Russian-Polish immigrants, Jacob Epstein grew up on the Lower East Side. Between 1893 and 1902, he studied drawing with James C. Beckwith at the Art Students League. Epstein's Hester Street neighborhood was a favorite subject for his drawings, executed in a candid realist style that, within a decade, would appear in works of Ashcan School artists like John Sloan. Some of Epstein's drawings illustrated *The Century* and *The Critic*, as well as Hutchins Hapgood's *The Spirit of the Ghetto* (1902). Epstein helped organize an informal Educational Alliance exhibition of local artists in 1898 and often casually coached students like Samuel Halpert. By 1900 he had experimented with sculpture and was working in a bronze foundry while studying at the League with George Grey Barnard.

In 1902 Epstein moved to Paris, sharing an apartment with Bernar Gussow, a Jewish painter whom he had met at the League. Epstein attended the École des Beaux-Arts in 1903. The following year he studied at the Académie Julian and created his first serious figural sculptures. Epstein moved to London in 1905 where he settled permanently and became friends with other American expatriates, such as the poets T. S. Eliot and Ezra Pound, an early supporter of his work. From the start, Epstein was attracted to the integration of sculpture and architecture, and in 1907 he received the commission to create eighteen figures for the British Medical Asso-

ciation Building on the Strand in London. These focused on humanist themes, and many reflect his interest at the time in Archaic Greek and primitive art. Though championed by a number of artists and critics, the sculptures' nudity met with great public hostility. During a trip to Paris in 1912 Epstein met Pablo Picasso, Constantin Brancusi and Amedeo Modigliani, and became increasingly interested in African sculpture. In 1913 the artist's work was represented in the Armory Show in New York and his first solo exhibition was held at the Twenty-one Gallery in London. Epstein met the Vorticist painter and writer Wyndham Lewis, whose style influenced much of Epstein's work of the time and who, in 1914, published his drawings in *Blast*.

By the following year, Epstein's figural work once again exhibited mainly modernist interpretations of Egyptian, Archaic and primitive art. His portrait sculptures, mostly bronzes, present a far greater degree of naturalism and their thick, impressionistic modeling reflects Brancusi's interest in truth to materials. The renowned American collector John Quinn began to purchase Epstein's work in the mid-teens, becoming one of his major patrons. By 1917 Epstein was established as a portrait sculptor patronized by a small but distinguished group of socialites and dignitaries. From 1917 to 1918, he served in a Jewish battalion of the British army, but never left England.

During the twenties, Epstein became a target of anti-Semitic attacks in the British press, the worst of which surrounded his W. H. Hudson Memorial, unveiled in Hyde Park, London, in 1925 and later defiled by Fascist groups in 1935. The criticism focused on what was felt to be his barbaric style and preference for non-Aryan features, and the artist received no large-scale public commissions between 1929 and 1953. In 1937 Epstein took part in the International Peace Campaign against Fascist aggression in Spain. His *Social Consciousness* was created for the Philadelphia Museum of Art in 1951. Epstein founded the London County Council Sculpture School at Camberwell in 1953 and the following year was knighted. The artist died in 1959 in England.

## SELECTED SOLO EXHIBITIONS

1913    *Jacob Epstein*, Twenty-one Gallery, London

1917    *The Sculpture of Jacob Epstein*, Leicester Galleries, London (also exhibited 1920, 1924, 1926, 1931, 1933, 1935, 1937, 1939, 1940, 1942, 1944, 1945, 1947, 1950, 1953, 1960, 1971)

1924    *Jacob Epstein*, Scott and Fowles, New York

1930    *Jacob Epstein*, Knoedler Gallery, London

1952    *Epstein*, The Tate Gallery, London (also exhibited 1961, 1980)

1959    *Memorial Exhibition: Jacob Epstein*, Ben Uri Art Gallery, London (also exhibited 1980)

1973    *Sculpture of Jacob Epstein: The Eisenberg-Robbins Collection*, The Corcoran Gallery of Art, Washington, D.C.

1974    *Jacob Epstein, Sculpture*, Museum of Contemporary Art, Chicago

1975    *Jacob Epstein (1880-1959): A Loan Exhibition*, Joe and Emily Lowe Art Gallery, Syracuse University, New York

1977    *Jacob Epstein*, National Gallery of Canada, Ottawa (traveled)

1980    *Rebel Angel: Sculpture and Watercolors by Sir Jacob Epstein, 1880-1959*, Birmingham Museum and Art Gallery, England

1987    *Jacob Epstein: Sculpture and Drawings*, Whitechapel Art Gallery, London (traveled)

## SELECTED GROUP EXHIBITIONS

1908    *Salon D'Automne*, Paris

1911    National Portrait Society, London (also exhibited 1918)

1913    *Post-Impressionists and Futurists*, Doré Gallery, London

1913    *International Exhibition of Modern Art*, organized by the Association of American Painters and Sculptors, 69th Regiment Armory, New York (traveled)

1914    *The London Group*, Goupil Gallery, Paris

1914    *Twentieth Century Art: A Review of Modern Movements*, Whitechapel Art Gallery, London

1939    *Art in Our Time*, The Museum of Modern Art, New York

1940    *The Educational Alliance Art School 25th Anniversary Exhibition*, Associated American Artists Galleries, New York

1950    *Jewish Artists—1950: Annual Exhibition*, Congress for Jewish Culture Art Center, The Jewish Museum, New York

1956    *Jewish Artists in England 1656-1956: A Tercentenary Exhibition*, Whitechapel Art Gallery, London

1963    *The Educational Alliance Art School Retrospective Art Exhibit*, American Federation of Arts Gallery, New York

1966    *The Lower East Side: Portal to American Life (1870-1924)*, The Jewish Museum, New York (traveled)

1974    *Vorticism and Its Allies*, Arts Council exhibition at Hayward Gallery, London

1975    *Jewish Experience in the Art of the Twentieth Century*, The Jewish Museum, New York

1976    *Jewish Art in Britain 1900-1950*, Fine Art Society, Glasgow

1978    *Jewish Artists of Great Britain, 1845-1945*, Belgrave Gallery, Ltd., London and Cartwright Hall Art Gallery and Museum, Bradford, Yorkshire.

1979    *Jewish Art: Paintings and Sculpture of 20th Century Jewish Artists of the French and British Schools*, Art Gallery and Museum, Glasgow

1983    *The Immigrant Generations: Jewish Artists in Britain, 1900-1945*, The Jewish Museum, New York

1990    *Chagall to Kitaj: Jewish Experience in 20th Century Art*, Barbican Art Gallery, London

## SELECTED BIBLIOGRAPHY

Buckle, Richard. *Jacob Epstein: Sculptor*. New York: World Publishing Co., 1963.

Epstein, Jacob. *Let There Be Sculpture*. New York: G. P. Putnam's Sons, 1940; reissued as *Epstein, An Autobiography*. New York: Dutton, 1955.

Grose, Irving. *Jewish Artists of Great Britain, 1845-1945*. London and Bradford: Belgrave Gallery, Ltd. and Cartwright Hall Art Gallery and Museum, 1978. Exh. cat.

Rothenstein, John. *Epstein*. London: The Tate Gallery, 1961. Exh. cat.

Schwarz, Karl. *Jewish Artists of the 19th and 20th Centuries*. Freeport, New York: Books for Libraries Press, for the Philosophical Library, Inc., 1949, reprint 1970.

Silber, Evelyn, and Terry Friedman. *Jacob Epstein: Sculpture and Drawings*. Leeds: W. S. Maney and Son in association with the Henry Moore Centre for the Study of Sculpture, 1989. Exh. cat.

Silber, Evelyn. *The Sculpture of Epstein, with a Complete Catalogue*. Lewisburg, Pennsylvania: Bucknell University Press, 1986.

Spencer, Charles. *Jewish Art: Paintings and Sculpture of 20th Century Jewish Artists of the French and British Schools.* Glasgow: Art Gallery and Museum, 1979. Exh. cat.

## PHILIP EVERGOOD (1901-1973)

Philip Howard Francis Dixon Blashki was born on October 26, 1901, in New York. His father was an Australian-Polish landscape painter who came from an Orthodox family and his mother was Episcopalian. Evergood was educated in England beginning in 1909. In 1914, the family surname was changed to Evergood after anti-Semitism prevented Philip from enrolling in an English naval academy. Instead, he studied at Eton from 1915 to 1919 and there began to draw and paint seriously. After one year at Cambridge University, the young artist entered the Slade School of Art in London, graduating in 1923 with a teaching certificate.

Evergood returned to New York that same year and studied with William von Schlegell and the Ashcan painter George Luks at the Art Students League, where he met fellow students Raphael Soyer and Barnett Newman. Evergood also attended classes at the Educational Alliance in 1924, where he met his close friends Chaim Gross and Moses Soyer and may have attended Louis Lozowick's art history lectures. Later that year, Evergood traveled to Paris, briefly attending the Académie Julian and exhibiting in the 1925 *Salon d'Automne.* The artist returned to New York in 1926. In 1927 he began sketching scenes of contemporary working-class life and the following year had his first solo exhibition at Dudensing Gallery in New York. He went to Paris in 1929 to study engraving for a year. In 1931 Evergood traveled to Spain and then returned to New York.

During the thirties, Evergood met Ben Shahn, Hugo Gellert and Reginald Marsh. All were active in the John Reed Club and later taught at its art school. Evergood also became close friends with the older Ashcan artist John Sloan, sharing with him a passion for depicting contemporary city life. During this decade Evergood developed his own style of Social Realism, presenting an objective view of reality depicted in an intentionally naive style, with skewed perspective and a multitude of detail, as in *Nude by the El* (1934). Brilliant accent colors and caricatures often energize scenes of everyday life. Evergood joined the Public Works of Art Project in 1933 and from 1935 to 1939 was the managing supervisor of the easel division of the WPA/FAP, while also at times working on the mural section. In 1935 he helped to organize the Artists Committee of Action and the Artists Union, serving as president of the latter from 1937 to 1939. Evergood became actively involved in the American Artists' Congress in 1936 and later taught at the American Artists School. In 1938 he held his first one-man show at the ACA Galleries in New York and exhibited with the Yiddish Popular Front group YKUF.

Evergood began to write articles proselytizing social awareness in art, appearing during the forties in such publications as the *New Masses* and *Daily Worker.* In 1943 Joseph Hirshhorn became one of Evergood's friends and most prominent patrons. The following year the artist participated in the National Council of American-Soviet Friendship. Around the mid-forties Evergood's work began to reflect an interest in Surrealism, with fantastic backgrounds and greater distortions of form and perspective. Evergood moved to Patchogue, Long Island, in 1947 and the following year was included in the Venice Biennale. He cofounded the magazine *Reality: A Journal of Artists' Opinions* along with friends Raphael Soyer, Ben Shahn, Edward Hopper and Yasuo Kuniyoshi, among others, in support of realist painting. He moved to Connecticut in 1952. Evergood was called before the House Un-American Activities Committee in 1959. Ironically, he also participated in the United States Information Agency's exhibition in Moscow that year. The following year the Whitney Museum of American Art held a retrospective of his work. The artist died in a fire at his home in Bridgewater, Connecticut, in 1973. Other retrospectives were mounted at the Hirshhorn Museum and Sculpture Garden in 1978 and the Center Gallery at Bucknell University in 1986.

### SELECTED SOLO EXHIBITIONS

1927    *Philip Evergood,* Dudensing Gallery, New York

1929    *Philip Evergood,* Montross Gallery, New York (also exhibited 1933, 1935)

1936    *Philip Evergood,* Denver Art Museum

1938    *Philip Evergood,* ACA Galleries, New York (also exhibited 1940, 1942, 1944, 1946, 1948, 1951, 1953, 1955, 1960, 1962)

1960    *Philip Evergood,* Whitney Museum of American Art, New York (traveled)

1963    *Philip Evergood,* La Galleria 63, Rome, Italy

1972    *Philip Evergood: Paintings and Drawings,* Kennedy Galleries, New York

1978    *Philip Evergood: Selections from the Museum,* Hirshhorn Museum and Sculpture Garden, Smithsonian Institution, Washington, D.C.

1986    *Philip Evergood: Never Separate from the Heart,* Center Gallery, Bucknell University, Lewisburg, Pennsylvania (traveled)

### SELECTED GROUP EXHIBITIONS

1925    *Salon d'Automne,* Paris

1926    Dudensing Galleries, New York (also exhibited 1929)

1932    *Murals by American Painters and Photographers,* The Museum of Modern Art, New York

1932    *Annual Exhibition,* Society of Independent Artists, New York (also exhibited 1934-1940, 1942)

1933    *The Social Viewpoint in Art,* John Reed Club, New York

1936    *New Horizons in American Art,* The Museum of Modern Art, New York

1937    *First Annual Membership Exhibition,* American Artists' Congress, New York (also exhibited 1938, 1939)

1938    *First Exhibition of Painting, Sculpture, Graphic Arts and Yiddish Books and Press,* World Alliance for Yiddish Culture (Yiddisher Kultur Farband), New York

1939    *Annual Exhibition,* Whitney Museum of American Art, New York (also exhibited 1941-1950)

1940    *The Educational Alliance Art School 25th Anniversary Exhibition,* Associated American Artists Galleries, New York

1947    *Depictions of the East Side,* Educational Alliance, New York

1948    *XXIV Biennale,* Venice, Italy

1950    *American Painting Today,* The Metropolitan Museum of Art, New York

1951    *Revolution and Tradition,* The Brooklyn Museum, New York

1954    *Abbo Ostrowsky Collection of the Educational Alliance Art School,* The Jewish Museum, New York

1959    *American Painting and Sculpture: American National Exhibition in Moscow,* organized by the United States Information Agency (USIA), Sokolniki Park, Moscow, U.S.S.R.

1963   *Retrospective Art Exhibit of the Educational Alliance Art School*, American Federation of Arts Gallery, New York

1982   *Realism and Realities: The Other Side of American Painting, 1940-1960*, Rutgers University Art Gallery, New Brunswick, New Jersey (traveled)

SELECTED BIBLIOGRAPHY

Archives of American Art, Smithsonian Institution, Philip Evergood Papers.

Baur, John I. H. *Philip Evergood*. New York: Abrams, 1975.

Lippard, Lucy. *The Graphic Works of Philip Evergood*. New York: Crown Publishers, 1966.

Syracuse University Library, Rare Book Section, Philip Evergood Papers.

Taylor, Kendall. *Philip Evergood: Never Separate from the Heart*. London and Toronto: Associated University Presses, 1987. Exh. cat.

## LOUIS G. FERSTADT (1900-1954)

Louis Goodman Ferstadt was born in Barrasstechky, Ukraine, on September 24, 1900, and came to America with his family when he was ten years old. He wrote later in life that the date of his birth was always remembered because it coincided with a severe pogrom which occurred in his village. Ferstadt studied painting at the Art Institute of Chicago beginning in 1918, while supporting himself by working evenings on the art staff of the Chicago *Tribune*. In 1923 he won a scholarship to the Art Students League and came to New York, where he studied with Kenneth Hayes Miller. When his scholarship funds ran out, he enrolled at the Educational Alliance Art School and later taught an art class there.

In the 1920s he painted representational works in a subdued palette. He made his living as a cartoonist for the New York *Evening Graphic*, illustrated a children's book and was a free-lance commercial artist. Ferstadt had his first one-man show at the Society for the Advancement of Judaism in New York in 1928 and exhibited at the Brooklyn Museum in 1932. In 1935 he joined the Mexican mural painter David Alfaro Siqueiros and others in organizing the Siqueiros Experimental Workshop in New York. The group's artists explored the potential use of synthetic and industrial materials in public works of art. Ferstadt's commitment to mural painting as a public art form coincided with his social consciousness. In the 1930s he worked to unionize muralists in the Mural Artists Guild, a local of the American Federation of Labor, and was a member of the Artists Equity Asso-

ciation. In his murals of the period he combined abstraction with classical realism, allowing form and color to assert themselves without giving up representation. He also supervised a mural project for the Fine Arts Project of the WPA in 1937 at Hunter College in New York.

His work was included in the collection of the Birobidzhan Museum that was established in the Jewish autonomous region of the Soviet Union with the assistance of leftist American artists near the end of the decade.

The artist frequently adopted diverse styles in the late 1930s to express different emotions and states of mind. Ferstadt also made technological innovations in the mural format, including collapsible, revolving, electronic and motorized murals. In 1939 he created a mural for the subway entrance to the New York World's Fair depicting workers across America at home, at work and coming to the Fair. A section of the mural represented Ferstadt's faith in technology in an abstracted vision of the "World of Tomorrow." Ferstadt showed at the Bonestell Gallery in the 1940s, although from 1940 to 1946 he completed few new paintings and devoted much of his time to writing and drawing for comic books. He died in 1954.

## SELECTED SOLO EXHIBITIONS

1928   *Louis G. Ferstadt*, Society for the Advancement of Judaism, New York

1931   *Louis G. Ferstadt*, Studio-Gallery of Louis G. Ferstadt, New York

1932   *Louis Ferstadt*, Hudson D. Walker Gallery, New York (also exhibited 1939)

1935   *Ferstadt*, ACA Galleries, New York

1950   *Exhibition of Oils and Gouaches by Louis G. Ferstadt*, Creative Gallery, New York

1952   *Ferstadt*, American Gallery, New York

## SELECTED GROUP EXHIBITIONS

1927   *Annual Exhibition*, Society of Independent Artists, New York (also exhibited 1928, 1933-1935)

1928   *Annual Exhibition*, Whitney Studio Club, New York

1932   *Summer Exhibition of Paintings, Sculpture and Drawings*, The Brooklyn Museum, Brooklyn, New York

1933   *Biennial Exhibition*, Whitney Museum of American Art, New York (also exhibited 1936, 1938, 1939, 1946, 1949)

1935   *Mural Painters Society*, Grand Central Art Galleries, New York

1940   *Exhibition of Paintings and Sculpture by the Art School Alumni of the Educational Alliance*, Associated American Artists Galleries, New York

SELECTED BIBLIOGRAPHY

"Louis G. Ferstadt, Artist, Sculptor," New York *Times*, August 20, 1954. Unpaginated clipping from the Louis G. Ferstadt file, Whitney Museum of American Art, New York.

*Louis G. Ferstadt*. New York: Studio Gallery of Louis G. Ferstadt, n.d. Exh. brochure.

*Louis G. Ferstadt*. New York: Society for the Advancement of Judaism, 1928. Exh. brochure.

"New York World's Fair. Fair Commissioned Sculpture." Department of Fair Publicity. Typescript. Museum of Modern Art Library.

## ARNOLD FRIEDMAN (1874-1946)

Arnold Friedman was born on February 23, 1874, on New York's Lower East Side, the son of Hungarian immigrants. After graduating from City College, Friedman took a full-time job as a postal clerk. Though he had made drawings as a child, he did not formally study art until the age of thirty-one, when he attended the Art Students League from 1905 to 1908. There he studied under Robert Henri, along with fellow students Edward Hopper, Rockwell Kent, George Bellows, Guy Pene Du Bois and Walter Pach, who remained a close friend.

After a six-month trip to Paris in 1908, Friedman experimented with various aspects of French modernism. In 1915 he was included in his first group show at Montross Gallery in New York. That same year he moved to Corona, Queens, New York, where he spent the rest of his life. Friedman was one of the initial organizers of the Society of Independent Artists in 1917.

During the twenties, Friedman exhibited occasionally, but withdrew from the social side of the art world in order to spend time with his family. His style tended toward flat linear compositions exhibiting a strong naturalism accented by decorative patterning. In 1925 Friedman had his first solo exhibition at the Bourgeois Galleries in New York. His main patrons over the years included Mr. and Mrs. Charles Liebman, the dealer J. B. Neumann, and Dr. S. Nat Wollf, who helped him exhibit his work in Berlin in 1927.

Friedman never received widespread acceptance or success, but was repeatedly praised by a small group of prominent critics, including Clement Greenberg and Hilton Kramer. The artist frequently vented his frustration over the public's persistent indifference by painting terse comments on the backs of his canvases. Beginning in the thirties, Friedman began to reexamine Impressionism. He developed a style that seemed to create a solid atmosphere by building up tiny flecks of color. However, unlike the Impressionists' juxtaposing of complementary hues, Friedman broke down a form or space into subtly shifting variations of the dominant natural color. His compositions achieve a rhythm and calm similar to that of French Post-Impressionist Pierre Bonnard, and his numerous portraits often recall the studies of nineteenth-century French artist J. A. D. Ingres, with the features of the body rendered in a crisp linearity and contrasted with a softening of surrounding forms.

In 1933, Friedman retired on a small government pension and was finally able to devote himself to painting. About this time he began to experiment with a loosely faceted Cubist style in some of his landscapes and in the small paintings depicted in the backgrounds of his interiors. During the late thirties and early forties, Friedman created murals in post offices in Virginia, South Carolina and Georgia. The artist died in Queens in 1946.

## SELECTED SOLO EXHIBITIONS

1925 *Exhibition of Paintings by Arnold Friedman*, Bourgeois Galleries, New York

1927 *Arnold Friedman*, Gallery Matthieson, Berlin

1929 *Arnold Friedman*, Kraushaar Galleries, New York

1934 *New Work of Arnold Friedman*, Contempora Art Circle, New York

1937 *Arnold Friedman Recent Work*, J. B. Neumann's New Art Circle, New York

1940 *Arnold Friedman*, Bonestell Gallery, New York

1944 *Paintings/Arnold Friedman*, Marquié Gallery, New York (also exhibited 1945, 1948–1950, 1955)

1947 *Arnold Friedman, 1874-1946: A Memorial*, George Walter Vincent Smith Art Museum, Springfield, Massachusetts

1950 *Arnold Friedman (Paintings): Memorial Exhibition*, The Jewish Museum, New York.

1957 *Arnold Friedman, 1874-1946*, Zabriskie Gallery, New York (also exhibited 1980, 1981, 1983, 1990)

1969 *Paintings/Arnold Friedman*, Egan Gallery, New York

1986 *Arnold Friedman (1874-1946) An Exhibition: Paintings, Drawings and Watercolors*, Salander-O'Reilly Galleries, New York (also exhibited 1989)

## SELECTED GROUP EXHIBITIONS

1915 *Autumn Exhibition*, Montross Galleries, New York (also exhibited 1917)

1917 *Exhibition of Nine Landscape Painters*, Bourgeois Galleries, New York (also exhibited 1929)

1917 *First Annual Exhibition of the Society of Independent Artists*, Grand Central Palace, New York (also exhibited 1919, 1920, 1922, 1923, 1941)

1923 *New Pictures and the New Gallery*, The New Gallery, New York

1930 *33 Moderns*, Grand Central Art Galleries, New York

1932 *Biennial Exhibition*, Whitney Museum of American Art, New York

1938 *First Exhibition of Painting, Sculpture, Graphic Arts and Yiddish Books and Press*, World Alliance for Yiddish Culture (Yiddisher Kultur Farband), New York

1968 *The 1930s: Paintings and Sculpture in America*, Whitney Museum of American Art, New York

1978 *Synchromism and American Color Abstraction, 1910-1925*, Whitney Museum of American Art, New York

1982 *Realism and Realities: The Other Side of American Painting, 1940-1960*, Rutgers University Art Gallery, New Brunswick, New Jersey (traveled)

1986 *Modern Times: Aspects of American Art, 1907-1956*, Hirschl and Adler Galleries, New York

## SELECTED BIBLIOGRAPHY

*Arnold Friedman: The Last Years*. Salander-O'Reilly Galleries, New York, 1989. Exh. cat.

Greenberg, Clement. *Arnold Friedman (1874-1946): Memorial Exhibition*. New York: The Jewish Museum, 1950. Exh. cat.

Kramer, Hilton. *Arnold Friedman (1874-1946) An Exhibition: Paintings, Drawings and Watercolors*. New York: Salander-O'Reilly Galleries, 1986. Exh. cat.

## AARON J. GOODELMAN (1890-1978)

Aaron J. Goodelman was born on April 1, 1890, in Ataki, Bessarabia, Russia, to Joseph and Mollie Fateles Goodelman. He attended religious and public schools, and then studied art and attended a trade school in Odessa. Goodelman immigrated with his two brothers to the United States in 1904, living at first in Massachusetts briefly, before settling in New York. Between 1905 and 1912 he attended Cooper Union and the National Academy of Design, both in New York, studying sculpture with Gutzon Borglum and Jo Davidson. Between 1914 and 1916 he studied in Paris at the École des Beaux-Arts and in New York at the Society of Beaux-Arts Architects.

His early work, including allegorial compositions, was influenced by Rodin. High praise for these pieces led to public art commissions, among them the carved façade of the first Sholem Aleichem Folk Shule in New York. During this period and continuing into the 1930s, he also illustrated Jewish children's magazines and Joseph Gaer's *The Burning Bush*, published in 1928, as well as many books of Yiddish poetry. Goodelman remained devoted to Yiddish culture throughout his life.

During his adult life he worked off and on as a machine cutter and at other factory jobs. Throughout the 1930s, he was a member of the Artists Union and the American Artists' Congress. His first one-man exhibition was held in New York at the Eighth Street Gallery in 1933, where he showed both naturalistic marble portrait busts and Cubist-influenced studies. His bronze entitled *Necklace* reflected his reaction to the highly publicized Scottsboro case in Alabama. Despite his academic training Goodelman was able to create powerfully expressive works often with very simplified forms. He carved directly in wood, marble and granite. Goodelman also modeled in clay and had his sculptures cast in bronze.

In 1933 Goodelman taught an art class for unemployed artists and other students under the auspices of the State Education Department in New York. During the thirties he also held classes at the John Reed Club School of Art, the American Artists School and the New York Industrial Art School. Three years later he was represented in *New Horizons in American Art*, a group show at the Museum of Modern Art. In 1938 he was included in the first exhibition of YKUF in New York.

Although most of his sculptures of men at work are devoid of architectural references, in the early 1940s he sometimes added metal elements to suggest the work environment.

During this period there are works in which the material dominates and the resulting forms are more abstract than in his earlier work. Often in such works, particularly those affected by the Holocaust, he addressed symbolic or religious themes. In the forties, Goodelman taught at City College and at the Jefferson School of Social Science. A retrospective exhibition of his work was held at the ACA Galleries

SELECTED SOLO EXHIBITIONS

1933    *Aaron J. Goodelman*, Eighth Street Gallery, New York

1935    *Aaron J. Goodelman*, Dorothy Paris Gallery, New York

1942    *Aaron J. Goodelman*, ACA Galleries, New York (also exhibited 1946)

1963    *Aaron J. Goodelman Retrospective, 1933-1963*, ACA Galleries, New York

1967    *Aaron J. Goodelman Sculptures*, The School of Fine Art, University of Judaism, Los Angeles

SELECTED GROUP EXHIBITIONS

1919    *Annual Exhibition*, Pennsylvania Academy of the Fine Arts, Philadelphia (also exhibited 1926, 1934)

1926    *Exhibition of Paintings, Drawings and Sculptures*, Jewish Art Center, New York

1926    *Sesqui-centennial International Exhibition*, Philadelphia

1933    *First Anniversary Exhibition*, Eighth Street Gallery, New York (also exhibited 1934)

1933    *First Biennial Exhibition*, Whitney Museum of American Art, New York (also exhibited 1936, 1939, 1942-1950)

1934    *Working Class Sculpture*, John Reed Club, New York

1936    *Exhibition of Works of Art Presented by American Artists to the State Museum of Birobidzhan*, Birobidzhan, Soviet Union (traveled)

1936    *New Horizons in American Art*, The Museum of Modern Art, New York

1938    *WPA Sculpture Exhibition*, Federal Art Gallery, New York

1938    *Artists Union National Exhibition*, Springfield Museum of Fine Arts, Massachusetts

1938    *First Exhibition of Painting, Sculpture, Graphic Arts and Yiddish Books and Press*, World Alliance for Yiddish Culture (Yiddisher Kultur Farband), New York

1939    *Art in a Skyscraper*, American Artists' Congress, New York (also exhibited 1940)

1939    *United American Sculptors*, New School for Social Research, New York

1939    *World's Fair*, New York

1965    Louisiana Pavilion, World's Fair, New York

SELECTED BIBLIOGRAPHY

Aaron Goodelman scrapbook in the collection of Dr. C. Weinstock

Klumak, Dr. Isaac. "Dramatic Art Symbols of Our Time." *Frayhayt* (April 7, 1946).

Lozowick, Louis. *One Hundred Contemporary American Jewish Painters and Sculptors.* New York: YKUF Art Section, 1947.

## ADOLPH GOTTLIEB (1903-1974)

Adolph Gottlieb was born in New York City on March 14, 1903. His parents were prosperous German-Jewish immigrants. While still in high school, Gottlieb studied at the Art Students League and, in 1920, at Cooper Union and the Parsons School of Design. He also studied with Robert Henri and John Sloan at the League through 1921. Gottlieb's father had wanted him to join the family's stationery business, but instead the young artist set out for Paris in 1921. He attended sketch classes at the Académie de la Grande Chaumière and then traveled throughout Europe, returning to New York in 1922. Gottlieb completed Parsons' art teacher training program in 1924, then studied again under Sloan at the League from 1923 to 1924 and again from 1927 to 1929 with Richard Lahey. At the League he also met John Graham, an influential figure in transmitting European modernism to New York. During these years Gottlieb also studied at the Educational Alliance Art School and by then had met Moses and Isaac Soyer, Chaim Gross, Ben Shahn, Louis Schanker and Barnett Newman. He met Mark Rothko in 1928. The next year Gottlieb became close friends with Milton Avery, whose flat compositions of contoured color areas influenced the younger artist.

In 1930 Gottlieb had his first solo exhibition at the Dudensing Gallery in New York and three years later moved to Brooklyn. By then he was close friends with Louis Harris and the sculptor David Smith. He spent the summers of 1933 through 1938 in Gloucester, Massachusetts, often in the company of Avery. In 1935 Gottlieb, Rothko, Harris and Schanker, among others, founded the Ten in response to the dominance of American Scene painting. The group championed formal issues in art over ideological content, and laid the foundation for Abstract Expressionism. Gottlieb, Rothko and Newman would be central figures of the movement. From 1936 to 1937 Gottlieb worked on the WPA/FAP. Around this time, he became increasingly interested in Cubism and Surrealism under Graham's influence.

Gottlieb's desert still lifes painted while he was living in Arizona from 1937 to 1938 reflect his interest in Indian art and legend. With these his work changed, becoming more simplified and symbolic. Along with Rothko and a number of other artists, Gottlieb left the American Artists' Congress in 1940 to protest the group's tolerance of the Soviet Union despite the Hitler-Stalin pact and the invasion of Finland. In 1941 Gottlieb began his series of Pictographs, gridded fields of color on which he painted ideographs, referring to American Indian legend, classical mythology, Jung and Freud. Between 1947 and 1949 Gottlieb contributed articles to the Surrealist periodical *Tiger's Eye*. The artist was included in *Abstract and Surrealist American Art* in 1947 at the Art Institute of Chicago. In 1948 Gottlieb's canvases evolved away from the grid format he had employed throughout the decade and toward broad color fields inflected with free-floating abstract shapes.

In 1950, Gottlieb joined other Abstract Expressionist painters and sculptors, afterward dubbed "The Irascibles," in protest of the exclusive exhibition policies at the Metropolitan Museum of Art, bringing wide public attention to the movement. In 1957 he began the Burst series, usually depicting the "cosmic explosion" of a single circular form. That same year an exhibition of his paintings was held at the Jewish Museum in New York and six years later he was represented at the Venice Biennale. Other important exhibitions of his work were held at the Institute of Contemporary Art, London (1959), at the Walker Art Center, Minneapolis (1963), and simultaneously at the Solomon R. Guggenheim Museum and the Whitney Museum of American Art, New York (1968). During the fifties and sixties Gottlieb created a number of designs for synagogues, including Torah arks, curtains, tapestries and stained-glass. The artist died in New York in 1974.

SELECTED SOLO EXHIBITIONS

1930    *Adolph Gottlieb*, Dudensing Gallery, New York

1940    *Adolph Gottlieb: Paintings*, The Artists' Gallery, New York (also exhibited 1942, 1943)

1944　*Adolph Gottlieb*, Wakefield Gallery, New York

1947　*Adolph Gottlieb*, Kootz Gallery, New York (also exhibited 1947, 1948, 1950-1954)

1957　*An Exhibition of Oil Paintings by Adolph Gottlieb*, The Jewish Museum, New York

1959　*Adolph Gottlieb: Paintings 1949-1959*, Institute of Contemporary Art, London

1963　*Adolph Gottlieb*, Walker Art Center, Minneapolis

1968　*Adolph Gottlieb*, Whitney Museum of American Art and the Solomon R. Guggenheim Museum, New York (traveled)

1981　*Adolph Gottlieb: A Retrospective*, Corcoran Gallery of Art, Washington, D.C., organized by the Adolph and Esther Gottlieb Foundation, Inc. (traveled)

1989　*Image and Reflection: Adolph Gottlieb's Pictographs and African Sculpture*, The Brooklyn Museum, New York

SELECTED GROUP EXHIBITIONS

1934　*American Moderns*, Uptown Gallery, New York

1934　Gallery Secession, New York

1935　*The Ten: An Independent Group*, Montross Gallery, New York (also exhibited 1936)

1936　*Opening Exhibition*, Municipal Art Gallery, New York

1936　*The Ten*, Galerie Bonaparte, Paris

1937　*The Ten*, Georgette Passedoit Gallery, New York (also exhibited 1938)

1938　*The Ten: Whitney Dissenters*, Mercury Gallery, New York

1940　*Annual Exhibition*, Whitney Museum of American Art, New York (also exhibited 1941, 1944-1959, 1961, 1963, 1965, 1967)

1944　*Abstract and Surrealist Art in America*, Mortimer Brandt Gallery, New York

1946　*Advancing American Art*, The Metropolitan Museum of Art, New York

1947　*Abstract and Surrealist American Art*, The Art Institute of Chicago

1949　*The Intrasubjectives*, Kootz Gallery, New York

1950　*Jewish Artists—1950: Annual Exhibition*, Congress for Jewish Culture Art Center, The Jewish Museum, New York

1955　*The New Decade—35 American Painters and Sculptors*, Whitney Museum of American Art, New York (traveled)

1958　*Nature in Abstraction*, Whitney Museum of American Art, New York

1958　*The New American Painting*, organized by the International Council, Museum of Modern Art, New York (traveled)

1961　*American Abstract Expressionists and Imagists*, Solomon R. Guggenheim Museum, New York

1963　*Retrospective Art Exhibit of the Educational Alliance Art School*, American Federation of Arts Gallery, New York

1967　*Dada, Surrealism and Their Heritage*, The Museum of Modern Art, New York (traveled)

1975　*Jewish Experience in the Art of the Twentieth Century*, The Jewish Museum, New York

1978　*Abstract Expressionism, The Formative Years*, Herbert F. Johnson Museum of Art, Cornell University, Ithaca, New York, and the Whitney Museum of American Art, New York (traveled)

1987　*Abstract Expressionism: The Critical Developments*, Albright-Knox Gallery, Buffalo

1990　*Chagall to Kitaj: Jewish Experience in 20th Century Art*, Barbican Art Gallery, London

SELECTED BIBLIOGRAPHY

Alloway, Lawrence, and Mary Davis MacNaughton. *Adolph Gottlieb: A Retrospective*. New York: The Arts Publisher, Inc. in association with the Adolph and Esther Gottlieb Foundation, Inc., 1981. Exh. cat.

Doty, Robert, and Diane Waldman. *Adolph Gottlieb*. New York: Frederick A. Praeger, published for the Whitney Museum of American Art and the Solomon R. Guggenheim Museum, 1968. Exh. cat.

Friedman, Martin. *Adolph Gottlieb*. Minneapolis: Walker Art Center, 1963. Exh. cat.

Greenberg, Clement. *An Exhibition of Oil Paintings by Adolph Gottlieb*. New York: The Jewish Museum, 1957. Exh. cat.

Newman, Barnett. *Adolph Gottlieb*. New York: Wakefield Gallery, 1944. Exh. cat.

## WILLIAM GROPPER (1897-1977)

William Gropper was born on December 3, 1897, on the Lower East Side of New York. His father was an intellectual who had no steady job; his mother worked in a sweatshop and did piecework at home. At the urging of his East European-born grandfather, Gropper attended an Orthodox religious school (*heder*) as well as public school. From 1912 to 1915 Gropper studied art at the anarchist Ferrer Center, where Robert Henri and George Bellows led informal art classes and discussions. From 1913 to 1914 he also attended the National Academy of Design, and then studied at the New York School of Fine and Applied Art, from 1915 to 1918. In 1917 Gropper began to work as a cartoonist and illustrator for the New York *Tribune*. He also contributed cartoons to leftist periodicals such as *The Liberator*, in which he developed a caricatured style of satirical social protest.

In 1920 Gropper traveled to Cuba, after which time he began contributing to a wide array of newspapers and journals, including *The Dial, Revolutionary Age, The Smart Set, The Village Quill, The Jewish Tribune*, the New York *Evening Post, The Nation* and *The New Republic*. From 1922 to 1924 Gropper also served as an editor of *The Liberator*. After spending half the year traveling in the West in 1925, he became a staff cartoonist for the *Frayhayt*, where he remained until 1948. In 1926, Gropper also became a cofounder of the *New Masses*. Two years later he spent a year traveling with the writers Theodore Dreiser and Sinclair Lewis throughout the U.S.S.R. where they attended celebrations of the tenth anniversary of the Revolution.

In 1929 Gropper became a founding member of the Communist-affiliated John Reed Club and periodically taught there during the thirties. Gropper's works generally attacked the excesses of the capitalist establishment, as in his United States Senators series, which he began in the thirties. He traveled to the U.S.S.R. in 1930 as a delegate to the Kharkov Conference of Writers and Artists and during the mid-thirties was a member of An American Group and American Artists Group, Inc., and helped to organize the American Artists' Congress. Toward the end of the decade Gropper painted murals for the WPA/FAP and in post offices for the Treasury Relief Art Project. In 1936 Gropper's first major exhibition was held at the ACA Galleries in New York and the following year he received a Guggenheim Fellowship to travel and create a series of paintings of the Dust Bowl. While these narrative or documentary works are domi-

nated by earth tones and traditional viewpoints, he also juxtaposed shockingly brilliant and contrasting colors and distorted perspective to increase the impact of his satirical subjects.

During World War II Gropper focused on anti-Nazi themes for cartoons, pamphlets and war-bond posters. In 1947 he helped to organize the Artists Equity Association, yet by the following year he had curtailed his activities as a cartoonist due to the unfavorable political climate, shifting his emphasis to painting and lithography. From 1948 to 1950 Gropper participated in the Congress of Intellectuals for Peace at Warsaw, Poland. His leftist politics led Gropper to be called before the House Un-American Activities Committee in 1953. Through the fifties and sixties he continued to exhibit regularly at the ACA Galleries. The artist died in 1977 in Great Neck, New York.

## SELECTED SOLO EXHIBITIONS

1921 *William Gropper*, Washington Square Bookshop, New York

1936 *Paintings by William Gropper*, ACA Galleries, New York (also exhibited 1937-1942, 1944, 1954, 1956, 1958, 1961-1962, 1965, 1968, 1970)

1945 *William Gropper*, Associated American Artists Galleries, New York (also exhibited 1951, 1965)

1948 *William Gropper*, Warsaw Museum, Warsaw, Poland (traveled)

1968 *William Gropper: Retrospective*, Joe and Emily Lowe Art Gallery, University of Miami, Coral Gables, Florida (traveled)

1971 *Gropper: Fifty Years of Drawing, 1921-1971*, ACA Galleries New York (traveled)

1989 *William Gropper, 1897-1977: Revisited*, Sid Deutsch Gallery, New York

## SELECTED GROUP EXHIBITIONS

1924 *Annual Exhibition*, Society of Independent Artists, New York

1924 *Annual Exhibition*, Whitney Studio Club, New York (also exhibited 1925–1927)

1929 *Young Israel Exhibition*, Young Israel magazine offices, New York

1932 *Murals by American Painters and Photographers*, The Museum of Modern Art, New York

1933 *Biennial Exhibition*, Whitney Museum of American Art, New York (also exhibited 1936, 1938, 1939, 1941-1947, 1950)

1938 *Trois Siècles d'Art aux États-Unis*, Musée du Jeu de Paume, Paris

1938 *First Exhibition of Painting, Sculpture, Graphic Arts and Yiddish Books and Press*, World Alliance for Yiddish Culture (Yiddisher Kultur Farband), New York

1939 *Art in Our Time*, The Museum of Modern Art, New York

1939 *Golden Gate International Exposition*, San Francisco

1943 *Artists for Victory*, The Metropolitan Museum of Art, New York

1947 *Depictions of the East Side*, Educational Alliance, New York

1966 *The Lower East Side: Portal to American Life (1870-1924)*, The Jewish Museum, New York (traveled)

1975 *Jewish Experience in the Art of the Twentieth Century*, The Jewish Museum, New York

1990 *Chagall to Kitaj: Jewish Experience in 20th Century Art*, Barbican Art Gallery, London

## SELECTED BIBLIOGRAPHY

Freundlich, August L. *William Gropper: Retrospective.* Los Angeles: Ward Ritchie Press, 1968. Exh. cat.

Gahn, J. Anthony. "William Gropper—A Radical Cartoonist: His Early Career, 1897-1928." *The New-York Historical Society Quarterly* 54, 2 (April 1970): 110-144.

Lozowick, Louis. *William Gropper.* Philadelphia: Art Alliance Press, 1983.

Lozowick, Louis. *One Hundred Contemporary American Jewish Painters and Sculptors.* New York: YKUF Art Section, 1947.

Schwarz, Karl. *Jewish Artists of the 19th and 20th Centuries.* Freeport, New York: Books for Libraries Press, for the Philosophical Library, Inc., 1949, reprint 1970.

## CHAIM GROSS (born 1904)

Chaim Gross was born into an Orthodox family on March 17, 1904, in the village of Wolowa in Galicia. His father was a lumber merchant who taught Gross to whittle at an early age. His large family moved to Kolomyja in 1911, where Gross attended both a public and a Hebrew school (*heder*). At the beginning of World War I the family was forced to flee the fighting. In 1919 Gross won a full scholarship to an art school in Budapest, but was deported back to Austria. Settling in Vienna, he studied at the local arts-and-crafts school.

In 1921 Gross immigrated to New York, joining his brother Naftoli, a Yiddish poet, on the Lower East Side. While working as a delivery boy, he attended the Educational Alliance Art School, often sleeping on its roof and eating the meals it provided. There he met Saul Baizerman, Peter Blume, Philip Evergood, Adolph Gottlieb, Barnett Newman, Concetta Scaravaglione and Isaac and Moses Soyer. Gross taught at the socialist Workmen's Circle Camp from about 1924 to 1933 and around the same time exhibited at the Jewish Art Center in New York. The artist studied sculpture for four years at the Beaux-Arts Institute of Design in New York, including two months under Elie Nadelman. Gross also studied direct carving briefly with Robert Laurent at the Art Students League in 1927, working mostly in wood. That same year Gross began to offer classes in sculpture at the Educational Alliance Art School, where he continued to teach through 1989. Louise Nevelson was one of his pupils around 1935. Most of his work has been figurative. His works in stone and wood are directly carved and often reflect the influence of Cubism and primitive art. Those modeled in clay have a rough, impressionistic surface, reflecting the artist's adherence to the modernist notion of truth to materials.

In 1932 Gross's first solo exhibition was held at Gallery 144 in New York, and the following year he was awarded a Louis Comfort Tiffany Foundation Fellowship. During the summers from 1934 to 1936 he taught in Cummington, Massachusetts. Around this time he was also a member of An American Group. During the later thirties, Gross received a number of monumental sculpture commissions from the U.S. Treasury Department, including one each at the Federal Trade Commission Building and the Post Office Department Building, both in Washington, D.C., and Queens College in New York, among others. Gross exhibited at the Exposition Universelle in Paris in 1938 and a year later with the Yiddish Popular Front organization YKUF. He also began to teach at the Design Laboratory in New York in 1938, remaining there for two years. The artist's work was exhibited in *Art in Our Time* at the Museum of Modern Art in 1939.

Gross taught at the Brooklyn Museum Art School beginning in 1942 and at the Museum of Modern Art People's Art Center from 1943 to 1949. He also joined the faculty at the New School for Social Research in New York in 1948. Gross was one of eleven artists who helped collect a hundred and forty paintings by American artists as a gift to Israel in 1949. This led to the first of many trips to Israel, the Middle East and Europe.

The Jewish Museum in New York held retrospectives of Gross's work in 1953 and 1977. Over the years Gross created numerous works with Jewish themes, such as those for the Hebrew University in Jerusalem (1966) and the International Synagogue of Kennedy Airport, New York (1969-1972). The artist lives in New York.

SELECTED SOLO EXHIBITIONS

1932 *Chaim Gross*, Gallery 144, New York

1942 *Chaim Gross*, Associated American Artists Galleries, New York (also exhibited 1946-1948, 1952)

1953 *Chaim Gross*, The Jewish Museum, New York

1962 *Chaim Gross: Sculpture, Drawings*, Forum Gallery, New York (also exhibited 1964, 1967, 1969, 1974, 1982, 1987)

1974 *Chaim Gross*, National Collection of Fine Arts, Smithsonian Institution, Washington, D.C.

1977 *Chaim Gross: Sculpture and Drawings*, Montclair Art Museum, Montclair, New Jersey

1977 *Chaim Gross: Retrospective*, The Jewish Museum, New York

1984 *Chaim Gross: Sculpture in Wood*, Nassau County Museum of Fine Art, Roslyn Harbor, New York

1988 *Chaim Gross and His Universal Themes*, Joseph Gallery, Hebrew Union College, New York

SELECTED GROUP EXHIBITIONS

1926 *Exhibition of Paintings, Drawings and Sculptures*, Jewish Art Center, New York (also exhibited 1927)

1927 *Annual Exhibition*, Society of Independent Artists, New York (also exhibited 1929, 1930, 1933, 1935)

1933 *Biennial Exhibition*, Whitney Museum of American Art, New York (also exhibited 1936, 1938, 1939, 1941-1950)

1937 *Exposition Universelle*, Paris

1938 *First Exhibition of Painting, Sculpture, Graphic Arts and Yiddish Books and Press*, World Alliance for Yiddish Culture (Yiddisher Kultur Farband), New York

1939 *Art in Our Time*, The Museum of Modern Art, New York

1940 *The Educational Alliance Art School 25th Anniversary Exhibition*, Associated American Artists Galleries, New York

1950 *Jewish Artists—1950: Annual Exhibition*, Congress for Jewish Culture Art Center, The Jewish Museum, New York

1959 *Four American Expressionists: Doris Caesar, Chaim Gross, Karl Knaths, Abraham Rattner*, Whitney Museum of American Art, New York (traveled)

1963 *Retrospective Art Exhibit of the Educational Alliance Art School*, American Federation of Arts Gallery, New York

1966 *The Lower East Side: Portal to American Life (1870-1924)*, The Jewish Museum, New York (traveled)

1975 *Jewish Experience in the Art of the Twentieth Century*, The Jewish Museum, New York

1979 *Vanguard American Sculpture, 1913-1939*, Rutgers University Art Gallery, New Brunswick, New Jersey (traveled)

SELECTED BIBLIOGRAPHY

*Chaim Gross: Exhibition*. New York: The Jewish Museum, 1953. Exh. cat.

Getlein, Frank. *Chaim Gross*. New York: Abrams, 1974.

Lozowick, Louis. *One Hundred Contemporary American Jewish Painters and Sculptors*. New York: YKUF Art Section, 1947.

Schwartz, Constance. *Chaim Gross: Sculpture in Wood*. Roslyn Harbor, New York: Nassau County Museum of Fine Art, 1984. Exh. cat.

Schwarz, Karl. *Jewish Artists of the 19th and 20th Centuries*. Freeport, New York: Books for Libraries Press, for the Philosophical Library, Inc., 1949, reprint 1970.

Tarbell, Roberta K. *Chaim Gross: Retrospective Exhibition: Sculpture, Paintings, Drawings, Prints*. New York: The Jewish Museum, 1977. Exh. cat.

## SAMUEL HALPERT (1883-1930)

Samuel Halpert was born on December 25, 1883, in Bialystok, Russia, where his friend Max Weber had been born three years earlier. His family immigrated to New York City in 1889. His father's preoccupation with religious devotion necessitated that Halpert sell Jewish newspapers, books and candy after school to help support the family. At the Neighborhood Guild, later called the University Settlement, he met Jacob Epstein, who gave him his first instruction in drawing. Halpert studied with Henry McBride at the Educational Alliance from around 1898 to 1902. Beginning in 1899 the young artist also attended the National Academy of Design for three years, and then left for France in 1902.

Halpert spent his first year in Paris studying under Léon Bonnat at the École des Beaux-Arts. However, upon seeing the work of the Post-Impressionists he left the academy to study independently and to travel. Halpert painted numerous scenes of Paris, in a style reflecting the influence of Impressionism, Cézanne and the Fauves. Halpert exhibited from 1905 through 1911 at the *Salon d'Automne* and established strong friendships with the artists Patrick Henry Bruce, Sonia and Robert Delaunay, Abel Warshawsky, Thomas Hart Benton, Fernand Léger and Jean Metzinger. In 1912 Halpert returned to New York. The following year he exhibited in the Armory Show and visited the artists' colony in Ridgefield, New Jersey, sharing a cottage with Man Ray, whom he had met at the anarchist Ferrer Center in New York. Other frequenters of the colony were the writer Alfred Kreymborg and the sculptor Adolf Wolff. The next year his first one-man show was held at the Daniel Gallery. In 1915 Halpert returned to Europe and traveled in France, Spain, Portugal and London with the Delaunays, whose abstract work had little influence on him.

Halpert returned to New York in 1916, and during the next two years exhibited in several People's Art Guild shows. Through the Guild he met Edith Gregor Fiviosioovitch (Fein) and they were married in 1918. Halpert joined the Society of Independent Artists in 1917, later becoming a vice president and director. The following year Halpert also began to exhibit at the Whitney Studio Club. After his marriage the artist began to also paint nudes, domestic scenes and landscapes, and showed a renewed interest in naturalism. For the summer of 1925 the couple visited Paris. The following year Edith Halpert opened the Downtown Gallery with Bea Goldsmith, the sister of the couple's close

friend Leon Kroll. The gallery represented Ben Shahn, Charles Sheeler and other important American artists. During the summers of 1926 and 1927 the Halperts rented a farmhouse at Perkins Cove in Ogunquit, Maine, an artists' colony established by the critic and patron Hamilton Easter Field and frequented by Yasuo Kuniyoshi, Bernard Karfiol and Marguerite and William Zorach, among others.

In the fall of 1927 Halpert separated from his wife and moved to Detroit to head the painting department at the School of the Detroit Society of Arts and Crafts and died there in 1930.

SELECTED SOLO EXHIBITIONS

1914 *Samuel Halpert*, Daniel Gallery (also exhibited 1916, 1918, 1919)

1923 *Samuel Halpert*, C. W. Kraushaar Art Galleries, New York (also exhibited 1926)

1924 *Samuel Halpert*, Rochester Memorial Art Gallery, Rochester, New York

1927 *Exhibition of Paintings by Samuel Halpert*, Detroit Institute of Art

1928 *Samuel Halpert*, Downtown Gallery, New York

1931 *Samuel Halpert*, Albright Art Gallery, Buffalo

1931 *Samuel Halpert*, California Palace of the Legion of Honor, San Francisco

1935 *Samuel Halpert*, Milch Galleries, New York

1969 *Samuel Halpert, 1884-1930: A Pioneer of Modern Art in America*, Bernard Black Gallery, New York

1977 *Samuel Halpert (1884-1930)*, Davis and Long Co., New York

1991 *Samuel Halpert*, The Federal Reserve, Washington, D.C.

SELECTED GROUP EXHIBITIONS

1905 *Salon d'Automne*, Paris (also exhibited 1906-1911)

1913 *International Exhibition of Modern Art*, organized by the Association of American Painters and Sculptors, 69th Regiment Armory, New York (traveled)

1914 *Opening Exhibition*, Daniel Gallery, New York (also exhibited 1915)

1917 *First Annual Exhibition of the Society of Independent Artists*, Grand Central Palace, New York (also exhibited 1918-1931, 1936)

1917 *People's Art Guild Exhibition*, Church of the Ascension Parish House, New York

1918 *Annual Exhibition*, Whitney Studio Club, New York (also exhibited 1920, 1922-1928)

1926 *Exhibition of Paintings, Drawings and Sculptures*, Jewish Art Center, New York (also exhibited 1927)

1930 *33 Moderns*, Grand Central Art Galleries, New York

1946 *Pioneers of Modern Art in America*, Whitney Museum of American Art, New York

1949 *Juliana Force and American Art*, Whitney Museum of America Art, New York

1965 *The Twenties Revisited*, Gallery of Modern Art, New York

SELECTED BIBLIOGRAPHY

Archives of American Art, Smithsonian Institution, Washington, D.C., Downtown Gallery Papers and Samuel Halpert Scrapbook

*Samuel Halpert, 1884-1930: A Pioneer of Modern Art in America*. New York: The Bernard Black Gallery, 1969. Exh. cat.

Schwarz, Karl. *Jewish Artists of the 19th and 20th Centuries*. Freeport, New York: Books for Libraries Press, for the Philosophical Library, Inc., 1949, reprint 1970.

Tepfer, Diane. "Edith Gregor Halpert and the Downtown Gallery Downtown: 1926-1940; A Study in American Art Patronage" (Volumes I and II). Ph.D. dissertation, University of Michigan, 1989. Unpublished.

**MINNA R. HARKAVY** (1895-1987)

Minna R. Harkavy was born in Estonia in 1895. The exact date of her arrival in the United States is not known. Harkavy traveled frequently in Europe and studied in Paris with the academic sculptor Antoine Bourdelle. Her figurative sculpture, usually carved wood, is characterized by an expressive surface treatment. In the 1920s she participated in exhibitions held at the Whitney Studio Club and the Jewish Art Center in New York. Like many of her fellow artists during the Depression, Harkavy expressed the plight of the American worker in her art. In her *American Miner's Family* of 1931 (The Museum of Modern Art, New York) she uses a reductivist geometric style in the half-length studies of the parents and heads of their three children. From the mid-thirties she worked on the Treasury Relief Art Project and on the WPA/FAP. She was also a member of the American

Artists' Congress. In 1936 she joined other Jewish-American artists, among them Francis Criss, Aaron Goodelman, William Gropper and Moses Soyer, in sending works to a new museum founded in Birobidzhan, the Jewish autonomous region in the Soviet Union. Also in that year she exhibited for the first time in the Whitney Biennial and continued to show her work there regularly over the next fifteen years. She traveled to Paris in 1937 with fellow artists Isaac Lichtenstein and Frank C. Kirk as the American representatives to the World Alliance for Yiddish Culture conference. There the YKUF Art Section was formed, and Harkavy was included in its large exhibition held in New York the following year. In 1938 Harkavy was one of the founding directors of the Sculptors Guild.

In the 1940s, as she learned of the Nazi atrocities in Europe, she depicted the suffering of her co-religionists in expressionist portraits of Jews at prayer. She attended the Art Students League in New York City in 1941-1942 and again in 1947-1948. An exhibition of her work was held at the Museum of Art, Rhode Island School of Design ,in 1956. Harkavy lived in New York until her death in 1987.

SELECTED SOLO EXHIBITIONS

1956 *Sculpture by Minna Harkavy*, Museum of Art, Rhode Island School of Design

SELECTED GROUP EXHIBITIONS

1923 *Annual Exhibition*, Whitney Studio Club, New York (also exhibited 1925-28)

1936 *Exhibition of Works of Art Presented by American Artists to the State Museum of Birobidzhan*, Birobidzhan, Soviet Union (traveled)

1936 *Biennial Exhibition*, Whitney Museum of American Art, New York (also exhibited 1938, 1939, 1941, 1943, 1945–1950)

1936 *Exhibition of Works of Art Presented by American Artists to the State Museum of Birobidzhan*, Birobidzhan, Soviet Union (traveled)

1938 *First Exhibition of Painting, Sculpture, Graphic Arts and Yiddish Books and Press*, World Alliance for Yiddish Culture (Yiddisher Kultur Farband), New York

1939 *Art in a Skyscraper*, American Artists' Congress, New York

1939 *Art in Our Time*, The Museum of Modern Art, New York

1939 *Annual Exhibition*, Pennsylvania Academy of the Fine Arts, Philadelphia (also exhibited 1945, 1950)

1951 *National Exhibition of American Science*, The Metropolitan Museum of Art, New York

1959 *Recent Sculpture, U.S.A.*, The Museum of Modern Art, New York

1975 *Jewish Experience in the Art of the Twentieth Century*, The Jewish Museum, New York

### SELECTED BIBILIOGRAPHY

Kampf, Avram. *Jewish Experience in the Art of the 20th Century*. South Hadley, Massachusetts: Bergin and Garvey, Publishers, Inc., 1984. Revised edition, London: Lund Humphries in Association with the Barbican Art Gallery, 1990. Exh. cat.

Lozowick, Louis. *One Hundred Contemporary American Jewish Painters and Sculptors*. New York: YKUF Art Section, 1947.

## LOUIS HARRIS (1902-1970)

Louis Harris was born in St. Louis on November 7, 1902, and came to New York City at the age of eighteen. He enrolled in the Art Students League, where he studied with Kenneth Hayes Miller and Max Weber. While at the League he met Mark Rothko, with whom he later shared a tenement flat on the Lower East Side. In 1928 he and Rothko were included in a group exhibition at the Opportunity Gallery. In 1933, Harris received his first solo show at the Contemporary Arts Gallery. In 1935 he was given another one-man show at Robert Ulrich Godsoe's Gallery Secession. The works displayed included his painting *Stuyvesant Place*. Later in that year he joined Rothko, Ilya Bolotowsky and Adolph Gottlieb, among others, in a defection from the Gallery Secession to form the group known as the Ten. These artists exhibited together eight times between 1935 and 1939. At the group's second exhibition, held at the City of New York's Municipal Art Galleries, Harris contributed three works: *Explosion, Boom Times* and *Highway*. In 1937, at their fifth exhibition, he showed a three-figure composition, *Discussion*.

A realist, Harris worked in oils and watercolors, creating contemplative and lyrical moods through his choice of palette. Specializing in female nudes, he painted landscapes and portraits as well. In 1951 he had a one-man show at the Burliuk Gallery which included *Maidens*, a reverie of two nudes in an outdoor setting. At his solo exhibition in 1964 at the Waverly Gallery, he showed the watercolor *Bronx Park* and a portrait of the artist Byron Browne.

Harris taught art for more than twenty years and was a president of the Federation of Modern Painters and Sculptors. He died in his studio on Bleecker Street.

### SELECTED SOLO EXHIBITIONS

1933 Contemporary Arts Gallery, New York

1935 Gallery Secession, New York

1947 Egan Gallery, New York

1951 Burliuk Gallery, New York (also exhibited 1952)

1960 Hartert Gallery, New York

1964 Waverly Gallery, New York

### SELECTED GROUP EXHIBITIONS

1928 Opportunity Galleries, New York

1935 *Twenty-two Painters: The 1931-1935 Presentations of Contemporary Arts*, Contemporary Arts Gallery, New York

1935 *The Ten: An Independent Group*, Montross Gallery, New York (also exhibited 1936)

1936 *Opening Exhibition*, Municipal Art Galleries, New York

1936 *The Ten*, Galerie Bonaparte, Paris

1937 *The Ten*. Georgette Passedoit Gallery, New York (also exhibited 1938)

1938 *The Ten: Whitney Dissenters*, Mercury Gallery, New York

1939 *The Ten*, Bonestell Gallery, New York

1941 *First Annual Exhibition of the Federation of Modern Painters and Sculptors*, Riverside Museum, New York

1950 *Jewish Artists—1950: Annual Exhibition*, Congress for Jewish Culture Art Center, The Jewish Museum, New York

1961 *Paintings from the W.P.A.*, Smolin Gallery, New York

### SELECTED BIBLIOGRAPHY

C[ampbell], L[awrence]. "Louis Harris at Waverly." *Art News* 62, 9 (January 1964): 14.

C[ampbell], L[awrence]. "Louis Harris at Burliuk." *Art News* 50, 1 (March 1951): 50.

B[urckhardt], E[dith]. "Louis Harris at Hartert." *Art News* 59, 1 (March 1960): 13.

Embick, Lucy. "The Expressionist Current in New York's Avant-Garde, 1935-40: The Paintings of 'The Ten.'" *The Rutgers Art Review* 5 (1984): 56-69.

L., J. "Versatility of Talent Exhibited by 'The Ten.'" *Art News* 35, 32 (May 8, 1937): 17.

## STEFAN HIRSCH (1899-1964)

Stefan Hirsch was born in Nuremberg, Germany, to American parents on January 2, 1899, and was raised there. He traveled in Europe with his parents as a boy and became acquainted with the work of the Old Masters through visits to museums. He was inspired by the art of Albrecht Dürer to make his own exacting drawings, although he was also exposed to modern art. From 1917 to 1919 Hirsch was a law student at the University of Zurich, the city which gave birth to the Dada movement. There he met the artists Marius de Zayas and Kurt Schwitters and the writer James Joyce, an experience that turned his attention from law to art.

Hirsch settled in New York in 1919 and studied painting with Hamilton Easter Field. That year and the next he participated in the annual exhibitions of the Society of Independent Artists. In 1921 he completed the canvas *Manhattan*, a view of the skyline and the river in a simplified geometric style that became a hallmark of the Precisionist style, shared by such artists as Charles Sheeler, Morton Schamberg and Louis Lozowick. During this period Hirsch also painted in a Surrealist style and in a naive mode influenced by American folk art. In 1925 his first solo show was held at the Bourgeois Galleries in New York. The following year he exhibited with the Jewish Art Center, New York. He began exhibiting at Edith Halpert's Downtown Gallery in New York in 1929.

From 1934 to 1940 Hirsch taught at Bennington College in Vermont, and then for a time at the Art Students League, New York. During this period he was also an active member of the American Artists' Congress. Hirsch was on the art faculty of Bard College in Annandale-on-Hudson, New York, from 1942 until 1961. He traveled to India in 1956-1957 on a Fulbright Fellowship and also visited Mexico. The artist died in New York in 1964. In 1977 the Phillips Collection in Washington, D.C., held an exhibition of his work.

SELECTED BIBLIOGRAPHY

Brown, Milton. *American Painting from the Armory Show to the Depression*. Princeton, New Jersey: Princeton University Press, 1955. First Princeton paperback edition, 1970; second printing, 1972.

Rubenfeld, Richard. "Stefan Hirsch, Pioneer Precisionist." *Arts* (November 1979): 96-97.

*Stefan Hirsch*. Washington, D.C.: Phillips Collection, 1977. Exh. cat.

Tsujimoto, Karen. *Images of America: Precisionist Painting and Modern Photography*. Seattle and London: University of Washington Press, 1982. Exh. cat.

## FRANK C. KIRK (1889-1963)

Frank C. Kirk was one of seven children born into a poor family in Zhitomir in the Ukraine on May 11, 1889. At the age of twelve he went to work for a house decorator and became aware of art through watching artists who came to Zhitomir to paint landscapes. When he was fifteen, his older brother, a violinist with the Kiev Opera, secured a recommendation from a member of the Russian aristocracy to allow Kirk to study at the Kiev Academy, where Jews were barred except under special circumstances. This intervention failed, however, and the regional governor would not allow Kirk to enter the art school.

Spurned, Kirk became involved in the revolutionary movement, but persecution under the Czar eventually forced him to flee to Galicia. There he worked in a soap factory and at other menial jobs until he found a position with a stained-glass decorator. In 1910 he received money from his parents, who had already immigrated to America, to allow him to make the journey by freighter, a voyage that lasted forty-two days. Kirk spent only five months with his family in Philadelphia before he felt compelled to return to the revolutionary movement in Russia. Not long after his arrival, conditions again forced him to leave the country despite his strong commitment to the fight for political freedom. This time he left for America for good, stopping in Paris on the way.

While living in Philadelphia between 1910 and 1920 Kirk worked during the day and studied English and other subjects at night. He spent his weekends taking classes at the Graphic Sketch Club and the Industrial Arts School. He was later given a scholarship to study at the Pennsylvania Academy of the Fine Arts, where his teachers included Hugh Breckenridge, Cecilia Beaux, Daniel Garber and Philip L. Hale, who established the academic style that Kirk never gave up. In 1925 he visited several European countries and was impressed by the Spanish realists, including Zuloaga. After he returned to the United States his social concerns were frequently expressed in his realist paintings of Pennsylvania coal miners. In the 1920s, he arranged an exhibition of a hundred paintings and sculptures by Jewish artists at the Philadelphia Literary Society.

In the 1930s Kirk was a member of the American Artists' Congress and was head of the art section in the United States of the World Alliance for Yiddish Culture (YKUF), a Yiddishist Popular Front organization. Around the same time he was also instrumental in fund-raising efforts for Birobidzhan in Khabarovsk in the Soviet Far East. In 1934 Birobidzhan was given the status of a "Jewish Autonomous Region" and leftist or Communist Jews, including many Jewish-American artists like Kirk, supported its establishment as an alternative to Zionism. He helped organize and attended the opening of an exhibition of works by Jewish artists held in Moscow and Birobidzhan in 1936 and aided in the founding of the Birobidzhan Museum.

Kirk had a studio overlooking Union Square in New York. He died in 1963.

Healthcare and Hospital Employees, and the Smithsonian Institution Traveling Exhibition Service (SITES), New York (traveled)

SELECTED BIBLIOGRAPHY

Archives of American Art, Smithsonian Institution, Frank C. Kirk Papers.

Lozowick, Louis. *One Hundred Contemporary American Jewish Painters and Sculptor.* New York: YKUF Art Section, 1947.

Waldemar, George (pseudonym). *The Life and Work of Frank C. Kirk.* New York: Oquagua Press, 1938.

Weinper, Z. *Frank C. Kirk: His Life and Work.* Intro. by A. J. Philpott. Translated from the Yiddish by Louis Lozowick. New York: YKUF Publishers, Inc., 1956.

## BENJAMIN KOPMAN (1887-1966)

Benjamin Kopman was born in Vitebsk, Russia, in 1887, and immigrated to the United States with his family in 1903. He first studied art in New York at the National Academy of Design. Kopman participated in exhibitions sponsored by the People's Art Guild from 1915 to 1917 held at settlement houses and neighborhood centers in Manhattan and the Bronx, including the Guild's major exhibition at the Forward Building on the Lower East Side in 1917. There he exhibited works in a romantic, subjective style, including *Dreamer* and *In the Mist*. Around the same time he also exhibited with Jennings Tofel and Claude Buck, as part of the Introspective group of painters.

The painter, who also wrote in Yiddish, received support from the writer David Ignatoff, the publisher of *Shriftn*, who reproduced his works in the journal in 1919.

In 1925 Kopman and Tofel founded the Jewish Art Center which held exhibitions for two seasons in the East Village. Many of Kopman's paintings of this period are apocalyptic visions comprised of grotesque animal forms out of scale in other-worldly landscapes. Their feeling for the macabre reveals the influence of Goya and Blake and in their naivete, Henri Rousseau. Kopman's Expressionism echoes the German Emil Nolde and his intense mysticism and emotionality have their source in the Kabbalah. His canvases could also be humorous as in his *Circus* of 1930 (Collection of Walter and Lucille Rubin).

During the 1930s Kopman was a member of An American Group and the American Artists' Congress. He also worked on the WPA/FAP, executing paintings and lithographs. Kopman received backing from J.B.

Neumann, the German émigré, who showed his work in 1937 at his New York gallery, the New Art Circle.

In his later work Kopman depicted neighborhoods in New York in thickly painted, dark and moody canvases. During World War II Kopman took up themes of Nazi aggression and militarism. During the forties he was included in shows at the ACA Galleries, New York, and was given a solo exhibition at the Phillips Memorial Gallery, Washington, D.C. He illustrated two books, *Crime and Punishment* in 1944 and *Frankenstein* in 1948. The artist died in Teaneck, New Jersey, in 1965.

SELECTED SOLO EXHIBITIONS

1937 *Benjamin Kopman*, New Art Circle, New York

1945 *Kopman*, ACA Galleries, New York

1945 *Paintings by Benjamin Kopman*, Phillips Memorial Gallery, Washington, D.C.

1950 *Jewish Artists—1950: Annual Exhibition*, Congress for Jewish Culture Art Center, The Jewish Museum, New York

1954 *Benjamin Kopman: Oils and Gouaches*, John Heller Gallery, New York

1958 *Benjamin Kopman: Paintings and Drawings*, World House Galleries, New York (also exhibited 1959)

1961 *Gouaches and Drawings by Benjamin Kopman*, Forum Gallery, New York (also exhibited 1963, 1965)

1967 *Paintings and Lithographs, Benjamin Kopman*, Davison Art Center, Wesleyan University, Middleton, Connecticut

SELECTED GROUP EXHIBITIONS

1914 *Annual Exhibition*, Pennsylvania Academy of the Fine Arts, Philadelphia (also exhibited 1915, 1917, 1932, 1941, 1944, 1946, 1947)

1916 *Annual Exhibition*, Whitney Studio Club, New York

1917 *People's Art Guild Exhibition at the Forward Building*, New York

1917 *Imaginative Paintings by Thirty Young Artists of New York City*, Knoedler Galleries, New York

1917 *Introspective Art*, Whitney Studio Club, New York

1926 *Exhibition of Paintings, Drawings and Sculptures*, Jewish Art Center, New York (also exhibited 1927)

1932 *First Biennial Exhibition*, Whitney Museum of American Art, New York (also exhibited 1942, 1945, 1946)

1934 *Modern Works of Art: Fifth Anniversary Exhibition*, The Museum of Modern Art, New York

1936 *Fantastic Art, Dada, Surrealism*, The Museum of Modern Art, New York

1941 ACA Galleries, New York

1943 *Romantic Painting in America*, The Museum of Modern Art, New York

SELECTED BIBLIOGRAPHY

Brown, Milton. *American Painting From the Armory Show to the Depression.* Princeton, New Jersey: Princeton University Press, 1955. First Princeton Paperback Edition, 1970; Second Printing, 1972.

Ignatoff, David. *Kopman.* New York: E. Weyhe, 1930.

King, Lyndel, intro. *American Paintings and Sculpture in the University Art Museum Collection.* Minneapolis: University of Minnesota, 1986.

Lozowick, Louis. *One Hundred Contemporary American Jewish Painters and Sculptors.* New York: YKUF Art Section. 1947.

## LEON KROLL (1884-1974)

Leon Kroll, son of Marcus Nathaniel and Henrietta Moss Kroll, was born in New York City on December 6, 1884, to a family of musicians. At the age of fifteen he began his studies at the Art Students League with John H. Twachtman. He then enrolled in classes at the National Academy of Design and demonstrated his skill by winning first prizes in painting, sculpture and etching. In 1908 Kroll won the Academy's Mooney Scholarship for two years of study in Europe. He went to Paris and enrolled in the Académie Julian, where he studied with Jean-Paul Laurens. After four months he won the Grand Prix for a painting of a nude. While in Paris he was deeply impressed by the paintings of Cézanne.

On his return to New York in 1910 he accepted a teaching position at the National Academy, which gave him his first solo show. Soon afterwards he met George Bellows, who invited him to exhibit with a group that included Henri, Glackens and Speicher, at their MacDowell Club annuals. His friendship with Bellows grew and was documented in his painting of 1916, *In the Country (George Bellows and His Family)*. During these years Kroll produced many New York cityscapes such as *Brooklyn Bridge* (1911). In 1913 he was invited to exhibit in the seminal Armory Show. This exposure led to an immediate

commercial success, with the sale in one week of twelve paintings. In 1917 Kroll participated in the People's Art Guild exhibition at the Forward Building. In 1919 his portrait, *Leo Ornstein at the Piano*, won three awards at the Art Institute of Chicago's Annual. Greater professional recognition followed in 1920, with his election to membership in the National Academy.

From 1925 to 1929 Kroll lived in France, where his circle of friends and acquaintances included Sonia and Robert Delaunay, Chagall, Matisse and Maillol. When Kroll returned to New York his reputation continued to rise with his inclusion in such exhibitions as *Painting and Sculpture by Living Americans* at the Museum of Modern Art. His abilities were again recognized, in 1936, when he was awarded first prize for his oil painting *Road from the Cove* at the Carnegie Institute's exhibition.

A painter in the realist tradition, Kroll specialized in nudes, landscapes and portraits. Inspired by Poussin, his figures appear idealized. The composition dominates the subject in his attempt to create a harmonious whole of forms and colors.

In 1935, Kroll received his first commission from the government to execute a mural for the Attorney General's office in the Justice Building in Washington, D.C. His two years of work yielded the *Defeat of Justice* and the *Triumph of Justice*. Other commissions for public buildings ensued, which included the War Memorial Murals in Worcester, Massachusetts (1938-1941); murals for the Senate Chamber, State Capitol of Indiana (1951-1952) and the mosaic dome for the Chapel of the U.S. Military in Omaha Beach, Normandy, France (1952-1953).

Active in professional organizations, Kroll served as president of the American Society of Painters, Sculptors, and Engravers. In 1953 he was designated a Chevalier of the Legion of Honor of France, and in 1954 he was elected a member of the American Academy of Arts and Letters. He died in 1974 at his home in Gloucester, Massachusetts.

## SELECTED SOLO EXHIBITIONS

1911 National Academy of Design, New York

1924 *Paintings by Leon Kroll*, The Art Institute of Chicago

1929 *Exhibition of Paintings by Leon Kroll*, Fine Arts Academy, Albright Art Gallery, Buffalo

1935 *An Exhibition of Paintings by Leon Kroll*, Carnegie Institute, Pittsburgh

1944 *Paintings and Drawings by Leon Kroll*, Museum of Fine Arts, Houston

1965 *Leon Kroll: Selections from Various Periods 1913-1965*, ACA Galleries, New York

1970 *The Rediscovered Years: Leon Kroll*, Bernard Danenberg Galleries, New York

1980 *Leon Kroll, Paintings 1910-1960*, Fort Lauderdale Museum of Art, Florida

1984 *Leon Kroll: A Retrospective*, ACA Galleries, New York

## SELECTED GROUP EXHIBITIONS

1913 *International Exhibition of Modern Art*, organized by the Association of American Painters and Sculptors, 69th Regiment Armory, New York (traveled)

1914 *Annual Exhibition*, Pennsylvania Academy of the Fine Arts, Philadelphia (also exhibited 1915-1935, 1937-1954)

1917 *The People's Art Guild Exhibition at the Forward Building*, New York

1919 *Annual Exhibition*, The Art Institute of Chicago (also exhibited 1924, 1933)

1922 *Annual Exhibition*, Whitney Studio Club, New York (also exhibited 1923, 1924)

1925 *International Exhibition*, Carnegie Institute, Pittsburgh (also exhibited 1936)

1930 *Painting and Sculpture by Living Americans*, The Museum of Modern Art, New York

1932 *First Biennial Exhibition*, Whitney Museum of American Art, New York (also exhibited 1936, 1942, 1944)

1965 *American Painting in the Twentieth Century*, The Metropolitan Museum of Art, New York

1975 *Memorial Exhibition: Adolph Gottlieb, Leon Kroll, Zoltan Sepeshy, Moses Soyer*, American Academy of Arts and Letters, New York

1980 *The Figurative Tradition and the Whitney Museum of American Art: Paintings and Sculpture from the Permanent Collection*, Whitney Museum of American Art, New York

1982 *Realism and Realities: The Other Side of American Painting, 1940-1960*, Rutgers University Art Gallery, New Brunswick, New Jersey (traveled)

## SELECTED BIBLIOGRAPHY

Hale, Nancy, and Fredson Bowers, eds. *Leon Kroll: A Spoken Memoir*. Charlottesville: University Press of Virginia for the University of Virginia Art Museum, 1983.

*The Rediscovered Years: Leon Kroll*. New York: Bernard Danenberg Galleries, Inc., 1970. Exh. cat.

*The Worcester War Memorial Murals by Leon Kroll*. Worcester, Massachusetts: Worcester World War Memorial Commission, 1941.

## JACK KUFELD (1907-1990)

Jack (Yankel) Kufeld was born in New York City on February 1, 1909, to Polish and Russian immigrants who lived on the Lower East Side. He studied painting briefly at Cooper Union. Kufeld was earning a living as a picture framer when he was discovered by Milton Avery, who encouraged him to pursue a career as an artist. On Avery's advice, Kufeld contacted Robert Ulrich Godsoe, the director of the Uptown Gallery, who promptly included him in his 1933 show, *From Realism to Surrealism*, held at the Hotel Roosevelt in Manhattan. One year later, Godsoe mounted a solo exhibition for him which featured thirty-nine paintings, including two self-portraits, industrial scenes, landscapes and the *Portrait of Godsoe*. Painted with thick brush strokes, the works often evoked a sense of nostalgia or tragedy. Many of the cityscapes were inspired by the waterfront in Greenpoint, Brooklyn, where he resided. Concurrently, Kufeld participated in a group exhibition at the Uptown Gallery with the inclusion of *Parthenon*, a study of a grain elevator whose white silos resembled Greek columns.

In December 1934, Kufeld, along with Louis Schanker, was presented in a group show at Godsoe's new Gallery Secession. The following fall, Kufeld and Schanker, with Joseph Solman, Rothko, Gottlieb and Bolotowsky, left the Secession to form the group called the Ten. Kufeld participated in the first five of the group's eight shows. In their exhibition at the Municipal Art Gallery he offered three oils: *Laughter, Portrait of a Young Man* and the *Head of Gargantua*. In his last appearance with the Ten at Georgette Passedoit's Gallery in 1937, he showed *Subway*, which focused on the design elements created by the train and tunnel. During this period Kufeld, Rothko, Gottlieb and Louis Harris met every Saturday at Milton Avery's home to sketch.

In 1934 Kufeld conducted classes in painting for the East Flatbush Branch of the Socialist Party. In the late 1930s he taught at

the Bauhaus-oriented Design Laboratory in New York where Chaim Gross was an instructor of sculpture. Around this time he was included in an exhibition by teachers of the Federal Arts Project at the FAP Gallery. Kufeld returned to painting in the 1970s after a long hiatus. His late works were no longer dark and expressionist in tone, but linear, abstract images influenced by Surrealism. He died in New York City in 1990.

## SELECTED SOLO EXHIBITIONS

1934    Uptown Gallery, New York

## SELECTED GROUP EXHIBITIONS

1933    *From Realism to Surrealism*, Hotel Roosevelt, New York

1934    *American Moderns*, Uptown Gallery, New York

1934    Gallery Secession, New York

1935    *The Ten*, Montross Gallery, New York

1936    *Opening Exhibition*, Municipal Art Galleries, New York

1936    *The Ten*, Galerie Bonaparte, Paris

1936    *The Ten*, Montross Gallery, New York

1937    *The Ten*, Georgette Passedoit Gallery, New York

## SELECTED BIBLIOGRAPHY

Archives of American Art, Smithsonian Institution, Washington, D.C. Jack Kufeld Papers.

Embick, Lucy, "The Expressionist Current in New York's Avant-Garde, 1935-1940: The Paintings of 'The Ten.'" *The Rutgers Art Review* 5 (1984): 56-69.

## LOUIS LOZOWICK (1892-1973)

Leib Lozowick was born on December 10, 1892, in Ludvinovka, Russia. His mother died when he was young and his father, an Orthodox Jew, made a meager living operating a gristmill and a small store. From 1903 to 1905, years of severe pogroms, Lozowick attended the Kiev Art School. Following the failed revolution of 1905, he fled the country to join a brother in Newark, New Jersey. After his arrival, Lozowick anglicized his name and worked at a factory part time while attending high school. From 1912 to 1915, he studied at the National Academy of Design under Emil Carsen and Leon Kroll. Lozowick attended Ohio State University and in 1918 received a B.A. degree with honors. He served

in the Army Medical Corps for over a year and then traveled across the United States. Lozowick lectured on art history at the Educational Alliance in New York in 1919-1920 and then sailed for Europe.

Settling first in Paris, Lozowick met artists Juan Gris and Fernand Léger. Lozowick began to use machine forms and mechanical elements in his art as symbols for the promise of industrial America. A prolific translator and writer on art and poetry, Lozowick contributed to the *Little Review* and *The Union Bulletin*. In 1920, he moved to Berlin and became a close associate of many expatriate Russian artists, particularly El Lissitzky, who introduced him to Russian Constructivism. In Berlin Lozowick also began to write for the city's leading Yiddish art and literary periodical, *Albatross*, and exhibited with the revolutionary Novembergruppe. In 1922 Lozowick had his first solo exhibition at the Twardy Gallery in Berlin, began to write for *Broom* and traveled to Russia, where he met Kasimir Malevich and Vladimir Tatlin. The following year in Berlin he was introduced to lithography and soon mastered this medium, executing over three hundred prints between 1923 and 1973.

In 1924, Lozowick returned to New York and soon became close friends with the Soyer brothers and William Gropper. At this time Lozowick's articles on Jewish art and artists began to appear in *The Menorah Journal* and other periodicals. He lectured at the Educational Alliance and at the Société Anonyme, which in 1925 published his *Modern Russian Art*. During the next two years the artist participated in exhibitions at the Jewish Art Center in New York. He also helped to organize the 1927 *Machine Age Exposition* in New York and wrote the introduction to its catalogue. From the mid-twenties through the thirties, Lozowick worked in numerous capacities for *The New Masses*.

With the advent of the Depression, Lozowick depicted Social Realist themes. From 1934 to 1940, Lozowick worked for the Public Works of Art Project (PWAP), the WPA/FAP and the Treasury Relief Art Project, for which he created two large paintings for New York City's main post office on Thirty-fourth Street. During the mid-thirties, Lozowick joined the American Artists Group and the American Artists' Congress. At this time he also taught at both the John Reed Club School of Art in New York and at its successor, the American Artists School, where he worked again during the forties. In 1938 he participated in the first exhibition of the Yiddish Popular Front group YKUF.

Lozowick was included in the 1943 *American Realists and Magic Realists* exhibition at the Museum of Modern Art in New York. The following year he attended the National Council of American-Soviet Friendship and also moved to South Orange, New Jersey. In 1947, Lozowick's *One Hundred Contemporary American Jewish Painters and Sculptors*, one of the first documents on Jewish artists in America, was published by YKUF. In the 1950s he was called to testify before the House Un-American Activities Committee. The Whitney Museum of American Art held a major retrospective of his lithographs in 1972. The artist died in South Orange in 1973.

## SELECTED SOLO EXHIBITIONS

1922    *Louis Lozowick: Paintings and Drawings*, Galerie Twardy, Berlin

1926    *Paintings and Drawings by Louis Lozowick*, J. B. Neumann's New Art Circle, New York

1928    *Drawings and Prints by Louis Lozowick*, Museum of Western Art, Moscow

1929    *Louis Lozowick*, Weyhe Gallery, New York (also exhibited 1931, 1936)

1961    *Louis Lozowick*, Zabriskie Gallery, New York (also exhibited 1972, 1981)

1972    *Louis Lozowick: Lithographs*, Whitney Museum of American Art, New York

1975    *Louis Lozowick: Drawings and Lithographs*, National Collection of Fine Arts, Smithsonian Institution, Washington, D.C.

1978    *Louis Lozowick, American Precisionist, Retrospective*, Long Beach Museum of Art, California

1983    *The Prints of Louis Lozowick*, National Museum of American Art, Smithsonian Institution, Washington, D.C.

1990    *Lozowick, 1892–1973: Paintings and Drawings*, Sid Deutsch Gallery, New York

## SELECTED GROUP EXHIBITIONS

1924    *Annual Exhibition*, Society of Independent Artists, New York (also exhibited 1925, 1928-1930, 1941)

1925    *Neue Sachlichkeit—Deutsche Malerei seit dem Expressionismus*, Mannheim, Germany

1926 *International Exhibition of Modern Art*, Société Anonyme, The Brooklyn Museum (traveled)

1926 *Exhibition of Paintings, Drawings and Sculptures*, Jewish Art Center, New York (also exhibited 1927)

1927 *Machine Age Exposition*, Steinway Hall, New York

1929 *Young Israel Exhibition*, Young Israel magazine offices, New York

1930 *33 Moderns*, Grand Central Art Galleries, New York.

1933 *Biennial Exhibition*, Whitney Museum of American Art, New York (also 1936, 1938, 1939, 1941, 1942, 1943)

1938 *First Exhibition of Painting, Sculpture, Graphic Arts and Yiddish Books and Press*, World Alliance for Yiddish Culture (Yiddisher Kultur Farband), New York

1939 *Art in a Skyscraper*, American Artists' Congress, New York

1940 *The Educational Alliance Art School 25th Anniversary Exhibition*, Associated American Artists Galleries, New York

1943 *American Realists and Magic Realists*, The Museum of Modern Art, New York

1960 *The Precisionist View in American Art*, Walker Art Center, Minneapolis (traveled)

1963 *Retrospective Art Exhibit of the Educational Alliance Art School*, American Federation of Arts Gallery, New York

1975 *Jewish Experience in the Art of the Twentieth Century*, The Jewish Museum, New York

1976 *The Golden Door: Artist-Immigrants of America 1876-1976*, Hirshhorn Museum and Sculpture Garden, Smithsonian Institution, Washington, D.C.

1976 *America as Art*, National Collection of Fine Arts, Smithsonian Institution, Washington, D.C.

1982 *Images of America: Precisionist Painting and Modern Photography*, San Francisco Museum of Modern Art (traveled)

1986 *The Machine Age in America, 1918-1941*, The Brooklyn Museum, New York

SELECTED BIBLIOGRAPHY

Archives of American Art, Smithsonian Institution, Louis Lozowick Papers.

Flint, Janet. *The Prints of Louis Lozowick: A Catalogue Raisonné*. New York: Hudson Hills Press, 1982.

*Louis Lozowick, American Precisionist Retrospective*. Long Beach, California: Long Beach Museum of Art, 1978. Exh. cat.

Lozowick, Louis. *One Hundred Contemporary American Jewish Painters and Sculptors*. New York: YKUF Art Section, 1947.

Rashell, Jacob. *Jewish Artists in America*. New York: Vantage Press, 1967.

Schwarz, Karl. *Jewish Artists of the 19th and 20th Centuries*. Freeport, New York: Books for Libraries Press, for the Philosophical Library, Inc., 1949, reprint 1970.

Zabel, Barbara Beth. *Louis Lozowick and Technological Optimism of the 1920s*. Ph.D. dissertation, University of Virginia, 1978. Unpublished.

## ABRAHAM MANIEVICH (1881-1942)

Abraham Manievich was born on November 25, 1881, in Mstislavl, in Bielorussia, and first studied art from 1903 to 1905 at the Imperial Art School in Kiev. A government stipend permitted him to study at the Academy in Munich from 1905 to 1907. Manievich was primarily a landscape painter. A solo exhibition of his work was held at the Kunstverein in Munich, before he returned to Russia in 1907. In Germany he would have been exposed to the Expressionist art of the Blaue Reiter and in Russia to the folk-inspired works of Larionov and Goncharova. His subjects included the wooden houses and small dwellings in the towns and villages of the Ukraine and Lithuania.

He exhibited with avant-garde groups in Russia, including *Mir Iskusstva* (World of Art), and in Vienna with the Secession. In 1910 a solo exhibition of his work was held at the State Museum in Kiev. Between 1910 and 1912 Manievich traveled in Germany, Italy, France, Switzerland and England. A solo exhibition of his work was held at the Galerie Durand-Ruel in Paris in 1913. Around 1914 Manievich moved to Moscow. He returned to Kiev and was appointed a professor of art at the Academy there in 1917. The rise in anti-Semitism following the Russian Revolution led Manievich to evolve a greater Jewish consciousness in his work. In 1918 he exhibited with *The Moscow Circle of Jewish Men of Letters and Artists*. The following year he lost his son in a pogrom in Kiev and marked the personal tragedy and public devastation of the event in the painting *Destruction of the Ghetto* (The Jewish Museum, New York). In 1921 he left Russia, and an exhibition of his work was held in Warsaw. Manievich arrived in New York in 1922. He adapted his cubo-futurist style to landscapes of the Bronx, where he lived. His work received immediate attention; in 1923 he was given a solo exhibition at the Peabody Art Institute in Baltimore and in 1928 another at the Baltimore Museum of Art. In the mid-twenties he exhibited with the Jewish Art Center along with his close friend, the sculptor Aaron Goodelman, with whom he shared a studio. He became a member of YKUF in the late 1930s and participated in its first exhibition in New York in 1938. The artist died in 1942.

SELECTED SOLO EXHIBITIONS

1907 Kunstverein, Munich

1910 Kiev State Museum, Ukraine, Russia

1913 Galerie Durand-Ruel, Paris

1916 *Abraham Manievich*, Dobychina Bureau, Petrograd

1923 Art Alliance, Philadelphia

1925 Boston Art Club

1923 *Abraham Manievich, Exhibition of Paintings*, Peabody Art Institute, Baltimore

1924 *Recent Paintings by Abraham Manievich*, Babcock Galleries, New York

1928 *Exhibition of Paintings by Abraham Manievich*, Baltimore Museum of Art

1937 Everhart Museum, Scranton, Pennsylvania

1943 French Art Galleries, New York

1949 Tel Aviv Museum, Israel

1972 The Western-Eastern Museum of Fine Arts, Kiev, Soviet Union (traveled)

SELECTED GROUP EXHIBITIONS

1907-1910 *Obshchestvo Pooshchereniya Khudozhnikov (Society for Advancement of Painters)*, Kiev, Ukraine

*Perio-dicheskaya Vistavka (Periodical Exhibition)*, Moscow

*Mir Iskusstva (The World of Art)*, Russia

*Secession*, Vienna

*Yuzhno-Russoye Obshchestvo Khudozhnikov (Society of Southern-Russian Painters)*, Odessa

1912    *Salon d'Automne*, Paris

1918    *The Moscow Circle of Jewish Men of Letters and Artists*, Moscow

1923    *Russian Painting and Sculpture*, The Brooklyn Museum, New York

1926    *Exhibition of Paintings, Drawings and Sculptures*, Jewish Art Center, New York (also exhibited 1927)

1936    *Exhibition of Works of Art Presented by American Artists to the State Museum of Birobidzhan*, Birobidzhan, Soviet Union (traveled)

1938    *First Exhibition of Painting, Sculpture, Graphic Arts and Yiddish Books and Press*, World Alliance for Yiddish Culture (Yiddisher Kultur Farband), New York

1975    *Jewish Experience in the Art of the Twentieth Century*, The Jewish Museum, New York

1986    *The Bronx Express*, Bronx Museum of the Arts, New York

## SELECTED BIBLIOGRAPHY

Kampf, Avram. *Jewish Experience in the Art of the 20th Century*. South Hadley, Mass.: Bergin and Garvey, Publishers, Inc., 1984. Revised edition, London: Lund Humphries in Association with the Barbican Art Gallery, 1990. Exh. cat.

Lozowick, Louis. *One Hundred Contemporary American Jewish Painters and Sculptors*. New York: YKUF Art Section, 1947.

Rashell, Jacob. *Jewish Artists in America*. New York: Vantage Press, 1967.

## WILLIAM MEYEROWITZ (1896? -1981)

William Meyerowitz, the eldest of the six children of Shendl Mittleman and Gershon Meyerowitz, was born in the Ukraine, Russia, on July 15 in the year variously given between 1887 and 1898. His father, a Zionist, was a cantor who instructed Meyerowitz in music and encouraged his singing in the synagogue.

Around 1908 Meyerowitz immigrated to the United States and lived on New York's Lower East Side. Supporting himself by singing in the Metropolitan Opera's chorus, he studied etching with Charles Mielatz at the National Academy of Design from 1912 to 1916.

In 1917 Meyerowitz participated in the first exhibition of the Society of Independent Artists, an organization he later served as treasurer and director. That year he also showed in the People's Art Guild Exhibition at the Forward Building. As an organizer of the event he solicited works by making the rounds of artists' studios. One of the doors he knocked on was that of the painter Theresa Bernstein, whom he subsequently married. From 1919 on the couple spent their summers in Gloucester, Massachusetts, painting, teaching, and receiving visits from friends such as Peter Blume, Raphael Soyer, their neighbor Stuart Davis, and the Dadaist and chess enthusiast Marcel Duchamp. Years later, Meyerowitz commemorated his games with Duchamp in the painting *Chess Players* (1964), which portrayed the two artists intensely engaged in the match, with Bernstein appearing as spectator.

Meyerowitz's earliest etchings focused on Jewish life observed on the Lower East Side and in the synagogue where he acted as cantor, and resulted in sensitive figure studies as *The Immigrant* (1918) and *The Talmudists* (1920). The summers in Gloucester broadened his range of subjects, now adding landscapes and harbor scenes. With his own printing press he developed a distinctive technique of etching in color, by applying the colors directly to the metal and superimposing them on the same plate. He made his first colored etching *Fishermen at Sunrise* in 1920, establishing himself as a pioneer in this medium. In the late 1920s he experimented with abstraction, influenced by Matisse and the Cubists, and produced the color etching *Crucifixion*, built upon compressed triangular forms.

An etching of Supreme Court Justice Oliver Wendell Holmes led in the thirties to a series of portraits commissioned by Justices Felix Frankfurter and Louis Brandeis, among others. During this period Meyerowitz worked as a muralist on the WPA. In 1938 he entered *Exodus* in the first exhibition of the World Alliance for Yiddish Culture (YKUF) in New York.

Though Meyerowitz continually explored religious and biblical themes, his interest extended to secular topics as well. In both oil paintings and prints he delineated favorite subjects as musicians, dancers, and horses, emphasizing their movement by accenting line, while keeping within the boundary of realism.

In 1943 Meyerowitz was elected to membership in the National Academy of Design. In 1952 he was elected president of the Friends of Zion II, an American Zionist organization. From that year to his death in 1981 he visited Israel thirteen times.

## SELECTED SOLO EXHIBITIONS

1919    *Etchings by William Meyerowitz*, Milch Galleries, New York (also exhibited 1920, 1923-1925)

1921    *Etchings by William Meyerowitz*, Corcoran Gallery of Art, Washington, D.C. (also exhibited 1930)

1923    *Etchings in Color by William Meyerowitz*, United States National Museum, Smithsonian Institution, Washington, D.C. (also exhibited 1941, 1942)

1930    *Work by William Meyerowitz*, Baltimore Museum of Art

1932    *Color Prints by William Meyerowitz*, Albany Institute, New York (traveled)

1957    Chase Gallery, New York, (Also exhibited 1959, 1965, 1968, 1972)

1973    *William Meyerowitz*, Butler Institute of American Art, Youngstown, Ohio

1987    *William Meyerowitz, 1887-1981*, Library of Congress, Washington, D.C.

## SELECTED GROUP EXHIBITIONS

1917    *First Exhibition*, Society of Independent Artists, New York (also exhibited 1918-1931, 1933-1944)

1917    *People's Art Guild Exhibition at the Forward Building*, New York

1917    *Annual Exhibition*, Pennsylvania Academy of the Fine Arts, Philadelphia (also exhibited 1918, 1923, 1924, 1926, 1928, 1930, 1933, 1935, 1936, 1938, 1941)

1920    *Oil Paintings by Theresa F. Bernstein and Etchings by William Meyerowitz*, Syracuse Museum of Fine Arts, New York

1920    *An Exhibition of Paintings by Robert Henri, Charles Bittinger, Theresa Bernstein and Etchings by William Meyerowitz*, The Memorial Art Gallery, Rochester, New York

1925    *Twenty-fourth Annual International Exhibition of Paintings*, Carnegie Institute, Pittsburgh (also exhibited 1926)

1927    *Seventh International Exhibition*, The Art Institute of Chicago (also exhibited 1933-1936)

1936    *Biennial Exhibition*, Whitney Museum of American Art, New York

1938    *First Exhibition of Painting, Sculpture, Graphic Arts and Yiddish Books and Press*, World Alliance for Yiddish Culture (Yiddisher Kultur Farband), New York

1947    *Depictions of the East Side*, Educational Alliance, New York

1950    *Jewish Artists—1950: Annual Exhibition*, Congress for Jewish Culture Art Center, The Jewish Museum, New York

1983    *New York Themes: Paintings and Prints by William Meyerowitz and Theresa Bernstein*, New-York Historical Society, New York

SELECTED BIBLIOGRAPHY

Burnham, Patricia M. "Theresa Bernstein." *Woman's Art Journal* 9, 2 (Fall/Winter 1989): 22-27.

*Current Biography 1942*. New York: H. W. Wilson Company, 1971, 588-590.

Lozowick, Louis. *One Hundred Contemporary American Jewish Painters and Sculptors*. New York: YKUF Art Section, 1947.

Meyerowitz, Theresa Bernstein. *William Meyerowitz: The Artist Speaks*. Philadelphia: The Art Alliance Press, 1986.

## ELIE NADELMAN (1882-1946)

Elie Nadelman, the seventh child of Hannah Arnstan and Philip Nadelman, a jeweler, was born in Warsaw on February 20, 1882, to a well-educated, artistic family. As a teenager he studied at the Warsaw Academy of Fine Arts, leaving in 1900 to serve one year in the Imperial Russian Army. In 1904 he settled in Munich, where he was impressed by the classical Greek sculpture and the collection of dolls and folk art in the local museums. After six months he went to Paris, where he remained for ten years. Working in marble and bronze, Nadelman created elegant, curvilinear female nudes and busts influenced by classical sculpture and the works of Michelangelo that he studied in the Louvre. He also produced many analytical drawings investigating geometric form and volume in the human figure. Nadelman was given his first one-man show at the Galerie Druet in 1909; composed of drawings and sculptures, it included his *Portrait of Thadée Natanson* (1909) in bronze, which reflected the influence of Rodin. He was given his second one-man show in 1911 at Paterson's Gallery in London, which included fifteen marble heads. This entire exhibition was bought by Helena Rubenstein, who became his patroness. In 1913 Nadelman participated in the seminal Armory Show in New York, exhibiting drawings and the plaster *Head of a Man*.

With the help of Mme. Rubenstein, Nadelman immigrated to the United States in 1914, settling in New York City. One year later Stieglitz mounted Nadelman's first one-man show in New York at his Photo-Secession Gallery 291, which offered a plaster of *Man in the Open Air*. The nonchalance and wit of this figure, with its derby hat and bow tie, introduced a new element in his work, which had previously appeared remote, generalized and formal. That same year, Nadelman's marble *Ideal Head* (ca. 1908) was purchased by the Rhode Island School of Design, making it the first of his sculptures to enter an American public collection. After Nadelman's successful second one-man show in New York at Scott & Fowles in 1917, he received numerous commissions for marble portrait busts. In contrast to these elegant portraits, Nadelman scandalized the patrons at a benefit exhibition in 1917 at the Ritz-Carlton Hotel with his *La Femme Assise* (*The Seated Woman*) which depicted a buxom mondaine. From 1917 to 1924 he created drawings and informal wooden figures of musicians, acrobats, burlesque queens and equestriennes which were inspired by his love of folk art and the world of performance. A series of dancers culminated in a cherrywood and gesso *Tango* (ca. 1923-1924) depicting an elegantly attired couple with their tapered and stylized bodies in motion. During these early years in New York, Nadelman also occasionally taught at the Educational Alliance and at the Beaux-Arts Institute. In 1920 Nadelman bought an estate in Riverdale, where he began to amass a collection of folk art that eventually numbered more than ten thousand pieces.

As a result of the stock-market crash in 1929, Nadelman suffered severe financial losses and withdrew from the art world, virtually becoming a recluse. Although he stopped exhibiting, he did undertake several architectural commissions, producing a limestone relief, *Construction Workers*, for the façade of the Fuller Building. He also worked with papier-mâché and ceramics, creating pairs of huge women, such as *Two Circus Women* (ca. 1930), the original model for one of the marble sculptures in the New York State Theater. In his last years, Nadelman worked primarily in plaster, fashioning hundreds of roughly finished doll-like figurines based on Greek prototypes and contemporary entertainers. He died in Riverdale in 1946.

SELECTED SOLO EXHIBITIONS

1909    *Exposition Elie Nadelman*, Galerie Druet, Paris (also exhibited 1913)

1911    Paterson's Gallery, London

1915    *Elie Nadelman Exhibition*, Photo-Secession Gallery, 291, New York

1919    *Nadelman*, M. Knoedler & Co., New York (also exhibited 1927)

1948    *The Sculpture of Elie Nadelman*, The Museum of Modern Art, New York

1967    *Elie Nadelman, 1882-1946*, Zabriskie Gallery, New York (also exhibited 1974, 1982, 1985-1987)

1975    *The Sculpture and Drawings of Elie Nadelman*, Whitney Museum of American Art, New York

1987    *Sculpture by Elie Nadelman*, Sidney Janis Gallery, New York

SELECTED GROUP EXHIBITIONS

1905    Salon d'Automne, Paris (also exhibited 1906, 1913)

1913    *International Exhibition of Modern Art*, organized by the Association of American Painters and Sculptors, 69th Regiment Armory, New York (traveled)

1917    *Allies of Sculpture*, Ritz Carlton Hotel, New York

1918    *Indigenous Sculpture*, The Whitney Studio, New York

1938    *Exhibition of American Sculpture*, Carnegie Institute, Pittsburgh

1944    *History of an American—Alfred Stieglitz: 291 and After; Selections from the Stieglitz Collection*, Philadelphia Museum of Art

1959    *The Collection of the Sara Roby Foundation*, Whitney Museum of American Art, New York

1959    *100 Drawings from the Museum Collection*, The Museum of Modern Art, New York

1962    *Modern Sculpture from the Joseph H. Hirshhorn Collection*, Solomon R. Guggenheim Museum, New York

1963    *The Educational Alliance Art School: Retrospective Art Exhibit*, American Federation of Arts Gallery, New York

1976    *The Golden Door: Artist-Immigrants of America, 1876-1976*, Hirshhorn Museum and Sculpture Garden, Smithsonian Institution, Washington, D.C.

1986    *The American Way in Sculpture 1890-1930*, The Cleveland Museum of Art

SELECTED BIBLIOGRAPHY

Baur, John I. H. *The Sculpture and Drawings of Elie Nadelman*. New York: Whitney Museum of American Art, 1975. Exh. cat.

Kirstein, Lincoln. *The Sculpture of Elie Nadelman*. New York: The Museum of Modern Art, 1948. Exh. cat.

Kirstein, Lincoln. *Elie Nadelman*. New York: The Eakins Press, 1973.

Kirstein, Lincoln. *Elie Nadelman Drawings*. New York: H. Bittner and Company, 1949

Wasserman, Jeanne L., and James B. Cuno. *Three American Sculptors and the Female Nude: Lachaise, Nadelman and Archipenko*. Cambridge, Massachusetts: Fogg Art Museum, 1980. Exh. cat.

Weichsel, John. "Eli Nadelman's Sculpture." *East and West* 1, 5, (August 1915): 144-148.

## LOUISE NEVELSON (1899-1988)

Leah Berliawsky was born on September 23, 1899, in Pereyaslav, near Kiev, Russia. Six years later, she moved with her family to Rockland, Maine. Her father's activities as a real estate developer and owner of a lumber-yard would have a major impact on the development of her sculpture, particularly her architectonic constructions in wood.

After her marriage in 1920 she settled in New York, where she began to study drama, dance and voice. In 1924 she attended Ann Goldwaithe's classes at the Art Students League and two years later she studied privately with the painters Theresa Bernstein and William Meyerowitz. In the later twenties Nevelson studied with Frederick Kiesler, the German émigré whose environmental approach to set design impressed the artist. From 1929 to 1931 she returned to study at the League with Kenneth Hayes Miller. Nevelson then studied with Hans Hoffmann in Munich and traveled throughout Europe, returning to New York at around the same time that Hoffmann immigrated, in 1932. She immediately studied with him again at the League, though briefly. In 1933, along with Ben Shahn and others, Nevelson worked as Diego Rivera's assistant on his mural series for the New Workers School in New York.

Nevelson continued to paint through the thirties generally using loose, expressionistic brushstrokes. In 1934 the artist also turned seriously to sculpture, studying with Chaim Gross at the Educational Alliance Art School. She worked primarily in terra-cotta, plaster and bronze, often shaping playful cubic figures and animals. From 1934 to 1939 she worked for the WPA/FAP, both on the easel division and teaching art to children at the Educational Alliance in 1937. Nevelson's first solo exhibition was held in 1941 at the Nierendorf Gallery in New York, where she exhibited small chunky figures influenced by Cubism and primitive art. In her 1943 Norlyst

show, Nevelson prefigured her later environments by playfully grouping Surrealist assemblages of found objects and wood scraps. At the same time Nevelson offered her home as a meeting place for, among others, the Federation of Modern Painters and Sculptors, organized in 1942 by a group including Adolph Gottlieb and Mark Rothko, who had seceded from the Artists' Congress.

Nevelson traveled twice to Central America in 1950 to visit archeological sites, an interest spurred by visits to the Museum of Natural History in New York. She began to work on a larger scale, and in 1954 again employed wood in her sculptures. In 1956 she constructed her first wall sculptures, composed of wood reliefs in open boxes stacked together. Painted in black or white, and later gold, these structures create a complex interplay of three-dimensional forms, shadows and textures.

Nevelson's solo exhibition at the Museum of Modern Art in 1959 brought her international acclaim, and between 1960 and 1980 major exhibitions of her work were also held at the Staatliche Kunsthalle in Baden-Baden, the Whitney Museum of American Art, the Museum of Fine Arts in Houston and the Walker Art Center. Nevelson became the first woman elected president of the National Artists Equity in 1962. That year she was also included in the Venice Biennale. Nevelson created the monumental *Homage to Six Million* in 1964, which was exhibited at the Jewish Museum in New York the following year. In the sixties she also began using a wider variety of materials, including aluminum, Plexiglas and Cor-ten steel. During the early 1970s Nevelson completed architectural commissions, including projects for Temple Beth-el in Great Neck, New York (1970), Temple Israel in Boston (1973) and St. Peter's Church at the Citicorp Center in New York (1977). The artist died in 1988 in New York.

SELECTED SOLO EXHIBITIONS

1941 *Louise Nevelson*, Nierendorf Gallery, New York (also exhibited 1942, 1943, 1946)

1943 *The Circus: The Clown Is the Center of His World*, Norlyst Gallery, New York

.1950 *Moonscapes*, Lotte Jacobi Gallery, New York (also exhibited 1954)

1955 *Nevelson: Sculptures, Sculpture-Collages, Etchings (Ancient Games and Ancient Places)*, Grand Central Moderns Gallery, New York (also exhibited 1956-1958)

1959 *Sky Columns Presence*, Martha Jackson Gallery, New York (also exhibited 1961-1963, 1969)

1959 *Dawn's Wedding Feast*, The Museum of Modern Art, New York

1961 *Louise Nevelson*, organized by the U.S.I.S. and The Museum of Modern Art, New York; Staatliche Kunsthalle, Baden-Baden, Germany

1964 *Louise Nevelson*, Pace Gallery, New York (also exhibited 1966–1972, 1974, 1976, 1977, 1980, 1983)

1965 *Louise Nevelson: Sculpture: "Hommage to Six Million,"* The Jewish Museum, New York

1967 *Louise Nevelson*, Whitney Museum of American Art, New York

1969 *Louise Nevelson*, Museum of Fine Arts, Houston (traveled)

1973 *Nevelson: Wood Sculptures*, Walker Art Center, Minneapolis (traveled)

1980 *Louise Nevelson: Atmospheres and Environments*, Whitney Museum of American Art, New York.

1980 *Louise Nevelson, The Fourth Dimension*, Phoenix Art Museum (traveled)

SELECTED GROUP EXHIBITIONS

1934 *Annual Exhibition*, Society of Independent Artists, New York

1934 Gallery Secession, New York

1935 *Sculpture: A Group Exhibition by Young Sculptors*, The Brooklyn Museum, New York

1937 *First Annual Membership Exhibition*, American Artists' Congress, New York

1943 *31 Women*, Art of This Century Gallery, New York

1946 *Annual Exhibition*, Whitney Museum of American Art, New York (also exhibited 1947, 1950, 1953, 1956-1958, 1960, 1962, 1964, 1966, 1969)

1959 *Sixteen Americans*, The Museum of Modern Art, New York

1962 *Biennale*, U.S. Pavilion, Venice, Italy

1963 *Retrospective Art Exhibit of the Educational Alliance Art School*, American Federation of Arts Gallery, New York

1964 *Documenta III*, Kassel, West Germany (also exhibited 1967)

1973 *American Art at Mid-Century*, National Gallery of Art, Washington, D.C.

1975 *Jewish Experience in the Art of the Twentieth Century*, The Jewish Museum, New York

1979 *Vanguard American Sculpture, 1913-1939*, Rutgers University Art Gallery, New Brunswick, New Jersey (traveled)

## SELECTED BIBLIOGRAPHY

Friedman, Martin. *Nevelson: Wood Sculptures, an Exhibition Organized by Walker Art Center.* New York: E. P. Dutton, 1973. Exh. cat.

Glimcher, Arnold B. *Louise Nevelson.* New York: Praeger, 1972; second edition revised and enlarged, New York: E.P. Dutton, 1976.

Lipman, Jean. *Nevelson's World.* Intro. by Hilton Kramer. New York: Hudson Hills Press in association with the Whitney Museum of American Art, distributed by Viking Penguin, 1983.

Lisle, Laurie. *Louise Nevelson.* New York: Summit, 1990.

*Louise Nevelson: Atmospheres and Environments.* Intro. by Edward Albee. New York: C. N. Potter, distributed by Crown, 1980.

Nevelson, Louise. *Dusks and Dawns: Taped Conversations with Diana Mackown.* New York: Scribner's, 1976.

Wilson, Laurie. *Louise Nevelson: Iconography and Sources.* Ph.D. dissertation, City University of New York, 1978. New York and London: Garland Publishing, 1981.

## BARNETT NEWMAN (1905-1970)

Barnett Newman was born on January 29, 1905, in New York City to a Russian-Polish family who had immigrated in 1900. By 1911 the family moved to the Bronx. Newman studied at the Educational Alliance Art School and with Duncan Smith, William Von Schlegell and John Sloan at the Art Students League from 1922 to 1924 but then entered City College, earning a bachelor's degree in philosophy in 1927. After graduation, Newman began working full time at his father's clothes-manufacturing business on Nassau Street in lower Manhattan. He returned to evening classes at the League in 1929.

Throughout the thirties the artist worked periodically as a substitute high school art teacher. In 1933 he ran unsuccessfully for mayor of New York City. During the campaign he wrote his first manifesto, "On the Need for Political Action by Men of Culture," and developed a reputation as a polemicist. Newman studied Henry David Thoreau and the Russian anarchist Peter Kropotkin. He learned Yiddish so as to be able to read the local anarchist newspaper.

During the summers of 1942 and 1943, the artist spent time in East Gloucester, Massachusetts; where he met Betty Parsons, who had a small gallery there. The summers of 1945 and 1946 Newman spent in Provincetown, Massachusetts, where he met Abstract Expressionist artists Hans Hoffmann, Clyfford Still and Tony Smith. After destroying most of his early work, around this time Newman began to depict a few perpendicular shafts and organic shapes, such as abstract birds, against an otherwise imageless background. With very active surfaces, these works reflect his interest in the evolution of nature and his study of botany and ornithology, as in his painting *Genesis—The Break* (1946).

Beginning in 1946, Newman organized a number of exhibitions for Betty Parsons' gallery in New York, including *Northwest Coast Indian Painting* that year. The following year he organized and exhibited in *The Ideographic Picture.* Between 1947 and 1949, Newman published five articles, including "The Sublime Is Now" in *Tiger's Eye.* The artist started the series he referred to as "zips" with *Onement I* (1948), in which vertical stripes were placed on an unmodulated surface. In 1949, Newman helped organize the Friday-evening program of lectures and discussion periods at the Subjects of the Artist School in New York, joining other faculty members William Baziotes, Robert Motherwell, David Hare and Mark Rothko.

In 1950 Newman made his first sculptures. That same year his first one-man show was held at the Betty Parsons Gallery. His work was poorly received by the critics and even friends considered it difficult and highly problematic. Newman did not have another exhibition until 1958, a retrospective mounted by Bennington College, which won the praise of the important formalist critic Clement Greenberg. In 1963 Newman created a model of a synagogue, which he exhibited at the Jewish Museum in New York. The artist died in New York in 1970.

## SELECTED SOLO EXHIBITIONS

1950 *Barnett Newman*, Betty Parsons Gallery, New York (also exhibited 1951)

1958 *Barnett Newman: First Retrospective Exhibition*, Bennington College, Bennington, Vermont

1966 *Barnett Newman: The Stations of the Cross, Lema Sabachthani*, Solomon R. Guggenheim Museum, New York

1971 *Barnett Newman*, The Museum of Modern Art, New York

1972 *Barnett Newman*, Stedelijk Museum, Amsterdam (also exhibited 1980)

1972 *Barnett Newman*, Grand Palais, Paris

1972 *Barnett Newman*, Tate Gallery, London

1988 *Barnett Newman*, Pace Gallery, New York

## SELECTED GROUP EXHIBITIONS

1947 *The Ideographic Picture*, Betty Parsons Gallery, New York (also exhibited 1948, 1949, 1955, 1956)

1947 *Abstract and Surrealist American Art*, The Art Institute of Chicago

1958 *The New American Painting: As Shown in Eight European Countries 1958-1959*, organized by the International Council, The Museum of Modern Art, New York (traveled)

1959 *Annual Exhibition*, Whitney Museum of American Art, New York (also exhibited 1963-1967, 1971)

1961 *American Abstract Expressionists and Imagists*, Solomon R. Guggenheim Museum, New York

1961 *Vanguard American Painting*, organized by the United States Information Service (traveled)

1963 *The Educational Alliance, Retrospective Art Exhibit*, American Federation of Arts Gallery, New York

1963 *Recent American Synagogue Architecture*, The Jewish Museum, New York

1963 *Black and White*, The Jewish Museum, New York

1965 *New York School: The First Generation: Painting of the 1940s and 1950s*, Los Angeles County Museum of Art

1967 *Dada, Surrealism and Their Heritage*, The Museum of Modern Art, New York (traveled)

1969 *The New American Painting and Sculpture: The First Generation*, The Museum of Modern Art, New York

1970 *New York Painting and Sculpture: 1940-1970*, The Metropolitan Museum of Art, New York

1975 *Jewish Experience in the Art of the Twentieth Century*, The Jewish Museum, New York

1978 *Abstract Expressionism, The Formative Years*, Herbert F. Johnson Museum of Art, Cornell University, Ithaca, New York, and the Whitney Museum of American Art, New York (traveled)

1987    *Abstract Expressionism: The Critical Developments*, Albright-Knox Gallery, Buffalo

1987    *The Spiritual in Art: Abstract Painting, 1890-1985*, Los Angeles County Museum of Art

SELECTED BIBLIOGRAPHY

Alloway, Lawrence. *Barnett Newman: The Stations of the Cross, Lema Sabachthani*. New York: Solomon R. Guggenheim Museum, 1966. Exh. cat.

Bois, Yve-Alain. *Barnett Newman*. New York: Pace Gallery, 1988. Exh. cat.

Hess, Thomas B. *Barnett Newman*. New York: The Museum of Modern Art, 1971. Exh. cat.

Rosenberg, Harold. *Barnett Newman*. New York: Abrams, 1978.

## ABBO OSTROWSKY (1889-1975)

Abbo Ostrowsky was born on October 23, 1889, in Elizavetgrad, Russia, to Favel and Rebecca Ethel Boguslavsky Ostrowsky. He studied art at the Imperial Academy in Odessa. His experience in 1906 as the assistant director of the People's Art Traveling Exhibitions, which brought art to the provinces of Kherson, Poltava and Kiev, shaped his belief in the social value of art. After his arrival in New York in 1908, he attended the classes of Maynard and Turner at the National Academy of Design. In 1914 he became an art teacher at the University Settlement on the Lower East Side, and three years later formally organized the Art School of the Educational Alliance.

From 1915 to 1917 Ostrowsky participated in exhibitions sponsored by the People's Art Guild at settlement and neighborhood houses in the Bronx and Manhattan, including the Guild's major exhibition at the Jewish Daily Forward Building. In the 1920s Ostrowsky exhibited with the Jewish Art Center in New York.

Ostrowsky painted portraits in a naturalistic, academic style; he also made etchings of the streets and the populace of the Lower East Side. The latter were included in the annual shows of the Society of American Etchers and numerous group exhibitions. In 1918, Ostrowsky organized an exhibition of students' work at the Educational Alliance, instituting a tradition of anniversary exhibitions in more prominent venues. His sister Ella taught batik classes and established a craft studio at the Art School.

Ostrowsky's teaching stressed draftsmanship, and he used residents of the neighborhood as models for his life classes at the

Alliance. This practice departed from the academic method of working from plaster casts. Ostrowsky believed that art could augment social progress in the community and that the spiritual source of an artist's strength must be drawn from the life and cultural tradition of his community.

In the mid 1930s Ostrowsky was a member of the American Artists' Congress. He was appointed chairman of the Visual Arts Committee of the National Federation of Settlements in 1936 and also served as the chairman of the Visual Arts Committee of United Neighborhood Houses of New York. In 1954 Ostrowsky presented the art collection of the Educational Alliance Art School to the Jewish Museum where it was exhibited on that occasion. Art School alumni Peter Blume, Philip Evergood and Elias Grossman were included in the show. Ostrowsky remained director of the Art School until his retirement in 1955. The artist died in 1975.

SELECTED SOLO EXHIBITIONS

1924    Anderson Galleries, New York

1931    *Abbo Ostrowsky: Etchings*, Baltimore Museum of Art

1937    *Abbo Ostrowsky: Etchings and Drawings*, Frederick Keppel and Co., New York

SELECTED GROUP EXHIBITIONS

1917    *People's Art Guild Exhibition at the Forward Building*, New York

1926    *Exhibition of Paintings, Drawings and Sculptures*, Jewish Art Center, New York

1926    *Sesqui-Centennial International Exhibition*, Philadelphia

1927    *Group Exhibition of Watercolor Paintings, Pastels and Drawings by American and European Artists*, The Brooklyn Museum, New York

1940    *Exhibition of Paintings and Sculpture by the Art School Alumni of the Educational Alliance*, Associated American Artists Galleries, New York

1950    *Jewish Artists—1950: Annual Exhibition*, Congress for Jewish Culture Art Center, The Jewish Museum, New York

1963    *The Educational Alliance Art School Retrospective Art Exhibit*, American Federation of Arts Gallery, New York

SELECTED BIBLIOGRAPHY

Lozowick, Louis. *One Hundred Contemporary American Jewish Painters and Sculptors*. New York: YKUF Art Section, 1947.

YIVO Institute for Jewish Research, New York, Abbo Ostrowsky Papers

## LOUIS RIBAK (1902-1980)

Louis Leon Ribak was born in Lithuania on December 3, 1902, and immigrated to the United States with his family in 1912. In 1920 he began his art studies at the Pennsylvania Academy of the Fine Arts, Philadelphia, with Daniel Barger. He moved to New York and in 1922 studied under John Sloan at the Art Students League. The following year he enrolled at the Art School of the Educational Alliance.

Following the example of Sloan, Ribak began to paint scenes of ordinary people at work and leisure in the city. Beginning in 1925 he exhibited in four consecutive annual exhibitions of the Whitney Studio Club. During 1926 and 1927 he showed with the Jewish Art Center, along with artists Raphael Soyer and Louis Lozowick, among others, who were also active in the John Reed Club. In the late 1920s and early 1930s he contributed drawings to the *New Masses*. In 1932 he married the artist Bea Mandelman. That same year the first solo exhibition of his work was held at the galleries of An American Group, a nonprofit artists' organization, in New York. In 1933 he was included in the exhibition *The Social Viewpoint in Art* sponsored by the John Reed Club.

Ribak's work became increasingly dominated by social content. In many paintings he depicted coal miners subsumed by the barren industrial landscape and in others he captured the plight of unemployed men living in "Hoovervilles." After the dissolution of the John Reed Club in 1936, he exhibited with the American Artists' Congress and in YKUF's first exhibition in 1938. He also worked as a muralist on the Fine Arts Project of the WPA. In 1939 his work was shown at the New York World's Fair and at the Golden Gate Exposition, San Francisco. During the 1940s his paintings were shown regularly in the Whitney Annuals.

In 1944 Ribak settled in Taos, New Mexico, where he had first visited with Sloan, and soon left behind his Social Realist style. Inspired by the bright atmosphere of the Southwest and its exotic culture, he was drawn to such new subjects as American Indians and the desert landscape. Influenced by Abstract Expressionism, by the end of the decade Ribak began to paint non-representational works,

which dominated his oeuvre for the remainder of his career. Ribak founded the Taos Valley Art School in 1947 and eight years later opened the Gallery Ribak. Two major museum exhibitions of his work have been held in New Mexico, one at the Museum of New Mexico, Santa Fe, in 1975, and the other, four years after the artist's death, at the Roswell Museum in 1984.

## SELECTED SOLO EXHIBITIONS

1932 *Paintings by Louis Ribak*, An American Group Galleries, New York

1937 *Louis Ribak: Paintings*, ACA Galleries, New York (also exhibited 1942, 1945, 1952)

1954 *Ribak*, Harry Salpeter Gallery, New York

1963 *Louis Ribak*, New Mexico Highlands University, Las Vegas, New Mexico

1975 *Louis Ribak Retrospective*, Museum of Fine Arts, Santa Fe, New Mexico

1983 *Louis Ribak Retrospective*, Linda Durham Gallery, Santa Fe, New Mexico

1984 *Louis Ribak*, Roswell Museum, Roswell, New Mexico

## SELECTED GROUP EXHIBITIONS

1925 *Tenth Annual Exhibition*, The Whitney Studio Club, Anderson Galleries, New York (also exhibited 1926–1928)

1932 *Summer Exhibition*, Whitney Museum of American Art, New York

1932 *An American Group, Second Annual Guest Exhibition*, An American Group Galleries, New York (also exhibited 1934)

1933 *Annual Exhibition*, Pennsylvania Academy of the Fine Arts, Philadelphia (also exhibited 1946, 1950, 1953)

1933 *Biennial Exhibition*, Whitney Museum of American Art, New York (also exhibited 1936, 1941, 1943, 1949)

1938 *First Exhibition of Painting, Sculpture and Graphic Arts and Yiddish Books and Press*, World Alliance for Yiddish Culture (Yiddisher Kultur Farband), New York

1939 *Art in a Skyscraper*, American Artists' Congress, New York

1939 World's Fair, New York

1940 *Exhibition of Paintings and Sculpture by the Art School Alumni of the Educational Alliance*, Associated American Artists Galleries, New York

1941 ACA Galleries, New York

1945 *Bi-Annual Exhibition*, Worcester Museum of Art, Massachusetts

1981 *The Neglected Generation of American Realist Painters: 1930-1948*, Wichita Art Museum, Kansas

## SELECTED BIBLIOGRAPHY

Lozowick, Louis. *One Hundred Contemporary American Jewish Painters and Sculptors.* New York: YKUF Art Section, 1947.

Luhan, Mabel Dodge. *Taos and Its Artists.* New York: Duell, Stown and Pearce, 1947.

Stiel, Donald O. *Louis Ribak Retrospective.* Santa Fe, New Mexico: Museum of Fine Arts, Museum of New Mexico, 1975. Exh. cat.

## MARK ROTHKO (1903-1970)

Born Marcus Rothkowitz in Dvinsk, Russia, on September 25, 1903, to Jacob and Anna Goldin Rothkowitz, Rothko was raised in a well-educated family with Zionist leanings. At the age of ten, Rothko and his mother and sister immigrated to America to join his father and brothers, who had previously settled in Portland, Oregon. From 1921 to 1923 Rothko attended Yale University on a full scholarship and then moved to New York City. In 1924 he enrolled in the Art Students League, studying with George Bridgman and Max Weber, in whose class he befriended Louis Harris. In 1929 Rothko began teaching children at the Center Academy of the Brooklyn Jewish Center, a position he retained for more than twenty years.

He was given his first one-man show in 1933 at the Museum of Art in Portland and his first in New York a few months later at the Contemporary Arts Gallery. The New York exhibition included landscapes, nudes, portraits, and city scenes such as *Riverside Drive*. At the end of 1934 Rothko participated in an exhibition at the Gallery Secession, whose members included Louis Harris, Adolph Gottlieb, Ilya Bolotowsky and Joseph Solman; several months later they left the Secession to form their own group, the Ten, which exhibited together eight times between 1935 and 1939. Rothko's paintings in the Ten's exhibitions, such as *Crucifixion* and *Woman Sewing*, were expressionistic in style. During this period he was employed by the WPA, where he produced many subway scenes emphasizing the isolation of the riders.

From the late 1930s to 1946 Rothko's oil and watercolor paintings reflected his interest in Greek mythology, primitive art and Christian tragedy. Influenced by the Surrealists Miró and André Masson, among others, he explored the technique of automatic drawing in creating abstract, diaphanous forms alluding to human and animal life, in such works as *Rites of Lilith* (1945) and *Gethsemane* (1945). In 1940, Rothko, along with his colleagues Gottlieb, Bolotowsky and Harris, broke with the American Artists' Congress on political grounds and became founding members of the Federation of Modern Painters and Sculptors. He was given, in 1945, a one-man exhibition at Peggy Guggenheim's gallery Art of This Century, which featured his Surrealist works. At the end of the year he was included in the Whitney's *Annual Exhibition of Contemporary American Painting*. In 1948 he joined William Baziotes, David Hare and Robert Motherwell in founding an art school, the Subjects of the Artist, which closed within a year.

By 1947 Rothko had eliminated all elements of Surrealism or mythic imagery from his works, and nonobjective compositions of indeterminate shapes emerged. Within three years he reached his signature format, painting two or three soft-edged, luminescent rectangles, stacked weightlessly on top of one another, floating horizontally against a ground. Now a recognized artist of the New York School, he was given, in 1954, a one-man show by the Art Institute of Chicago. In 1958 Rothko accepted his first commission for a series of paintings for the Four Seasons restaurant. He received his second commission for murals in 1961 for the Holyoke Center at Harvard University. From 1964 to 1967 Rothko worked on his third and last commission, a Roman Catholic chapel in Houston, now interdenominational, creating fourteen canvases, numerically corresponding to the Stations of the Cross. From 1968 on, he worked in acrylic on canvas and paper, reducing his palette to brown, gray and black.

Rothko was elected to the National Institute of Arts and Letters in 1968. The following year Yale University awarded him an honorary Doctor of Fine Arts degree. In 1970, Rothko committed suicide in his studio.

## SELECTED SOLO EXHIBITIONS

1933 Museum of Art, Portland, Oregon

1933 *An Exhibition of Paintings by Marcus Rothkowitz*, Contemporary Arts Gallery, New York

1945 *Mark Rothko Paintings*, Art of This Century, New York

1954 *Recent Paintings by Mark Rothko*, The Art Institute of Chicago (traveled)

1957 *Mark Rothko*, Contemporary Arts Museum, Houston

1961 *Mark Rothko*, The Museum of Modern Art, New York (traveled)

1970 *Mark Rothko 1903-1970*, The Museum of Modern Art, New York

1978 *Mark Rothko, 1903-1970: A Retrospective*, Solomon R. Guggenheim Museum, New York (traveled)

1981 *Mark Rothko: The Surrealist Years*, The Pace Gallery, New York (also exhibited 1983, 1985, 1990)

1984 *Mark Rothko: Works on Paper*, National Gallery of Art, Washington, D.C.

1987 *Mark Rothko 1903-1970*, The Tate Gallery, London

SELECTED GROUP EXHIBITIONS

1928 Opportunity Galleries, New York

1934 *Group Exhibition*, Gallery Secession, New York

1935 *The Ten*, Montross Gallery, New York

1938 *Second Annual Membership Exhibition: American Artists' Congress*, New York

1938 *The Ten: Whitney Dissenters*, Mercury Galleries, New York

1945 *Annual Exhibition*, Whitney Museum of American Art, New York (also exhibited 1947-1950)

1947 *Abstract and Surrealist American Art*, The Art Institute of Chicago

1951 *Abstract Painting and Sculpture in America*, The Museum of Modern Art, New York

1961 *American Abstract Expressionists and Imagists*, Solomon R. Guggenheim Museum, New York

1968 *Dada, Surrealism and Their Heritage*, The Museum of Modern Art, New York

1969 *The First Generation. New York Painting and Sculpture: 1940-1970*, The Metropolitan Museum of Art, New York

1975 *Jewish Experience in the Art of the Twentieth Century*, The Jewish Museum, New York

1976 *The Golden Door: Artist-Immigrants of America, 1876-1976*, Hirshhorn Museum and Sculpture Garden, Smithsonian Institution, Washington, D.C.

1978 *Abstract Expressionism: The Formative Years*, Herbert F. Johnson Museum of Art, Ithaca, New York

1987 *Abstract Expressionism: The Critical Developments*, Albright-Knox Art Gallery, Buffalo, New York

SELECTED BIBLIOGRAPHY

Ashton, Dore. *About Rothko*. New York: Oxford University Press, 1983.

Barnes, Susan J. *The Rothko Chapel: An Act of Faith*. Houston: A Rothko Chapel Book, 1989.

Breslin, James E. B. "The Trials of Mark Rothko." *Representations* 16 (Fall 1986): 1-41.

Chave, Anna C. *Mark Rothko: Subjects in Abstraction*. New Haven and London: Yale University Press, 1989.

Clearwater, Bonnie. *Mark Rothko: Works on Paper*. New York: Hudson Hill's Press, 1984. Exh. cat.

Rosenblum, Robert. *Mark Rothko: Notes on Rothko's Surrealist Years*. New York: The Pace Gallery, 1981. Exh. cat.

*Mark Rothko 1903-1970*. London: The Tate Gallery, 1987. Exh. cat.

Waldman, Diane. *Mark Rothko, 1903-1970: A Retrospective*. New York: Abrams, in collaboration with the Solomon R. Guggenheim Foundation, 1978. Exh. cat.

**CONCETTA SCARAVAGLIONE** (1900-1975)
Born on July 9, 1900, in New York City, Concetta Scaravaglione grew up on the Lower East Side, the youngest of nine children in a poor family of immigrants from Calabria, Italy. At the age of sixteen, she began to study sculpture at the National Academy of Design in a special free class for women which was taught by Frederick Roth. Concurrently, she attended classes at the Educational Alliance Art School. A scholarship to the Art Students League then made study with Boardman Robinson possible. In 1924 she studied direct carving with Robert Laurent. In 1925 Scaravaglione returned to the Educational Alliance as a teacher, marking the beginning of a career that led to posts at the Masters Institute, New York University, Black Mountain College, Sarah Lawrence College and, finally, Vassar College.

Her success as a teacher was paralleled by her recognition as an artist. Scaravaglione first exhibited in 1925 at the Salons of America. Although not Jewish, in 1926 she showed at the Jewish Art Center together with Chaim Gross, Samuel Halpert and Abraham Walkowitz. She was first included in the annuals of the Whitney Studio Club in 1926 and the Whitney Museum of American Art in 1933, and showed in the Pennsylvania Academy of the Fine Arts Annual in 1934, winning the Widener Gold Medal for her *Mother and Child*. A figurative artist, Scaravaglione focused on female forms, both life-size and monumental, often pairing her curvilinear women with children or animals. She worked in a variety of materials including terra-cotta, mahogany, marble, limestone and bronze.

In 1938 Scaravaglione joined Chaim Gross and William Zorach in becoming a charter member of the Sculptors Guild, an organization opposed to restrictive concepts of art which sought new venues for exhibiting modernistic works. The group's first exhibition included her *Girl with Gazelle*, which was executed under the aegis of the WPA. As a recipient of government commissions from the Treasury Section of Painting and Sculpture, she produced *Railway Express Postman 1862* in 1935 for the United States Post Office in Washington, D.C.; *Harvest* in 1937 (also known as *Agriculture*) for the Federal Trade Commission Building in Washington, D.C., and the monumental *Woman with Mountain Sheep* for the Federal Building at the New York World's Fair of 1939.

In 1940 she participated in the twenty-fifth Anniversary exhibition of the Educational Alliance Art School. One year later the Virginia Museum of Fine Arts gave Scaravaglione her first one-woman show. Her professional accomplishments were further acknowledged with a grant in 1946 from the American Academy of Arts and Letters. In 1947 Scaravaglione became the first woman to win the Prix de Rome, enabling her to live abroad for three years, during which time she completed the *Icarus Falling*. After her return from Rome, she accepted a teaching position at Vassar College. A distinguished faculty member for fifteen years, she was given a retrospective exhibition in 1967 on the occasion of her retirement. At the age of seventy-four Scaravaglione received her first one-woman show in New York at the Kraushaar Galleries, which included sculptures from the 1960s and 1970s created from welded copper sheets. She died in 1975 in New York City.

SELECTED SOLO EXHIBITIONS

1941 *The Sculpture of Concetta Scaravaglione*, The Virginia Museum of Fine Arts, Richmond, Virginia

1967 *Retrospective Exhibition of Sculpture by Concetta Scaravaglione*, Vassar College Art Gallery, Poughkeepsie, New York

1974 *Sculpture and Drawings by Concetta Scaravaglione*, Kraushaar Galleries, New York (also exhibited 1983)

## SELECTED GROUP EXHIBITIONS

1926 *Exhibition of Paintings, Drawings and Sculptures*, Jewish Art Center, New York

1926 *Annual Exhibition*, Whitney Studio Club, New York (also exhibited 1927, 1928)

1927 *Sculpture by New York Artists*, The Brooklyn Museum, New York

1934 *Annual Exhibition*, Pennsylvania Academy of the Fine Arts, Philadelphia (also exhibited 1935, 1938, 1940, 1941-1947, 1952-1954, 1958, 1960, 1962, 1966)

1933 *First Biennial Exhibition*, Whitney Museum of American Art, New York (also exhibited 1936, 1938, 1939, 1941, 1943-1947)

1936 *New Horizons in American Art*, The Museum of Modern Art, New York

1940 *25th Anniversary Exhibition of the Educational Alliance Art School*, Associated American Artists Galleries, New York

1941 *Annual Exhibition*, The Art Institute of Chicago, (also exhibited 1942, 1943)

1942 *Artists for Victory*, The Metropolitan Museum of Art, New York

1954 *The Abbo Ostrowsky Collection of the Educational Alliance Art School*, The Jewish Museum, New York

1956 *The Figure in Contemporary Sculpture*, Munson-Williams-Proctor Institute, Utica, New York

1965 *Women Artists of America 1707-1964*, The Newark Museum, New Jersey

1976 *7 American Women: The Depression Decade*, Vassar College Art Gallery, Poughkeepsie, New York

1980 *The Figurative Tradition and the Whitney Museum of American Art: Paintings and Sculpture from the Permanent Collection*, Whitney Museum of American Art, New York

1988 *Women Artists of the New Deal Era: A Selection of Prints and Drawings*, The National Museum of Women in the Arts, Washington, D.C.

## SELECTED BIBLIOGRAPHY

Gerdts, William H. *Women Artists of America, 1707-1964*. Newark, New Jersey: The Newark Museum, 1965. Exh. cat.

Harrison, Helen A., and Lucy R. Lippard. *Women Artists of the New Deal Era: A Selection of Prints and Drawings*. Washington, D.C.: The National Museum of Women in the Arts, 1988. Exh. cat.

Marling, Karal Ann, and Helen A. Harrison. *7 American Women: The Depression Decade*. Poughkeepsie, New York: Vassar College Art Gallery, 1976. Exh. cat.

Rubinstein, Charlotte Streifer. *American Women Artists*. Boston: G. K. Hall and Co., 1982.

*The Sculpture of Concetta Scaravaglione*. Foreword by Thomas C. Colt, Jr. Richmond: The Virginia Museum of Fine Arts, 1941. Exh. cat.

## MORTON L. SCHAMBERG (1881-1918)

Morton Livingston Schamberg was born into a prosperous German-Jewish Philadelphia family on October 15, 1881. Following his mother's death, Schamberg was raised by relatives. He studied architecture at the University of Pennsylvania from 1899 to 1903. From 1903 to 1906 he studied at the Pennsylvania Academy of the Fine Arts with William Merritt Chase and met fellow student Charles Sheeler, who later became a photographer and leading figure of American Precisionism. Schamberg accompanied Chase's class on summer trips to England and Holland in 1904 and to Spain in 1906. Later in 1906 Schamberg left for Paris for a year. The influence of the French Impressionists was soon apparent in his *plein-air* paintings. In 1908 he again visited Paris and then Italy, where he saw the Renaissance art collections of the museums in Rome, Siena, Florence, Venice and Milan. He returned to Paris in 1909 where he saw the works of Cézanne, Picasso, Matisse, van Gogh and other French modernists. Some of his works of that year began to reflect the simplified structure and reduced forms of Post-Impressionism. The artist returned to Philadelphia that same year.

In 1910 his first solo exhibition was held at the McClees Galleries in Philadelphia. During the next five years his works reflected more strongly his engagement with Cézanne, Fauvism and Cubism. He also created monumental portraits in the style of the French moderns.

Schamberg worked as a commercial photographer beginning in 1912. Although he continued to live in Philadelphia, he maintained connections to the New York art world. He exhibited five works in the Armory Show of 1913. In 1913-1914 he created some of his most abstract pictures, with transparent overlapping color planes similar to the earlier Orphist works of Frantisek Kupka and Robert Delaunay. Conceived perhaps as early as 1912, by 1916 Schamberg had completed a series of pastels and paintings of machine forms, or parts, that link him to New York Dada. These works, in either vivid colors or more subdued hues, reveal the irony of the technological age: its optimism and its impersonality. Around this time he also began to frequent the New York salon of Walter Arensberg, a patron of Marcel Duchamp and other leading figures in the avant-garde.

In 1917 Schamberg exhibited in a show of advanced art sponsored by the People's Art Guild, which included the work of the French artists Picabia and Picasso and the Americans Samuel Halpert, Ben Benn and Abraham Walkowitz, among others. This was his only participation in the Guild, a proletarian organization that often exhibited avant-garde work alongside that of unknown immigrant artists. Also that year he exhibited in the first exhibition of the Society of Independent Artists. Schamberg died in the influenza epidemic of the following year. After his death he was recognized as a major pioneer of American Precisionism.

## SELECTED SOLO EXHIBITIONS

1910 *Exhibition of Paintings by Morton Livingston Schamberg*, McClees Galleries, Philadelphia

1919 *Paintings and Drawings by Morton L. Schamberg*, M. Knoedler Galleries, New York

1963 *Paintings by Morton L. Schamberg*, Pennsylvania Academy of the Fine Arts, Philadelphia

1964 *Morton L. Schamberg*, Zabriskie Gallery, New York

1982 *Morton Livingston Schamberg (1881-1918)*, Salander-O'Reilly Galleries, New York (traveled) (also exhibited 1986)

## SELECTED GROUP EXHIBITIONS

1913 *International Exhibition of Modern Art*, organized by the Association of American Painters and Sculptors, 69th Regiment Armory, New York

1915 *Exhibition of Paintings, Drawings, and Sculptures*, Montross Gallery, New York

George Bellows. Also known as the Ferrer Center, it was an anarchist school located on East 107th Street. By 1924 he started teaching life drawing at the Educational Alliance, where he taught periodically throughout his life. Soyer began to exhibit with the Whitney Studio Club in 1925 and was awarded a fellowship by the Educational Alliance to travel in Europe from 1926 to 1928. Drawn to a style of naturalism which explored the subtle nuances of character, Soyer focused on the human figure throughout his life, often within a studio setting and always with a intimate and humanist quality to his vision.

Upon his return to New York, Soyer taught at various New York schools including the Contemporary Art School, the New Art School and the New School for Social Research. From 1928 to 1934 he also taught again at the Educational Alliance and came to know or instruct such students as Barnett Newman, Mark Rothko, Philip Evergood and Ben Shahn. Soyer's first one-man show was held at J. B. Neumann's New Art Circle in New York in 1929. Like many other Social Realists, he lived in the Union Square area, but Soyer's style was neither political propaganda nor satire. He preferred young women and friends as subjects rather than the highly charged themes of artists like Ben Shahn. Moses at times exhibits a subtle sense of humor and his depictions of the ballet reflect an appreciation of the French Impressionist painter Edgar Degas.

Soyer was periodically involved with the Yiddish poets of the *Di Yunge* literary movement. In 1935 he created designs for a series of portable canvas murals for the WPA/FAP, entitled *Children at Play and Sport*. These were installed in children's libraries and hospitals throughout New York. Soyer worked on the art committee of the World Congress for Jewish Culture, known as YKUF, in 1937 and around the same time was a member of the American Artists' Congress and An American Group. With Raphael, Moses painted two murals in Kinglessing Post Office, Philadelphia, in 1939. Soyer participated in the National Council of American-Soviet Friendship in 1944. The artist died in New York in 1974.

The Whitney Museum of American Art honored Soyer with a retrospective in 1985.

## SELECTED SOLO EXHIBITIONS

1929    *Moses Soyer: Recent Paintings*, J. B. Neumann's New Art Circle Gallery, New York

1936    *Moses Soyer*, Kleeman Galleries, New York

1940    *An Exhibition of Paintings by Moses Soyer*, Macbeth Galleries, New York (also exhibited 1941, 1943)

1944    *Moses Soyer*, ACA Galleries, New York (also exhibited 1947, 1962, 1963, 1965, 1970, 1972, 1977, 1980, 1985)

1968    *Moses Soyer*, Reading Museum, Pennsylvania

1970    *Moses Soyer—A Selection of Paintings, 1960-1970*, Albrecht Gallery Museum of Art, St. Joseph, Missouri

1972    *Moses Soyer: A Human Approach*, ACA Galleries, New York (traveled)

1985    *Moses Soyer: Selected Works*, Whitney Museum of American Art, New York

## SELECTED GROUP EXHIBITIONS

1925    *Annual Exhibition*, The Whitney Studio Club, New York (also exhibited 1926)

1926    J. B. Neumann's New Art Circle Gallery, New York

1929    *Young Israel Exhibition, Young Israel* magazine offices, New York

1933    *Biennial Exhibition*, Whitney Museum of American Art, New York (also exhibited 1936, 1944, 1947, 1948)

1938    *Annual Exhibition*, Pennsylvania Academy of the Fine Arts, Philadelphia (also exhibited 1940-1944, 1946, 1947, 1951, 1952, 1958, 1964, 1966)

1938    *First Exhibition of Painting, Sculpture, Graphic Arts and Yiddish Books and Press*, World Alliance for Yiddish Culture (Yiddisher Kultur Farband), New York

1939    *Art in a Skyscraper*, American Artists' Congress, New York

1940    *The Educational Alliance Art School 25th Anniversary Exhibition*, Associated American Artists Galleries, New York

1963    *The Educational Alliance Art School Retrospective Art Exhibit*, American Federation of Arts Gallery, New York

1966    *The Lower East Side: Portal to American Life (1870-1924)*, The Jewish Museum, New York (traveled)

1975    *Jewish Experience in the Art of the Twentieth Century*, The Jewish Museum, New York

1988    *Drawing on the East End, 1940-1988*, Parrish Art Museum, Southampton, New York

1990    *Chagall to Kitaj: Jewish Experience in 20th Century Art*, Barbican Art Gallery, London

## SELECTED BIBLIOGRAPHY

Lozowick, Louis. *One Hundred Contemporary American Jewish Painters and Sculptors.* New York: YKUF Art Section, 1947.

*Moses Soyer: A Human Approach.* New York: ACA Galleries, New York, 1972. Exh. cat.

Smith, Bernard. *Moses Soyer.* New York: ACA Galleries, New York, 1944. Exh. cat.

Soyer, David. *Moses Soyer.* South Brunswick, New Jersey: A.S. Barnes and Co., 1970.

Willard, Charlotte. *Moses Soyer.* Cleveland and New York: World Publishing Co., 1962.

## RAPHAEL SOYER (1899-1987)

Raphael Schoar was born, as was his twin brother Moses, on December 25, 1899, in Borisoglebsk, Russia. His father was a Hebrew scholar who was persecuted and forced to emigrate in 1912. He changed their surname to Soyer and settled in the Bronx, New York. From 1914 to 1918 Soyer attended the free evening art classes at Cooper Union and the National Academy of Design. He stayed on at the Academy full time until 1922, studying with George Maynard and Charles Courtney Curran and meeting fellow students Ben Shahn and Meyer Schapiro. Soyer also studied briefly at the Art Students League from 1920 to 1921 and in 1923 with Guy Pene du Bois, who encouraged the painting of people in everyday situations. Soyer credits du Bois with exercising the greatest influence on his work and recommending him to the Daniel Gallery, where Soyer first exhibited in 1929. During the twenties, Soyer was periodically involved with the *Di Yunge* Yiddish literary movement.

The young artist studied briefly with Boardman Robinson in 1926 and joined the Whitney Studio Club the following year. During the mid-twenties Soyer also frequented the Jewish Art Center, where he met both Abraham Walkowitz and Nicolai Cikovsky. They acquainted him with the John Reed Club where he met Louis Lozowick and Diego Rivera. During the latter half of the twenties, Soyer turned away from his academic training by intentionally flattening forms and space in his seemingly naive portraits and depictions of city life.

During the thirties, Soyer's Fourteenth Street studio near Union Square was a popular meeting place for artists, including the group of figurative painters later referred to as the Fourteenth Street School, which included Soyer, Isabel Bishop, Reginald Marsh and Kenneth Hayes Miller, among others. Soyer taught at the John Reed Club School of Art as well as at the Art Students League from around 1933 to 1942. Though he was a member of numerous political and artists groups, such as the Artists Equity Association, the American Artists' Congress, the Artists Union and the American Artists Group, Soyer's work was never overtly political or satirical. A self-described humanist, Soyer's style shifted to a painterly, sober realism, favoring a dark palette and models from the neighborhood such as workers and the unemployed. While always sympathetic, his was an objective and unsentimental eye, which focused on the tenacity of humans amid hardship, rather than on their despair. In 1935, Soyer attended the World Congress of Writers Against War and Fascism and lectured at the International Society of Artists in Moscow. Three years later he was on the art committee of the Yiddish Popular Front organization YKUF. The artist periodically illustrated the stories of his friend Isaac Bashevis Singer. During the late forties Soyer taught at the American Artists School. At this time his work began to focus more on single nudes and female portraits.

In 1950 Soyer cofounded the magazine *Reality—A Journal of Artists' Opinions* along with other Social Realists, such as Philip Evergood, Ben Shahn and Yasuo Kuniyoshi. During this decade Soyer produced a few large symbolic group portraits, and his work was generally more complex with a lighter palette. Beginning in 1957 Soyer taught for five years at the New School for Social Research, New York. In 1962 and 1967, his work was exhibited at the Whitney Museum of American Art. Soyer taught at the National Academy of Design from 1965 to 1967. The Hirshhorn held an exhibition of his late, large-scale paintings in 1980. The artist died in New York in 1987.

## SELECTED SOLO EXHIBITIONS

1929 *Raphael Soyer*, Daniel Gallery, New York

1932 *Raphael Soyer*, Elan Gallery, New York

1933 *Recent Paintings by Raphael Soyer*, Valentine Gallery, New York (also exhibited 1935, 1938)

1939 *Small Paintings by Raphael Soyer*, Frank K. M. Rehn Galleries, New York

1941 *Raphael Soyer*, Associated American Artists Galleries, New York (also exhibited 1947, 1948, 1953, 1960, 1965, 1981)

1960 *Raphael Soyer*, ACA Galleries, New York

1962 *Raphael Soyer*, Whitney Museum of American Art, New York (also exhibited 1967)

1966 *Raphael Soyer*, Forum Gallery, New York (also 1967, 1977, 1989)

1967 *Raphael Soyer*, Whitney Museum of American Art, New York

1980 *Raphael Soyer*, Hirshhorn Museum and Sculpture Garden, Smithsonian Institution, Washington, D.C. (also exhibited 1982)

1984 *Raphael Soyer's New York: People and Places*, Cooper Union, New York (traveled)

## SELECTED GROUP EXHIBITIONS

1922 *Annual Exhibition*, Society of Independent Artists, New York (also exhibited 1925, 1940, 1941)

1927 *Exhibition of Paintings, Drawings and Sculptures*, Jewish Art Center, New York

1927 *Annual Exhibition*, Whitney Studio Club, New York (also exhibited 1928)

1932 *Biennial Exhibition*, Whitney Museum of American Art, New York (also exhibited 1933, 1934, 1936, 1938, 1939, 1941-1950)

1933 *The Social Viewpoint in Art*, John Reed Club, New York

1936 *New Horizons in American Art*, The Museum of Modern Art, New York

1938 *First Exhibition of Painting, Sculpture, Graphic Arts and Yiddish Books and Press*, World Alliance for Yiddish Culture (Yiddisher Kultur Farband), New York

1939 *Art in a Skyscraper*, American Artists' Congress, New York

1959 *American Painting and Sculpture: American National Exhibition in Moscow*, Sokolniki Park, Moscow, U.S.S.R.

1966 *The Lower East Side: Portal to American Life (1870-1924)*, The Jewish Museum, New York (traveled)

1975 *Jewish Experience in the Art of the Twentieth Century*, The Jewish Museum, New York

1982 *Realism and Realities: The Other Side of American Painting, 1940-1960*,

Rutgers University Art Gallery, New Brunswick, New Jersey (traveled)

1990 *Chagall to Kitaj: Jewish Experience in 20th Century Art*, Barbican Art Gallery, London

## SELECTED BIBLIOGRAPHY

Brown, Milton, foreword. *Raphael Soyer (1899-1987)*. New York: Forum Gallery, 1989. Exh. cat.

Goodrich, Lloyd. *Raphael Soyer*. New York: Harry N. Abrams, 1972.

Hills, Patricia. *Raphael Soyer's New York: People and Places*. New York: Cooper Union, 1984. Exh. cat.

Lerner, Abraham. *Soyer Since 1960*. Washington, D.C.: Smithsonian Institution Press, 1982. Exh. cat.

Lozowick, Louis. *One Hundred Contemporary American Jewish Painters and Sculptors*. New York: YKUF Art Section, 1947.

Soyer, Raphael. *A Painter's Pilgrimage: An Account of a Journey with Drawings by the Author*. New York: Crown Publishers, 1962.

Soyer, Raphael. *Homage to Thomas Eakins, Etc.* Rebecca L. Soyer, ed. South Brunswick, New Jersey: T. Yoseloff, 1966.

Soyer, Raphael. *Self-Revealment: A Memoir*. New York: Random House, 1967.

Soyer, Raphael. *Diary of an Artist*. Washington, D.C.: New Republic Books, 1977.

## JENNINGS TOFEL (1891-1959)

Yehudah Toflevicz was born on October 18, 1891, in Tomashev, Poland, the son of a tailor. Although the official language under the Czar was Russian, the artist came from a Yiddish-speaking home and from a family which had in previous generations included rabbis and scholars. His mother, Chaya, died of typhus in 1898. By 1902, his father, Yosif, had remarried and settled in America, leaving Tofel in the care of relatives. As a child Tofel suffered a back injury which left him a hunchback. Limited physically, he concentrated on his studies and attended the Russian Alexander School in Tomashev from 1900 to 1903. He was curious and had an active imagination, which led him, without exposure to art, to experiment on his own with bits of colored scrap paper that he assembled in collages. In 1905 Yosif Toflevicz sent for his son. During his first years here, Tofel met and formed lasting friendships with the Yiddish poets of *Di Yunge*, David Ignatoff and Mani Leib. In 1910 he entered City College and that same year began to paint. In 1912, no

longer able to afford city living, he moved to Newburgh, New York, where he worked in the family store. Tofel's spiritual and subjective nature never inclined him toward radical experiments in art, such as Cubism or abstraction. His earliest canvases are dark and romantic, like those of Ryder. Tofel shared this subjective vision with his close friend, the painter Benjamin Kopman. They exhibited, along with other artists, as the Introspectives at the Whitney Studio Club in 1917. That same year Tofel participated in the People's Art Guild's Forward exhibition.

In 1919 Tofel's first solo show was held at the Bourgeois Galleries in New York. Two of his essays, *Form in Painting* (1921) and *Expression* (1923), were published by the Société Anonyme, New York. He also wrote on art for Yiddish publications. While he continued to depict subjects from mythology as well as genre scenes, Tofel's palette became lighter and his handling less impastoed during the 1920s. In 1925 he and Benjamin Kopman organized the Jewish Art Center, which held exhibitions downtown. With the support of Alfred Stieglitz, Tofel left for Europe in 1927, and one of his essays appeared in the *American Caravan*. Tofel returned to New York briefly in 1929, but later that same year Stieglitz again found donors to finance a second European sojourn.

Tofel went first to Paris, then to Tomashev, and was married there. Afterward he returned to Paris for a year and a half before settling in New York in 1930. In 1934 he began working for the WPA. A member of the American Artists' Congress, he participated in its first annual show in 1937. In 1943 twenty of his paintings were acquired by Joseph Hirshhorn. Using fiery, contrasting colors and loose, broad divisionist brushwork, he painted allegorical and symbolic paintings in the 1940s and 1950s, which relate to the Holocaust. Tofel died in New York in 1959. Retrospective exhibitions of his work were held at Zabriskie Gallery, New York, in 1964, and at the Ramapo College Art Gallery, in Mahwah, New Jersey in 1983.

## SELECTED SOLO EXHIBITIONS

1919 *Jennings Tofel*, Bourgeois Galleries, New York

1928 *Jennings Tofel*, Galerie Zak, Paris

1931 *Paintings and Drawings by Jennings Tofel*, S.P.R. Galleries, New York

1937 *Jennings Tofel*, Artists' Gallery, New York (also exhibited 1947, 1950, 1952, 1954, 1956, 1958)

1941 Bonestell Gallery, New York

1959 Memorial Exhibition, Congress for Jewish Culture Art Center, Atron House, New York

1964 *Jennings Tofel*, Zabriskie Gallery, New York

1983 *Jennings Tofel*, Ramapo College Art Gallery, Mahwah, New Jersey (traveled)

## SELECTED GROUP EXHIBITIONS

1917 *Introspective Art*, Whitney Studio Club, New York

1917 *Imaginative Paintings by Thirty Young Artists of New York City*, Knoedler Galleries, New York

1917 *People's Art Guild Exhibition at the Forward Building*, New York

1919 Smith College Museum of Art, Northampton, Massachusetts

1921 *Introspectives*, Arts Club of Chicago, New York

1922 *Modern Sculpture, Watercolors and Drawings*, Colony Club, New York

1922 *Annual Exhibition of Modern Art*, Bourgeois Galleries, New York

1926 *Exhibition of Paintings, Drawings and Sculptures*, Jewish Art Center, New York (also exhibited 1927)

1929 New Art Circle, New York

1937 *First Annual Membership Exhibition*, American Artists' Congress, Rockefeller Center, New York (also exhibited 1939)

1938 Artists' Gallery, New York (also exhibited 1939)

1948 *Jewish Artists*, The Jewish Museum, New York

1950 *Jewish Artists—1950: Annual Exhibition*, Congress for Jewish Culture Art Center, The Jewish Museum, New York

1975 *Jewish Experience in the Art of the Twentieth Century*, The Jewish Museum, New York

1990 *Chagall to Kitaj: Jewish Experience in 20th Century Art*, Barbican Art Gallery, London

## SELECTED BIBLIOGRAPHY

Davidson, Abraham A. *The Eccentrics and Other Visionary Painters*. New York: Dutton, 1978.

Eldredge, Charles C. "American Introspectives After 1900." In *American Imagination and Symbolist Painting*. New York: Grey Art Gallery and Study Center, New York University, 1979. Exh. cat.

Granick, Arthur. *Jennings Tofel*. New York: Abrams, 1976.

Hayes, Jeffrey R. *Jennings Tofel*. Mahwah, New Jersey: Ramapo College Art Gallery, 1983. Exh. cat.

YIVO Institute for Jewish Research, Jennings Tofel Papers

## NAHUM TSCHACBASOV (1899-1984)

Nahum Tschacbasov, the second of nine children, was born in Baku, Russia, in 1899. During the revolution of 1905 his father, Stephan, immigrated to Chicago, where his family joined him in 1907. In the United States the family used the name Licterman. Tschacbasov studied electrical engineering at night while working to help support his family in 1913. During World War I he served in the Navy. He then earned a degree in business and operated his own firm. Between 1926 and 1929 he lived in New York, and around this time became interested in drawing and painting. In 1930 he began to study art in Chicago. He lived briefly in New York again in 1932 before leaving for Paris, where he studied with Leopold Gottlieb, Marcel Gromaire, and for a short time with Fernand Léger. His first solo exhibition was held at the Galerie Zak, Paris, two years later. Both Cubism and the style of the School of Paris, the latter with its vivid colors and impastoed surfaces, had a lasting influence on his work.

Tschacbasov settled in New York in 1934. The following year he became associated with the Gallery Secession, where he was given a solo show. He also worked on the WPA/FAP. Like other artists of the period, he turned to subjects of daily life during the Depression, allying himself with the Social Realists. In 1935, along with Joseph Solman, Adolph Gottlieb and Mark Rothko, Tschacbasov organized the Ten, an independent exhibiting group. Tschacbasov's Social Realist canvases, however, put him at odds with the other members of the Ten, who were more interested in formal issues, and he remained with the group less than a year. In 1936-1937 he was business manager for *Art Front*. Tschacbasov taught at the American Artists School in the late thirties, and was a member of the American Artists' Congress. His circle of artist friends at the time included Philip Evergood, Milton Avery, Stuart Davis, David Burliuk, William Gropper, Raphael Soyer, Marsden Hartley and Max Weber. Around 1939 he began Jungian psychoanalysis. The next year he took up photography and started a profitable art slide business. The experience of eight years of analysis had a profound effect on his work and by the early

1940s he was working in a style he called "Abstract Surrealism," combining Cubist structure with fantasy images from the unconscious. The artist had also become aware of the Surrealist technique of automatic drawing while working at Atelier 17 in New York in 1944. During the forties, he also created paintings reflecting the atrocities of war, sometimes with specific Jewish subjects.

He taught at the Art Students League from 1945 to 1951. From the early fifties Tschacbasov's work became increasingly abstract, with images more fractured and ambiguous and dominated by a Cubist grid structure. In the later fifties he painted more simplified single-figure compositions. Tschacbasov also made ceramics which were shown alongside his paintings at the Jewish Museum in 1956.

Throughout the following decades he continued to paint, making complex figural compositions. In 1970 he purchased a house in Amagansett, Long Island, and by 1978 Tschacbasov had a larger house in East Hampton, Long Island, and also lived at the Chelsea Hotel in Manhattan. In 1979 he turned seriously to writing poetry. Three years later a book of his poems, *Machinery of Fright*, accompanied by reproductions of his graphics, was published. The artist died in 1984.

## SELECTED SOLO EXHIBITIONS

1934    Galerie Zak, Paris

1935    Gallery Secession, New York

1937    ACA Galleries, New York (also exhibited 1938, 1940, 1942, 1943)

1945    *Tschacbasov, Recent Paintings*, Perls Gallery, New York (also exhibited 1946-1948)

1951    *Tschacbasov*, John Heller Gallery, New York (also exhibited 1953)

1954    *Tschacbasov*, Butler Art Institute, Youngstown, Ohio

1956    *Nahum Tschacbasov: Paintings and Ceramics*, The Jewish Museum, New York

1987    *Nahum Tschacbasov: Paintings, 1936-1982*, Luise Ross Gallery, New York

## SELECTED GROUP EXHIBITIONS

1935    *The Ten: An Independent Group*, Montross Gallery, New York

1936    *Members of the Artists Union*, ACA Galleries, New York (also exhibited 1938-1941)

1936    *Opening Exhibition*, Municipal Art Gallery, New York

1936    *The Ten*, Galerie Bonaparte, Paris

1936    *Biennial Exhibition*, Whitney Museum of American Art, New York (also exhibited 1937, 1945, 1949)

1938    *First Exhibition of Painting, Sculpture, Graphic Arts and Yiddish Books and Press*, World Alliance for Yiddish Culture (Yiddisher Kultur Farband), New York

1939    *Art in a Skyscraper*, American Artists' Congress, New York

1942    *Artists for Victory*, The Metropolitan Museum of Art, New York

1936    *Biennial Exhibition*, Whitney Museum of American Art, New York (also exhibited 1937, 1945, 1949)

1946    *Darrell Austin and Nahum Tschacbasov*, Vigeveno Gallery, Los Angeles (traveled)

1947    *Surrealist American Art*, Art Institute of Chicago

1983    *The Expressionist Vision*, Hillwood Art Gallery, C.W. Post Center, Greenvale, Long Island

## SELECTED BIBLIOGRAPHY

Goddard, Don L. *Tschacbasov*. New York: American Archives of World Art, Inc., Publishers, 1964.

Frost, Rosamond. "The Liberation of Nahum Tschacbasov." *Art News* 44,2 (March, 1945): 1-14.

Lozowick, Louis. *One Hundred Contemporary American Jewish Painters and Sculptors*. New York: YKUF Art Section, 1947.

*Machinery of Fright: Poems by Tschacbasov*, Southampton, New York: Southampton College Press, 1982.

Tschacbasov, Nahum. "Fear of Influences," *The Art of the Artist*. Arthur Zaidenberg, ed. New York: Crown Publishers, 1951.

## ABRAHAM WALKOWITZ (1878-1965)

Abraham Walkowitz was born on March 28, 1878, in Tyumen, Siberia. In 1893 the family immigrated and settled on the Lower East Side, where his mother ran a newspaper stand. Walkowitz began his art training in 1892 at Cooper Union and frequently attended evening art classes at the Educational Alliance, where he probably studied with Henry McBride and fraternized with his friend and neighbor Jacob Epstein. From 1898 to 1900 Walkowitz studied at the National Academy of Design. His early work reflects a deep appreciation of Whistler and his concern with the similarities between music and painting.

After the turn of the century, Walkowitz also taught at the Educational Alliance Art School. In 1906 he traveled to Paris, where he saw the large 1907 Cézanne retrospective at the *Salon d'Automne* and met Max Weber, who introduced him to various advanced art circles. Like Weber, Walkowitz studied at the Académie Julian with Jean-Paul Laurens. Around this time Walkowitz also met Isadora Duncan and began a series of drawings and prints of her dancing that would occupy him throughout his life. Walkowitz felt that freedom of bodily movement also freed the spirit, and this was reflected in his rapid, loose drawing style. With Weber, Walkowitz took a trip to Italy in the spring of 1907 and returned to New York the following summer. His work at this time was inspired mainly by Post-Impressionism.

With only a few New York galleries sporadically exhibiting modern American art, Walkowitz arranged to have his first one-man show at the frame shop of his friend Julius Haas in 1908. The following year Walkowitz shared a studio with Weber and helped his friend arrange a showing at Haas's shop. Around 1911 Walkowitz attended Robert Henri's classes at the anarchist Ferrer Center, where Man Ray was a fellow student. The following year he met Alfred Stieglitz, with whom he became close friends, and the first of Walkowitz's four solo shows at 291 was held. The artist also exhibited in the 1913 Armory Show. By the mid-teens Walkowitz's style had shifted to a cubo-futurist rendering of modern urban life. Such works became increasingly abstract. Around this time Walkowitz met John Weichsel and was an active member of the People's Art Guild, participating in a number of Guild exhibitions. Though his work generally had no political content, Walkowitz contributed to numerous leftist and socialist publications. He also published in *Shriftn*, *Di Yunge's* Yiddish anthology.

From 1918 to 1920 Walkowitz was a director of the Society of Independent Artists and during the mid-twenties participated in shows organized by the Jewish Art Center. Around this time, Walkowitz returned to a more representational and less innovative style, with somber still lifes and some regional and social themes. The artist's work was exhibited in 1930 at Edith Halpert's Downtown Gallery, and later that decade appeared in the *New Masses*. In the forties, Walkowitz created a series of political drawings focusing on anti-Fascist ideas. Exhibitions of the artist's work were held at the Newark Museum in 1941 and at the Jewish Museum in 1948. By the end of the decade, the artist became in-

creasingly blind and less able to paint. He died in Brooklyn in 1965.

## SELECTED SOLO EXHIBITIONS

1908 *Abraham Walkowitz*, Haas Gallery, Julian Haas Frame Shop, New York

1912 *Drawings and Paintings by Abraham Walkowitz*, Little Galleries of the Photo-Secession, 291, New York (also exhibited 1913, 1914, 1916, 1917)

1941 *Walkowitz*, The Newark Museum, New Jersey

1949 *Abraham Walkowitz*, The Jewish Museum, New York

1952 *Abraham Walkowitz*, ACA Galleries, New York (also exhibited 1955, 1959).

1959 *Abraham Walkowitz*, Zabriskie Gallery, New York (also exhibited 1964, 1966, 1973)

1982 *Abraham Walkowitz: Figuration 1895-1945*, Long Beach Museum of Art, California

1982 *Abraham Walkowitz: New York Cityscapes*, Neuberger Museum, State University of New York, Purchase

## SELECTED GROUP EXHIBITIONS

1913 *International Exhibition of Modern Art*, organized by the Association of American Painters and Sculptors, 69th Regiment Armory, New York (traveled)

1916 *The Forum Exhibition of Modern American Painters*, Anderson Galleries, New York

1917 *First Annual Exhibition of the Society of Independent Artists*, Grand Central Palace, New York (also exhibited 1918-1938)

1917 *People's Art Guild Exhibition at the Forward Building*, New York

1917 *People's Art Guild Exhibition*, Church of the Ascension Parish House, New York

1917 *Futurist Paintings by American Artists*, Gamut Club, New York

1926 *Exhibition of Paintings, Drawings and Sculptures*, Jewish Art Center, New York (also exhibited 1927)

1926 *International Exhibition of Modern Art*, Société Anonyme, The Brooklyn Museum, New York (traveled)

1929 *Exhibition of American Art*, Bourgeois Galleries, New York

1932 *Biennial exhibition*, Whitney Museum of American Art, New York (also exhibited 1936, 1938, 1941, 1945, 1947, 1949)

1938 *First Exhibition of Painting, Sculpture, Graphic Arts and Yiddish Books and Press*, World Alliance for Yiddish Culture (Yiddisher Kultur Farband), New York

1950 *Jewish Artists—1950: Annual Exhibition*, Congress for Jewish Culture Art Center, The Jewish Museum, New York

1963 *Retrospective Art Exhibit of the Educational Alliance Art School*, American Federation of Arts Gallery, New York

1966 *The Lower East Side: Portal to American Life (1870-1924)*, The Jewish Museum, New York (traveled)

1976 *The Golden Door: Artist-Immigrants of America 1876-1976*, Hirshhorn Museum and Sculpture Garden, Smithsonian Institution, Washington, DC.

1976 *America as Art*, National Collection of Fine Arts, Smithsonian Institution, Washington, D.C.

1977 *Paris-New York*, Centre National d'Art et de Culture Georges Pompidou, Musée National d'Art Moderne, Paris

1984 *Into the Melting Pot*, Joseph and Margaret Muscarelle Museum, William and Mary College, Williamsburg, Virginia

1986 *Modern Times: Aspects of American Art, 1907-1956*, Hirschl and Adler Galleries, New York

1990 *Curator's Choice, American Artists of the Alfred Stieglitz Circle*, The Brooklyn Museum, New York

## SELECTED BIBLIOGRAPHY

Archives of American Art, Smithsonian Institution, Abraham Walkowitz Papers.

Eversole, Theodore Wayne. *Abraham Walkowitz and the Struggle for an American Modernism*. Cincinnati: University of Cincinnati, 1976.

Gelburd-Kimler, Gail. "The Art of Abraham Walkowitz: A Political and Social Reevaluation." M.A. Thesis, Ohio State University, 1977. Unpublished.

Kopman, Benjamin. *A. Walkowitz*. Paris: Editions Le Triangle, n.d.

Lozowick, Louis. *One Hundred Contemporary American Jewish Painters and Sculptors*. New York: YKUF Art Section, 1947.

Sawin, Martica. *Abraham Walkowitz, 1878-1965*. Salt Lake City: Utah Museum of Fine Arts, 1975. Exh. cat.

Schwarz, Karl. *Jewish Artists of the 19th and 20th Centuries*. Freeport, New York: Books for Libraries Press, for the Philosophical Library, Inc., 1949, reprint 1970.

Siegel, Priscilla Wishnick. "Abraham Walkowitz: The Early Years of an Immigrant Artist." M.A. thesis, University of Delaware, 1976. Unpublished.

Smith, Kent. *Abraham Walkowitz: Figuration 1895-1945*. Long Beach, California: Long Beach Museum of Art, 1982. Exh. cat.

Walkowitz, Abraham. *Art From Life to Life*. Girard, Kansas: Haldeman-Julius Publications.

Walkowitz, Abraham. *Faces from the Ghetto*. New York: Machmadim Art Editions, Inc., 1946.

Walkowitz, Abraham. *One Hundred Drawings by A. Walkowitz*. New York: B. W. Huebsch, Inc., 1925.

Weinberg, Louis. "Jewish Artist in America: Abraham Walkowitz." *The America Hebrew* (August 1917).

## MAX WEBER (1881-1961)

Max Weber was born on April 18, 1881, in Bialystok, Russia, into an Orthodox Jewish family and remained committed to Judaism throughout his life. His father, a tailor, immigrated ahead of his family. Max and the others joined him in Williamsburg, Brooklyn, in 1891. There Weber was put in the charge of a Hasidic rabbi to continue his religious instruction. His first language was Yiddish and he later learned to speak German and French. He left Boys High School in 1897, without graduating, to study at Pratt Institute, Brooklyn, under Arthur Wesley Dow, earning a teaching degree in 1900. Dow had worked with the Orientalist Ernest Fenollosa and Paul Gauguin and helped introduce Post-Impressionist ideas to the United States. On a scholarship from 1900 to 1901 Weber studied privately with Dow. From the fall of 1901 to August 1905, he taught in public schools, first in Virginia and then in Minnesota.

In 1905 Weber sailed for France where he studied with Jean-Paul Laurens at the Académie Julian in Paris. The following year he also studied unofficially at the Académie Colarossi and the Académie de la Grande Chaumière. In Paris he met numerous leaders of the avant-garde, including the writer Gertrude Stein and artists Henri Matisse, Pablo Picasso, Robert Delaunay and Henri Rousseau, who became a close friend. Weber also formed ties with the American painters Bernard Karfiol, Samuel Halpert and Abraham Walkowitz. He exhibited in the 1906 Salon and in 1907 traveled to Italy with Walkowitz and visited the Cézanne retrospective at the *Salon d'Automne*. In 1908 Weber helped to organize, as well as attended for one year, Henri Matisse's art school. As a result, Weber began to work in a style influenced by Fauvism and primitive art. He returned to New York in 1909.

Weber briefly shared an apartment with Walkowitz, who helped him secure his first solo exhibition at Haas Gallery in 1909. Fellow artist Arthur B. Davies was an early patron of Weber's, however few others were receptive to his radical style. Soon after his return to New York Weber met Alfred Stieglitz and exhibited at 291 in a group show in 1910 and had his first solo exhibition in 1911. Though invited to exhibit at the Armory Show in 1913, Weber withdrew his work feeling he had not been given enough space. In 1914 he published his book, *Cubist Poems*, and about the same time began a series of cubo-futurist cityscapes of New York. Weber lectured on art history and gave criticism to students at the Clarence H. White School of Photography, New York, between 1914 and 1918 and later published his lectures under the title *Essays on Art* (1916). From 1917 to 1919 he also served as a director of the Society of Independent Artists and exhibited in their first annual exhibition. Weber also participated in People's Art Guild exhibitions around this time, and in 1919 joined a group of artists that included William Zorach and Ben Benn in sponsoring an exhibition of work to benefit the building fund of the socialist *New York Call*.

By 1919 religious themes began to appear frequently, as in *Sabbath*. The artist was also involved with the group of Yiddish poets, *Di Yunge*, publishing numerous poems, woodcuts and three essays in *Shrifin* between 1919 and 1925. With Jennings Tofel, he co-illustrated H. Leivick's play *Der Goylem (The Golem)*, published in 1921. From 1919 to 1921 and from 1925 to 1927 Weber taught life drawing and painting at the Art Students League. He also took up the themes depicted

by the Social Realists in the twenties and thirties.

In 1937 he was elected national chairman of the American Artists' Congress and also worked on the art committee of the World Congress for Jewish Culture. During the forties, Weber increasingly used strategies of expressionist distortion, though this tapered off in his final years. In 1948 in a letter published in *Masses and Mainstream*, he continued his anti-Fascist stance by supporting the Hollywood Ten, along with Raphael Soyer, Philip Evergood and other intellectuals and writers, in defiance of McCarthyism. The artist died in Great Neck, Long Island, in 1961.

## SELECTED SOLO EXHIBITIONS

1909 *Max Weber*, Haas Gallery, Julius Haas Frame Shop, New York

1911 *Max Weber*, Little Galleries of the Photo-Secession, 291, New York

1913 *Max Weber*, The Newark Museum, New Jersey

1915 *Paintings by Max Weber*, Montross Gallery, New York (also exhibited 1923, 1924)

1924 *Max Weber*, J.B. Newmann's New Art Circle, New York (also exhibited in 1925, 1927, 1930, 1933, 1935, 1937)

1924 *Exposition: Max Weber*, Galerie Bernheim-Jeune, Paris

1928 *Max Weber*, The Downtown Gallery, New York (also exhibited 1929-32)

1930 *Max Weber, Retrospective Exhibition, 1907-1930*, The Museum of Modern Art, New York

1943 *Exhibition of Paintings by Max Weber*, Carnegie Institute, Pittsburgh

1949 *Max Weber: Retrospective Exhibition*, Whitney Museum of American Art, New York (traveled)

1956 *Max Weber: Paintings*, The Jewish Museum, New York

1957 *Max Weber*, Downtown Gallery, New York (also exhibited 1958, 1963)

1959 *Max Weber*, The Newark Museum, New Jersey

1974 *Max Weber*, Forum Gallery, New York (also exhibited 1975, 1979, 1981, 1986)

1982 *Max Weber: American Modern*, The Jewish Museum, New York (traveled)

1989 *Max Weber: Selected Works: 1908-1932*, Meredith Long and Co., Houston

1991 *Max Weber: The Cubist Decade*, High Museum, Atlanta (traveled)

## SELECTED GROUP EXHIBITIONS

1906 *Salon des Indépendents*, Paris (also exhibited 1907)

1906 *Salon d'Automne*, Paris (also exhibited 1907-1908)

1910 *Younger American Painters*, Little Galleries of the Photo-Secession, 291, New York

1913 *Grafton Group*, Alpine Club Gallery, London

1917 *First Annual Exhibition of the Society of Independent Artists*, Grand Central Palace, New York (also exhibited 1918, 1919, 1936)

1917 *People's Art Guild Exhibition at the Forward Building*, New York

1926 *International Exhibition of Modern Art*, Société Anonyme, The Brooklyn Museum, New York (traveled)

1929 *Nineteen Living American Artists*, The Museum of Modern Art, New York

1930 *33 Moderns*, Grand Central Art Galleries, New York

1931 *International Exhibition*, Société Anonyme, New School for Social Research, New York

1932 *Biennial Exhibition*, Whitney Museum of American Art, New York (also exhibited 1933, 1934, 1936, 1939, 1941-1950)

1933 *A Century of Progress Exhibition of Paintings and Sculpture*, The Art Institute of Chicago (also exhibited 1934)

1935 *24 Years of Abstract Painting in America*, Whitney Museum of American Art, New York

1939 *Art in Our Time*, The Museum of Modern Art, New York.

1946 *Pioneers of Modern Art in America*, Whitney Museum of American Art, New York

1950 *Jewish Artists—1950: Annual Exhibition*, Congress for Jewish Culture Art Center, The Jewish Museum, New York

1951 *Abstract Painting and Sculpture in America*, The Museum of Modern Art, New York

1953 *Modern Art*, The Metropolitan Museum of Art, New York

1965 *Roots of Abstract Art in America, 1910-30*, National Collection of Fine Arts, Washington, D.C.

1966 *The Lower East Side: Portal to American Life (1870-1924)*, The Jewish Museum, New York (traveled)

1975 *Jewish Experience in the Art of the Twentieth Century*, The Jewish Museum, New York

1976 *The Golden Door, Artist—Immigrants of America: 1876-1976*, Hirshhorn Museum and Sculpture Garden, Smithsonian Institution, Washington, D.C.

1983 *Early Modernism in America: The Stieglitz Circle*, University of Minnesota Art Museum, Minneapolis

1990 *Chagall to Kitaj: Jewish Experience in 20th Century Art*, Barbican Art Gallery, London

## SELECTED BIBLIOGRAPHY

Lozowick, Louis. *One Hundred Contemporary American Jewish Painters and Sculptors.* New York: YKUF Art Section, 1947.

North, Percy B. *Max Weber: American Modern.* New York: The Jewish Museum, 1982. Exh. cat.

Rubenstein, Daryl R. *Max Weber: A Catalogue Raisonné of His Graphic Work.* Chicago: The University of Chicago Press, 1980.

Schwarz, Karl. *Jewish Artists of the 19th and 20th Centuries.* Freeport, New York: Books for Libraries Press, for the Philosophical Library, Inc., 1949, reprint 1970.

Werner, Alfred. *Max Weber.* New York: Abrams, 1975.

## MARGUERITE THOMPSON ZORACH

(1887-1968)

Marguerite Thompson was born on September 25, 1887, in Santa Rosa, California. Her father was a successful lawyer and she was educated by private tutors in the small frontier town of Fresno, where she grew up.

In 1908, Marguerite went to live in Paris with her aunt, who introduced her to Gertrude Stein, through whom she met Picasso, Rousseau and Matisse. Thompson was immediately drawn to the most avant-garde styles, particularly that of Henri Matisse, whose flattened space, and rhythmic, painterly strokes of bold Fauve colors began to appear in her own work. Most notably her landscapes reveal a deep sensitivity to the fluid rhythms of nature and her lifelong preference for the country over the city. A number of her drawings and linoleum cuts were published at this time in the English avant-garde magazine *Rhythm*. Marguerite traveled widely throughout Europe and studied at the École de la Grande Chaumière with John Duncan Fergusson and Jacques-Émile Blanche and at La Palette, where she met her future husband, William Zorach, in 1911. Marguerite's modernist influence on Zorach led to a striking similarity between their work up until 1920. At the end of 1911 she returned with her aunt to California via Venice, the Middle East, India and Asia.

The couple married in New York in December of 1912 and from then on divided their time between the city and long summers in the countryside of New England. Both were represented in the Armory Show of 1913. Between 1915 and 1918 she participated in several exhibitions organized by the People's Art Guild. Her participation in the *Forum Exhibition* of 1916 is often overlooked because she did not show paintings, but a series of fans. During the mid-teens, both Zorachs taught at the art school at the anarchist Ferrer Center in New York. In Provincetown, Massachusetts, in 1916, the Zorachs began acting and designing sets and costumes for the Provincetown Players. They continued the association for a number of years, both in Provincetown and New York. The Zorachs were friends with the critic, gallery owner, patron and antique and folk-art enthusiast Hamilton Easter Field, as well as artists Bernar Gussow, John Marin, Abraham Walkowitz, Max Weber, Marsden Hartley and the sculptor Gaston Lachaise. Around this time Zorach became increasingly interested in Cubism, evidenced by a shift towards faceted surfaces and more restricted palettes.

The demands of raising two children left her little time to paint after 1917. Instead she employed brilliant-colored yarns and fabric in large embroidered tapestries. Her handwork attracted the patronage of Abby Aldrich Rockefeller, the wife of John D. Rockefeller, Jr., and other prominent collectors. Beginning in 1919, her work began to exhibit an intentionally naive folk-art quality.

In 1925 Zorach was elected the first president of the New York Society of Women Artists. Though she continued her handwork throughout her life, she returned to painting in the thirties and embraced the predominant American Scene subjects in her landscapes of rural Maine and portraits. Landscape was the major theme of her late paintings. The artist died in 1968 in Brooklyn.

## SELECTED SOLO EXHIBITIONS

1912 *Post-Impressionist Paintings and Etchings by Marguerite Thompson*, Royar Galleries, Los Angeles

1928 *Paintings and Drawings by Marguerite Zorach*, Downtown Gallery, New York (also exhibited 1930, 1934)

1933 *Marguerite Zorach*, Brummer Gallery, New York

1944 *Marguerite Zorach Exhibition*, M. Knoedler and Co., New York

1968 *Marguerite Zorach*, Colby College, Waterville, Maine (traveled)

1969 *California Drawings by Marguerite Zorach*, California Palace of the Legion of Honor, San Francisco (traveled)

1973 *Marguerite Zorach: The Early Years, 1908-1920*, National Collection of Fine Arts, Smithsonian Institution, Washington, D.C. (traveled)

## SELECTED GROUP EXHIBITIONS

1910 *American Women's Art Association of Paris*, American Art Students' Club, Paris

1911 *Vingt-huitième Exposition*, Société des Artistes Indépendents, Quai d'Orsay, Paris

1911 *Salon d'Automne*, Paris

1913 *International Exhibition of Modern Art*, organized by the Association of American Painters and Sculptors, 69th Regiment Armory, New York (traveled)

1915 *Opening Exhibition*, Daniel Gallery, New York (also exhibited 1916)

1915 *Panama-Pacific International Exposition*, Palace of Fine Arts, San Francisco

1915 *Exhibition of Paintings and Watercolors by William and Marguerite Zorach*, Daniel Gallery, New York (traveled) (also exhibited 1916, 1918, 1919)

1916 *The Forum Exhibition of Modern American Painters*, Anderson Galleries, New York

1917 *First Annual Exhibition*, Society of Independent Artists, Grand Central Palace, New York (also exhibited 1918, 1921-1924, 1941)

1917 *Imaginative Paintings by Thirty Young Artists of New York City*, Knoedler Galleries, New York

1922 *William and Marguerite Zorach: Paintings, Watercolors, Embroideries, Prints, Batiks*, Dayton Museum of Art, Ohio

## SELECTED BIBLIOGRAPHY

Hoffman, Marilyn Friedman. *Marguerite and William Zorach: The Cubist Years, 1915-1918*. Hanover, New Hampshire: University Press of New England for Currier Gallery of Art, 1987. Exh. cat.

*Marguerite Zorach*. New York: Kraushaar Galleries, 1962. Exh. cat.

*Marguerite Zorach: The Early Years, 1908-1920*. Text by Roberta K. Tarbell. Washington, D.C.: Smithsonian Institution Press, 1973. Exh. cat.

Tarbell, Roberta K. *William and Marguerite Zorach: The Maine Years*. Rockland, Maine: William A. Farnsworth Library and Art Museum, 1979. Exh. cat.

## WILLIAM ZORACH (1889-1966)

William Zorach was born on February 28, 1889, in Euberick, Lithuania. His family immigrated to the United States in 1893, eventually settling in Cleveland, Ohio. There his father peddled secondhand goods and the family took in boarders. In 1902 Zorach left school to apprentice at a lithography shop. By 1907 Zorach was in New York, where he studied at the National Academy of Design and briefly at the Art Students League. The artist left for Europe in 1910, and once in Paris he met the sculptor Constantin Brancusi. Brancusi's method of direct carving would later have a major impact on Zorach's sculpture. At this time, however, Zorach focused on painting and exhibited at the *Salon d'Automne* of 1911. He also studied art at La Palette, where he met his future wife, Marguerite Thompson. Influenced by her modernist paintings, Zorach soon simplified forms and employed Expressionist colors in his own canvases.

Zorach returned to Cleveland in 1911, where his first solo show was held at the Taylor Gallery. In December of 1912 he returned to New York. The Zorachs were married that year and soon settled into an apartment and studio in Greenwich Village. The following year Zorach participated in the Armory Show and around the same time taught at the Educational Alliance. The Zorachs attended informal art classes and discussions led by Robert Henri and George Bellows at the anarchist Ferrer Center. Between 1916 and 1918 Zorach exhibited paintings in a number of People's Art Guild exhibitions and in 1916 was included in the *Forum Exhibition*. The summer of that year Zorach lived and painted in Provincetown, Massachusetts, where he met the artists Marsden Hartley and Charles Demuth and the writer Hutchins Hapgood. The Zorachs acted in and designed sets and costumes for productions of the Provincetown Players, whose members included Communist author John Reed and playwright Eugene O'Neill. Around this time the Zorachs also met the painter Bernar Gussow and the sculptor Gaston Lachaise, who became a particularly close friend.

In 1917 Zorach made his first serious sculpture. His paintings and carvings of the late teens reflect a strong interest in the angular, faceted surfaces of Cubism and African art. Beginning in the twenties, Zorach taught art at numerous progressive schools in New York. In 1922 he abandoned oil painting completely. The following year he purchased a summer house in Maine. Around this time Zorach began to carve directly in stone, creating rounder, more volumetric sculptures. His figures and family groups have a static monumentality reminiscent of Egyptian and Archaic Greek sculpture. In the later twenties, the Zorachs spent summers at Perkins Cove in Ogunquit, Maine, an artists' colony established by the critic and gallery owner Hamilton Easter Field. Samuel and Edith Halpert were other summer residents of the colony. Starting in 1929 Zorach taught at the Art Students League in New York for thirty years.

A solo exhibition of Zorach's work was held at Edith Halpert's Downtown Gallery in 1931. In 1932 the artist submitted a design for the Lenin Memorial competition in Moscow and was commissioned to create *Spirit of the Dance* for Radio City Music Hall in New York. From 1935 to 1937, Zorach worked on the WPA/FAP and the Section of Fine Arts for the Treasury Department. During World War II the artist began to depict Jewish subjects, as in *Head of a Prophet* (1946). The Whitney Museum of American Art organized a traveling exhibition of Zorach's work in 1959. The artist died in Maine in 1966.

## SELECTED SOLO EXHIBITIONS

## SELECTED GROUP EXHIBITIONS

1930    *33 Moderns,* Grand Central Art Galleries, New York

1932    *Biennial Exhibition,* Whitney Museum of American Art, New York (also exhibited 1933, 1934, 1936-1939, 1941-1950)

1938    *First Exhibition of Painting, Sculpture, Graphic Arts and Yiddish Books and Press,* World Alliance for Yiddish Culture (Yiddisher Kultur Farband), New York

1946    *Pioneers of Modern Art in America,* Whitney Museum of American Art, New York

1950    *Jewish Artists—1950: Annual Exhibition,* Congress for Jewish Culture Art Center, The Jewish Museum, New York

1959    *American Painting and Sculpture: American National Exhibition in Moscow,* Sokolniki Park, Moscow, U.S.S.R.

1965    *Roots of Abstract Art in America 1910-1930,* National Collection of Fine Arts, Smithsonian Institution, Washington, D.C.

1979    *Vanguard American Sculpture, 1913-1939,* Rutgers University Art Gallery, New Brunswick, New Jersey (traveled)

1987    *Marguerite and William Zorach: The Cubist Years, 1915-1918,* Currier Gallery of Art, Manchester, New Hampshire (traveled)

SELECTED BIBLIOGRAPHY

Baur, John I. H. *William Zorach.* New York: F. A. Praeger for the Whitney Museum of American Art, 1959. Exh. cat.

Hoffman, Marilyn Friedman. *Marguerite and William Zorach: The Cubist Years, 1915-1918.* Hanover, New Hampshire: University Press of New England for Currier Gallery of Art, 1987. Exh. cat.

Hoopes, Donelson F. *William Zorach: Paintings, Watercolors and Drawings, 1911-1922.* Brooklyn, New York: The Brooklyn Museum, 1969. Exh. cat.

Schwarz, Karl. *Jewish Artists of the 19th and 20th Centuries.* Freeport, New York: Books for Libraries Press, for the Philosophical Library, Inc., 1949, reprint 1970.

Tarbell, Roberta K. "Catalogue Raisonné of William Zorach's Carved Sculpture." Ph.D. dissertation, University of Delaware, 1976. Unpublished.

Zorach, William. *Art Is My Life.* Cleveland and New York: World Publishing Co., 1967.

# BIBLIOGRAPHY

*Additional bibliography and references to
monographic studies are provided in the
artists' biographies section of this catalogue.*

## ARCHIVAL SOURCES

The manuscripts and personal papers of many
of the artists in this exhibition are available at
the Archives of American Art, Smithsonian
Institution, Washington, D.C. Available on
microfilm at the Archives' New York branch.
See individual artists' biographies.

The manuscript archives of YIVO Institute
for Jewish Research and the Alfred Stieglitz
Collection at the Beinecke Rare Book and
Manuscript Library, Yale University Library,
have been invaluable, as have the vertical files
at the Whitney Museum of American Art,
New York, the Metropolitan Museum of Art,
New York, and the Museum of Modern Art,
New York.

## BOOKS, DISSERTATIONS,
## EXHIBITION CATALOGUES

### Art History

Armstrong, Tom. *200 Years of American
Sculpture*. New York: Whitney Museum of
American Art, 1976. Exh. cat.

Ashton, Dore. *The New York School: A Cul-
tural Reckoning*. New York: Viking Press, 1973.
Reprint, London: Penguin Books, 1985.

Auping, Michael et. al. *Abstract Expression-
ism: The Critical Developments*. New York:
Harry N. Abrams, Inc. in association with
Albright-Knox Art Gallery, 1987. Exh. cat.

Baigell, Matthew. *A Concise History of Ameri-
can Painting*. New York: Harper and Row,
1984.

Baigell, Matthew. *A History of American
Painting*. New York: Praeger Publishers, 1971.

Baigell, Matthew. *The American Scene:
American Painting During the 1930s*. New
York: Praeger Publishers, 1974.

Baigell, Matthew and Julia Williams. Editors.
*Artists Against War and Fascism: Papers of the
First American Artists' Congress*. New
Brunswick, New Jersey: Rutgers University
Press, 1986.

Berman, Greta and Jeffrey Wechsler. *Realism
and Realities: The Other Side of American
Painting, 1940-1960*. New Brunswick, New
Jersey: Rutgers University Art Gallery, Rutgers,
The State University of New Jersey, 1981.
Exh. cat.

Baur, John I. H. *Revolution and Tradition in
Modern American Art*. Cambridge, Massa-
chusetts: Harvard University Press, 1951.
Reprint, New York: Frederick A. Praeger,
1967.

Botwinick, Michael. Foreword. *Modernist Art
from The Edith and Milton Lowenthal Collec-
tion*. New York: The Brooklyn Museum, 1981.
Exh. cat.

Breeskin, Adelyn. *Roots of Abstract Art in
America, 1910-1930*. Washington, D.C.:
National Collection of Fine Arts, 1965. Exh.
cat.

Brown, Milton. *American Painting From the
Armory Show to the Depression*. Princeton, New
Jersey: Princeton University Press, 1955. First
Princeton paperback edition, 1970; second
printing, 1972.

Brown, Milton W. *The Story of the Armory
Show*. New York: Abbeville Press and the
Joseph H. Hirshhorn Foundation, 1988.

Cohen, Ronny. Introduction. *Realizmo a New
York Negli Anni Trenta*. Torino: Società
Editrice Umberto Allemandi & Co., 1990.

Cox, Annette. *Art-as-Politics: The Abstract
Expressionist Avant-Garde and Society*. Ann
Arbor, Michigan: UMI Research Press, 1982.

Davidson, Abraham A. *Early American Mod-
ernist Painting: 1910-1935*. New York:
Harper and Row, 1981.

*The Decade of the Armory Show, New Direc-
tions in American Art 1910-1920*. New York:
Whitney Museum of American Art, 1963.
Exh. cat.

*The Ebsworth Collection: American Modern-
ism 1911-1947*. St. Louis, Missouri: The Saint
Louis Art Museum, 1987. Exh. cat.

*The Educational Alliance Art School Retrospec-
tive Art Exhibit*. Preface by John I.H. Baur.
New York: The Educational Alliance, 1963.
Exh. cat.

*The Educational Alliance Art School Exhibi-
tion of Paintings and Sculpture*. Preface by Abbo
Ostrowsky. New York: The Educational Alli-
ance, Associated American Artists Galleries,
1940. Exh. cat.

Embick, Lucy. "The Expressionist Current in
New York's Avant-Garde: The Paintings of
'The Ten.'" M.A. Thesis, University of Or-
egon, 1982. Unpublished.

*The Forum Exhibition of Modern American
Painting*. New York: Anderson Galleries,
1916. Exh. cat.

Frank, Waldo, Lewis Mumford, Dorothy
Norman, Paul Rosenfeld and Harold Rugg.
Editors. *America and Alfred Stieglitz: A Collec-
tive Portrait*. Garden City, New York:
Doubleday, Doran and Co., Inc., 1934.

Friedman, Martin L. *The Precisionist View in
American Art*. Minneapolis: Walker Art Cen-
ter, 1960. Exh. cat.

Geldzahler, Henry. *New York Painting and
Sculpture 1940-1970*. New York: Metropoli-
tan Museum of Art, 1970. Exh. cat.

Goodman, Susan T., *The Immigrant Genera-
tions: Jewish Artists in Britain, 1900-1945*. New
York: The Jewish Museum, 1983. Exh. cat.

Goodrich, Lloyd. *Pioneers of Modern Art in
America*. New York: Whitney Museum, 1963.
Exh. cat.

Goodrich, Lloyd and John I H. Baur. *American
Art of Our Century*. New York: Whitney
Museum, Frederick A. Praeger, 1961. Exh.
cat.

Guilbaut, Serge. Translated by Arthur
Goldhammer. *How New York Stole the Idea of
Modern Art: Abstract Expressionism, Freedom,
and the Cold War*. Chicago and London: The
University of Chicago Press, 1983.

Halasz, Piri. *The Expressionist Vision: A Cen-
tral Theme in New York in the 1940s*.

Greenvale, New York: Hillwood Art Gallery, School of the Arts, C.W. Post Center, Long Island University, 1983. Exh. cat.

Harrison, Helen A. and Lucy R. Lippard. *Women Artists of the New Deal Era: A Selection of Prints and Drawings*. Washington, D.C.: The National Museum of Women in the Arts, 1988. Exh. cat.

Heller, Nancy and Julia Williams. *The Regionalists*. New York: Watson-Guptill Publications, 1976.

Hills, Patricia. *The Artist's America*. New York: Whitney Museum of American Art, 1974. Exh. cat.

Hills, Patricia. *Social Concern and Urban Realism: American Painting of the 1930s*. Boston: Boston University Art Gallery, 1983. Exh. cat.

Hobbs, Robert Carleton and Gail Levin. *Abstract Expressionism, The Formative Years*. Ithaca, New York and New York: Herbert F. Johnson Museum of Art, Cornell University and Whitney Museum of American Art, 1978. Exh. cat.

Homer, William Innes. *Alfred Stieglitz and the American Avant-Garde*. Boston: New York Graphic Society, 1977.

Homer, William Innes. Editor. *Avant-Garde Painting and Sculpture in America, 1910-1925*. Wilmington, Delaware: Delaware Art Museum, 1975. Exh. cat.

Homer, William Innes, with the assistance of Violet Organ. *Robert Henri and His Circle*. Ithaca, New York: Cornell University Press, 1969.

Hunter, Sam and John Jacobus. *American Art of the 20th Century*. New York: Harry N. Abrams, Inc. and Englewood Cliffs, New Jersey: Prentice-Hall, n.d.

*Jewish Art Center: Aims and Aspirations*. New York: Congress for Jewish Culture, n.d.

*Jewish Experience in the Art of the Twentieth Century*. New York: The Jewish Museum, 1975. Exh. cat.

Johnson, Una E. *American Prints and Printmakers*. New York: Doubleday & Co., 1980.

Kampf, Avram. *Contemporary Synagogue Art*. Philadelphia: The Jewish Publication Society, 1965.

Kampf, Avram. *Jewish Experience in the Art of the 20th Century*. South Hadley, Massachusetts: Bergin and Garvey, Publishers, Inc., 1984. [revised edition, *Chagall to Kitaj: Jewish Experience in 20th Century Art*. London: Lund Humphries in Association with the Barbican Art Gallery, 1990. Exh. cat.]

King, Lyndel. Introduction. *American Paintings and Sculpture in the University Art Museum Collection*. Minneapolis: University of Minnesota, 1986.

Landsberger, Franz. *A History of Jewish Art*. Cincinnati: Union of American Hebrew Congregations, 1946. Revised edition, Port Washington, New York, and London: Kennikat Press, 1973.

Lane, John R. and Susan C. Larsen. Editors. *Abstract Painting and Sculpture in America, 1927-1944*. Pittsburgh and New York: Museum of Art, Carnegie Institute, in association with Abrams, 1983. Exh. cat.

Larkin, Oliver W. *Art and Life in America*. New York: Rinehart and Company, Inc. 1949. Second revised edition, New York: Rinehart and Company, Inc., 1960.

Levin, Gail. *Synchromism and American Color Abstraction 1910-1925*. New York: Braziller, 1978. Exh. cat.

Lowe, Sue Davidson. *Stieglitz: A Memoir/Biography*. London: Quartet/Or Books, 1983.

Lozowick, Louis. *One Hundred Contemporary American Jewish Painters and Sculptors*. New York: YKUF Art Section, 1947.

Mann, Vivian and Norman L. Kleeblatt. Editors. *Treasures of the Jewish Museum*. New York: Universe Books, 1986.

Mayer, L. *Bibliography of Jewish Art*. Edited by Otto Kurz. Jerusalem: Magnes Press, the Hebrew University, 1967.

McBride, Henry. *The Flow of Art: Essays and Criticisms of Henry McBride*. New York: A Chancellor Hall book published by Athenaeum Publishers, 1975.

McCabe, Cynthia Jaffe. *The Golden Door: Artist-Immigrants of America, 1876-1976*. Washington, D.C.: Smithsonian Institution Press, 1976. Exh. cat.

McKinzie, Richard D. *The New Deal for Artists*. Princeton: Princeton University Press, 1973.

Mecklenburg, Virginia M. *The Patricia and Phillip Frost Collection: American Abstraction 1930-1945*. Washington, D.C.: Smithsonian Institution Press, 1989. Exh. cat.

O'Connor, Francis V. Editor. *Art for the Millions: Essays from the 1930s by Artists and Administrators of the WPA Federal Art Project*. Greenwich, Connecticut: New York Graphic Society, Ltd., 1973.

O'Connor, Francis V. Editor. *The New Deal Art Projects: An Anthology of Memoirs*. Washington, D.C.: Smithsonian Institution Press, 1972.

O'Gorman, James F. Editor. *Aspects of American Printmaking, 1800-1950*. Syracuse, New York: Syracuse University Press, 1988.

Olson, Arlene R. *Art Critics and the Avant-Garde: New York, 1900-1913*. Ann Arbor, Michigan: UMI Research Press, 1975, 1980.

*Paris and the American Avant-Garde, 1900-1925*. Foreword by Frederick J. Cummings. Lansing, Michigan: John Henry Company for the Detroit Institute of Arts, in coordination with the University of Michigan Publications Office, 1980. Exh. cat.

Park, Marlene and Gerald E. Markowitz. *New Deal For Art: The Government Art Projects of the 1930s with Examples from New York City and State*. New York: The Gallery Association of New York State, 1977. Exh. cat.

Petruck, Peninah R. Y. "American Art Criticism, 1910-1939." Ph.D. dissertation, New York University, 1979; New York: Garland Publishing, Inc., 1981.

Pisano, Ronald G. *The Art Students League: Selections from the Permanent Collection*. Biographical essays by Beverly Rood. Hamilton, New York: Gallery Association of New York for the Heckscher Museum, 1987. Exh. cat.

Rashell, Jacob. *Jewish Artists in America*. New York: Vantage Press, 1967.

Ritchie, Andrew Carnduff. *Abstract Painting and Sculpture in America*. New York: Museum of Modern Art, 1951. Exh. cat.

Rose, Barbara. *American Art Since 1900*. Revised edition, New York: Praeger, 1975.

Rosenau, H. *A Short History of Jewish Art*. London: J. Clarke, 1948.

Roth, Cecil. *Jewish Art: An Illustrated History*. Greenwich, Connecticut: New York Graphic Society Ltd., 1961. Revised edition, 1971.

Rubinstein, Charlotte Streifer. *American Women Artists*. Boston: G.K. Hall and Co., 1982.

Sandler, Irving. *The Triumph of American Painting: A History of Abstract Expressionism*. New York: Harper and Row, 1970.

Schwarz, Karl. *Jewish Artists of the 19th and 20th Centuries*. Freeport, New York: Books for Libraries Press, for the Philosophical Library, Inc., 1949, reprinted 1970.

Shapiro, David. Editor. *Social Realism: Art as a Weapon*. New York: Frederick Ungar, 1973.

Shapiro, David and Cecile Shapiro. *Abstract Expressionism: A Critical Record*. Cambridge, England: Cambridge University Press, 1990.

*Story of Jewish Art*. New York: Office of Jewish Information, American Jewish Congress, 1946.

Strauss, H. *Die Kunst der Juden im Wandel Der Zeit und Umwelt - Das Judenproblem im Spiegel der Kunst.* Tübingen, Germany: Verlag Ernst Wasmuth, 1972.

*Synchromism and Related Color Principles in American Painting 1910-1930.* New York: Museum of Modern Art, 1967. Exh. cat.

Tashjian, Dickran. *Skyscraper Primitives: Dada and the American Avant-Garde, 1910-1925.* Middletown, Connecticut: Wesleyan University Press, 1975.

Taylor, Joshua C. *America as Art.* New York: Harper and Row, 1976. Exh. cat.

Taylor, Joshua C. *The Fine Arts in America.* Chicago: The University of Chicago Press, 1969.

Tepfer, Diane. "Edith Gregor Halpert and the Downtown Gallery: 1926-1940; A Study in American Art Patronage." (Volumes I and II). Ph.D. dissertation, University of Michigan, 1989. Unpublished.

Todd, Ellen Wiley. "Gender, Occupation and Class in Paintings by the Fourteenth Street School, 1925-1940." Ph.D. dissertation, Stanford University, 1987. Unpublished.

Tsujimoto, Karen. *Images of America: Precisionist Painting and Modern Photography.* Seattle and London: University of Washington Press, 1982. Exh. cat.

Watrous, James. *A Century of American Printmaking, 1880-1980.* Poughkeepsie, New York: Apollo, 1987.

Weichsel, John. "People's Art Guild." M.A. thesis, Hunter College, City University of New York, 1965. Unpublished.

Whiting, Cécile. *Antifascism in American Art.* New Haven and London: Yale University Press, 1989.

Wilson, Richard Guy, Dianne H. Pilgrim and Dickran Tashjian. *The Machine Age in America 1918-1941.* New York: Abrams, 1986. Exh. cat.

Wischnitzer, Rachel. *Synagogue Architecture in the United States.* Philadelphia: The Jewish Publication Society, 1955.

Zilczer, Judith Katy. "The Aesthetic Struggle in America, 1913-1918: Abstract Art and Theory in the Stieglitz Circle." Ph.D. dissertation, University of Delaware, 1975. Unpublished.

Zurier, Rebecca. *Art for the Masses: A Radical Magazine and its Graphics, 1911-1917.* Philadelphia: Temple University Press, 1988. Based on the catalogue of an exhibition organized by the Yale University Art Gallery, 1985-1986.

*Social, Cultural and Historical Background*

Abrahams, Edward. *The Lyrical Left: Randolph Bourne, Alfred Stieglitz and the Origins of Cultural Radicalism in America.* Charlottesville: University Press of Virginia, 1986.

*The American Jewish Experience.* Philadelphia: National Museum of Jewish History, 1989. Exh. cat.

Avrich, Paul. *Anarchist Portraits.* Princeton: Princeton University Press, 1988.

Avrich, Paul. *The Modern School Movement: Anarchism and Education in the United States.* Princeton: Princeton University Press, 1980.

Baumgarten, Murray. *City Scriptures: Modern Jewish Writing.* Cambridge, Massachusetts: Harvard University Press, 1982.

Bellow, Adam. *The Educational Alliance: A Centennial Celebration.* New York: Educational Alliance, 1990.

*Biographical Encyclopedia of American Jews.* New York: M. Jacobs and L.M. Glassman, 1935.

Doroshkin, Milton. *Yiddish In America: Social and Cultural Foundations.* Rutherford, New Jersey: Fairleigh Dickinson University Press, 1969.

*Encyclopedia Judaica.* Jerusalem: Keter Publishing House, Ltd., 1972.

Hapgood, Hutchins. *The Spirit of the Ghetto.* New York: Funk and Wagnalls Co., 1902; New York: Schocken Books, 1966.

Harshav, Benjamin and Barbara. Translated with the participation of Kathryn Hellerstein, Brian McHale and Anita Norich. *American Yiddish Poetry: A Bilingual Anthology.* Berkeley, Los Angeles, London: University of California Press, 1986.

Howe, Irving and Lewis Coser. *The American Communist Party: A Critical History (1919-1957).* Boston: Beacon Press, 1957.

Howe, Irving and Kenneth Libo. *How We Lived: A Documentary History of Immigrant Jews in America, 1880-1930.* New York: Richard-Marek Publishers, 1979.

Howe, Irving, with the assistance of Kenneth Libo. *World of Our Fathers.* New York: Touchstone Book published by Simon and Schuster, 1976.

Liebman, Arthur. *Jews and the Left.* New York: John Wiley and Sons, 1979.

Peeler, David P. *Hope Among Us Yet: Social Criticism and Social Solace in Depression America.* Athens, Georgia: University of Georgia Press, 1987.

Rischin, Moses. *The Promised City, New York Jews, 1870-1914.* Cambridge, Massachusetts: Harvard University Press, 1962.

Rose, Peter I. Editor. *The Ghetto and Beyond: Essays on Jewish Life in America.* New York: Random House, 1969.

Rosenfeld, Paul. *Port of New York: Essays on Fourteen American Moderns.* New York: Harcourt, Brace and Company, 1924.

Roskolenko, Harry. *The Lower East Side, 1900-1914: An Intimate Chronicle by Harry Roskolenko.* New York: The Dial Press, 1971.

Saperstein, Jeffrey. "A Craving for History: Immigrant Themes in Jewish-American Literature." Ph.D. dissertation, University of New Hampshire, 1984. Unpublished.

Schoener, Allon. Editor. *The Lower East Side: Portal to American Life (1870-1924).* New York: The Jewish Museum, 1966. Exh. cat.

Schoener, Allon. Editor. *Portal to America: The Lower East Side, 1870-1925.* New York: Holt, Rinehart, and Winston, 1967.

*Souvenir Book of the Fair in Aid of the Educational Alliance and the Hebrew Technical Institute.* New York, 1895.

Wertheim, Arthur Frank. *New York Little Renaissance: Iconoclasm, Modernism and Nationalism in American Culture, 1908-1917.* New York: New York University Press, 1976.

**ARTICLES**

*Art History*

Amishai-Maisels, Ziva. "The Jewish Jesus." *Journal of Jewish Art* 9 (1982): 84-104.

Anderson, Maxwell. "Do Immigrants Beat Us At the Artistic Game?" *New York Globe* (June 29, 1919): 12.

"The Art Students League, Part I." *Archives of American Art Journal* 13, 1 (1973): 1-25.

"The Art Students League, Part II." *Archives of American Art Journal* 13, 2 (1973): 1-17.

Baigell, Matthew. "American Art and National Identity: The 1920s." *Arts* 61, 6 (February 1987): 48-55.

Baigell, Matthew. "The Beginnings of 'The American Wave' and the Depression." *The Art Journal* 27, 4 (Summer 1968): 387-397.

Benson, Gertrude. "Art and Social Theories." *Creative Art* 12, 3 (March 1933): 216-218.

Corn, Wanda M. "Coming of Age: Historical Scholarship in American Art." *The Art Bulletin* 70, 2 (June 1988): 188-207.

Dervaux-Travis, Isabelle. "The Ten (1935-1939)." Talk presented at the